Ceramics in America

CERAMICS

IN AMERICA

2010

Edited by Robert Hunter
and Luke Beckerdite

Photography by Gavin Ashworth

Published by the CHIPSTONE FOUNDATION

Distributed by University Press of New England

Hanover and London

Cover Illustration: Bowl, attributed to
Solomon Loy, Alamance County,
North Carolina, 1825–1840. Lead-glazed
earthenware. D. 6³⁄₁₆". (Private collection;
photo, Gavin Ashworth.)

Endpapers: Details of the post-production
marks on the back of two dishes, Alamance
County, North Carolina, 1790–1820.
(Courtesy, Old Salem Museums &
Gardens and private collection; photo,
Gavin Ashworth.)

Design: Wynne Patterson, VT
Copyediting: Mary Gladue, CT
Proofreading: Fronia W. Simpson, VT
Type: Aardvark Type, CT
Printing: Meridian Printing, RI

Published by the Chipstone Foundation
Distributed by University Press of New England
1 Court Street
Lebanon, New Hampshire 03766

© 2010 by the Chipstone Foundation
All rights reserved
Printed in United States of America
ISSN 1533-7154
ISBN 0-9767344-6-8

Contents

Editorial Statement

Ceramics in America is an interdisciplinary journal intended for collectors, historical archaeologists, curators, decorative arts students, social historians, and studio potters. We seek articles on the broad role of historical ceramics in the American context, including essays on ceramic history, archaeological research, technology, social history, studio pottery, and collecting. Further information about this process can be found at the Chipstone Foundation's website, www.chipstone.org. Authors are encouraged to contact the editor before submitting materials.

Of particular interest are submissions regarding new ceramic discoveries; these statements should be limited to five hundred words and one or two high-quality illustrations. Authors should contact New Discoveries editor Merry Abbitt Outlaw directly, at xkv8rs@aol.com.

The Chipstone Foundation offers significant honoraria for full-length manuscripts accepted for publication and reimburses authors for photography that is approved in writing by the editor.

If an article is accepted for publication, the author will be asked to submit photocopies of the title page and copyright page for all cited published sources. Authors are encouraged to provide digital files for all images, along with permission to reprint. Low-resolution digital images or photographs of poor quality will not be accepted for publication.

Questions and comments from readers and authors are welcome.

Robert Hunter
Editor, Ceramics in America
P.O. Box 114
Yorktown, Va. 23690
CeramicJournal@aol.com

Preface

▼ DURING THE LAST five years, Old Salem Museums & Gardens, the Chipstone Foundation, and the Caxambas Foundation have collaborated on *Art in Clay*, an ambitious project encompassing a traveling exhibition of North Carolina earthenware masterworks, two volumes of *Ceramics in America*, an online virtual tour, and an Internet-accessible database of information and images of more than six hundred objects. The show opens in Milwaukee in September 2010, then travels to the Horton Center in Old Salem, the DeWitt Wallace Decorative Arts Museum at Colonial Williamsburg, and the Huntsville Museum of Art in Alabama.

The educational initiatives associated with *Art in Clay* required the commitment of three organizations and a dedicated and diverse group of museum scholars and independent professionals. From the outset, our goal has been to reach the widest possible audience and the incorporation of multiple interpretive voices will help make this happen. In the twenty-first century, museums and other educational organizations must dedicate themselves to interacting with their audiences and with each other by supporting new research and disseminating it through creative exhibitions, thought-provoking publications, and relevant websites and networks.

Old Salem Museums & Gardens, the Chipstone Foundation, and the Caxambas Foundation firmly believe that the collaborative process yields innumerable benefits for all parties involved, and we will continue to cultivate partnerships of this sort in the years to come.

Jonathan Prown
Executive Director, Chipstone Foundation

Lee L. French
President, Old Salem Museums & Gardens

Martha Parker
President, Caxambas Foundation

Robert Hunter

Introduction

▼THE 2009 AND 2010 issues of *Ceramics in America* examine the eighteenth- and nineteenth-century earthenware traditions of the North Carolina piedmont. The 2009 volume focuses on eighteenth- and nineteenth-century Moravian potters and the products they made in the Bethabara and Salem communities. The 2010 volume addresses current pre(and mis)conceptions of North Carolina slipware by identifying other potters who worked in the piedmont concurrently with the Moravians. These revelations, which document several community-based potting traditions organized along family lines, alter current attributions. In tandem, the two volumes serve as a compendium catalog for the traveling exhibition *Art in Clay: Masterworks of North Carolina Earthenware,* jointly sponsored by Old Salem Museums & Gardens, the Chipstone Foundation, and the Caxambas Foundation.

The importance of the 2010 volume for students of American ceramic history cannot be overstated. Prior to the outcome of this research effort, pottery that was slip-decorated and thought to have originated in the South was almost universally labeled with the term "Moravian." For the past three or four decades, major auction houses, museum curators, and prominent dealers have erroneously attributed this southern genre of ceramics, as can be seen in a review of any collector's guide or Americana auction catalog written during this period. Historical research has suggested that dozens of potters worked in the various communities throughout the North Carolina piedmont, yet linking their names to specific pots has been difficult. Scholars usually have assumed that many of the potters working outside the Moravian communities only made unembellished utilitarian wares.

Archaeology has led the way in rewriting North Carolina's ceramic history with the excavation of several key potteries within a radius of sixty miles of the Moravian centers. The findings have shown without question that some of the most ambitious slip-decorated earthenware in America from the late eighteenth and early nineteenth centuries was made by other piedmont potters. Beyond archaeology, however, the current volume is distinguished by its reflection of a comprehensive interdisciplinary effort, drawing on art history, social history, oral history, and materials science. It is hoped that this transdisciplinary approach will serve as the model for future initiatives in the research of other American regional ceramic traditions.

As with most new research, the information presented in these volumes builds on earlier scholarship. Unfortunately, many scholars wait a lifetime

before publishing their findings rather than risk being found wrong or overruled in their conclusions. Fortunately for the history of scholarship and collecting of North Carolina earthenware, a good record exists of the institutions and individuals who first recognized the importance of these distinctively southern products. In "Collectors and Scholars of North Carolina Earthenware," the opening essay of this volume, Luke Beckerdite and Robert Hunter pay homage to those who have paved the way—yet remain fully aware that future research and new discoveries will undoubtedly improve and expand on what is presented herein.

The second article, written by Luke Beckerdite, Johanna Brown, and Linda F. Carnes-McNaughton, best summarizes the new classification paradigm for North Carolina earthenware. The authors identify a group of potters named for the area in and around the St. Asaph's district of Orange County, which is now southern Alamance County. Their study of this group revealed numerous non-Moravian potters who produced a diverse variety of vessel forms and decorative schemes, a tradition so prolific, in fact, as to suggest that much of the antique slipware previously identified as Moravian should now be firmly attributed to the St. Asaph's potters. In addition to identifying the functional and decorative attributes of the earthenware made in this region, the authors have developed a cultural narrative about this community of immigrants of Germanic origin that was preserved through kinship, apprenticeship, and social networks. Of particular note is their recognition of the culturally significant, French-inspired cruciform motif used by these potting families. Among the most important craftsmen are members of the Albright and Loy families, who maintained their cultural identity through generations of potting pursuits.

Hal Pugh and Eleanor Minnock-Pugh, themselves working potters, further the story of North Carolina earthenware in "The Quaker Ceramic Tradition in Piedmont North Carolina," a comprehensive overview of the history of Quaker potters who served communities in Randolph and Guilford counties. In the mid- and late eighteenth centuries these areas saw a large influx of Quakers settlers from the mid-Atlantic and New England states that not only included potters but also established a ready-made market for their wares. The authors' extensive and years-long research is based on the excavation of pottery sites and kiln structures, genealogical and historical studies, and the documentation and reattribution of extant wares. Their work provides not only a glimpse of the wares left behind by these prolific potting families but in some cases has unearthed actual photographs of and written words by these undercelebrated craftspeople.

Going from these general overviews to specific case studies, the next two articles examine makers from each of these two traditions. Linda F. Carnes-McNaughton presents information about Solomon Loy, a long-standing member of that potting family from the St. Asaph's tradition. Loy made both salt-glazed stoneware and lead-glazed earthenware, and archaeological evidence gathered by Carnes-McNaughton demonstrates that he built very sophisticated kilns, made a wide variety of forms, and employed a variety of slip-decorating techniques. The author also identifies a large

number of intact surviving objects from Loy's tenure using the ceramic fragments recovered from his kiln sites. This study confirms Loy's continued use of the cruciform motif in his slip decorating, a motif that was central in the work of earlier potters in the St. Asaph's tradition. Another exciting, aesthetically innovative embellishment is Loy's "dripped" decoration, achieved when several colors of slip were arbitrarily dropped onto the clay surface to create an abstract and surprisingly modern effect.

In the second case study, Hal Pugh and Eleanor Minnock-Pugh examine the earthenware forms and decoration of Quaker potters William Dennis and his son Thomas in what is now northern Randolph County. The Pughs' expertise as potters is evident, as they are able to identify the hands of three separate potters from the sherds recovered from the William Dennis pottery site in the course of archaeological examination of the kiln and related features. Working with minuscule fragments, the Pughs used their informed potting skills to replicate whole dishes to fully illustrate some of the Dennis wares. It is clear that these Quaker potters not only made more than unadorned utilitarian pottery, but their slip-decorated wares rank as some of the most distinctively designed and executed ceramics produced in all America.

Ceramic historians usually have relied on traditional methods of connoisseurship to divine the origin of unsigned or otherwise unattributed objects, and even though for decades techniques have existed to provide scientific analysis of clay bodies and glazes, this type of study has been surprisingly slow to catch on in America. The utility of implementing such a rigorous analytic approach to the problem of identifying North Carolina earthenware is presented by Victor Owen and John Greenough in their article "Mineralogical and Geochemical Characterization of Eighteenth-Century Moravian Pottery from North Carolina." While the title might sound daunting to the average ceramic enthusiast, the underlying premise is fairly simple to understand. The mineralogical composition of clay varies from one geographic location to another. Assuming that local and regional potters exploited the clay from their immediate vicinity, the finished products of a particular location should have the same compositional fingerprint. Using selected samples of pottery excavated from six North Carolina potworks and samples from the Moravian potteries in Bethlehem, Pennsylvania, Owen and Greenough advocate that such analysis, by using the mineralogical composition of the clay to narrow its source, could have great value in identifying unattributed pots. The recent development of hand-held portable X-ray fluorescence (XRF) devices greatly expands the possibility of safely obtaining such data from intact objects residing in private and public collections.

From using the most technological advanced techniques, we turn to the practiced eye of a master potter to inform us about the attribution of pots. In her beautifully illustrated article "Making North Carolina Earthenware" Mary Farrell demonstrates how a Moravian slipware dish is constructed differently from an Alamance County one. Master potters Mary and David Farrell have spent nearly thirty years studying and reproducing various

examples of North Carolina earthenware. Through their work, the Farrells have provided independent confirmation that many of the attributions of published North Carolina slipware in the last four decades were wrong. The Farrells for years had relied on standard reference books and actual examples housed in both museum and private collections to create reproductions for their business in Seagrove, North Carolina. During the replication process, Mary puzzled over numerous contradictions in the shapes, profiles, and rim styles often attributed to a single pottery. Furthermore, like a handwriting expert deciphering written scripts, she was able to detect inconsistencies in slip-trailing styles among the published group of wares identified as North Carolina Moravian. The detective work of the Farrells reinforces the key visual elements that distinguish the various piedmont potters and confirms the importance of consulting working potters in the course of historical ceramic studies.

A shorter technology article follows, written by Michelle Erickson and Robert Hunter, which illustrates a distinctive striped and marbled slip-decorating technique that seems to have been unique to the eighteenth-century Moravian potters working at Bethabara and Salem and Jacob Meyers at the Mount Shepherd pottery in Randolph County. The technique differs significantly from the carefully trailed floral imagery associated with Moravian slipware. Recent research by Brenda Hornsby Heindl, a graduate student at Winterthur, suggests that the early Pennsylvania Moravian potters also employed similar decoration on small bowls and dishes. Most intriguing, evidence of a nearly identical technique was found on circa 1720–1745 dish fragments excavated at the pottery of William Rogers in Yorktown, Virginia. Perhaps future researchers will take up the challenge to study the geographic distribution of this distinctive decoration in order to fully understand its origins and cultural context.

Future students of North Carolina earthenware will benefit from new information gleaned from a variety of sources including archaeological findings and specimens identified in private collections, public auctions, and estate sales. One such new discovery occurred while the 2009 *Ceramics in America* was being printed. A previously unrecorded Moravian turtle bottle came up for sale at a North Carolina public auction, and although hundreds of figural earthenware bottles were made in the Salem workshop under master potter Rudolph Christ, the dark green turtle bottle is one of only four known. Johanna Brown, whose 2009 article discussed these rare and iconic figural bottles, contributes a short note on the acquisition of this turtle bottle to the collections of Old Salem, home to America's foremost collection of Moravian decorative arts.

Another late-breaking research note is the reevaluation by Luke Beckerdite of a small, slip-decorated barrel or rundlet previously thought to be of Moravian origin. This is the only known North Carolina slip-decorated barrel, but its decoration is related to a dish attributed to the St. Asaph's tradition in Alamance County. The reassessment of the barrel underscores the diverse production of forms by these potters and offers hope that many additional objects will come to light.

A final new discovery made just prior to publication is offered by Hal Pugh and Eleanor Minnock-Pugh, who discuss a slip-decorated dish that descended through six generations of a North Carolina Quaker family. This remarkable dish had a paper label attached to the back, identifying the original owner as Hannah Piggott Davis, who lived between 1774 and 1812. The Pughs attribute the dish to the Dennis potteries in New Salem, North Carolina, and its decorative elements may serve as a Rosetta stone for other currently unattributed pieces.

The 2010 volume concludes with a visual index to the objects included in the *Art in Clay* exhibit. The exhibit opens in September 2010 at the Milwaukee Art Museum, then travels to Old Salem Museums & Gardens, Colonial Williamsburg, and the Huntsville Museum of Art. The exhibit showcases about 160 objects, approximately half of which are from Old Salem's comprehensive collection. The remaining objects are from regional archaeological labs, private collections, and such notable public collections as The Henry Ford and Colonial Williamsburg.

Currently in preparation is the North Carolina Earthenware Digital Database, a photographic resource comprising more than six hundred images that will be accessible through the Chipstone Foundation's website, www.chipstone.org. This much-anticipated database will offer researchers and scholars broad access to the extensive research and documentation undertaken for this project.

Acknowledgments

▼ T H E E D I T O R S wish to recognize the individuals and institutions that have contributed to the success of this project. In particular, we are grateful to the work and dedication of scholars who led the way in North Carolina earthenware research: Joe Kindig Jr., Stanley South, John Bivins Jr., Frank Horton, Brad Rauschenberg, and Charles G. Zug III.

Institutional assistance was provided by staff members of Old Salem Museums & Gardens, the Chipstone Foundation, The Henry Ford, the High Museum of Art, The Barnes Foundation, the Colonial Williamsburg Foundation, the Winterthur Museum, the North Carolina Pottery Center, and the Research Laboratories of Archaeology at the University of North Carolina, Chapel Hill.

Scholars and professionals who made exceptional contributions to this volume include Gavin Ashworth, Johanna Brown, Linda F. Carnes-McNaughton, Michelle Erickson, David Farrell, Mary Farrell, John Greenough, Eckhard Hensel, William Ivey, Eleanor Minnock-Pugh, Victor Owen, Bob Pearl, and Hal Pugh. We also recognize Mary Gladue, Wynne Patterson, Peggy Scholley, and Fronia W. Simpson for their talents and patience in the production of these volumes.

We are particularly grateful to the many private collectors who generously allowed their objects to be photographed and studied.

The editors especially appreciate the contributions of Jon Prown, executive director of the Chipstone Foundation; Lee French, president of Old Salem Museums & Gardens; and Martha Parker, president of the Caxambas Foundation. We relied on their encouragement and friendship throughout, and we are thankful for their support in bringing *Art in Clay* to a successful conclusion.

Ceramics in America

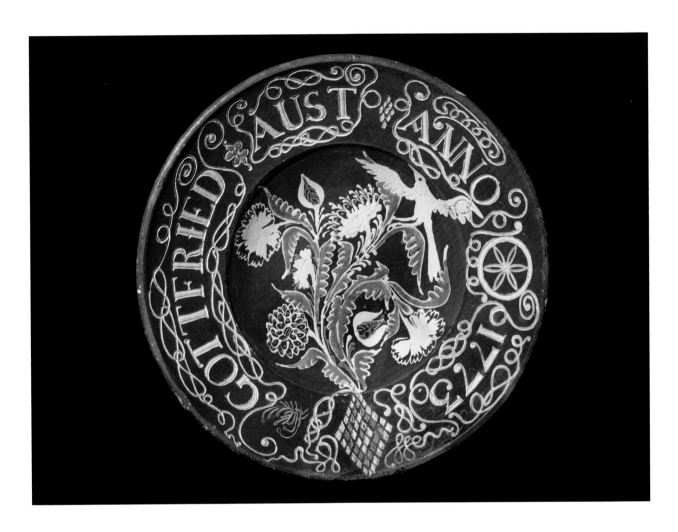

Figure 1 Shop sign made during Gottfried Aust's tenure as master of the pottery at Salem, North Carolina, 1773. Lead-glazed earthenware. D. 21¾". (Courtesy, Wachovia Historical Society; unless otherwise noted, photos by Gavin Ashworth.)

*Luke Beckerdite and
Robert Hunter*

Collectors and
Scholars of
North Carolina
Earthenware

▼ THE 2009 AND 2010 volumes of *Ceramics in America* are intended to serve as catalogs for *Art in Clay: Masterworks of North Carolina Earthenware,* a traveling exhibition co-sponsored by Old Salem Museums & Gardens, the Chipstone Foundation, and the Caxambas Foundation. As is the case with most new research, the information presented in these journals builds on earlier scholarship. This essay will examine the contributions of institutions and individuals who formed the first private and public collections of North Carolina earthenware and the scholars who first recognized the importance of that subject in the history of American ceramics.

Scholarly interest in the history of slipware transcends many centuries and world traditions. Numerous British ceramic historians writing in the nineteenth and early twentieth centuries lauded the artistic achievements of master potters Thomas and Ralph Toft while museums assembled landmark collections of highly decorative seventeenth- and eighteenth-century Staffordshire slipware.[1] In America, early ceramic historians also recognized slipware as a particularly significant artifact of indigenous manufacture. The most prominent of these early writers was Edwin Atlee Barber, who mined the Pennsylvania countryside in search of the sgraffito-decorated slipwares of the eighteenth- and nineteenth-century German settlements. Writing in 1893 Barber confessed, "there are no products of the potter's art more interesting to the antiquary and the collector than the rude 'slipware-decorated' pieces."[2] Barber recorded many early examples of dishes decorated with both sgraffito and slip trailing but restricted his research and attributions to the Pennsylvania German products.

Writing slightly later, in 1926, John Spargo, another American ceramic historian, also asserted that "of all the types of early American pottery, none merits the serious attention of the collector to a greater degree than the slip-decorated slipwares."[3] Spargo noted that after the publication of Barber's work, many antique dealers instigated the practice of attributing all American slipware to Pennsylvania, although, he confided, a "great deal of the slip-decorated pottery that is offered by dealers—and quite honestly—as Pennsylvania pottery was actually made in Connecticut."[4] Spargo also noted slipware production in New Jersey, New York, Vermont, Maryland, and Virginia, although he stopped short of acknowledging, at least geographically speaking, the existence of North Carolina slipware.

For many areas of the South, the history of collecting decorative arts has been predominantly regional. For those in the piedmont region of North Carolina, efforts to collect and preserve Moravian pottery began during the second half of the nineteenth century. A late-nineteenth-century issue of *People's Press* described "POTTERY AND PIPES" in the Forsyth County exhibit at the North Carolina State Fair:

> Past and present are combined in this department for there are plate molds bearing the stamp "R. C., Bethabara, 1788" and also 1789. Then there is a monster plate of earthenware used as a sign by Salem's first potter. Pipes of a dozen varieties, and of useful design, are exhibited by D. T. Crouse, the largest maker of them in the State. He also shows flowerpots, vases for lawns and mantels, cake molds, hanging baskets &c., all tasteful and cheap, and all the products of his potteries.[5]

The "monster plate" sign (fig. 1) appears to have been lent to the Forsyth County exhibit by the Young Men's Missionary Society of the Moravian Church, which between 1845 and 1895 assembled a collection of "curios from the mission fields, mineral specimens . . . stuffed birds, old coins, and local curiosities." The society subsequently donated its collection, which included the sign, to the Wachovia Historical Society, which in the first half of the twentieth century took the lead in collecting Moravian artifacts.

Figure 2 "Additions to Collection of Relics in 1907–8," Wachovia Historical Society, Salem, North Carolina, 1908. (Courtesy, Wachovia Historical Society.)

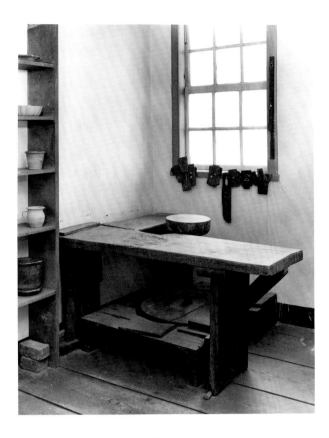

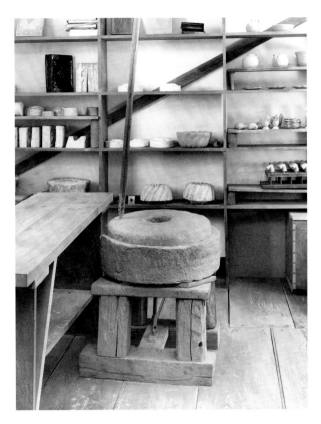

Figure 3 Potter's wheel, Bethabara or Salem, North Carolina, 1756–1800. (Courtesy, Wachovia Historical Society.)

Figure 4 Glaze mill, Bethabara or Salem, North Carolina, 1756–1800. (Courtesy, Wachovia Historical Society.)

Figure 5 Ribs, Bethabara or Salem, North Carolina, 1780–1820. Brass. (Courtesy, Wachovia Historical Society.)

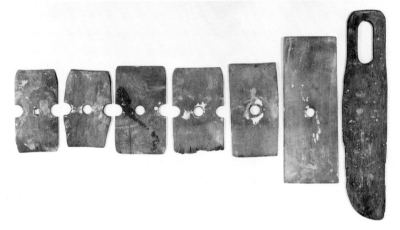

A 1908 report suggests that the molds exhibited at the North Carolina State Fair came from the Schaffner family (fig. 2), who apparently retained ownership of Heinrich Schaffner's pottery after it was taken over by Daniel Krause (Crouse). The report indicates that the Schaffners gave the Wachovia Historical Society a large group of tiles, molds, tools, and implements. All of these objects are currently in the collection of Old Salem Museums & Gardens under a custodial agreement with the historical society (figs. 3–5).[6]

The first serious scholar of North Carolina earthenware was Joe Kindig Jr., an antique dealer from York, Pennsylvania, who scoured the South for decorative arts during the depression era (fig. 6). By January 1935, when his

article "A Note on Early North Carolina Pottery" was published in *The Magazine Antiques*, Kindig had learned enough about the subject to form conclusions that remain accurate today (fig. 7). As one might expect, he was acutely aware of features that distinguished North Carolina earthenware from contemporaneous Pennsylvania work:

> I have never seen any *sgraffito* ware from North Carolina. All the decoration known to me is in slip. Nor have I seen any . . . plates bearing inscriptions, such as we frequently find in Pennsylvania. Such negative evidence, of course, does not afford proof that *sgraffito* and inscribed items were never made in North Carolina; but it is safe to say that they were, at least, very rarely produced.[7]

Kindig's observations about the range of clays and slip grounds used by North Carolina potters suggest that he had studied wares from most of the earthenware traditions in the piedmont region. His reference to "pieces whose body is almost white" most likely alluded to Moravian work, which

Figure 6 Photograph of Joe Kindig Jr., York, Pennsylvania, ca. 1960. Kindig was considered by many to be the most knowledgeable antique dealer of his generation.

Figure 7 Joe Kindig Jr., "A Note on Early North Carolina Pottery," *The Magazine Antiques* 27, no. 1 (January 1935): 15. The pitcher, large sugar pot, and dish are in the collection of The Henry Ford, Dearborn, Michigan; the small sugar pot, fat lamp, and mug are owned by Old Salem Museums & Gardens. All of the pottery illustrated in Kindig's article is now attributed to Alamance County, based on research presented in this volume of *Ceramics in America*.

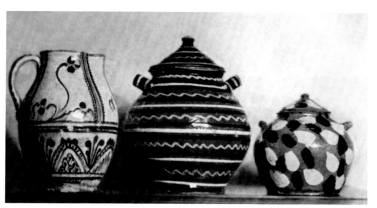

Fig. 3 — NORTH CAROLINA JUG AND SUGAR JARS
Left to right: Cream ground with red, black, and green slip decoration. *Height,* 11 inches. Red ground with cream, green, and black slip decoration. Pumpkin ground with black and cream slip decoration. Note horizontal placement of handles on jars

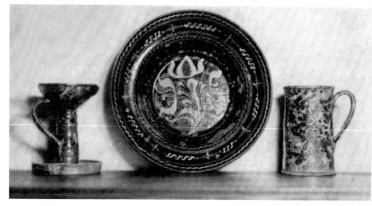

Fig. 4 — NORTH CAROLINA LAMP, PLATE, AND MUG
Left to right: Yellow-brown ground decorated in black, green, and cream slip. *Height,* 6 ½ inches. Black ground with cream, red, and green slip decoration. *Diameter,* 12 inches. Pumpkin ground mottled with black and cream slip

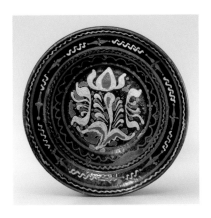

Figure 8 Dish, Alamance County, North Carolina, 1785–1810. Lead-glazed earthenware. D. 12½". (Courtesy, The Henry Ford.) Joe Kindig owned this dish and described it in "A Note on Early North Carolina Pottery" (fig. 7).

occasionally was made with clay that fired to a light buff color. Similarly, illustrations in Kindig's article and his description of objects with "chocolate" to "almost black" slip grounds (fig. 8) and "initials scratched on the back" attest to his familiarity with pottery from Alamance County.[8]

One of Kindig's most interesting observations pertains to the survival of "sugar jars," which he described as the most common form other than dishes. Although lidded containers could have been used for all manner of dry goods, he claimed to "have found several that still contained sugar" and noted that *sugar jar* was the term by which "these vessels are locally known."[9] Inventory research conducted for "Slipware from the St. Asaph's Tradition" by Luke Beckerdite, Johanna Brown, and Linda Carnes-McNaughton in this volume indicates that Alamance County appraisers began using the term *sugar pot* by the 1770s. Moreover, Kindig noted how the form of North Carolina sugar pots was distinctive:

> The lidded jars of Pennsylvania are of a different shape, with straighter sides, larger mouth, and proportionally more expansive lid. The handles of Pennsylvania jars are usually set vertically. North Carolina jar handles, on the contrary, are invariably horizontal and often extremely small.[10]

In fact, all of the sugar pots recorded for this volume of *Ceramics in America* conform to the profile Kindig established more than fifty years ago.

Many examples of North Carolina earthenware in private collections passed through Kindig's hands, but he also deserves credit for furnishing much of the North Carolina slipware on view in museum collections today. Objects illustrated in his January 1935 article and subsequent advertisement in *The Magazine Antiques* (fig. 9) are now in the collections of The Henry Ford, The Barnes Foundation, and Old Salem Museums & Gardens.

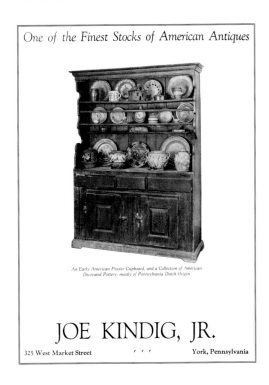

One of the Finest Stocks of American Antiques

An Early American Pewter Cupboard, and a Collection of American Decorated Pottery, mostly of Pennsylvania Dutch Origin

JOE KINDIG, JR.

325 West Market Street ' ' ' York, Pennsylvania

Figure 9 Advertisement by Joe Kindig Jr., *The Magazine Antiques* 27, no. 4 (April 1935): 121.

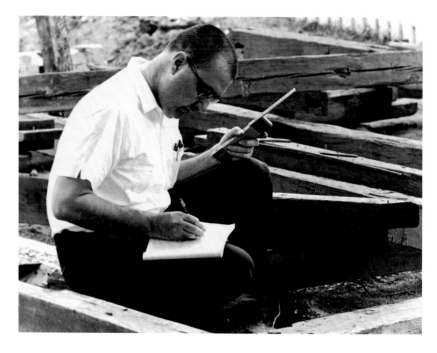

Since its establishment in 1950, Old Salem Museums & Gardens has become the center of the study of North Carolina earthenware. The person most directly responsible for that is Frank L. Horton (fig. 10), who supervised the restoration and reconstruction of approximately fifty buildings in Salem and Bethabara and acquired most of the furnishings for them (fig. 11).[11] Early accession records provide little information on the histories of ceramic objects in Old Salem's collection, but it is clear that Horton purchased a significant amount of earthenware from Kindig, then donated it to Old Salem.[12] One gift in 1959 included more than fifty examples (figs. 12, 13).

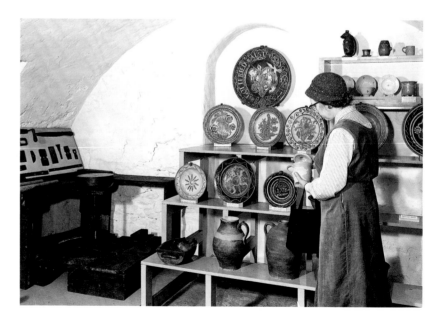

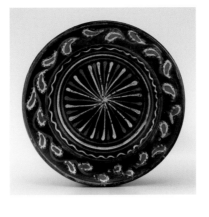

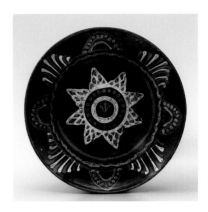

Figure 12 Dish, Alamance County, North Carolina, 1790–1820. Lead-glazed earthenware. D. 10⅞". (Courtesy, Old Salem Museums & Gardens.)

Figure 13 Dish, Alamance County, North Carolina, 1790–1820. Lead-glazed earthenware. D. 10". (Courtesy, Old Salem Museums & Gardens.)

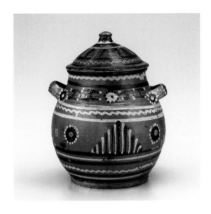

Figure 14 Sugar pot, Alamance County, North Carolina, 1790–1810. Lead-glazed earthenware. H. 10". (Courtesy, Old Salem Museums & Gardens.)

Figure 15 Stanley South, 2008. (Photo, Chester DePratter.)

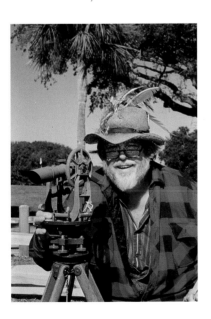

From the outset Horton recognized the artistic appeal of North Carolina earthenware. During the 1950s he displayed slipware in the bay window of the administration building to show the residents of Winston-Salem and visitors the types of objects Old Salem was collecting. One important local source was a man named Willie Jones. While walking from the Happy Hill community south of the restoration to downtown Winston-Salem, Jones noticed Horton's display and asked if Old Salem was interested in purchasing comparable objects. Horton answered affirmatively and Jones returned the following day with an Alamance County sugar pot (fig. 14) that he had gotten from an acquaintance; subsequently he sold Horton two other major pieces of slipware from the same source.[13]

Horton's research on Moravian decorative arts has contributed immensely to the study of North Carolina earthenware. To facilitate the restoration and interpretation of Bethabara and Salem, he created detailed profiles of virtually everyone who lived in those communities or was mentioned in the Moravian records. Comprising thousands of note cards filled with information transcribed from church documents, public records, and private papers, the files at Old Salem have served as the foundation for nearly every book and article written on Moravian decorative arts.[14] Without Horton's work, the groundbreaking research presented in the 2009 volume of this publication would not have been possible.

All of the books and articles written on Moravian pottery owe an enormous debt of gratitude to archaeologist Stanley South, who conducted excavations at Bethabara and Salem during the 1960s (fig. 15). The artifacts he recovered at sites in those communities are benchmarks for understanding the Moravian earthenware tradition and its historical context. Although his book *Historical Archaeology in Wachovia: Excavating Eighteenth-Century Bethabara and Moravian Pottery* was not published until 1999, the reports he prepared for the Bethabara excavations in 1966 and the Salem excavations in 1972 greatly informed the work of John Bivins Jr., Bradford Rauschenberg, and all of the authors who contributed to the 2009 volume of *Ceramics in America*.[15] South was also responsible for locating and publishing artifacts from the site of John Bartlam's manufactory in South Carolina. Journeymen from that manufactory were catalysts for the Moravians' efforts to produce creamware.

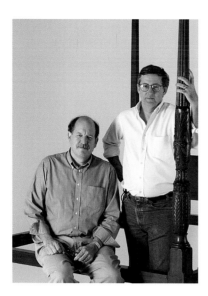

Figure 16 Photograph of John Bivins Jr. and Bradford Rauschenberg taken for the dust jacket of their book *The Furniture of Charleston, 1680–1820* (Winston-Salem, N.C.: Museum of Early Southern Decorative Arts, 2003).

John Bivins Jr. and Bradford L. Rauschenberg deserve equal billing as leading twentieth-century scholars of the Moravian earthenware tradition (fig. 16). Bivins's book *The Moravian Potters in North Carolina* and Rauschenberg's articles "Escape from Bartlam: The History of William Ellis of Hanley" and "Carl Eisenberg's Introduction of Tin-Glazed Ceramics to Salem, North Carolina, and Evidence for Early Tin-Glaze Production Elsewhere in North America" offer valuable insights on their subjects to this day.[16] Bivins's chapters on the master potters and their workmen may be the best account of the day-to-day operation of an early American pottery in print. Rauschenberg was the first scholar to argue that some of the slipware Bivins attributed to Rudolph Christ (see fig. 12) was not part of the Moravian tradition, a theory substantiated by articles on the St. Asaph's tradition and Solomon Loy in this volume.

Seventeen objects illustrated in *Moravian Potters in North Carolina* were part of an extensive collection assembled by George and Carolyn Waynick. From their house in Old Salem, they scoured the piedmont region of North Carolina for antiques, particularly those associated with the Moravians. The Waynicks generously allowed the staff of Old Salem Museums & Gardens and visiting scholars to study and publish their collection, which was featured in the June 1988 issue of *Early American Life*.[17]

As this volume of *Ceramics in America* reveals, much of the slipware formerly attributed to Moravian craftsmen was actually made by potters in other areas of the piedmont. Although misattributions have stifled research for more than half a century, scholars like Dorothy and Walter Auman (fig. 17) began to assemble information on non-Moravian potters during the 1960s. Descendants of potting families from the Seagrove area, the Aumans knew that the ceramic history of North Carolina was far less

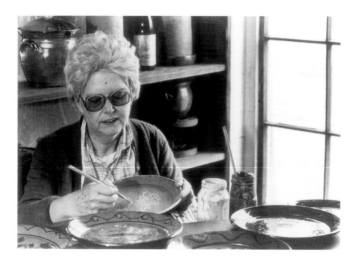

Figure 17 *Top*: Dorothy Auman, ca. 1982; *right*: Walter Auman, 1969. (Courtesy, Auman family.)

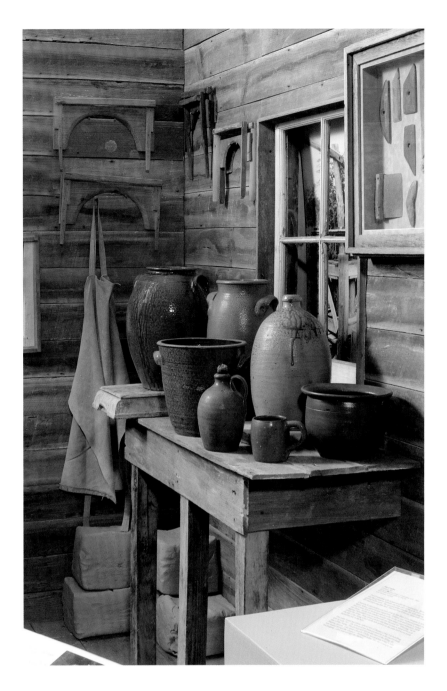

Figure 18 Interior view of the North Carolina Pottery Center, Seagrove, North Carolina, ca. 2008. This installation is reminiscent of the displays at the Seagrove Pottery Museum.

monolithic than most scholars assumed. They established the Seagrove Pottery Museum, in which they displayed an earthenware flask inscribed "Thos. Andrews 1784 (see fig. 18)." Oral tradition maintains that a Chatham County farmer uncovered the flask in a field and gave it to potter Charles C. Cole, Dorothy Auman's father. She later discovered that Andrews was a potter who left London at age thirty-five with the intention of settling in North Carolina.[18] The Aumans transferred ownership of many of the objects in their museum to The Mint Museum in Charlotte, North Carolina.

Figure 19 Charles G. Zug III, ca. 2004.

Inspired in part by the Aumans' love of piedmont ceramics, Professor Charles G. Zug III (fig. 19) was the first scholar to take a transdisciplinary approach in the study of North Carolina pottery. Although primarily focused on stoneware, his *Turners and Burners: The Folk Potters of North Carolina* has a chapter on earthenware that remains essential reading for anyone interested in that subject.[19] Most important, Zug's book shows that family and community were vital to the rural pottery trade, and accounts for the flourishing state of North Carolina's ceramic tradition today.

Scholarly interest in the products of North Carolina's piedmont potters will persist well into the twenty-first century. It is hoped that archaeological research will continue on the known production sites, that previously undocumented potteries will come to light, and that new, informative examples will continue turning up in private collections and estate sales. Just recently, a Moravian turtle bottle sold by a North Carolina auction house attracted national attention in the antique trade press.[20] It is further hoped that the publication of the 2009 and 2010 volumes of *Ceramics in America* as well as the interest generated from the accompanying exhibition *Art in Clay: Masterworks of North Carolina Earthenware* will lead to the discovery of previously unrecognized examples in public and private collections.

1. J. F. Blacker, *The ABC of Collecting Old English Pottery*, 4th ed. (London: Stanley Paul and Co., 1900).

2. Edwin Atlee Barber, *Pottery and Porcelain of the United States: An Historical Review of American Ceramic Art* (1893; reprint with new introduction and bibliography, Watkins Glen, N.Y.: Century House Americana, 1971).

3. John Spargo, *Early American Pottery and China* (Garden City, N.Y.: Garden City Publishing, 1926), p. 121.

4. Ibid., p. 123.

5. Undated photocopy, private collection, Winston-Salem, N.C. The authors thank Nathan Sapp for this information.

6. Adelaide L. Fries, "The Wachovia Historical Society," in *Literary and Historical Activities in North Carolina, 1900–1905*, edited by William Joseph Peale (Raleigh: North Carolina Department of Archives and History, 1907), p. 169. According to Fries, the Wachovia Historical

Society received the collection of the Young Men's Missionary Society, which began acquiring "curios from the mission fields, mineral specimens and stuffed birds, old coins, and local curiosities" before 1850.

7. Joe Kindig Jr., "A Note on Early North Carolina Pottery," *The Magazine Antiques* 27, no. 1 (January 1935): 14–15. This article was reprinted with annotations in *The Art of the Potter*, edited by Diana Stradling and J. Garrison Stradling (New York: Main Street/Universe Books, 1977), pp. 26–27.

8. Ibid.

9. Ibid. Kindig had not heard the term *sugar jar* applied to comparable Pennsylvania forms.
10. Ibid.

11. Luke Beckerdite, "The Life and Legacy of Frank L. Horton: A Personal Recollection," *American Furniture*, edited by Beckerdite (East Hampton, Mass.: Antique Collectors' Club for the Chipstone Foundation, 2006), pp. 9–12.

12. Some of Horton's acquisitions came from local dealers or individuals in whose family pottery had descended.

13. The authors are grateful to Bradford L. Rauschenberg for the information on Willie Jones.

14. For more on Horton's contributions, see Beckerdite, "Frank L. Horton," pp. 2–27.

15. Stanley South, *Historical Archaeology in Wachovia: Excavating Eighteenth-Century Bethabara and Moravian Pottery* (New York: Kluwer Academic/Plenum Publishers, 1999).

16. John Bivins Jr., *The Moravian Potters in North Carolina* (Chapel Hill: University of North Carolina Press for Old Salem, Inc., 1972); Bradford L. Rauschenberg, "Escape from Bartlam: The History of William Ellis of Hanley," *Journal of Early Southern Decorative Arts* 17, no. 2 (November 1991): 80–102; Bradford L. Rauschenberg, "Carl Eisenberg's Introduction of Tin-Glazed Ceramics to Salem, North Carolina, and Evidence for Early Tin-Glaze Production Elsewhere in North America," *Journal of Early Southern Decorative Arts* 31, no. 1 (Summer 2005), pp. 47–52.

17. Rick Mashburn, "Collecting Moravian Antiques," *Early American Life* 19, no. 3 (June 1988): 18–23.

18. Charles G. Zug III, *Turners and Burners: The Folk Potters of North Carolina* (Chapel Hill: University of North Carolina Press, 1986), p. 12.

19. Ibid.

20. Eleanor Gustafson, "Endnotes: A Turtle's Tale," *The Magazine Antiques* 177, no. 2 (March 2010): 88.

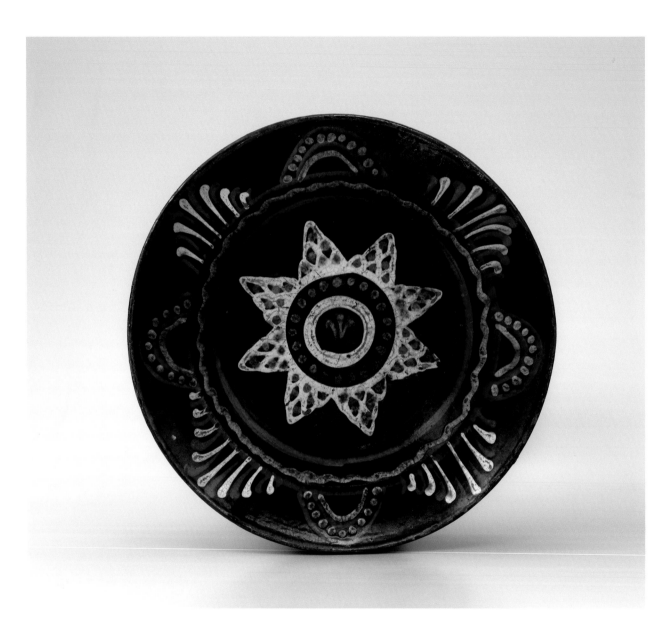

Figure 1 Dish, Alamance County, North Carolina, 1790–1820. Lead-glazed earthenware. D. 10". (Courtesy, Old Salem Museums & Gardens; unless otherwise noted, photos by Gavin Ashworth.)

Luke Beckerdite,
Johanna Brown,
and Linda F.
Carnes-McNaughton

Slipware from the St. Asaph's Tradition

▼ F O R M O R E T H A N forty years the Moravian potteries at Bethabara and Salem have been considered the primary production sites for Germanic slip-decorated earthenware in the piedmont region of North Carolina, based on several factors. The Moravian records contain detailed information on the locations of potteries, the personal and professional lives of craftsmen, the types of wares made, and the technologies employed, as well as the business dealings both within and outside their communities. These documents provided a framework for archaeology conducted by Stanley South during the 1960s and 1970s and for John Bivins Jr.'s ground-breaking monograph, *The Moravian Potters in North Carolina* (1972).[1] Since the publication of that book, nearly every major example of slip-decorated earthenware from North Carolina has been attributed to Moravian potters. Recent research indicates, however, that non-Moravians working in and around the St. Asaph's district of Orange County (now southern Alamance County) made much of the slipware that survives (figs. 1, 2). As this essay will reveal, the ceramic tradition of these potters was shaped in the cultural melting pot of southwestern Germany, brought to America in the Palatine migration of the mid-eighteenth century, and preserved through kinship, apprenticeship, and community networks.

Origin and Exodus

For much of the seventeenth century, the population of southwestern Germany was in flux as people moved to escape war and disease and Protestant princes brought in settlers from other areas of the Holy Roman Empire to repopulate the region. Tax concessions and religious toleration attracted Mennonites from Switzerland, Jews from Portugal, Walloons from Belgium, Lutherans and other reformed sects from poorer territories of Germany, and Huguenots, primarily from the northeastern provinces of France. Historian Philip Otterness has shown how migration within the Palatinate and its repopulation by people from various parts of central and Western Europe made the region one of the most culturally diverse areas of early modern Germany. By the beginning of the eighteenth century, most villages and towns in southwestern Germany were inhabited by people who "spoke different dialects, practiced different religions, and observed different customs." In fact, argues Otterness, "[m]any of the people whom the British called Palatines would have been more comfortable referring to themselves as French or Swiss or natives of some other region of the Holy Roman Empire."[2]

Figure 2 Bottle, Alamance County, North Carolina, 1790–1820. Lead-glazed earthenware. H. 6". (Private collection.)

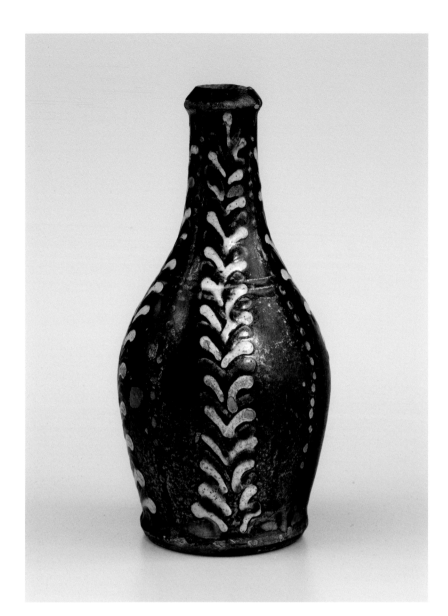

Although emigrants from southwestern Germany may have lacked a strong regional identity, most were from small towns and villages where communal bonds developed through religion, intermarriage, and the activities of everyday life. Craftsmen were an essential part of that process on both sides of the Atlantic. In the Palatine migration of 1709, which included ancestors of the Efland family of Alamance County, approximately one-third of the migrants were artisans.[3] That percentage may have increased over the next four decades owing to demographic and economic shifts in southwestern Germany. On the ship *Elizabeth*, which arrived in Philadelphia on August 27, 1733, were, among others, Palatines who settled in Pennsylvania and later moved to Guilford County and Alamance County; nearly half of the adult males were craftsmen.[4] As historian David Warren Sabean has noted, artisans were among the wealthiest inhabitants of German villages at the beginning of the eighteenth century, but by the end that was seldom the case.[5]

Many of the Palatines arriving in America were married couples who had been marginalized by war, population growth, high taxes, agricultural failures, serfdom, and partible inheritance. These factors influenced migration more than the enticing descriptions of British North America circulating by word of mouth and in printed propaganda during the first half of the eighteenth century. As historian Mark Häberlein has observed, "émigré couples typically arrived with dependent children who could provide labor or be bound out to pay passage costs or supplement income." His study of emigration from the principality of Baden-Durlach also suggests that many of the families as well as single individuals who came to Pennsylvania were related. Immigrants settled in areas where land was available and members of their family had established themselves earlier.[6] As land became scarce in eastern Pennsylvania, this paradigm shifted to the south and west.

Community Development

In her study of German migration and adaptation in the Catawba Valley region of North Carolina, historian Susanne Mosteller Rolland noted that immigrants who settled there often did so in "a series of clusters." Although geographically dispersed, these communities forged connections through "kinship, acquaintanceship, and religious networks."[7] That was certainly true in the central piedmont as well. In an August 1772 diary entry, Moravian missionary George Stolle alluded to ties between the German-speaking communities of southeastern Guilford County (known during the period as "Stinking Quarter") and southern Alamance County:

> The settlers . . . are nearly all German. They have four churches, one in Alamance and three in Stinking Quarter; the newest is large, and has a pulpit and galleries. [Samuel Sutor] preaches in all of them, and Nott [Stinking Quarter's school teacher] reads when there is no preaching. Sutor was a Swiss, unlettered and unordained, [and] from my heart I pitied the poor people, who spent their money where there is nothing to buy. They had engaged Sutor for four years.[8]

The experiences of the Clapp (Klapp), Albright (Albrecht), Foust (Faust), Loy (Laye), and Sharp (Schärp) families reflect many of the broader demographic patterns cited by the aforementioned historians. The Clapps who settled in southeastern Guilford County, which adjoins Alamance, trace their ancestry to brothers George Valentine Clapp and John Ludwig Clapp. George was born at Weisenheim, Germany, in 1702 and married Anna Barbara Steiss in the Lutheran Church there on October 24, 1723.[9] The couple arrived at Philadelphia on the ship *James Goodwill* on September 27, 1727, settled near Olney in Berks County, Pennsylvania, and had at least four children before moving to Guilford County. John Ludwig's birth date is not known, but he married Anna Barbara Strader before emigrating. They also arrived on the *James Goodwill*, settled near Olney, and had several children before moving to North Carolina. Five of their nine children married members of the Foust family, two married members of the Albright family, and at least five followed their parents south.[10] Most of the Clapps attended the German Reformed

Church that George Valentine Clapp and his brother John Ludwig helped found on Beaver Creek.[11]

Most of the Albrights who came to North Carolina settled in southern Alamance County and initially were affiliated with a German Reformed Church (later referred to as Steiner's Church or sometimes Stoner's Church) that Jacob Albright Sr. helped found on Alamance Creek.[12] He was five when his parents, Johannes and Anna, and siblings—Ludwig, Anna Barbara, Magdalena, and Christian—arrived on the ship *Johnson* on September 18, 1732.[13] Johannes may have moved to the Palatine region from Switzerland. Several family genealogies maintain that Jacob's father was Johannes Ludwig Albrecht von Oberenstringer, who was born at Wyniger, Switzerland, in 1694 and married Anna Barbara Gossauer von Reisbach.[14] As was the case with the Clapps, the Albright family that immigrated in 1732 settled in Berks County. Johannes and his wife remained in Pennsylvania, but Jacob, Ludwig, and Anna Barbara moved to Alamance County.[15] Anna Barbara and her sister Magdalena married into the Foust family.[16]

Johan Peter Foust, a farmer from Langenselbold, Hessen, Germany, was one of the first members of his family to emigrate from the Palatinate.[17] He, his second wife, Anna Elizabeth (Grauel), and eleven of their twelve children arrived on the ship *Elizabeth* on August 27, 1733, and subsequently settled in Berks County. The passenger list noted that Johan and his eldest son, Peter, who was twenty at the time, were farmers.[18] At least two of Johan and Anna's children moved to Alamance County: Johannes, who married Anna Barbara Albright, and Anna Elizabeth, who married Philip Snotherly.[19]

Generations of family tradition have maintained that the Loys were Huguenots who left France after the revocation of the Edict of Nantes in 1685 and settled in Germany. Five men with the surname Lay or Laye arrived in Philadelphia on ships with Palatine passengers during the 1730s and 1740s: Christopher on September 25, 1732; Matthias on August 17, 1733; Ludwig on November 25, 1740; Johannes on November 25, 1740; and Martin on September 26, 1741.[20] Although the relationships among these men are not known, it is possible that they were kin.

Martin is the only émigré-generation Loy who moved to North Carolina. He might have been born at "Hertzenhausen" (probably Herzenhausen), Hessen, where his father Johannes worked as a tailor. Johannes and his wife, Anna Martha, subsequently relocated to Mussbach, which is about 250 miles to the south. On December 4, 1729, Martin married Anna Margaretha Fechter in the Reformed Church at Mussbach.[21] Their children— Catharina, Johan Jacob, and Emmanuel—were baptized there in 1730, 1734, and 1737, respectively.[22] Martin and Anna arrived in Philadelphia on the ship *St. Mark* on September 26, 1741, but there is no record that they brought their children with them.[23] Anna must have died shortly thereafter, since Martin married Anna Catrina Foust about two years later. Anna Catrina was almost certainly related to Johan Peter Foust. The passenger list of the ship *Elizabeth* noted that she was twenty-one, which suggests that she may have been the daughter of Johan and his first wife, Magdalena (Adams).[24] Martin and Anna Catrina had four children: George, John,

Henry, and Mary.[25] The Loys apparently moved to Augusta County, Virginia, before February 17, 1753, when the estate of Colonel James Patton held a joint bond of Martin Loy, John Sharp, and Ernest Sharp. The following year, Loy purchased 230 acres of land on Tom's Creek, adjacent to property owned by George Sharp.[26] Although the relationship is not fully understood, it is known that the Loys and Sharps were connected.[27] Isaac Sharp III, brother of John and George, witnessed Martin Loy's will, and Isaac's daughter Philopena married Loy's grandson John.[28] Members of both families settled in Alamance County and attended the same German Reformed Church.[29] Martin bought 251 acres of land on Great Alamance Creek from Henry McCulloh in December 1765, but the precise date he and his family arrived in North Carolina is not known.[30] He acquired an additional 112 acres on the south side of Great Alamance Creek on February 1, 1769.[31]

Bloodlines and Claylines

Documentation for Martin Loy's trade remains elusive, but at least one of his grandsons and six of his great-grandsons were potters (see Loy family tree, p. 108, fig. 2, in this volume).[32] In Europe and America potters working outside large metropolitan areas typically relied on kinship networks to safeguard craft knowledge, provide an affordable and trustworthy workforce, pass trade secrets from generation to generation, absorb competition and build patronage networks through intermarriage, secure raw materials and financing, and establish links to their community. As folklorist John Burrison observed, rural potters "guarded their family lines as carefully as they did their craft traditions."[33] As a result, family potting traditions were often as stylistically and technically monolithic as those associated with urban guilds or other governing associations. This was especially true when potters were part of a culturally homogeneous community, since makers and consumers were inextricably bound in the production of objects.[34]

Documentary and archaeological evidence suggests that much of the slipware made in the vicinity of southern Alamance County was the product of a multigenerational family tradition. The legacy of these potters has only recently come to light. Most of the objects associated with them were formerly attributed to Moravian potters, particularly Rudolph Christ. In *Moravian Potters in North Carolina,* Bivins refers to the imbricated triangles, stylized grass motifs, lunetting, and rows of dots on the dish illustrated in figure 1 as "signatures" of Christ's work.[35] Bivins's assumptions were not unreasonable at that time, since a small group of dish fragments with comparable designs had been excavated at Bethabara and Salem. Subsequent archaeological research has shown, however, that Alamance County potter Solomon Loy used all of those details (fig. 3).[36] Moreover, there is no evidence that Moravian potters applied polychrome slip on black grounds. When Bivins published his book, he was unaware that a dish nearly identical to the example illustrated in figure 1 survives with a history of descent in the Shoffner family of Alamance County.[37] The 1787 tax list for the St. Asaph's district lists Michael Shoffner Sr. and his sons, Michael Jr.,

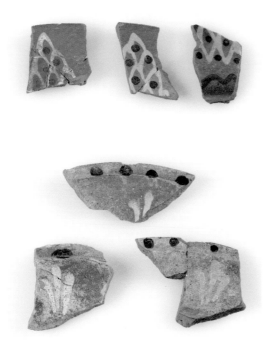

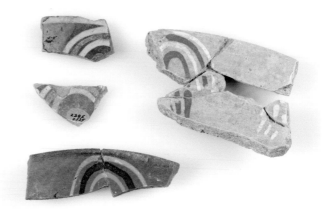

Figure 3 Dish and bowl fragments recovered at Solomon Loy's pottery site, Alamance County, North Carolina, 1825–1840. Lead-glazed earthenware and bisque-fired earthenware. (Courtesy, Research Labs of Archaeology, UNC-Chapel Hill.) All of these Solomon Loy fragments are from site 31AM191.

Martin, Frederick, and George.[38] The elder Michael and his wife, Margaretha Fogleman (Vogleman), were born at Frankfurt am Main, Germany, and reputedly immigrated in the 1750s.[39]

The St. Asaph's Tradition

A small flask with a dark brown ground serves as a point of departure for exploring the emergence and persistence of designs in Alamance County slipware (fig. 4). References to flasks and bottles occur in local inventories from the fourth quarter of the eighteenth century, but in most instances appraisers failed to specify whether such objects were ceramic or glass. Five "bottles" were listed in the 1792 inventory and estate settlement of Alamance County blacksmith Jacob Albright Sr., the most expensive of which was a "flask bottle" that sold for 4s.[40] One side of the small flask mentioned above is decorated with a vertically oriented fleur-de-lis (fig. 5) resembling those of molded form on the ends of seventeenth-century costrels from southwestern France, whereas the other side is decorated with four fleurs-de-lis radiating from the center of a stylized cross with dots representing pomettes, or bobbles.[41] As Hyacinthe Rigaud's *Cardinal de Bouillon* (fig. 6) and Antoine Raspal's *Portrait de Jeune Fille en Costume d'Arles* (fig. 7) suggest, crosses with fleur-de-lis were associated with both Catholicism and Protestantism in France.[42] The Huguenot cross, hanging from the neck of Raspal's sitter, differs from its Catholic counterpart in having a dove suspended from the bottom. Although the origin of the Huguenot cross is obscure, it appears to date from the late seventeenth century. The prominence of fleurs-de-lis in the decoration of the flask suggests that some of the earliest motifs in Alamance County slipware originated in an area of French cultural influence.

Figure 4 Flask, Alamance County, North Carolina, 1770–1790. Lead-glazed earthenware. H. 5⅜". (Courtesy, Old Salem Museums & Gardens.)

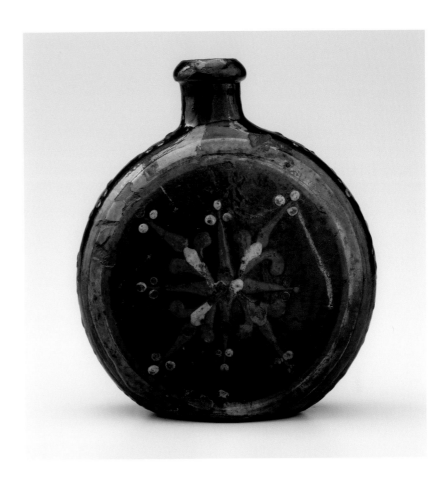

Figure 5 Detail of the decoration on one side of the flask illustrated in fig. 4.

Figure 6 Detail of Hyacinthe Rigaud, *Cardinal de Bouillon*, Perpignan, France, 1708. Oil on canvas, 97" x 95". (Courtesy, Musée Hyacinthe Rigaud.)

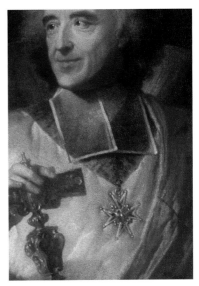

For Huguenot artisans, craft was a vehicle for preserving and expressing cultural and religious identity. In *Fortress of the Soul: Violence, Metaphysics, and Material Life in the Huguenots' New World, 1517–1751*, historian Neil Kamil asserts that French Protestant artisans used their trades to develop "portable and individualistic modes of personal security." According to Kamil, the earliest proponent of that strategy was Huguenot alchemist,

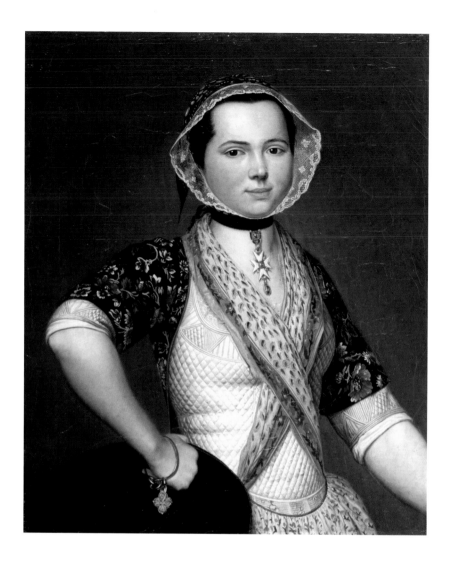

natural philosopher, and potter Bernard Palissy, who predicted the fall of La Rochelle in 1628. Palissy chose the snail, which is ubiquitous in his rustic faience, as a metaphor for "artisanal security." Like snails, which construct their shells from the inside out, use stealth to evade their predators, and develop a symbiotic relationship with their environments, Huguenot artisans forged "containers of the soul hidden inside the self mastered body." By guarding the secrets of their craft and developing subterranean patronage networks to satisfy and influence consumer demand, Huguenot artisans accessed, manipulated, and appropriated aspects of the dominant culture.[43] The cross design on the flask may have functioned in much the same way as Palissy's snail, its meaning transparent to some but opaque to others. Given the Loy family's Huguenot origins and long-term involvement in the Alamance County potting trade, it is noteworthy that the cross motif persisted there until the mid-nineteenth century.

Three other pieces of slipware appear to be by the decorator of the flask. The dish illustrated in figure 8 was formerly attributed to Rudolph Christ but differs from contemporary Moravian examples in having a rim that is rectangular in cross section rather than rounded and undercut (fig. 9). The

Figure 8 Dish, Alamance County,
North Carolina, 1770–1790. Lead-glazed
earthenware. D. 12½". (Courtesy, Old
Salem Museums & Gardens.)

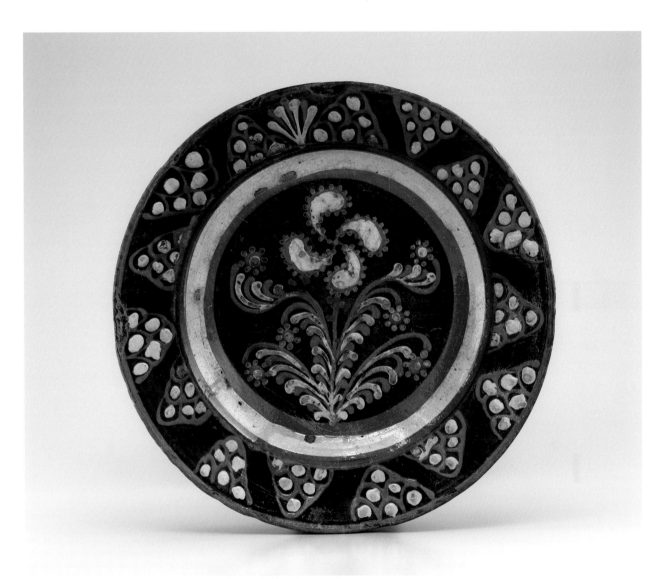

Figure 9 Details showing the back
profiles of the dish illustrated in fig. 8
(left) and a dish attributed to the
Moravian pottery in Salem, North
Carolina (right).

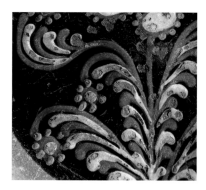

Figure 10 Detail of the cavetto decoration on the dish illustrated in fig. 8.

marly is decorated with imbricated triangles that alternate in direction, and the cavetto features a stylized plant with a large flower represented by a fylfot and smaller flowers represented by white dots with red perimeters and green jeweling (fig. 10). The latter motif also occurs on the shoulders of the small flask (fig. 11), but in that context it may have mimicked wire or bone inlay, commonly found on European powder flasks from the sixteenth and

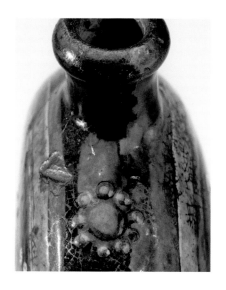

Figure 11 Detail of the decoration on the shoulder of the flask illustrated in fig. 4.

Figure 12 Powder flask, probably Germany, 1600–1650. Wood, brass, and wire inlay. (Private collection.)

seventeenth centuries (fig. 12). Fylfots are common on slipware and other decorative arts from rural areas of central Europe and regions of the American backcountry where Germanic families settled, but they do not appear on any objects made by Moravian craftsmen in North Carolina. Most of the first-generation artisans at Bethabara and Salem had learned their trades in congregation towns in Europe and America.

Much of the ornamental and compositional vocabulary introduced by the first generation of St. Asaph's potters remained intact for more than seventy years. An Alamance County dish likely made by Solomon Loy between 1825 and 1840 has a fylfot in the center of the cavetto and triangles around the perimeter. His triangles can be read as visual analogs for the imbricated triangles on the dish illustrated in figure 8.[44]

Figure 13 shows the site of a pottery owned by Jacob Albright Jr., and sherds recovered there (figs. 14–17) document the production of earthenware

Figure 13 Map showing pottery site locations for Henry Loy, Jacob Albright Jr., Solomon Loy, and Joseph Loy.

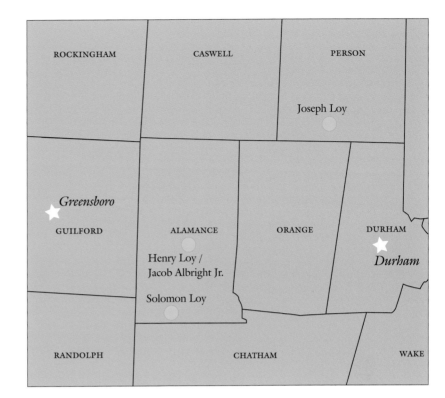

Figure 14 Dish fragments recovered at Jacob Albright Jr.'s pottery site, Alamance County, North Carolina, 1795–1820. Lead-glazed earthenware. (Courtesy, Research Labs of Archaeology, UNC-Chapel Hill.) The fragment at the upper right has marbleized decoration. Slip-decorated earthenware might have been produced at this site before it was occupied by Albright and his son-in-law Henry Loy.

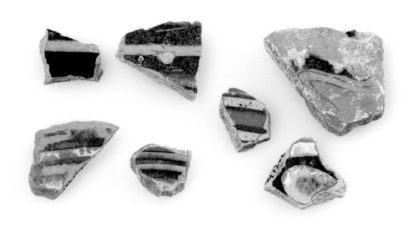

Figure 15 Details showing a cavetto fragment (lead-glazed earthenware) recovered at Jacob Albright Jr.'s pottery site and the marly decoration on the dish illustrated in fig. 30.

Figure 16 Dish fragments recovered at Jacob Albright Jr.'s pottery site, Alamance County, North Carolina, 1795–1820. Bisque-fired earthenware. (Courtesy, Research Labs of Archaeology, UNC-Chapel Hill.)

Figure 17 Mug fragments recovered at Jacob Albright Jr.'s pottery site, Alamance County, North Carolina, 1795–1820. Lead-glazed earthenware. (Courtesy, Research Labs of Archaeology, UNC-Chapel Hill.)

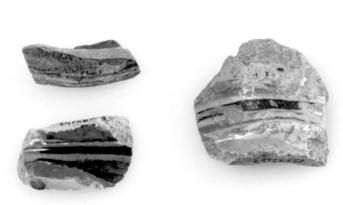

with dark brown and black grounds and slip colors similar to those on the flask and dish illustrated in figures 4 and 8.[45] The decorative vocabulary of Albright's pottery included marbleizing—a technique rare in Southern slip-ware—as well as trailing in both stylized and naturalistic modes (figs. 15, 16). Most of the fragments are from dishes, but base remnants from three mugs with polychrome banding (fig. 17) indicate that Albright's pottery also made decorated hollow ware (fig. 18). In contrast, there is no archaeological evidence for the production of slip-decorated hollow ware at Moravian sites. The designation "potter" appears next to Albright's name in the 1800 tax list for the St. Asaph's district, but it is unclear whether he worked in that trade or provided land and financing for a pottery operated by his son-in-law Henry Loy (1777–1832).[46] The Albrights were prominent landowners in Alamance County, making either scenario possible. "An Inventory and an Account of Sales of the Estate of Jacob Albright Dec[d]," dated March 24, 1825, lists "two potter's wheels, a glaze mill, a clay mill, a grindstone, a pipe mold, and a stove mold"—a sufficient amount of equipment for a modest workforce.[47] In 1780 the pottery in Salem had three wheels, a glaze mill, and a variety of pipe, plate, and tile molds plus at least five workmen.[48]

Archaeology conducted at pottery sites associated with Solomon Loy's brother Joseph also yielded fragments of earthenware with black slip grounds

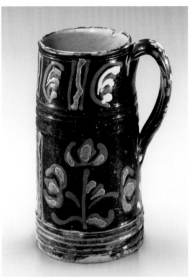
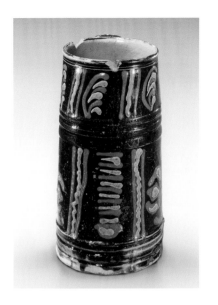
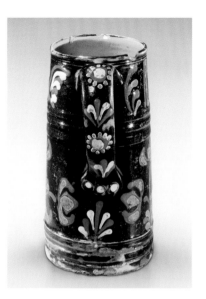

Figure 18 Side, front, and rear views of a tankard, Alamance County, North Carolina, 1785–1810. Lead-glazed earthenware. H. 9". (Courtesy, The Henry Ford.)

and polychrome decoration. Among the most revealing is a handle fragment from a small pitcher or other hollow-ware form discarded at Joseph Loy's pottery, which was in operation from about 1833 to the 1850s. The upper edge of the handle is decorated with a stylized grass motif in green over white slip (fig. 19). Similar designs occur on the handles of earlier examples of hollow ware from the St. Asaph's tradition, including the tankard illustrated in figure 18. Alamance County potters used a variety of motifs on handles, such as circles with dots in the center, zigzag lines, and cross-hatching. The occurrence of polychrome slipware with black grounds

Figure 19 Handle fragment recovered at Joseph Loy's pottery site, Person County, North Carolina, ca. 1833. Lead-glazed earthenware. (Courtesy, Research Labs of Archaeology, UNC-Chapel Hill.)

at sites where Henry, Joseph, and Solomon Loy worked suggests that members of their family were responsible for much of the decorated earthenware attributed to Alamance County. If Martin Loy was the progenitor of the St. Asaph's tradition, it would be reasonable to assume that he trained at least one of his sons. George and John Loy would have been eligible for apprenticeship during the early 1760s, followed by their brother Henry a few years later.

Alamance County potters clearly were producing slipware during the last quarter of the eighteenth century if not before. Establishing a precise chronology for this material is problematic, but date ranges can be assigned

by comparing the decoration on surviving examples with that on artifacts from similar cultures and contexts. The trailing on the dishes illustrated in figures 20–22 has parallels in painted decoration on chests attributed to Berks County (figs. 23, 24), where members of several Alamance County families initially settled. Motifs occurring on both groups of objects include stems with jeweled edges, awkwardly perched birds, and both abstract and naturalistic plant forms. The chests, which probably represent the work of at least three decorators, bear dates ranging from 1776 to 1803. An example dated 1784 belonged to Heinrich Foust, who had the same great-grandfather as the Fousts who settled in Alamance County.[49]

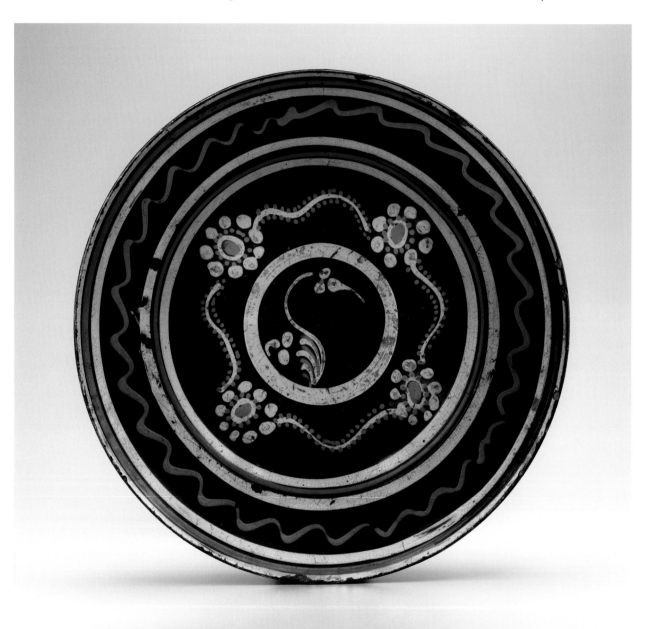

With their brilliant yellow and red slip decoration and lustrous black grounds, the dishes illustrated in figures 20–22 are benchmarks for understanding the morphology of that form in the St. Asaph's tradition. All have marlys with the same sequence of concentric and wavy trailed lines, and cavetti with stylized or naturalistic motifs. The cavetto decoration on the dish illustrated in figure 20 is almost completely abstract, featuring a stylized plant encircled by a wide band and undulating vines with jeweled edges and flowers.[50] The decorator used similar jeweling around the upper flower of the dish illustrated in figure 21. Although the plant motif on that example is more naturalistic, its serpentine stem and tightly clustered,

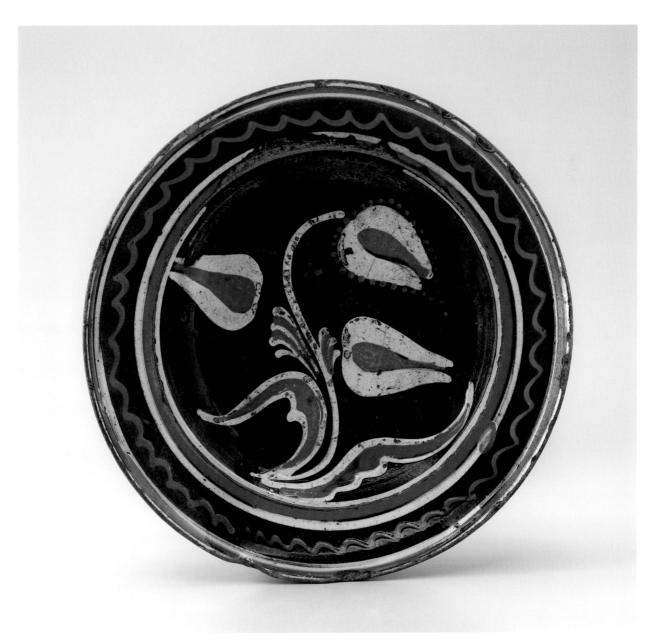

Figure 22 Dish, Alamance County, North Carolina, 1775–1795. Lead-glazed earthenware. D. 14⅞". (Courtesy, The Henry Ford.)

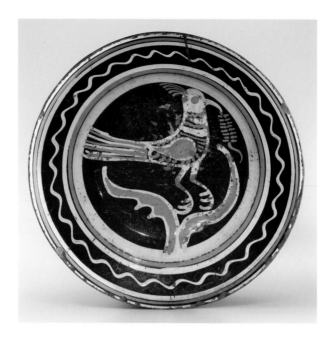

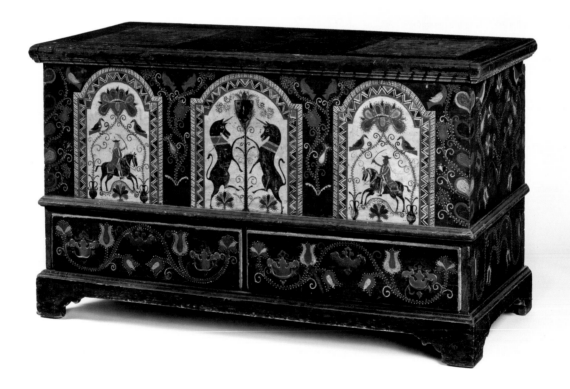

Figure 23 Chest, attributed to Bern Township, Berks County, Pennsylvania, 1785–1795. Tulip poplar and pine. H. 28⅝", W. 52½". (Courtesy, The Metropolitan Museum of Art.)

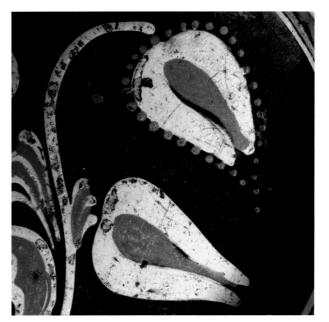

comma-shaped leaves are larger versions of those on its abstract counterpart (fig. 25). The ornament on the remaining dish (see fig. 22) relates most closely to that on the naturalistic example (see fig. 21). Their large leaves are basically the same, having peaked lobes, yellow slip outlines, and red slip interiors. The bird on the dish illustrated in figure 22 is unique in North Carolina slipware, although avian subjects are common in earthenware from Pennsylvania, Great Britain, and Europe. Dishes with birds depicted in a similar manner occur on slipware from Hessen, Germany, by the mid-seventeenth century.[51] Several of the families that emigrated from the Palatinate to Berks County and relocated to southeastern Guilford County and southern Alamance County were from that part of Germany.

Figure 26 Details showing the back profiles of the dishes illustrated in fig. 20 (top) and fig. 21 (bottom).

In addition to being by the same decorator, the dishes illustrated in figures 20–22 may have been thrown by the same hand (fig. 26). They differ significantly from contemporary Moravian examples (see fig. 9) in having little to no visible booge at the rear and rims that are somewhat rectangular in cross section. The Alamance County dishes are also unmarked, whereas those made at Bethabara and Salem frequently have either Roman or Arabic

Figure 27 Dish, Alamance County, North Carolina, 1785–1810. Lead-glazed earthenware. D. 12½". (Courtesy, The Henry Ford.)

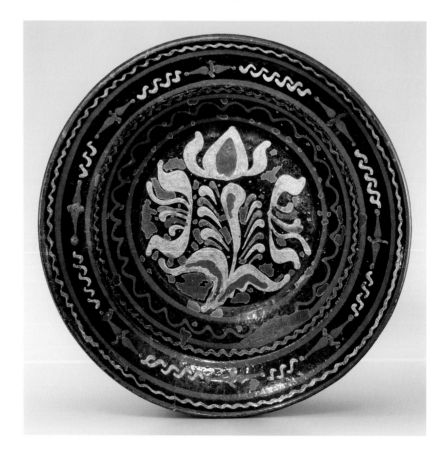

numerals that were incised on the back before firing. No slipware from the St. Asaph's tradition is marked in that manner.

Another dish that appears to date from the late-eighteenth or very early nineteenth century (fig. 27) introduces details that persisted in Alamance County slipware for decades: cymas arranged in a chainlike pattern and motifs resembling abutting teardrops with dots in the middle and at each end. Variations of the latter device also occur on Germanic pottery, as well as on dishes attributed to William and Thomas Dennis of Randolph County. Although there is not enough evidence to attribute this dish or the preceding examples to a specific craftsman, it is clear that Jacob Albright's pottery produced earthenware decorated in a similar manner. A fragment recovered at his site (fig. 28) has petals that extend to the edge of the cavetto and are shaped like those on the upper flower of the dish illustrated in figure 27. Several Pennsylvania dishes with flowers oriented in a similar manner are known, and most date from the late 1760s to the 1790s.

Figure 28 Detail showing the decoration in the cavetto of the dish illustrated in fig. 27 (left) and a cavetto fragment (right) recovered at Jacob Albright Jr.'s pottery site.

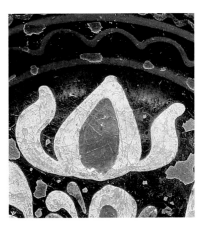

Related dishes likely made between 1790 and 1820 reveal that the stylistic repertoire of Alamance County's slipware potters was both cohesive and complex. Although no two motifs on these objects are the same, all have cavetto designs that radiate from the center. One has imbricated triangles emanating from a circle with a ring of jeweled dots and a simple grass motif in the middle (see fig. 1); one resembles a starburst, with alternating lines of red and yellow slip intersecting in the center (fig. 29); one has bisecting fronds of stylized leaves (fig. 30); and one has a cruciform motif with dots at the tips and leaves at the intersections (fig. 31). The design in figure 31 has antecedents in the flask illustrated in figure 4 and is a clear precursor to Solomon Loy's simple cruciform motif (see fig. 51). The marly decoration on these dishes is equally varied, featuring clusters of stylized grass separated by lunettes (see fig. 1), an undulating vine with jeweled, comma-shaped leaves (see fig. 29), small clusters of grass extending from the inner edge to the rim alternating with similar clusters oriented in a counterclockwise pattern (see fig. 30), and lozenge-shaped panels with marbleized centers and jeweled perimeters separated by interconnected cymas and straight and wavy lines (see fig. 31). The decorator responsible for this work

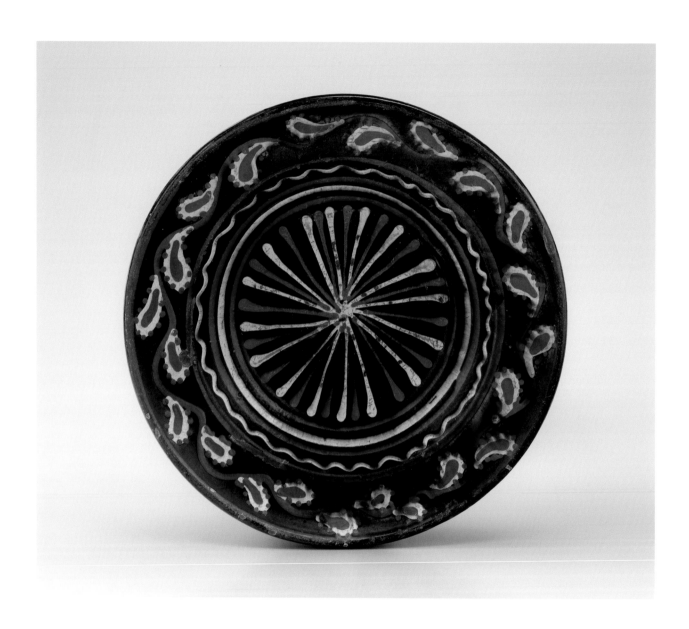

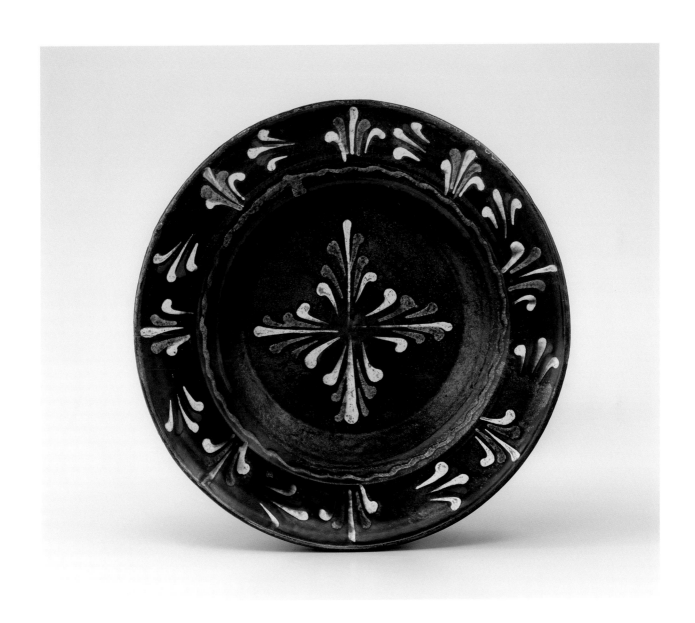

Figure 31 Dish, Alamance County, North Carolina, 1790–1820. Lead-glazed earthenware. D. 11″. (Courtesy, Colonial Williamsburg Foundation; photo, Hans Lorenz.)

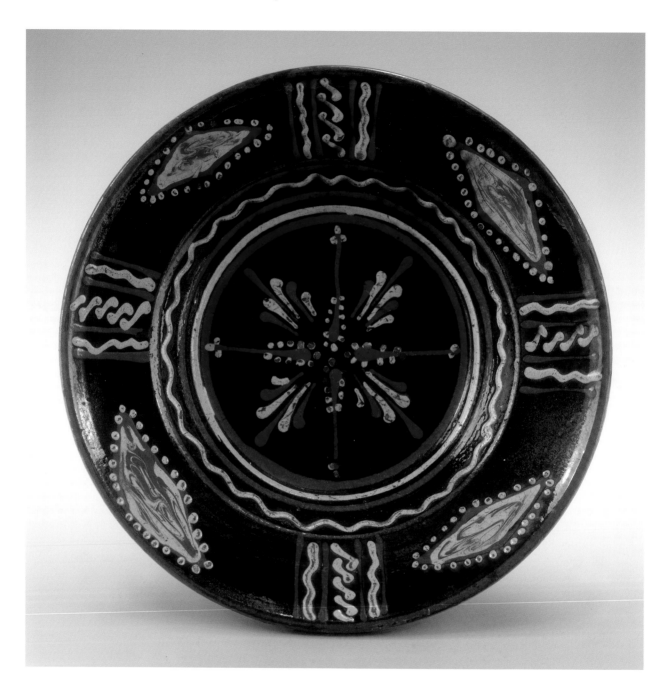

Figure 32 Details showing the back profiles of the dishes illustrated in (from left to right) figs. 1, 29, and 30.

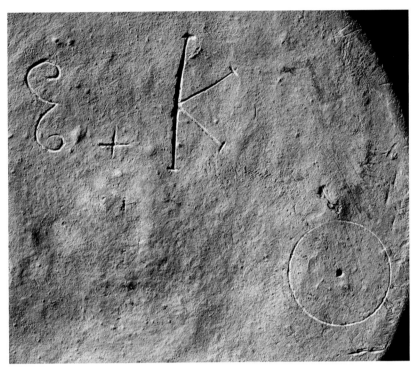

Figure 33 Detail of the fluted separator on the back of the dish illustrated in fig. 29.

Figure 34 Detail of the post-production marks on the back of the dish illustrated in fig. 1.

was skillful and efficient. On the dish illustrated in figure 30 he applied all of the white slip first, then the red, then the green. Although working rapidly, he was able to produce a cavetto design that seems almost stenciled.

The bodies and profiles of these dishes also indicate that they are from the same pottery. All are made of pink- to buff-colored clay and have rounded, rolled rims (fig. 32), and two (see figs. 29, 31) have fluted separators stuck to their bottoms (fig. 33). The dish illustrated in figure 1 and the identical example that descended in the Shoffner family also have post-production marks inscribed on their bases (fig. 34).[52] Similar marks occur on dishes made by other Alamance potters, including Solomon Loy.

On the bottom of another dish (fig. 35) are the letters E and K, which appear to have been inscribed by the same person whose initials appear on the dish illustrated in figure 1. In both examples the E curls at the top and bottom and the body and serifs of the K are virtually identical (figs. 34, 36). The cavetto ornament on the dish illustrated in figure 35 includes stylized fronds that extend from the center like those on the example shown in figure 30, but the trailing is clearly by different hands. The profile

of the dish illustrated in figure 35 also differs from those of the examples with black grounds in having a more pronounced cyma shape and a relatively square, unrolled rim.

Another dish by the decorator of the example shown in figure 35 has a fernlike design in the cavetto and grass clusters alternating with broad comma-shaped leaves with serpentine stems on the marly (fig. 37). Cognates for the latter detail can be found in slipware from many areas of German

Figure 35 Dish, Alamance County, North Carolina, 1790–1820. Lead-glazed earthenware. D. 10". (Private collection.)

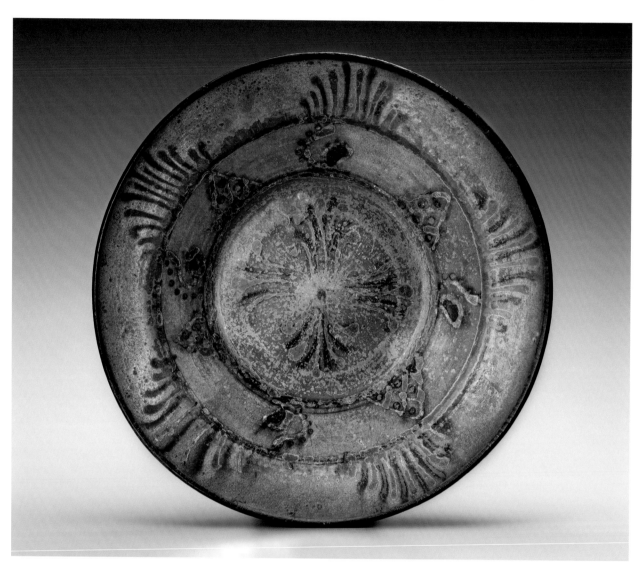

Figure 36 Detail of the post-production marks on the back of the dish illustrated in fig. 35.

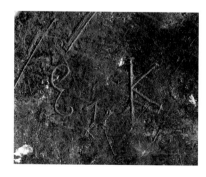

Figure 37 Dish, Alamance County, North Carolina, 1790–1820. Lead-glazed earthenware. D. 10". (Private collection.) This dish has a twentieth-century recovery history in Alamance County.

cultural influence, including Montgomery County, Pennsylvania, and Salem, North Carolina (fig. 39).[53] An exceptionally rare punch bowl (fig. 40)—related to the dishes illustrated in figures 35 and 37—presents a more refined expression of the leaf-and-serpentine-stem motif. Indeed, in its precise and methodical application, the trailing on the bowl is closer to that on the dishes illustrated in figures 1 and 29–31 than those shown in figures 35 and 37. The production of a vessel associated with punch, which was almost

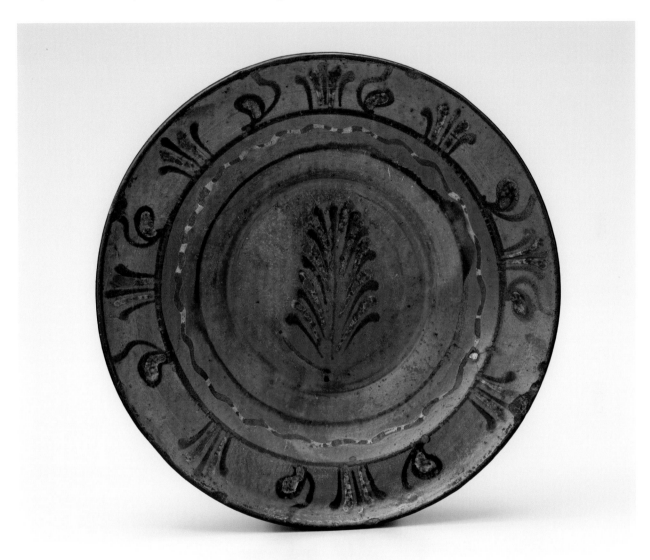

Figure 38 Detail of the back profile of the dish illustrated in fig. 37. The profile of this example is virtually identical to that of the dish illustrated in fig. 35.

Figure 39 Dish fragment recovered from lot 49 in Salem, North Carolina, 1780–1820. Bisque-fired earthenware. (Courtesy, Old Salem Museums & Gardens.)

Figure 40 Punch bowl, Alamance County, North Carolina, 1790–1810. Lead-glazed earthenware. H. 5¾". (Private collection.)

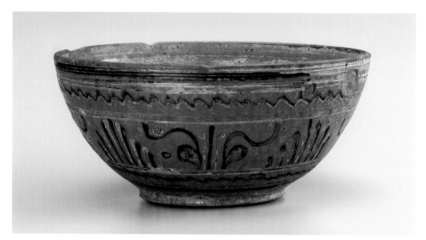

exclusively a British libation, raises a number of questions. Was the bowl commissioned by a patron of British descent, made for a public house that served punch, or simply inspired by English bowls that made their way into the Southern backcountry during the last quarter of the eighteenth century? The latter hypothesis seems most likely in light of the decoration on the exterior. If the maker had wished to mimic contemporary English creamware, he simply could have coated the bowl with white slip and fired it with a clear lead glaze. Moravian potters in North Carolina produced imitation creamwares with tortoiseshell colors in that manner.

The earliest Alamance County dishes with white slip grounds appear to date from the first quarter of the nineteenth century (figs. 41, 42). With their coved profiles and delicate squared rims (fig. 43), these dishes are closer in shape to those made by Solomon Loy than the examples with black slip grounds (see fig. 32). Continuities with earlier examples of Alamance County slipware are, however, evident in the decoration of the dishes illustrated in figures 41 and 42. The central design on the first (see fig. 41), which can be read as either a geometric composition or a stylized flower, has clear antecedents in the dish illustrated in figure 1 and a nearly identical

Figure 41 Dish, Alamance County,
North Carolina, 1800–1835. Lead-glazed
earthenware. D. 11½". (Courtesy, Old
Salem Museums & Gardens.)

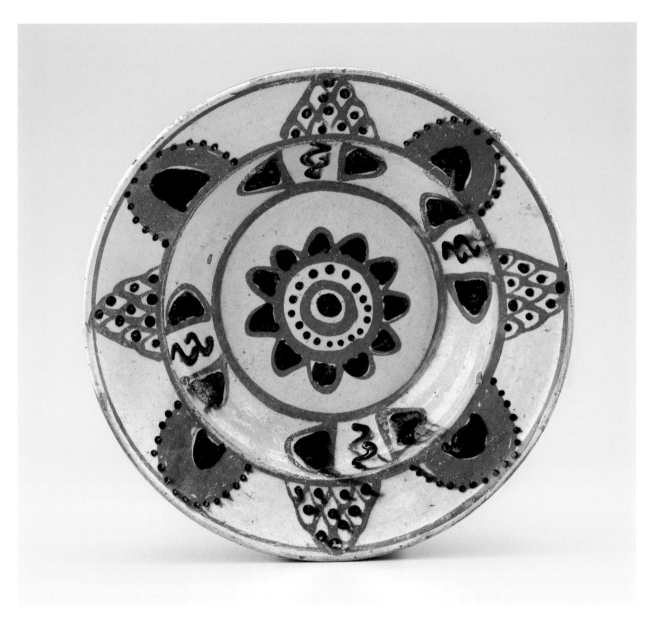

Figure 42 Dish, Alamance County, North Carolina, 1800–1835. Lead-glazed earthenware. D. 11". (Courtesy, Old Salem Museums & Gardens.) This is the earliest dish with "nested triangles," a motif com-monly employed by Solomon Loy. Ante-cedents for this motif can be seen on the front panels of paint-decorated chests attributed to Bern Township in Berks County, Pennsylvania (see fig. 23).

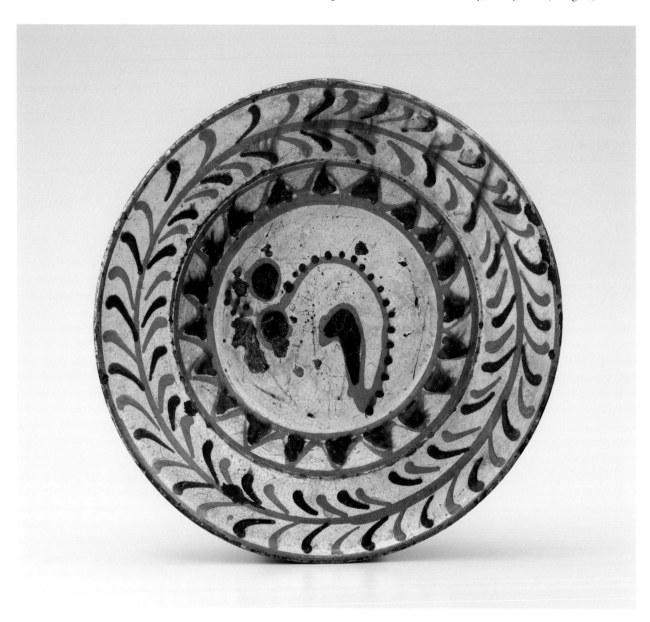

Figure 43 Details showing the back profiles of the dishes illustrated in fig. 41 (left) and fig. 42 (right).

Figure 44 Details showing the decoration in the cavetti of the dishes illustrated in fig. 1 (left) and fig. 41 (right).

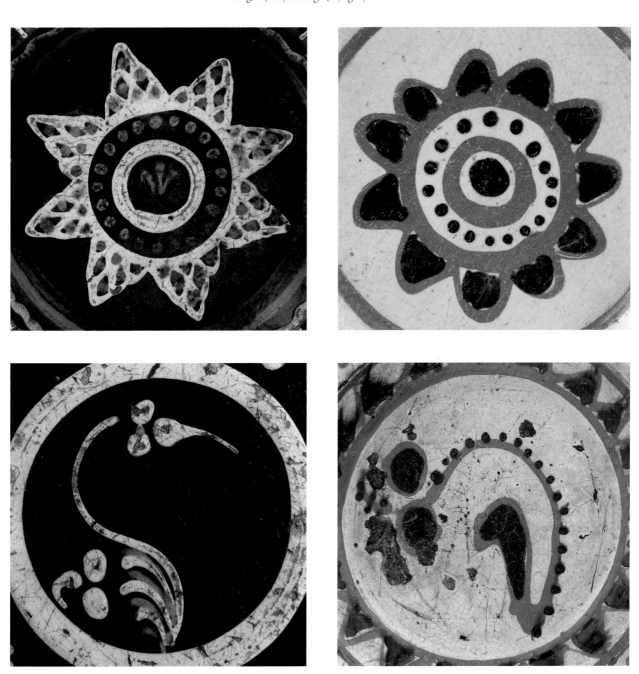

Figure 45 Details showing the decoration in the cavetti of the dishes illustrated in fig. 20 (left) and fig. 42 (right).

43 THE ST. ASAPH'S TRADITION

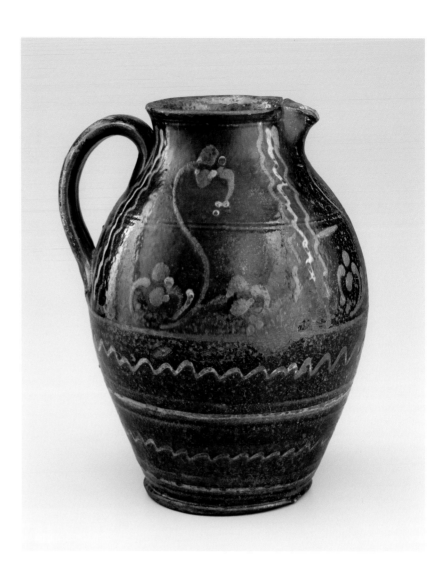

Figure 46 Pitcher, Alamance County, North Carolina, 1785–1810. Lead-glazed earthenware. H. 10". (Courtesy, Old Salem Museums & Gardens.)

example that descended in the Shoffner family. On the white dish the decorator simply substituted a central dot and perimeter lunettes for the stylized grass motif and imbricated triangles of the black example (fig. 44). Similarly, the origin for the abstract plant in the cavetto of the other white dish can be found on several examples of slipware from the St. Asaph's tradition (fig. 45), including the dish illustrated in figure 20 and two early pitchers (see figs. 46, 56).

The term *pitcher* appears to have entered use in the central piedmont region of North Carolina during the last quarter of the eighteenth century, whereas hollow ware vessels with handles and pouring spouts were referred to as "jugs" in most other areas well into the nineteenth century. Jacob Albright Sr.'s inventory listed four "pichers" ranging in value from eight pence to 3*s.* 1*d.*, and the stock in his son's pottery included nine pitchers with three different values. Jacob Jr.'s pottery also produced narrow-neck jugs in at least two sizes.[54]

The pottery responsible for the pitchers shown in figures 46–48 appears to have been in operation from at least the late eighteenth century to the 1820s. The plant motifs on the sides and front of the earliest example (fig. 46)

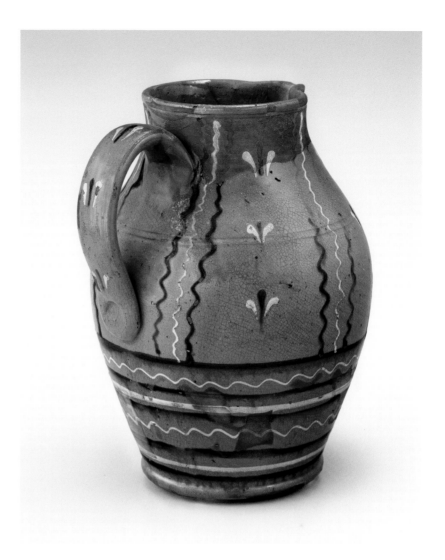

Figure 47 Fragmentary pitcher, Alamance County, North Carolina, 1790–1820. Lead-glazed earthenware. (Courtesy, Research Labs of Archaeology, UNC-Chapel Hill.)

Figure 48 Pitcher, Alamance County, North Carolina, 1800–1835. Lead-glazed earthenware. H. 10". (Private collection.)

have flowers trailed in much the same manner as those in the center of the dish illustrated in figure 20. As is the case with most decorated hollow ware attributed to Alamance County, the principal motifs on the pitcher are set in panels. To frame their designs, local potters used straight and wavy lines, rows of dots, stacked dashes, and interconnected cymas. A fragmentary pitcher found under the floorboards of a dormitory constructed in 1822 at the University of North Carolina, Chapel Hill (fig. 47), has two of those details as well as rows of tiny lunettes with white dots in the center.[55] The arcaded vine-and-leaf decoration on the base resembles designs on British mocha ware, but the slip was applied in an entirely different manner.[56] All of the pitchers in this group have rounded feet, and the intact examples feature nearly identical moldings on their rims and shoulders. The handle on the earliest pitcher (see fig. 46) has cross-hatching on the upper edge and multiple finger impressions on the terminal, whereas the handle on the later example (fig. 48) is decorated with simple grass motifs and has a single thumb impression (fig. 49). Three-leaf grasses are common in Alamance County slipware, occurring as late as the mid-nineteenth century in pottery by Solomon Loy (figs. 50, 51).

Figure 49 Details showing the rims and handles of the pitchers illustrated in fig. 46 (left) and fig. 48 (right).

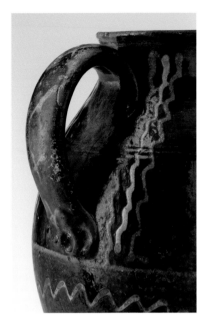

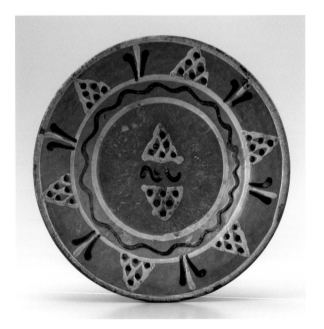

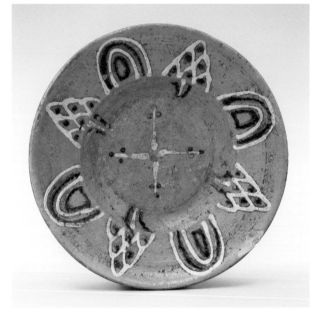

Figure 50 Dish, Alamance County, North Carolina, 1800–1835. Lead-glazed earthenware. D. 10⅞". (Private collection.)

Figure 51 Dish, attributed to Solomon Loy, Alamance County, North Carolina, 1825–1840. Lead-glazed earthenware. D. 12". (Private collection.)

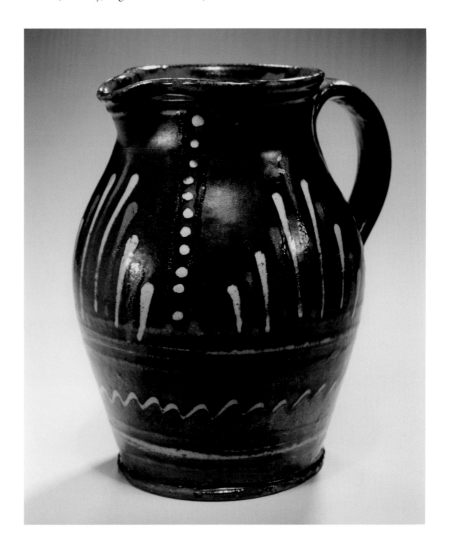

Two smaller pitchers with black grounds (figs. 52, 53) might be from the same pottery that produced the preceding examples. Both have identically molded rims (fig. 54) that relate very closely to those on the larger pitchers (see figs. 46, 48, 49), pulled strap handles with deep thumb impressions at the terminal (fig. 55), and small rounded feet. The pitcher illustrated in figure 53 is a rare survivor, because earthenware overfired to that degree usually was discarded at the production site. In contrast, the other pitcher fired perfectly and displays almost no sign of use (see fig. 52). The potter used iron and manganese in almost equal proportion to produce its purple-black ground.[57]

The pitchers illustrated in figures 56 and 57 differ from the preceding examples in having proportionally larger openings, broader necks, and less prominent spouts and feet. At the same time, the abstract plant motifs in the upper panels of the pitcher with the white ground are clearly related to those on the pitcher illustrated in figure 46. The decorator of the former object used rows of dots and vertical lines to frame the upper panels and

Figure 53 Pitcher, Alamance County,
North Carolina, 1790–1820. Lead-glazed
earthenware. H. 10″. (Private collection.)

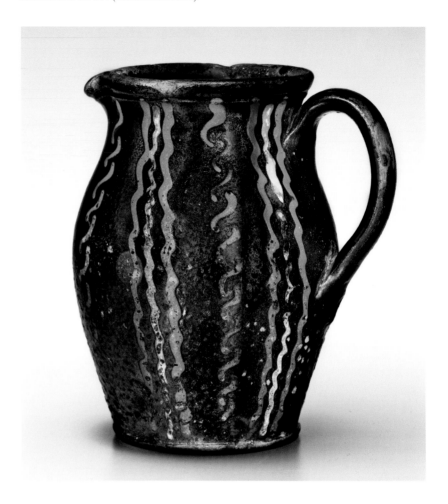

Figure 54 Detail of the rim of the pitcher
illustrated in fig. 53.

Figure 55 Detail of the handle terminal
and foot of the pitcher illustrated in fig. 53.

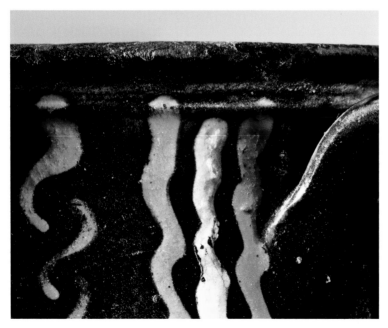

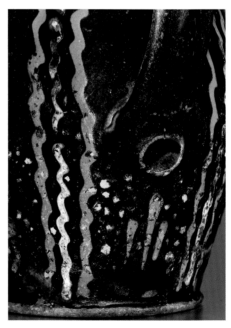

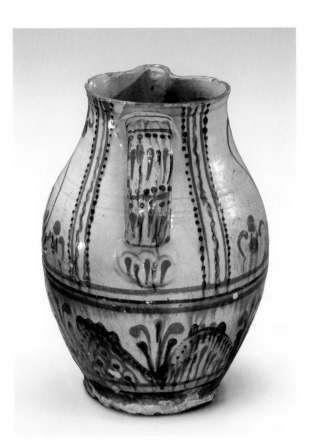

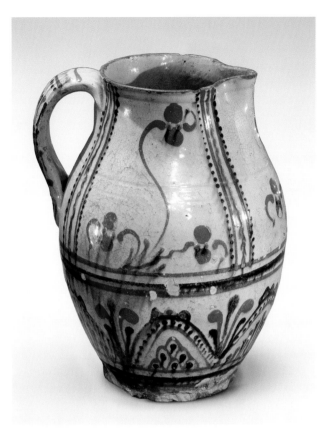

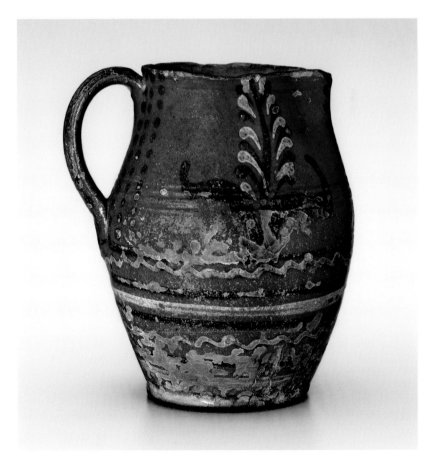

Figure 56 Rear and side views of a pitcher, Alamance County, North Carolina, 1790–1820. Lead-glazed earthenware. H. 10½". (Courtesy, The Henry Ford.)

Figure 57 Pitcher, Alamance County, North Carolina, 1790–1820. Lead-glazed earthenware. H. 6½". (Courtesy, Old Salem Museums & Gardens.)

bands of slip to separate them from the repeat of fronds, lunettes, and imbricated triangles below. Although the pitcher with the red slip ground (see fig. 57) has less complex trailing, its rim and handle have delicate moldings and its midsection is defined by a series of fine concentric lines (fig. 58). Similar moldings occur on the handles, bodies, and lids of other hollow ware forms attributed to Alamance County (see figs. 74–78).

A fragmentary pitcher (fig. 59), which appears to be from the same pottery that produced the examples illustrated in figures 46 and 48, suggests that some early motifs associated with the St. Asaph's tradition degenerated over time. The abstract plant decoration is clearly related to that on the dish and pitcher illustrated in figures 20 and 46, but the stem has lost its dramatic serpentine shape and the curled tip of the flower is much less defined (fig. 60). On a contemporary dish that probably represents the work of Solomon Loy, or another potter of his generation, the leafy tip of the flower is omitted (fig. 61).

Figure 58 Detail of the handle and body of the pitcher illustrated in fig. 57.

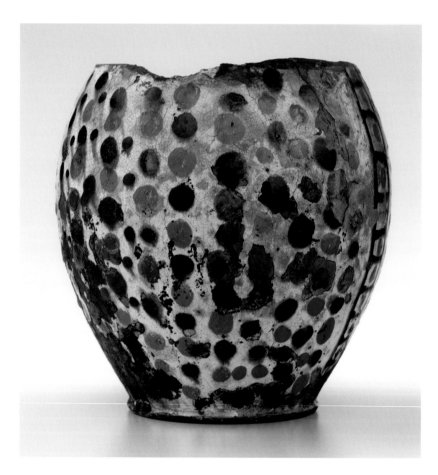

Figure 59 Fragmentary pitcher, Alamance County, North Carolina, 1800–1835. Lead-glazed earthenware. (Courtesy, Old Salem Museums & Gardens.) The stylized plant motif on this object is visible in fig. 60 (right).

Figure 60 Detail showing the decoration on the pitchers illustrated in fig. 46 (left) and fig. 59 (right).

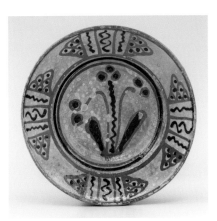

Figure 61 Dish, Alamance County, North Carolina, 1800–1835. Lead-glazed earthenware. D. 10". (Private collection.)

Similar continuities in form and decoration can be observed in sugar pots made in and around Alamance County (figs. 62–65). References to the form occur in local inventories from the 1770s well into the nineteenth century.[58] When the remainder of Jacob Albright Sr.'s estate was dispersed in 1812, a sugar pot and "sugar dish" sold for 2*s*. 6*d*. apiece.[59] The 1825 inventory of his son Jacob's pottery listed one sugar pot valued at 13¢, attesting to their continued popularity. In his seminal article "A Note on Early North Carolina Pottery," decorative arts scholar and dealer Joe Kindig Jr. stated that several examples he acquired during the early 1930s still contained sugar. Obviously these pots could have been used for the storage of other goods. A "sugar Pot & Peas" brought 31¢ in the 1830 estate sale of John Albright, Jacob Jr.'s brother. [60]

As was the case with several dishes and pitchers from the St. Asaph's tradition, most of the surviving sugar pots were formerly attributed to Moravian potters based on mistaken assumptions about their formal

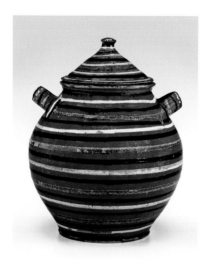
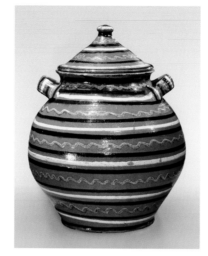
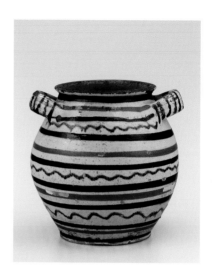

Figure 62 Sugar pots, Alamance County, North Carolina, 1790–1820. Lead-glazed earthenware. H. 12¾" (left), 13" (center), 7" (right). (Courtesy, The Metropolitan Museum of Art [left], The Henry Ford [center], private collection [right].) The pot with the white ground descended in the Crouse family of Alamance County.

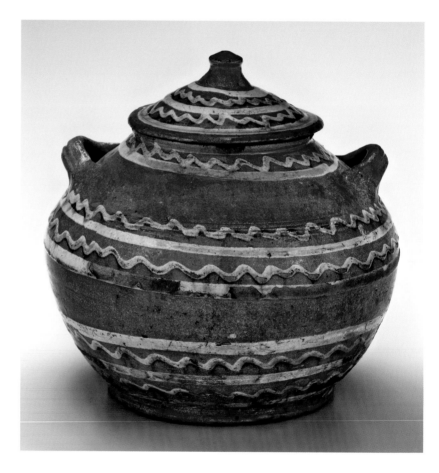

Figure 63 Sugar pot, Alamance County, North Carolina, 1800–1820. Lead-glazed earthenware. H. 8". (Private collection.) This jar descended in the Löffler (Spoon) family of Alamance County and southeastern Guilford County. The 1787 tax list for the St. Asaph's district lists "Widow Sarah Spoon." John, Adam, and Peter Spoon were listed in the 1792 assessment.

characteristics and references to sugar bowls in inventories of the Salem pottery.[61] In those inventories, entries for sugar bowls almost invariably occur adjacent to those for teapots, indicating that the former were tableware rather than storage vessels.[62] Archaeology at Moravian sites has yielded fragments of sugar bowls with tortoiseshell colors and swirled slip decoration but no hollow ware with abstract or naturalistic trailing. Alamance County potters made lidded "sugar dishes," condiment pots (fig. 66), and

Figure 64 Sugar pots, Alamance County, North Carolina, 1800–1830. Lead-glazed earthenware. H. 8" (left), 8" (right). (Courtesy, Old Salem Museums & Gardens.)

small bowls (fig. 67) for table use, but their forms and decorative techniques have no parallel in the North Carolina Moravian tradition.

All of the sugar pots from the St. Asaph's tradition are ovoid with horizontal loop handles that are attached high on the body and angled slightly upward. As Kindig noted, lidded pots from Pennsylvania typically have

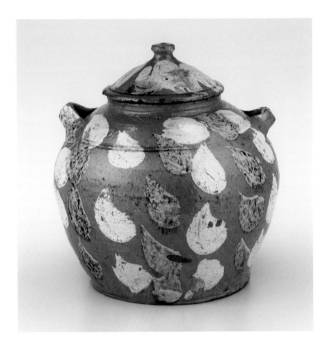

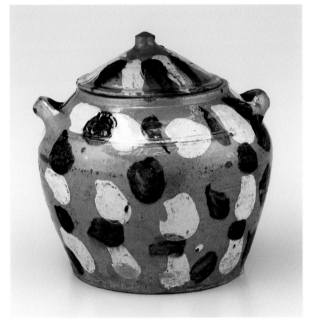

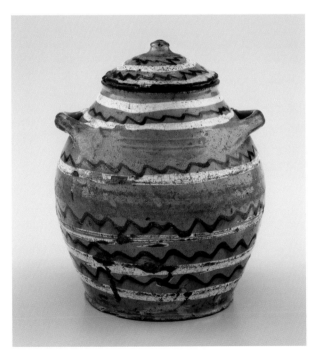

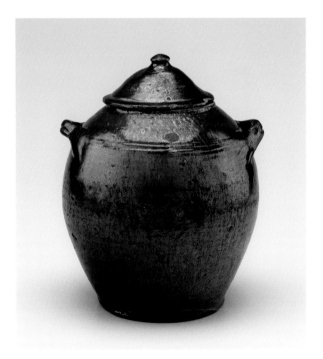

Figure 65 Sugar pots, Alamance County, North Carolina, 1800–1830. Lead-glazed earthenware. H. 10" (left), 10" (right). (Private collection.)

Figure 66 Condiment pot, Alamance
County, North Carolina, 1795–1820.
Lead-glazed earthenware. H. 5". (Courtesy,
Old Salem Museums & Gardens.) The
lower section of this pot has a partition
in the center.

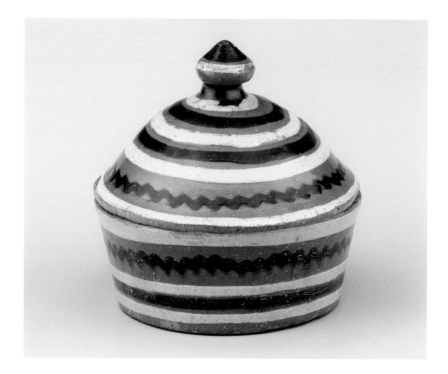

Figure 67 Bowl, Alamance County,
North Carolina, 1790–1820. Lead-glazed
earthenware. H. 3". (Private collection.)

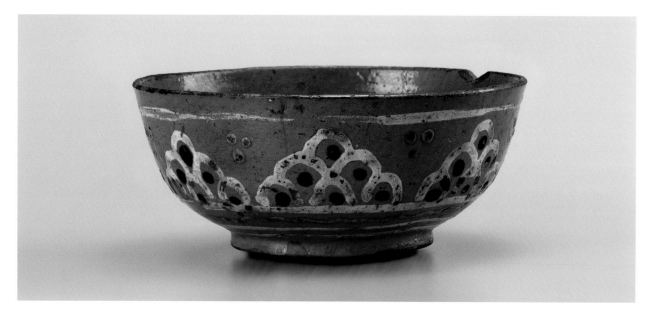

vertical loop handles or horizontal lug handles. All of the handles on their
Southern counterparts are pulled and feathered into the shoulder. On the
most elaborate sugar pots, slip-trailed designs help mask the attachment
points (figs. 68, 69). Many handles are molded (see fig. 69), but those of
some later pots are plain (see fig. 65).

One of the earliest sugar pots from the St. Asaph's tradition has a dark
brown ground and thick slip decoration resembling that on the dish with
the fylfot flower (see figs. 8, 69). The pot is unusual in having a flanged
rim, but a lid that appears to be by the same decorator (fig. 70) suggests
that the pottery responsible for the former object also made sugar pots

Figure 68 Sugar pot, Alamance County, North Carolina, 1770–1790. Lead-glazed earthenware. H. 8¼". (Courtesy, Old Salem Museums & Gardens.)

Figure 69 Detail of the rim and handle of the sugar pot illustrated in fig. 68.

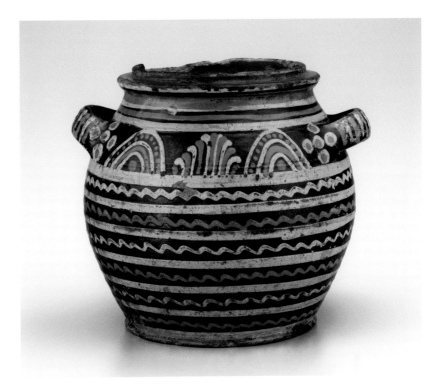

Figure 70 Exterior and interior views of a sugar pot lid, Alamance County, North Carolina, 1770–1790. Lead-glazed earthenware. D. 7". (Courtesy, Old Salem Museums & Gardens.)

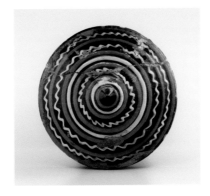

with plain rims. The diameter of the lid and its inner flange indicates that it was made for a vessel with an unusually broad opening, such as that of the sugar pot illustrated in figure 71. The latter object and lid were "married" prior to April 1935, when they appear together in an advertisement by Kindig.[63]

Only one other local sugar pot with a flanged rim is known (fig. 72). It is almost certainly from the same pottery that produced the example illustrated in figure 68 but is later in date and decorated by a different hand. Like the early flask (see fig. 4), the sugar pot illustrated in figure 72 has cross-shaped motifs with fleurs-de-lis extending from the center. The slip on the pot is much thinner and migrated during firing, which gives it the appearance of having been applied with a brush when actually it was trailed. In its application and attenuated form, the cross and fleur-de-lis on the sugar pot are much closer to the decoration in the cavetto of the dish shown in figure 31 than the trailing on the flask (figs. 4, 73).

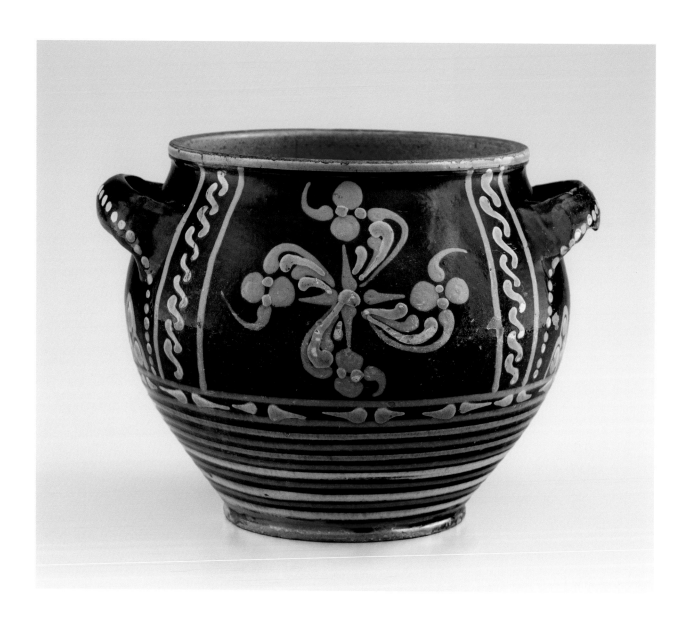

Figure 72 Sugar pot, Alamance County, North Carolina, 1790–1820. Lead-glazed earthenware. H. 10½". (Private collection.)

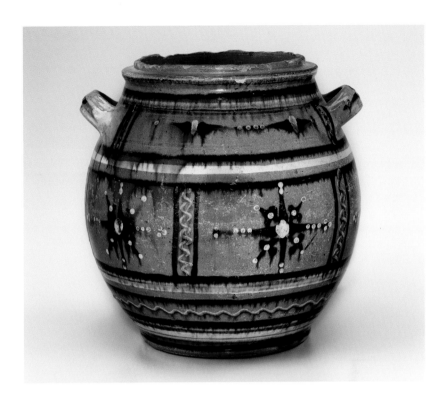

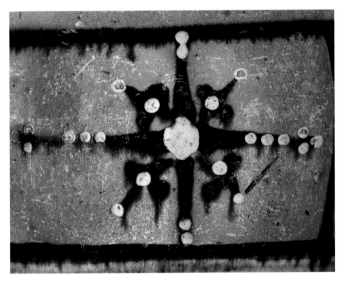

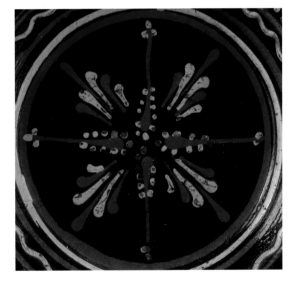

Figure 73 Details showing the cross and fleur-de-lis decoration on the sugar pot illustrated in fig. 72 (left) and the dish illustrated in fig. 31 (right).

The sugar pots illustrated in figures 74 and 75 are among the most refined examples of hollow ware from the St. Asaph's tradition. Both have shoulders defined by fine concentric lines, pulled handles with fluted moldings (figs. 76, 77), and small round feet. The even spacing and consistent depth of the flutes makes these handles appear extruded, but they were probably produced with a rib or a thin, smooth stick.[64] Although possibly from the same pottery, these pots clearly were decorated by different hands. The trailing on the example with the reddish orange slip ground (see fig. 74) is more accomplished and relates very closely to that on the punch bowl (see fig. 40), whereas the decoration on the other sugar pot (see fig. 75) is more heavy-handed, resembling that on the tankard shown in figure 18.

Only two sugar pots with white slip grounds are known (see figs. 62 [right], 78). The example illustrated in figure 78 has a twentieth-century history of descent in the Huffman (Hoffman) family of southeastern Guilford County and southern Alamance County.[65] Migration of the polychrome decoration, which is most evident on the bands at the shoulder, indicates that the pot was fired upside down. Although this differs from most of the surviving examples, potters probably arranged their hollow ware in whatever fashion facilitated efficient loading of their kilns. The Huffman pot is also distinguished by having handles that break sharply as they return to

Figure 74 Sugar pot, Alamance County, North Carolina, 1790–1810. Lead-glazed earthenware. H. 10". (Courtesy, Old Salem Museums & Gardens.)

Figure 75 Sugar pot, Alamance County, North Carolina, 1790–1810. Lead-glazed earthenware. H. 6¼". (Courtesy, Colonial Williamsburg Foundation.)

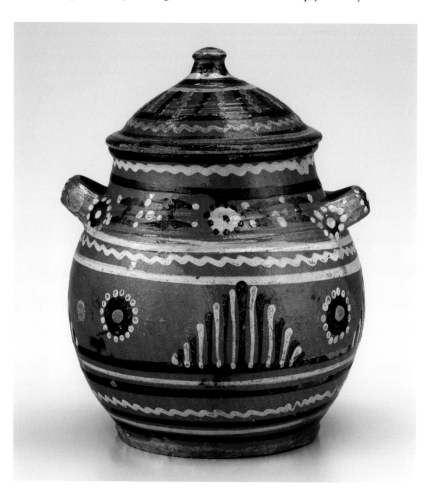

Figure 76 Detail of the rim, handle, and body of the sugar pot illustrated in fig. 74.

Figure 77 Detail of the rim, handle, and body of the sugar pot illustrated in fig. 75.

the body, notched terminals that resemble cut-card work in metal (fig. 79), a molded rim, and a lid with an acorn-shaped finial. The only other object with a comparable finial is the condiment pot shown in figure 66.[66]

The Huffman pot probably dates from the first decade of the nineteenth century, like most of the white slipped dishes from the St. Asaph's tradition. Sugar pots from this period often have handles that are indistinctly molded and seem almost vestigial (see figs. 64, 65). Otherwise the form of these nineteenth-century examples differs only slightly from that of their eighteenth-century counterparts.

Figure 78 Sugar pot, Alamance County, North Carolina, 1795–1820. Lead-glazed earthenware. H. 10". (Courtesy, Old Salem Museums & Gardens.) The color and surface texture of the lid are somewhat different from those of the body. Although it is possible that this discrepancy denotes an early "marriage," the fit of the lid suggests that it is original. Placement in the kiln and subsequent use could account for the differences visible here.

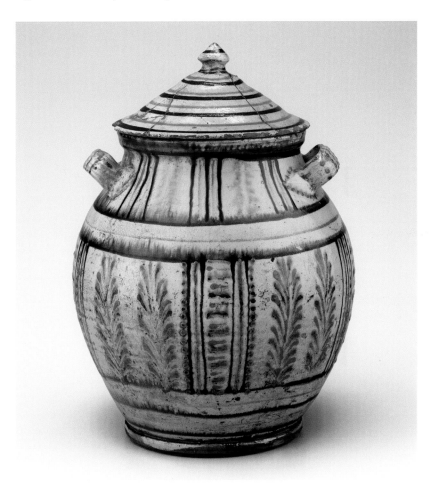

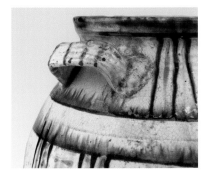

Figure 79 Detail of the rim, handle, and body of the sugar pot illustrated in fig. 78.

Two other sugar pots have histories of descent in Alamance County families. The example with the white slip ground in figure 62, right, was purchased at an auction of the Crouse family estate just a few miles southwest of Burlington, near the Guilford County line, and the pot illustrated in figure 78 descended in the Johannes Löffler (Spoon) family along with a confirmation certificate done for his son and namesake in 1779 (figs. 63, 80).[67] The Löfflers originally settled in the St. Asaph's district, where Johannes Sr.'s widow, Sarah, is listed on the tax list in 1788.[68] The couple had moved from Pennsylvania to southern Alamance County, by March 29, 1772, when they purchased one hundred acres of land "on the waters of Stinking Creek" from James McCarroll.[69] Family genealogies suggest that the Löfflers

Figure 80 Confirmation certificate for Johannes Löffler Jr., Guilford County, North Carolina, 1779. Ink and watercolor on paper, 8½" x 12⅞". (Courtesy, Old Salem Museums & Gardens; photo, Wesley Stewart.)

Figure 81 Dish, Alamance County, North Carolina, 1800–1835. Lead-glazed earthenware. D. 12½". (Courtesy, The Barnes Foundation.) This dish is probably an early example by Solomon Loy or one of his immediate predecessors.

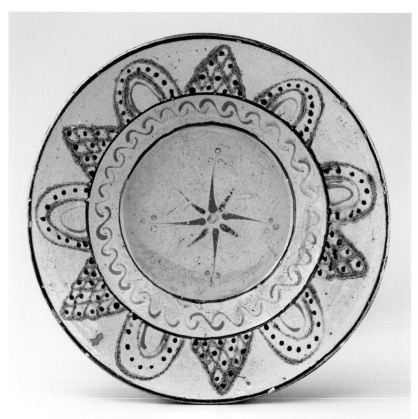

Figure 82 Details showing the marly decoration on the dishes illustrated in fig. 1 (left) and fig. 81 (right).

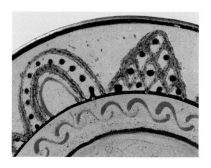

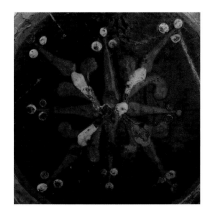

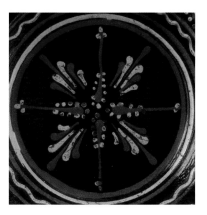

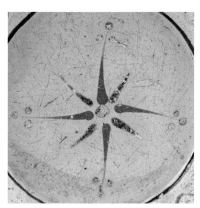

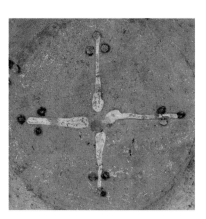

Figure 83 Details showing the decoration on (from top to bottom) the flask and dishes illustrated in figs. 4, 31, 81, and 51.

traveled with a party that included members of the Shoffner and Fogleman families.[70] The elder Johannes's brothers Adam and Christian also moved to Alamance County and are listed on the 1792 tax list for the St. Asaph's district.[71] The Löfflers apparently worshiped at the Brick Church, which may explain why Guilford County is cited as the place of confirmation on Johannes Jr.'s certificate.[72]

The Löffler pot is almost certainly from the same manufactory as four of the sugar pots illustrated in this article and three not shown.[73] Some vary in shape—one is squat and spherical (fig. 63), two are similar but have a sharper break at the shoulder (fig. 64), and five are ovoid (see fig. 65)—but their clay bodies, thin pulled handles, and shoulder incising are remarkably similar. These pots appear to be later than those shown in figure 62; however, their conical lids and embryonic finials suggest a direct connection. Similar "generational" parallels can be drawn between many of the hollow ware and dish forms (see figs. 48, 50, 68, 74) discussed above. This should come as no surprise, given the fact that some of this slipware likely represents the work of fathers and sons. There can be little doubt, for example, that Solomon Loy either trained under or worked in the shadow of the potter responsible for the dishes illustrated in figures 1 and 29–31 (figs. 81, 82). Although there is no conclusive evidence that Jacob Albright Jr.'s pottery was responsible for the earlier dishes (figs. 1, 29–31), the fact that Henry Loy worked and presumably trained his sons there lends credence to that theory. Albright's pottery was probably one of the most important factors in the persistence of form and decoration in the St. Asaph's tradition.

Continuity

Slipware from the St. Asaph's tradition challenges one aspect of folklorist Henry Glassie's assertion that backcountry decorative arts changed little over time but considerably over space. The styles and technologies introduced by the earliest potters who settled in southern Alamance County coalesced in southwestern Germany, arrived with immigrant craftsmen, and persisted for nearly one hundred years. Unlike some areas of the backcountry, where interactions with different ethnic groups or various social and economic forces led to the assimilation of Old World craft traditions, the interrelated and interdependent Germanic communities of southeastern Guilford County and southern Alamance County were resistant to change. The cruciform motif, which found its last expression in Solomon Loy's slipware, attests to the strength of artisanal and family traditions in that area of the piedmont (fig. 83).

1. Stanley South, *Historical Archaeology in Wachovia: Excavating Eighteenth-Century Bethabara and Moravian Pottery* (New York: Kluwer Academic/Plenum Publishers, 1999). John Bivins Jr., *The Moravian Potters in North Carolina* (Chapel Hill: University of North Carolina Press for Old Salem, Inc., 1972).

2. Philip Otterness, *Becoming German: The 1709 Palatine Migration to New York* (Ithaca, N.Y.: Cornell University Press, 2004), pp. 9–25. For more on the religious and constitutional sources of violence in the Palatinate, see Brennan C. Pursell, *The Winter King: Frederick V of the Palatinate and the Coming of the Thirty Years' War* (Burlington, Vt.: Ashgate Publishing, 2003).

3. Otterness, *Becoming German*, pp. 20–21.

4. The passenger list for the ship *Elizabeth* lists the names and trades of adult males; see http://immigrantships.net/v4/1700v4/elizabeth17330827.html (accessed June 1, 2009).

5. David Warren Sabean, *Power in the Blood: Popular Culture and Village Discourse in Early Modern Germany* (1984; repr., Cambridge: Cambridge University Press, 1997), pp. 9–10. For more on family relationships in southern German villages, see David Warren Sabean, *Property, Production, and Family in Neckarhausen, 1700–1870* (Cambridge: Cambridge University Press, 1990).

6. Mark Häberlein, "German Migrants in Colonial Pennsylvania: Resources, Opportunities, and Experience," *William & Mary Quarterly* 50, no. 3 (July 1993): 555–60. Philip Otterness refers to the Palatine migration of 1709 as a "migration of families" (Otterness, *Becoming German*, p. 19).

7. As quoted in Aaron Spencer Fogleman, *Hopeful Journeys: German Immigration, Settlement, and Political Culture in Colonial America, 1717–1775* (Philadelphia: University of Pennsylvania Press, 1996), p. 76.

8. *Diary of George Stolle,* compiled by Adelaide Fries (Raleigh, N.C.: Department of Archives and History, 1968), p. 800. The churches mentioned by Stolle were probably those later known as Stoner's Church (Alamance County), St. Paul's Church (Guilford County), Friedens Church (Guilford County), and the Old Brick Church (Guilford County).

9. For a genealogy of the Clapp family of Guilford and Alamance counties, see http://freepages.genealogy.rootsweb.ancestry.com/~djwm/html/fam01711.htm (accessed June 1, 2009).

10. For a passenger list of the *James Goodwill*, see www.progenealogists.com/palproject/pa/1727jgood.htm (accessed June 1, 2009). For the Clapp family in Berks County and information on marriage into other families there and in North Carolina, see http://freepages.genealogy.rootsweb.ancestry.com/~djwm/html/fam01711.htm (accessed June 1, 2009).

11. For information on the Beaver Creek Church and its successor, the Old Brick Church, see www.rootsweb.ancestry.com/~ncalaman/brick.html (accessed June 1, 2009).

12. Genevieve E. Peters, *Know Your Relatives: The Sharps, Gibbs, Graves, Efland, Albright, Loy, Miller, Snoderly, Tillman, and Other Related Families*, microreproduction of typescript (Arlington, Va.: G. Peters, 1953), p. 8, North Carolina State Library, Raleigh.

13. For a list of the passengers on the ship *Johnson*, see www.ristenbatt.com/genealogy/shplst12.htm (accessed June 1, 2009). The names of Johannes and Anna Barbara Albright's children are also given in an early deed: "Barbara Albracht . . . widow of John Albracht, deceased, together with Christian Albracht, yeoman, Jacob Albracht, wheelwright, Lodowick Albracht, wheelwright, they being the three sons of John Albracht, Philip Faust, yeoman, and his wife Mary (Magdalene) one of the daughters of the said John Albracht and Judith Albracht, another daughter of John Albracht" (December 12, 1752, deed book A-3, p. 27, as quoted in Peters, *Know Your Relatives*, p. 119).

14. See www.faustfamily.us/.

15. Members of the Albright family probably moved to North Carolina between 1762 and 1763. A Berks County deed made out in 1762 and proven on January 20, 1763, lists "Anna Barbara Albrecht, widow . . . of John Albrecht" along with sons Christian and Jacob and daughters Magdalene and Judith (Deed book A-3, p. 137, as quoted in Peters, *Know Your Relatives*, p. 119). Johannes and Anna Barbara's son Ludwig is not mentioned, which suggests he might have been in North Carolina at that date. Ludwig purchased 325 acres of land in Orange (now Alamance) County from Henry McCulloh in 1763, and the following year his brother Jacob (referred to as James in one deed) bought two tracts totaling 415 acres (*Register of Orange County, North Carolina Deeds, 1752–1768 and 1793*, transcribed by Eve B. Weeks [Danville, Ga.: Heritage Papers, 1984], n.p.).

16. See note 13 above.

17. For genealogical information on the Foust family, see Howard Faust, *Faust-Foust Family in Germany & America* (Baltimore, Md.: Gateway Press, 1984), and www.faustfamily.us/.

18. Faust, *Faust-Foust Family*, D1–D5. Most genealogies of the Faust family do not include Anna Catrina Foust, who was twenty-one when she arrived on the ship *Elizabeth*; see

www.olivetreegenealogy.com/ships/pal_eliz1733.shtml (accessed June 1, 2009). Anna Catrina might be the daughter of Johan Peter Foust and his first wife, Magdalena Adams, who died in 1713, shortly after giving birth to their son Peter.

19. Johannes moved to North Carolina after May 12, 1764, when he sold his land in Berks County, Pennsylvania, to his brother-in-law Christian Albright (Faust, *Faust-Foust Family,* p. D1 52). For marriages into the Albright and Snoderly families, see Peters, *Know Your Relatives,* pp. 120, 220–24. For Anna Catrina Foust, see note 18 above. Martin Loy purchased 251 acres of land in Orange (now Alamance) County in 1764 (*Register of Orange County, North Carolina Deeds*).

20. For passenger lists for the ships *Loyal Judith* (1732), *Samuel, Harle,* and *Loyal Judith* (1740), see http://freepages.genealogy.rootsweb.ancestry.com/~pagermanpioneers/ (accessed June 1, 2009).

21. Marriages, Evangelisch-Reformierte Kirche, Mussbach, film 488536. It is presumed that Martin was born between 1700 and 1705, since it was illegal to marry without parental consent before the age of twenty-five.

22. Hasslock Baptisms, Evangelisch-Reformierte Kirche, church in Mussbach, film 1418010.

23. Martin and Anna Margaretha are both listed as passengers; see www. progenealogists. com/palproject/pa/1741smark.htm (accessed June 1, 2009). Their daughter Catharina married Ludwig Adam Stehli in Mussbach on August 25, 1759. She died there on June 1, 1794 Evangelisch-Reformierte Kirche, Mussbach, film 1418010.

24. See note 18 above.

25. The website www.voiceinverse.com/family/genealogy/ (search FOUST, select Person ID I904; accessed July 27, 2010) gives approximate dates for Martin and Anna Catrina's children but some of the information provided in this site is incorrect. See note 30 below.

26. Lyman Chalkley, *Chronicles of the Scotch-Irish Settlement in Virginia: Extracted from the Original Court Records of Augusta County, 1745–1800,* 3 vols. (1912; repr., Baltimore, Md.: Genealogical Publishing Co., 1965–74), 3:73, 321. All three volumes are available online at www.rootsweb.ancestry.com/~chalkley/ (accessed June 1, 2009).

27. Isaac Sharp, born at Langensbold, Isenberg, Hessen, was the first member of his family to immigrate. He arrived in Philadelphia on September 16, 1738, with his sons Isaac II (26), George (36), and Ernst (39). This generation settled in Berks and Lancaster counties, Pennsylvania. Isaac II had nine children: Ernest, George, John Joseph, Henry, Isaac III, Veronica, Margaret, Barbara, and Rebecca. Isaac III and his wife, Philopena Graves, moved from Pennsylvania to Botetourt County, Virginia, before relocating to Alamance County. Their children married into the Albright and Foust families. This information came from a message posted by Roger Sharpe on February 3, 2008, at http://genforum.genealogy.com/sharp/messages/5893.html (accessed June 1, 2009).

28. *Orange County, NC Wills Vol. 2, 1775–1787,* transcribed by Laura Willis (Melber, Ky.: Simmons Historical Publications, 1998), pp. 13–14. For John Loy's marriage, see http://homepages.rootsweb.ancestry.com/~asbellm/genealogy/fam00937.htm; and Linda Carnes-McNaughton, "Transitions and Continuity: Earthenware and Stoneware Pottery Production in Nineteenth-Century North Carolina" (Ph.D. diss., Department of Anthropology, University of North Carolina at Chapel Hill, 1997), p. 96.

29. Members of both families are listed on an 1803 communicant roll for Stoner's Church, www.rootsweb.ancestry.com/~ncalaman/stoners.html (accessed June 1, 2009).

30. A December 1755 arrival date is cited, without a source, at www.voiceinverse.com/family/genealogy/ (search last name LOY, first name MARTIN, select Person ID I903; accessed June 5, 2009). This date might not be correct, since *Register of Orange County, North Carolina Deeds* refers to Martin Loy's purchase of 251 acres of land in Orange (now Alamance) County from Henry McCulloh in 1765.

31. www.voiceinverse.com/family/genealogy/ (search last name LOY, first name MARTIN, select Person ID I903; accessed June 5, 2009). In 1775, Martin began distributing land to his heirs, with sons George and John receiving 120 and 121 acres, respectively. In his will of July 15, 1777, the elder Loy left an additional acre to George, and his land, plantation, and "moveable Estate" to John, with the caveat that "his beloved wife Catheriney" retain use of the latter property during her lifetime. Martin named George Loy and Jacob Albright Sr. his executors (*Orange County, NC Wills Vol. 2, 1775–1787,* pp. 13–14).

32. Carnes-McNaughton, "Transitions and Continuity," pp. 95–103.

33. As quoted in ibid., p. 94.

34. For more on this idea, see ibid., p. 95; and Robert Blair St. George, *The Wrought Covenant: Source Material for the Study of Craftsmen and Community in Southeastern New England, 1620–1700* (Brockton, Mass.: Brockton Art Center, Fuller Memorial, 1979), pp. 13–21.

35. Bivins, *Moravian Potters in North Carolina*, pp. 244–45. Bivins wrote that the dish illustrated in fig. 1 and several related pieces probably "represent the work of one man . . . whom we now presume to be Christ." He referred to the slip motifs on that dish as "signatures" in John Bivins Jr., "Slip-decorated Earthenware in Wachovia: The Influence of Europe on American Pottery," *American Ceramic Circle Bulletin/ 1970–1971*, no. 5 (1975): 100–106; and John Bivins Jr. and Paula Welshimer, *Moravian Decorative Arts in North Carolina* (Winston-Salem, N.C.: Old Salem, Inc., 1981), pp. 40–41, fig. 2-7.

36. Carnes-McNaughton, "Transitions and Continuity," pp. 197–99.

37. The accession card file for the dish illustrated in fig. 1 indicates that in 1974 representatives of the Museum of Early Southern Decorative Arts in Winston-Salem, North Carolina, examined an identical example in the collection of S. S. Shoffner. He reported that the dish descended in his family and that they lived in Snow Camp.

38. Tax list for the St. Asaph's district of Orange County, North Carolina, 1787, North Carolina State Archives (hereafter NCSA), Raleigh.

39. http://lmkmfamily.com (search first name MICHAEL, last name SHOFFNER, select Person ID I763; accessed July 27, 2010).

40. Inventory of the Estate of Jacob Albright [Sr.], submitted to court in February 1792 and settled in November 1795, loose estate papers, Jacob Albright file, NCSA.

41. For a drawing of a sixteenth-century costrel from Saintonge with a vertically oriented fleur-de-lis at each end, see Hans-Georg Stephan, *Die bemalte Irdenware der Renaissance in Mitteleuropa* (Munich, Germany: Deutscher Kunstverlag, 1987), p. 211, fig. 201.

42. Alain Mérot, *French Painting in the Seventeenth Century* (New Haven: Yale University Press, 1995), pp. 202–4.

43. Neil Kamil, *Fortress of the Soul: Violence, Metaphysics, and Material Life in the Huguenots' New World, 1517–1751* (Baltimore, Md.: Johns Hopkins University Press, 2005), pp. 1, 74–75, 194–95, 211–17, and passim; Neil Kamil, "Hidden in Plain Sight: Disappearance and Material Life in Colonial New York," in *American Furniture*, edited by Luke Beckerdite and William N. Hosley (Hanover, N.H.: University Press of New England for the Chipstone Foundation, 1995), pp. 233–41.

44. Sotheby's, New York, *Important Americana, Furniture, and Folk Art*, sale cat., January 16–17, 1999, lot 296.

45. The site from which the fragments were recovered is on a thirty-acre parcel that has been in the family of the current owner since the mid-1890s. Deed research suggests that the site was part of a much larger tract owned by members of the Albright family (see Jacob Albright to Joseph Albright, May 13, 1778, and Joseph Albright to Andrew Albright, August 13, 1778, as cited by Linda F. Carnes-McNaughton in "Solomon Loy: Master Potter of the Carolina Piedmont," p. 134, n. 16, in this volume).

46. Henry Loy (1777–1832) was the son of John and the grandson of Martin. Tax list for the St. Asaph's district of Orange County, North Carolina, 1800, County Tax Records, NCSA. The contents of Albright's pottery were sold on March 24, 1825, and listed in "An Inventory and an Account of Sales of the Estate of Jacob Albright Dec^d," NCSA. Among the items listed in the inventory of his property were "1 pair pipe molds" valued at 12¢, "1 turning wheel" valued at 10½¢, and "1 mill" valued at 5¢. The pipe molds were purchased by Henry's son John (Sale of the Property of Henry Loy Dec^d., 1832, loose estate papers, Henry Loy file, NCSA). The absence of pottery in the inventory suggests that Henry had either ceased production or transferred his stock-in-trade to another party, possibly one or more of his sons. Land transactions recorded between 1826 and 1839 involving two of Henry's sons, William and Solomon, suggest that they were purchasing land and might have been relocating the pottery in the years prior to their father's death (Carnes-McNaughton, "Transitions and Continuity," pp. 98–103).

47. Albright's stock-in-trade was small: 255 crocks, 62 basins, 20 dishes, 9 pitchers, 7 jugs, 2 cream pots, 2 pans, 2 "P pots," and 1 sugar pot.

48. "Inventory of the things and tools in the Pottery, by Gottfried Aust in Salem, which had occurred new in March 1780," Moravian Archives, Southern Province, Winston-Salem, N.C.

49. For more on these chests, see Monroe H. Fabian, *The Pennsylvania-German Decorated Chest* (1978; repr., Atglen, Pa.: Schiffer Publishing for the Heritage Center of Lancaster County and the Pennsylvania German Society, 2004), pp. 128–32, nos. 84–91. The Foust chest is illustrated and discussed in Beatrice B. Garvan and Charles F. Hummel, *The Pennsylvania Germans: A Celebration of Their Arts, 1683–1850* (Philadelphia: Philadelphia Museum of Art, 1982), pp. 30, 33, pl. 11.

50. John Bivins attributed the dish illustrated in fig. 22 to Christ and referred to the design in the center as a "bird of paradise" motif (Bivins, "Slip-decorated Earthenware in Wachovia," pp. 103–4, fig. 11; Bivins and Welshimer, *Moravian Decorative Arts*, pp. 40–41).

51. For a fragmentary dish with a bird and the date 1659 trailed in the cavetto, see Stephan, *Die bemalte Irdenware der Renaissance in Mitteleuropa*, p. 112, fig. 106.

52. MESDA did not photograph the Shoffner dish, but its design and marks are described on the accession card for the dish illustrated in figure 1 (89.27).

53. Montgomery County jars with similar decoration are illustrated in Beatrice B. Garvan, *The Pennsylvania German Collection* (Philadelphia: Philadelphia Museum of Art, 1982), p. 208, no. 10.

54. Inventory of Jacob Albright Sr.

55. E-mail from R. P. Stephen Davis, Archaeological Research Lab, University of North Carolina, Chapel Hill, to Luke Beckerdite, September 22, 2002.

56. The authors thank Robert Hunter for suggesting the connection to British pearlware.

57. John P. Kieckbusch, Report from Aspen Consulting on quantative energy dispersive spectroscopy performed on the pitcher illustrated in fig. 47, file no. 97056, February 18, 1997, facsimile copy in Luke Beckerdite's papers.

58. For early references to sugar pots, see "Inventory of the estate of John Howell decd.," Orange County Court, August 1774; "A True Inventory of the Effects of William Bolton Deceased," Orange County Court, April 13, 1783; and "The Personal Estate formerly Belonging to James McCanles," Orange County Court, May 1784 (*Orange County Inventories 1758–1785*, pp. 123, 165, 189). Orange County inventories also list forms described as "sugar boxes" and "sugar canisters," but it is impossible to determine whether any were ceramic.

59. Document with heading "This 28th Day of August 1812. I as Executor of Jacob Albright & my Mother Cathy Albright have offered at public Sail the balance of What She my Mother was furnisht at the Last is as follows," loose estate papers, Jacob Albright file, NCSA. Jacob Albright Sr. died in 1791; the inventory of his estate was submitted to court in February 1792.

60. Document titled "1830 Account of Sales of personal property of John Albright Decd," loose estate papers, Jacob Albright file, NCSA.

61. Bivins, *Moravian Potters in North Carolina*, pp. 244, 249, fig. 257.

62. Entries for 17 sugar bowls occur adjacent to entries for 16 teapots in an inventory titled "Finished pottery ware that Rudolph Christ brought to the Salem Pottery from Bethabara as well as what was in the pottery here, and also what material and tools and equipment was here on 1st February 1789," Moravian Archives, Southern Provence, Winston-Salem, N.C.

63. Advertisement by Joe Kindig Jr. in *The Magazine Antiques* 27, no. 4 (April 1935): 121.

64. John Bivins notes similarities between the handles of these objects in *Moravian Potters in North Carolina*, p. 254. Although he speculates that the handles might have been extruded, their tapering cross sections indicate that they were formed by hand.

65. This sugar pot reputedly came from the Vance Huffman estate sale near Burlington, North Carolina. Members of the Huffman family are listed on eighteenth-century tax assessments from the St. Asaph's district and in the records of Old Brick Church (successor to the Church at Beaver Creek) in southeastern Guilford County.

66. Document with heading "This 28th Day of August 1812. I as Executor of Jacob Albright & my Mother Cathy Albright have offered at public Sail the balance of What She my Mother was furnisht at the Last is as follows," NCSA.

67. The author thanks Bob Pearl for providing the recovery history of the sugar pots and fraktur. For information on the Löffler (Spoon) family, see www.spoongenealogy.com/histories/nc.php. Johannes Löffler Jr. is buried in the cemetery of Low's Lutheran Church, which was a successor of Old Brick Church in Guilford County.

68. Tax List for the St. Asaph's District of Orange County, North Carolina, 1788, County Tax Records, NCSA.

69. See www.spoongenealogy.com/histories/nc.php.

70. Ibid.

71. Ibid.

72. Two sugar pots with sponged decoration like that on the examples illustrated in fig. 64 are in the collection of the Barnes Foundation (acc. nos. 01.09.33ab and 01.12.13ab). Another sugar pot in the collection of the Winterthur Museum is of the same basic form as the sugar pots illustrated in fig. 65 and is decorated with concentric and wavy lines in yellow and green.

73. One of the sugars pots is in the Winterthur Museum and two are in the collection of the Barnes Foundation.

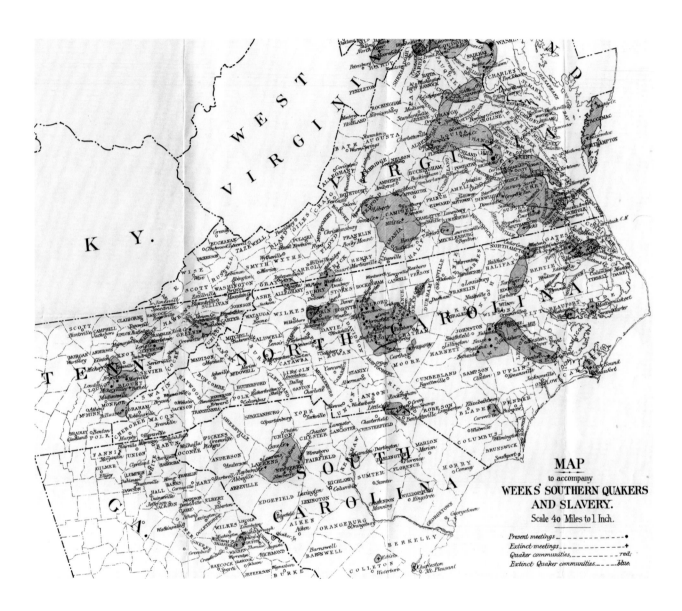

Figure 1 Map showing southern Quaker communities. Reproduced from Stephen B. Weeks, *Southern Quakers and Slavery: A Study in Institutional History* (Baltimore, Md.: Johns Hopkins Press, 1896). (Courtesy, Friends Historical Collection, Guilford College.)

Hal E. Pugh and Eleanor Minnock-Pugh

The Quaker Ceramic Tradition in Piedmont North Carolina

▼ RESEARCH OF QUAKER potters in North Carolina has been limited due to the scarcity of signed wares and identifiable pottery sites. Because these craftsmen typically lived in agrarian areas, supplemented their trade with farming, and led rather plain lifestyles, it has been assumed that their production was largely limited to utilitarian ware. That hypothesis is changing with the discovery of more pottery sites, kiln structures, genealogical and historical research, and documentation and reattributions of extant wares.

The Religious Society of Friends originated in 1644 in Leicestershire, England.[1] In 1650, after he and his followers were charged with blasphemy, founder George Fox told the judges to "tremble at the word of the Lord," whereupon Justice Gervase Bennet of Derby reportedly referred to the Friends as "Quakers."[2] Quakerism has been described as "primitive Christianity revived." Believing an "inner light" would guide the conscience, their basic tenets were to refuse to fight or swear, to pay no tithes, to acknowledge no man as master, and to make no distinction between clergy and lay persons. The teachings of Fox and the beliefs of the Quakers originally spread through northern England and then throughout the country, eventually progressing to Scotland, Ireland, Wales, the West Indies, and America.[3]

In England, Quaker meetinghouses were often located in and around pottery centers such as Staffordshire and Bristol. Several British Quakers achieved acclaim in the field of ceramics, including chemist and pottery manufacturer William Cookworthy and his cousin Richard Champion, who pioneered the early porcelain industry in England. In the colonies, Joshua Tittery began making earthenware in Philadelphia by 1698, and the Osborne family followed suit in Essex and Bristol counties, Massachusetts, by the 1740s. By the end of the eighteenth century, many Quaker potters were active in Chester County, Pennsylvania, and Philadelphia.[4]

In the mid- to late eighteenth century there was a large migration of Quakers into North Carolina. These families left the mid-Atlantic and New England states and traveled down the Great Wagon Road and Colonial Trading Path from such areas as Philadelphia and Nantucket, carrying with them the cultural knowledge and techniques of ancestors and relatives. Areas of poor soil, unsuitable for productive farming, produced an abundance of "fat" clay, useful for turning pottery, as well as the raw minerals required by farmer-potters for the decoration and glazing of their wares (fig. 1).

Quakers were required to obtain "certificates of removal" if they left their congregation, known as meeting: "All Friends removing out of the limits of their monthly meetings, whether for continuance, or for any considerable length of time, are advised to apply to their respective meetings for certificates directed to those within which they propose to sojourn or settle."[5] Surviving certificates of removal have made possible the tracking of a family's movement from one area to another.

Members of the Society of Friends were required to marry within their religion or relinquish "their right in society, and monthly meetings may accordingly disown them."[6] This requirement, among others, resulted in close-knit communities with intertwined families, encouraged ongoing contact among Quaker meetings and settlements, and created opportunity for the emergence of a ceramic tradition.

The Dennis Family

Thomas Dennis (b. ca. 1650) was living in the county of West Meath, near Athlone, Ireland, by 1673. He had two children by his first wife, whose name is unknown. In 1681 Thomas married his second wife, Jane Tatnall, in Edenderry, Ireland. The following year, the couple immigrated to western New Jersey and settled with other Quakers on a 64,000-acre tract of wilderness in Gloucester County called the Irish Tenth. In 1684 Thomas received forty acres on Newton Creek, near present-day West Collingswood.[7] About 1687/88 he rented a lot on the south side of Walnut Street,

Figure 2 Dennis and Webb family tree. (Compiled by Hal Pugh and Eleanor Minnock-Pugh; artwork, Wynne Patterson.)
■ Documented potter

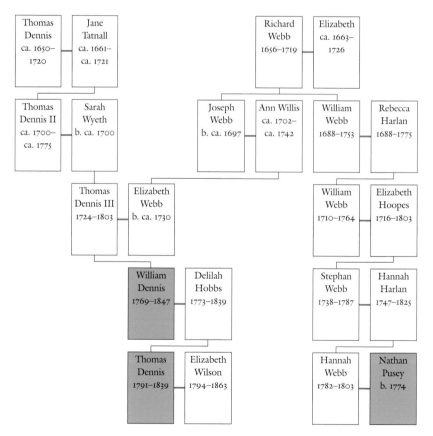

east of Fifth Street, in Philadelphia, and purchased adjoining land to the east in 1692. Shortly thereafter, Thomas moved back to Gloucester County, New Jersey, where he most likely resided until his death in 1720.[8]

Thomas and Jane had two boys and four girls. Thomas II was born to them about 1700 (fig. 2), and in 1720 married Sarah Wyeth. They lived in Gloucester County, New Jersey, until 1728, when they moved to Chester County, Pennsylvania, with their sons, Thomas III (b. 1724) and Edward (b. ca. 1726). In 1748 Thomas II purchased a 263-acre tract in East Fallowfield Township in Chester County.[9] Thomas III married Elizabeth Webb, daughter of Joseph and Ann Willis Webb, of Lancaster County, Pennsylvania, in 1757, after which he and his wife evidently continued to live with his parents on their 263-acre tract. In 1766 Thomas II sold his land and moved, with his wife and his son Thomas III's family, to North Carolina.[10]

These two families settled on a 300-acre tract in what is now north-central Randolph County, North Carolina. The property was bounded on the southeastern side by Polecat Creek and sat astride the Trading Road—formerly the Indian Trading Path—that ran from Petersburg, Virginia, to

Figure 3 Plat map showing the location of the Dennis Pottery and surrounding landowners. Dates represent the year individuals either applied for or were granted land from the state of North Carolina.

Figure 4 Indenture of George Newby, Randolph County, North Carolina, May 3, 1813. (Courtesy, North Carolina State Archives, Raleigh.)

South Carolina (fig. 3). In his will probated in 1775, Thomas II bequeathed his land to his wife and Thomas III.[11] On April 19, 1779, however, Robert and William Rankin received a grant encompassing that land, which Thomas III had to forfeit after refusing to swear an Oath of Allegiance and fight in the Revolutionary War.[12] Like many other Quakers, he was treated harshly for his pacifist beliefs. He was able to buy his property back after the war, and in 1786 a new state land grant for the 300-acre tract was issued in his name.[13] After his death in 1803, this property passed to his son, William (1769–1847).[14]

William Dennis had married Delilah Hobbs, daughter of Elisha and Fanney McLana Hobbs, on May 16, 1790.[15] They had three girls and seven boys. The eldest son, Thomas (1791–1839), who was born in Randolph County, North Carolina, followed his father in the potting trade. William lived on Thomas III's land, and in 1796 he purchased, from his aunt Rachel Dennis and her sons, 100 acres of property that adjoined the east side of his

father's property (see fig. 3). He acquired an additional 60 acres in 1800, and three years later inherited the family's 300-acre homestead.[16] In his will, Thomas III also left William the "remainder of [his] . . . moveable or personable estate & effects, goods & chattles both within doors & without with all debts due to me."[17]

William Dennis was a member in good standing of the Society of Friends. He attended Centre Monthly Meeting and in 1815 donated property for the establishment of Salem Friends Meeting under the auspices of Marlborough Monthly Meeting, where he was appointed first clerk.[18] Like many Quakers, William was opposed to slavery. He was a member of the Manumission Society, for which he served as a delegate and representative to several meetings between 1819 and 1828.[19] William's views on the equality of men may have influenced his acceptance of George Newby, an African American youth, as an apprentice in 1813.[20] Newby's indenture is the earliest written evidence that William was a potter (fig. 4).

North Carolina Quakers occasionally apprenticed their children to Friends in other states. In 1794, for example, Richard Mendenhall of Jamestown, North Carolina, was sent to Chester County, Pennsylvania, to learn the pottery-making trade.[21] Since William Dennis remained at Centre Monthly Meeting throughout his youth, it is likely that he apprenticed with a local potter. The occupation of William's father is not known, but his grandfather was listed as a cordwainer in an early New Jersey deed, and as a yeoman in his will. Deeds in New Jersey and Pennsylvania indicate that Thomas Dennis I worked as a shoemaker.[22]

Of the Quaker potters in North Carolina, those most likely to have trained William Dennis are members of the neighboring Dicks or Hockett (Hoggatt) families. William and Randolph County potter Peter Dicks (b. 1771) both attended Centre and Marlborough Monthly Meetings and traveled together later in life, journeying to Tennessee and Indiana in 1825 and 1826.[23] As commissioners, the two men helped lay out and sell lots for the town of New Salem in 1816.[24]

William Dennis's land acquisitions suggest that he farmed until at least 1820, when he moved to New Salem and built a house on lot 4 (fig. 5).[25] Before moving to Indiana in 1832, he sold Peter Dicks the property on which his original home and pottery were located.[26] In September of that year, Dennis, his wife, and son, Nathan, were granted certificates from Marlborough Monthly Meeting to Springfield Monthly Meeting in Wayne County, Indiana. The Springfield Meeting accepted them the following month.[27]

There is no evidence that William Dennis made pottery after arriving in Indiana; indications are that he continued to farm and actively campaign against slavery. The Springfield Monthly Meeting disowned him in 1844 for joining the "separatists"—abolitionist Friends whose more radical anti-slavery approach led them to establish separate meetings—but reinstated him two years later. In a letter of apology, William wrote:

> Whereas, I have had a birthright in the Society of Friends upwards of seventy years, but for the want of attending to the manifestations of truth in my own breast, I have given way so far as to be led by the reasoning of

Figure 5 William Dennis House, New Salem, North Carolina, ca. 1820. (Photo, Hal Pugh.)

others as to unite in setting up separate meetings and attending them; for which I have been disowned; which has caused me for months past to feel sorrow; now I feel very desirous that Friends would pass by my offense, and receive me into the unity of the Society again, and the love of Friends as I once was.[28]

William died the following year, at the age of seventy-seven.

In 1812 William's son Thomas purchased from William Welborn a 164-acre tract adjoining the north side of his father's property.[29] The following year Thomas married Elizabeth Wilson, daughter of Jesse and Elizabeth Beeson Wilson, at Providence Friends Meeting under the auspices of Centre Monthly Meeting. Three of the witnesses to the marriage—William Dennis, Mahlon Hockett, and Peter Dicks—were potters; apparently none of Thomas and Elizabeth's ten children became potters.[30]

A published biography of this Thomas Dennis states that, "In his early life he followed farming until he was near twenty years of age, when he commenced to learn the potter's trade, which he followed with that of farming until his removal to Wayne County, Ind., landing Oct. 1, 1822, in the city of Richmond."[31] This account and archaeological evidence (figs. 6–8)

Figure 6 Dish fragment recovered at the Thomas Dennis pottery site, New Salem, North Carolina, 1812–1821. Lead-glazed earthenware. (Private collection; unless otherwise noted, all photos by Gavin Ashworth.)

Figure 7 Kiln tiles recovered at the Thomas Dennis pottery site, New Salem, North Carolina, 1812–1821. High-fired clay. (Private collection.) The tiles on the right are fused together with glaze.

Figure 8 Saggar recovered at the Thomas Dennis pottery site, New Salem, North Carolina, 1812–1821. H. 7". High-fired clay. (Private collection.) The saggar is representative of the type and size used at both Dennis potteries. On this example, part of the rim has been pinched between the thumb and forefinger to form a decoration, but the vessel was never finished.

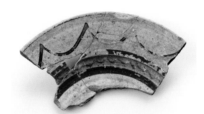

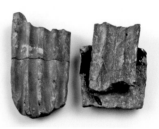

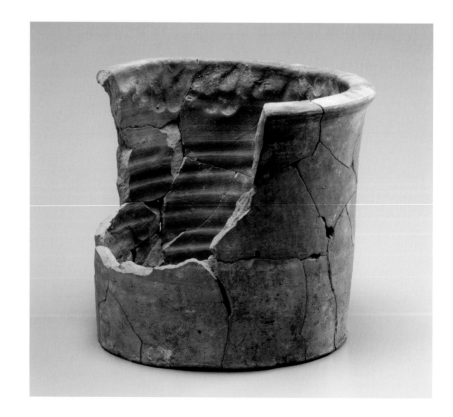

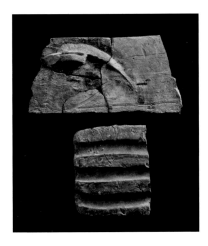

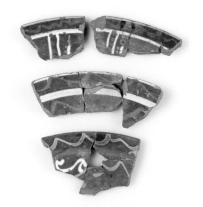

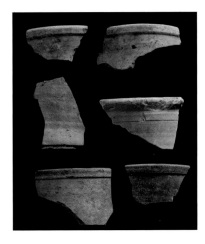

Figure 9 Kiln furniture recovered at the William Dennis pottery site, New Salem, North Carolina, 1790–1832. High-fired clay. (Private collection.) The ungrooved tile shown at top is vitrified from continual refiring and has adhering saggar and creampot rims from a kiln mishap.

Figure 10 Dish fragments recovered at the William Dennis pottery site, New Salem, North Carolina, 1790–1832. Bisque-fired earthenware. (Private collection.)

Figure 11 Saggar fragments recovered at the William Dennis pottery site, New Salem, North Carolina, 1790–1832. High-fired clay. (Private collection.)

Figure 12 Dish, attributed to the William Dennis pottery, New Salem, North Carolina, 1812. Lead-glazed earthenware. D. 13⅛". (Courtesy, Old Salem Museums & Gardens.)

Figure 13 Dish, attributed to the Dennis potteries, New Salem, North Carolina, 1790–1832. Lead-glazed earthenware. D. 13½". (Courtesy, North Carolina Pottery Center.)

suggest that Thomas learned to make pottery by 1811; soon thereafter he established his own shop, which he continued to operate seasonally for eleven years before moving from New Salem to Indiana. Earthenware fragments and kiln furniture from his site (figs. 6–8) resemble those associated with his father, William Dennis, who probably taught Thomas the pottery trade (figs. 9–11). If Thomas opened his own shop following his marriage in 1813, it may explain his father's need to take George Newby as an apprentice that year.

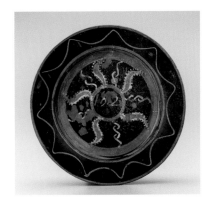

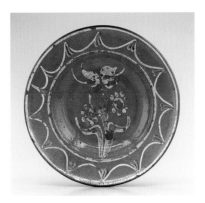

Before departing to Indiana, Thomas sold 164 acres containing his pottery shop and clay beds to Edward Bowman.[32] Although it is not known why he left North Carolina, a nineteenth-century history of Wayne County suggests that slavery was the primary catalyst: "Mr. Dennis was an active member of the Society of Friends . . . [and] could not bear the idea of rearing his children in the midst of slavery."[33] A descendant also points out that good farming land was available in Indiana.[34]

It is not known whether Thomas continued to produce earthenware in Indiana, but Eleazar Hiatt operated a pottery in Indiana from about 1818 to at least 1824. Originally from Guilford County, North Carolina, Hiatt employed a minimum of three potters: John Scott, George Bell, and Isaac Beeson.[35] The latter journeyman was likely the same Isaac Beeson who had apprenticed with Peter Dicks in Randolph County, North Carolina, beginning in 1806.[36] Thomas subsequently settled on a 154-acre tract in Dalton

Township, also in Wayne County. He was appointed county treasurer in 1839 but died while in office, at the age of forty-seven.[37]

George W. and Moses Newby

George W. Newby was born in Randolph County, North Carolina, about 1801. According to historian Paul Heinegg, both George and potter Moses Newby (b. ca. 1782) were part of the Peter Newby family, six "free persons of colour" according to the 1800 census of Randolph County.[38] Quaker owners had freed several members of the Newby family prior to that time. In 1805 the Guilford County Court gave Moses his freedom, acknowledging that Quakers had emancipated his parents.[39]

William Dennis took George Newby as an apprentice in 1813 (see fig. 4).[40] According to Friends' annual meeting records, several African American youths had been placed under the care of members to acquire "a suitable education to enable them to minister to their own necessities, and fit them for the enjoyment of freedom."[41] The terms of Newby's indenture required that he be bound out and taught the trade of a potter until the age of twenty-one. This apprenticeship would have ended in 1822, the same year William's son Thomas moved to Richmond, Indiana. Although there is no evidence that Newby left with Dennis, the former was in Richmond by 1830.[42] Newby married a woman named Agnes, and in about 1837 they had a daughter, Elliana, and continued living in Richmond until at least 1840.[43] By 1850, however, the family had moved to the Cabin Creek Settlement in western Randolph County, Indiana, a community composed of 80–100 African American families from North Carolina and Virginia.[44] The census taken in that year lists Newby as a blacksmith and indicates that he could read and write.[45] By the time of the 1860 census he had purchased four acres of land in West River Township and was listed as a farmer.[46] Four years later he sold this property and four adjoining acres to his neighbor Eli Townsend,[47] then moved to Van Buren County, Michigan, where in 1870 he was recorded as a farmworker living in Arlington Township.[48]

Moses Newby was born to free parents about 1782.[49] In August 1798 he was apprenticed to John Bullock of Orange County, North Carolina, to learn the potter's trade (fig. 14).[50] Six years later a Guilford County court reaffirmed Newby's status as a freeman:

> It appearing to the Satisfaction of the Court here that Moses [Newby], a man of Colour, . . . was born [to] parrents emansiapted by people called Quakers, tho no record of [this] . . . can now be found and it further appearing to the Court that the said man Mosses is of a fair moral charecter and Enquiring the trade of a potter which he Learned as a apprentice under John Bullock, late of Orange County. It is ordered that the said Moses be emansipated [and] . . . be entitled to all the rights previleages of a free man of Colour according to the Laws of North Carolina.[51]

This ruling was issued about two years after the end of Newby's apprenticeship. The absence of later records pertaining to him suggests that he may have left North Carolina.

Henry Watkins

Henry Watkins, the son of William and Lydia (maiden name unknown) Watkins, was born in Randolph County, North Carolina, in 1798 or 1799. He was accepted into the Marlborough Monthly Meeting on November 1, 1817, and two years later married Elizabeth Elliot, daughter of Obadiah and Sarah Chamness Elliot.[52] The Randolph County tax list for 1820 indicates that Henry owned lot 8 in New Salem.[53] Later, he purchased lots 9, 10, and 11, which were east of lot 8.[54] In 1821 Henry took his brother Joseph Watkins as an apprentice to the potter's trade. Joseph had been formerly bound in 1818, to Seth Hinshaw in the hatter's trade (fig. 15).[55] This bond is the earliest record of Henry being a potter.

Henry Watkins may have apprenticed with William Dennis or with his son Thomas, or perhaps worked at one of their potteries as a journeyman. Henry lived two miles from the Dennises, attended the same Quaker meeting, and witnessed the marriage of William's daughter Mary to Simeon McCollum in 1816.[56] Watkins was clearly working independently by the time of his brother's apprenticeship in 1821. That date corresponds with Thomas's disposition of property in preparation for his move to Indiana and William's establishment of residence in New Salem. Thomas's departure would have lessened competition and perhaps gave Watkins incentive to remain in the pottery trade in New Salem.

Figure 16 Jar, Henry Watkins, Randolph or Guilford County, North Carolina, 1821–1850. Lead-glazed earthenware. H. 7½". (Courtesy, Old Salem Museums & Gardens.)

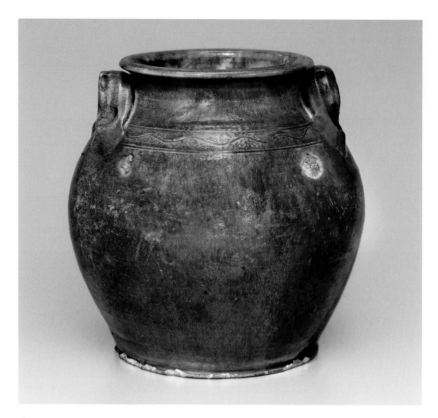

Figure 17 Detail of the incised signature on the bottom of the jar illustrated in fig. 16.

In 1824 Henry Watkins bought 100 acres of land on the north side of William Dennis's 300-acre tract.[57] Nine years later he purchased a sixteen-acre tract from William's son Absalom.[58] This tract adjoined the north side of property formerly owned by William, and the west side of property formerly owned by his son Thomas. About 1837 Watkins moved to southern Guilford County, where he bought a one-hundred-acre tract formerly belonging to his brother-in-law John Beard.[59] He continued making pottery there and is listed as a potter in the 1850 census of Guilford County.[60] Henry subsequently moved back to northern Randolph County, where the 1860 census lists him as a miller, living near potter Himelius Hockett.[61] Watkins was one of ten neighbors who in May 1863 signed a petition to Jefferson Davis seeking to exempt Hockett, his brother Jesse, and two other Quakers from having to serve in the Confederate Army. All were being held in a Confederate prison in Kinston, North Carolina, after refusing to bear arms.[62]

Fortunately, pottery documented and attributed to Henry Watkins survives. A two-handled jar with its bottom boldly signed in script (figs. 16, 17), along with a dish and fat lamp likely made by him, descended through a family living near New Salem in Randolph County. The dish was splashed with copper green over the natural buff clay background and covered with a clear lead glaze (fig. 18). The fat lamp, decorated with an incised sine wave around the cup, shifted in the kiln and, as a result, fired upside down, which caused the heavy lead glaze to run and form drips on the handle and rim of the cup. Another fat lamp, with a similar style, has been attributed to Watkins (fig. 19).

Figure 18 Dish, attributed to Henry Watkins, Randolph or Guilford County, North Carolina, 1821–1850. Lead-glazed earthenware. D. 12". (Courtesy, Old Salem Museums & Gardens.)

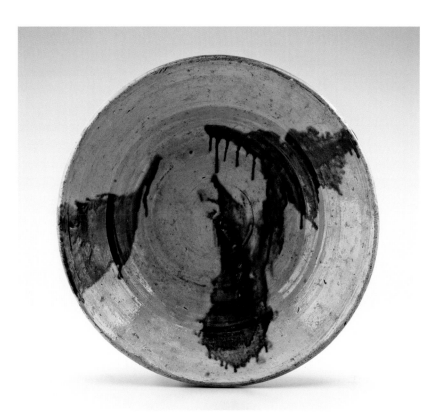

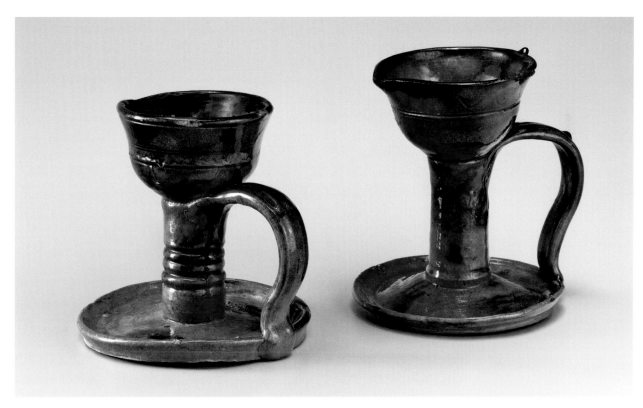

Figure 19 Fat lamps, attributed to Henry Watkins, Randolph or Guilford County, North Carolina, 1821–1850. Lead-glazed earthenware. H. 6⅛" (right). (Private collection [left]; courtesy, Old Salem Museums & Gardens [right].) The example on the right shifted in the kiln and fired upside down.

The Dicks Family

Family tradition maintains that Peter Dicks (ca. 1720–1796) was a potter.[63] He moved to present-day Guilford County from Warrington Meeting in York County, Pennsylvania, in 1755 and settled on a 640-acre tract of land located "on both sides of the upper fork of Polecat Creek."[64] Peter and four other early Quaker settlers—William Hockett, Isaac Beeson, John Beals, and Matthew Osborne—organized Centre Monthly Meeting, and Peter gave the land on which the meetinghouse was built.[65]

The Hockett and Beeson families were also involved in the pottery trade, and some of the four families mentioned married into the Dicks families (fig. 20). Three of the five children born to Peter Dicks's son, James (ca. 1748–

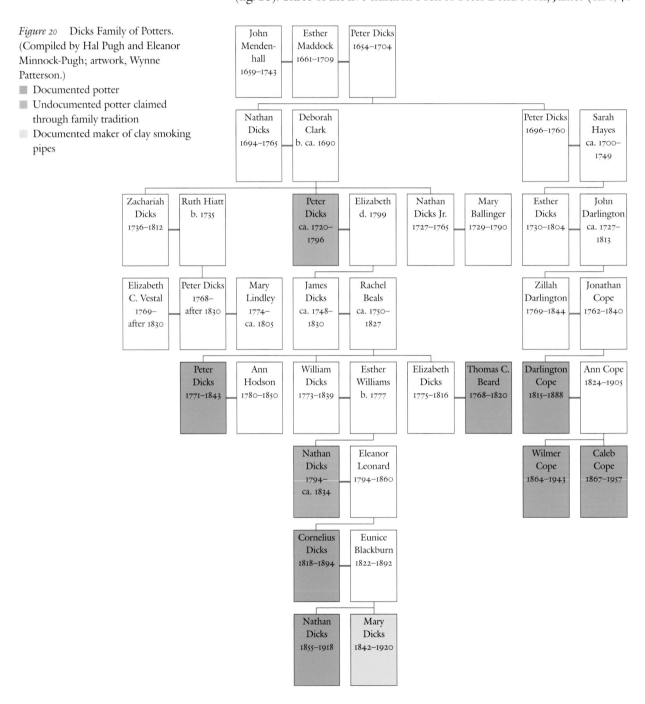

Figure 20 Dicks Family of Potters. (Compiled by Hal Pugh and Eleanor Minnock-Pugh; artwork, Wynne Patterson.)

▪ Documented potter

▪ Undocumented potter claimed through family tradition

▪ Documented maker of clay smoking pipes

1830), were associated either directly or indirectly with the pottery trade: Peter (1771–1843), William (1773–1839), and Elizabeth (1775–1816). Peter, discussed below, has been documented as a potter through an apprentice indenture and estate inventories. Although William's profession is not known, his son Nathan (1794–ca. 1834) is reputed to have been a potter, and his grandson Cornelius (1818–1894) and great-grandson Nathan (1855–1918) are documented as having worked in that trade. Elizabeth Dicks married Thomas Beard, a potter in Guilford County, North Carolina.[66]

Peter Dicks, who was born in Guilford County, married Ann Hodson, the daughter of Joseph and Margaret, at Centre Monthly Meeting on October 26, 1797. The couple moved to north-central Randolph County, purchased land in 1804, and in 1806 established an oil and gristmill on the Deep River.[67] In November 1806 Peter took eighteen-year-old orphan Isaac Beeson as an apprentice in the pottery trade (fig. 21), an agreement set to expire when Beeson reached the age of twenty-one.[68] In 1816 Peter was

Figure 21 Indenture of Isaac Beeson, Randolph County, North Carolina, November 3, 1806. (Courtesy, North Carolina State Archives.)

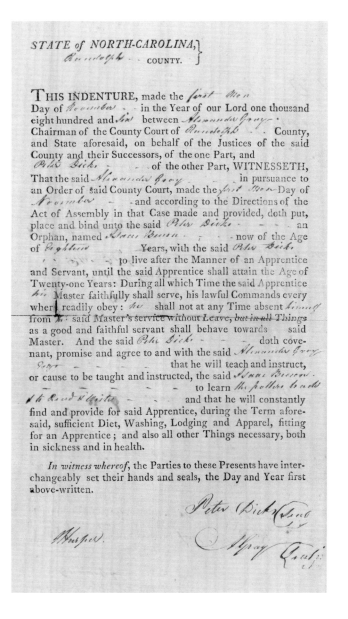

one of five commissioners appointed to lay out and sell lots in New Salem.[69] The town was located approximately one mile northeast of his mill on Deep River. Like many of his Quaker brethren, Peter Dicks was innovative and entrepreneurial. In addition to potting, he served as a minister and member of the Manumission Society, worked as a merchant in New Salem, and farmed several tracts of land he owned nearby. He bought the Dennis family farm and pottery when William Dennis moved to Indiana in 1832.[70] The duration of Peter's career as a potter is not known, but his estate inventory taken on May 23, 1843, noted the sale of "1 pair pipes moles" to his son James for $1 and debts of $6.52 and $10.03 owed by Henry Watkins and his brother-in-law John Beard, respectively. Peter's estate sold additional pottery equipment to his son James Dicks the following year, including "1 potters Lathe & glaseing mill" valued at $5.00.[71] Despite his purchases of pottery equipment, there is no physical evidence that James made pottery.

William Dicks's grandson Cornelius first made pottery in southern Guilford County, where he also attended Centre Monthly Meeting. In 1841 he was disowned for marrying Eunice Margaret Blackburn out of unity. The 1850 and 1860 censuses for the Southern Division of Guilford County list Cornelius as a farmer, but an account of his earthenware production written by R. R. Ross in 1927 suggests that he also made pottery:

> Up the County line about a mile you will find a deposit of potter's clay of the best variety. There were two potter shops near by, H. M. Hocket in Randolph, and C. T. Dicks on the Guilford side, much of the ware that was used in the homes was made at these shops. It was also hauled in wagons for many miles, and had the reputation of being the red ware that would stand fire, and was used for cooking vessels in many of the kitchens at that time. No pot or kettle has ever been made that would cook dried fruit and pumpkins like the old red stew jars that our mothers and grandmothers used, and no dish has ever been found that would cook a chicken pie for a corn shucking like the old dish made by Hocket and Dicks.[72]

Soon after 1860 Cornelius Dicks moved to New Market Township in northern Randolph County and established a residence and pottery near Plank Road, which ran from Fayetteville to Winston-Salem, North Carolina, on property he had purchased at an earlier date. According to his granddaughter, Nettie Dicks Lamb (b. 1900), he "made [pottery] . . . for years, because I heard dad tell about getting in the wagon and taking it . . . down to Fayetteville and selling . . . big loads . . . he went with him many times down the Plank Road." Lamb also noted that her grandfather made a variety of utilitarian wares including "things you cooked with . . . crocks, churns, [and vessels for] . . . molasses" as well as some decorative objects, including "a great big old [brown clay] duck" that her mother "kept setting on her fireplace."[73] Cornelius also made press-molded smoking pipes (fig. 22). After his death, his daughter, Mary Elizabeth Dicks Davis (1842–1920; fig. 23), inherited his press and continued to make pipes, firing them in the coals of her wood cookstove (fig. 24).[74]

Cornelius was living in his son Nathan's house in New Market Township when he made his will in June 1891.[75] The federal census describes Nathan

Figure 22 Pipe press and molds, Cornelius Dicks, Randolph County, North Carolina, 1850–1920. Hardwood (press) and pewter (molds). H. 13½". (Private collection; photo, Hal Pugh.)

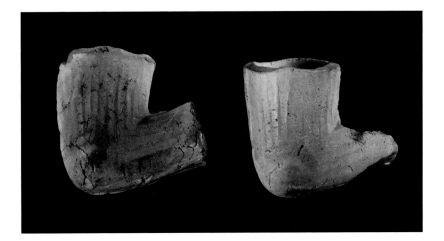

Figure 23 Photograph of Mary Elizabeth Dicks Davis (1842–1920). (Courtesy, Ann S. Turner.)

Figure 24 Clay smoking pipes, Mary Elizabeth Dicks Davis, Randolph County, North Carolina, ca. 1900. (Private collection.)

(1855–1918) as a potter in both 1880 and 1900; in the latter he was described as a manufacturer of "fire proof ware."[76] The 1910 census states that Nathan was a potter in Greensboro, Guilford County, and that he rented his property.[77] Nevertheless, Nathan appears to have returned to Randolph County occasionally. According to Iro Swaim (b. 1908), who lived next door to Nathan as a child, the potter came "out here in front of the house and [dug] . . . clay to make . . . dishes, and crocks, and . . . things like that."[78]

Another local resident, Eleanor Hartley (b. 1903), described buggy rides past Nathan Dicks's pottery and recalled that he would roll up the slatted blinds on his porch to display new wares.[79] Like many rural potters, Nathan made forms similar to those produced by earlier members of his family. The jug illustrated in figure 25 bears the inscription "N. B. DICKS.

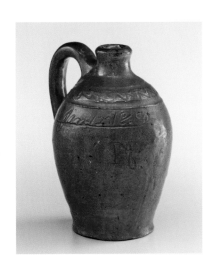

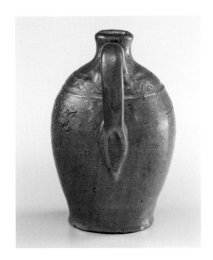

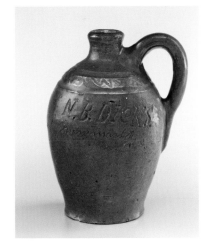

Figure 25 Jug, Nathan Dicks, Randolph County, North Carolina 1890. Lead-glazed earthenware. H. 5½". Inscribed on shoulder: "N. B. DICKS. new market n.c. Jan 12 1890 1 Pt." (Private collection.) Handles on earthenware associated with Dicks family potters often have an elongated lower terminal.

new market n.c. Jan 12 1890 1 Pt," has an iron tinted lead glaze over a buff-colored body, and concentric and wavy lines incised on the shoulder. One could imagine this jug, a gift to one of Nathan's friends, having been made nearly one hundred years earlier.

A bulbous-handled earthenware skillet with a history of use in the New Market community could be an example of Dicks's "fire proof ware" (fig. 26). Its green lead glaze is spotted as a result of impurities in the clay. A similar

glaze can also be seen on a pitcher that descended in a local family and reportedly was made by Dicks (fig. 27). The pitcher has the same incised line decoration as the signed jug, and the handles of both vessels exhibit elongated lower terminals like those on the storage jars illustrated in figure 28. Surface artifacts at the Nathan Dicks pottery site revealed fragments having glazes and clay paste similar to his surviving pottery (fig. 29).

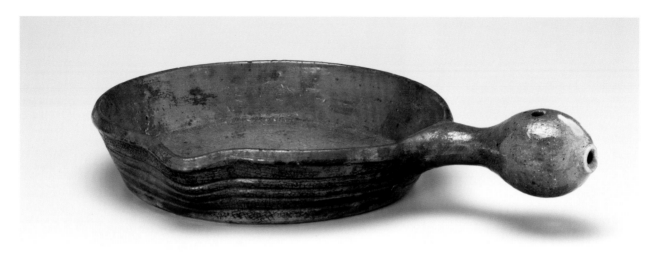

Figure 26 Skillet, attributed to Nathan Dicks, Randolph County, North Carolina, 1875–1910. Lead-glazed earthenware. D. 10⅝" with 5¼" handle. (Private collection.)

Figure 27 Pitcher, attributed to Nathan Dicks, Randolph County, North Carolina, 1875–1910. Lead-glazed earthenware. H. 6¼". (Private collection.)

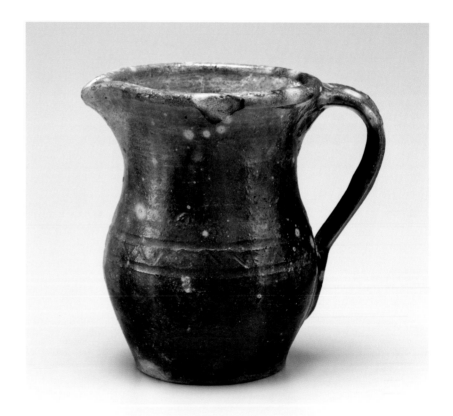

Figure 28 Jars, attributed to Nathan Dicks, Randolph County, North Carolina, 1875–1910. Lead-glazed earthenware. H. 9½" (right). (Private collection.)

These jars exhibit the elongated handle terminal and incised wavy line decoration characteristic of Nathan Dicks.

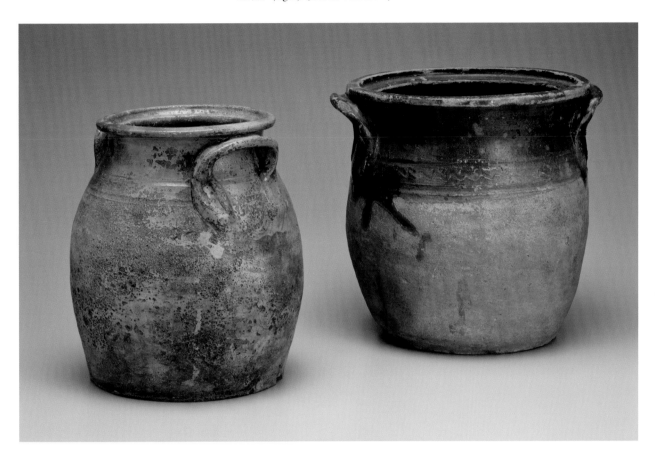

Figure 29 Fragments recovered at the Nathan Dicks pottery site, Randolph County, North Carolina, 1875–1910. Lead-glazed earthenware. (Private collection.)

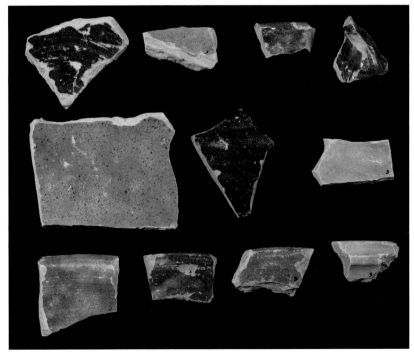

The Beeson Family

After serving his apprenticeship with Peter Dicks, Isaac Beeson (1788–1869) married Sarah Gorrell on June 6, 1811, in Guilford County, North Carolina. During the early 1820s they moved to Richmond, Indiana, where he worked at Eleazor Hiatt's pottery.[80] The 1850 census of Wayne County shows that Isaac and his son Mahlon were making pottery at that time.[81] Soon afterward, Isaac moved to Hancock County, Indiana:

> In the early fifties Isaac Beeson established a pottery . . . on the site now occupied by the Western Grove Church. He made jars, jugs, etc., from clay, which, after being burned in a kiln, were dipped in a solution and then burned again until glazed. The potter's wheel was in operation for about nine years.[82]

According to an early history, Beeson also made some of the first clay drainage tiles in Hancock County:

> They were round tile, turned by hand on a potter's lathe. After being used for half century they were taken up and found in good condition. Some of them may now be seen in the geological museum at the State House at Indianapolis. In 1863, Jacob Schramm built a tile factory on his farm in the German Settlement, in Sugar Creek Township, and manufactured what were known as "horseshoe" tile. It had no bottom, but was constructed with two sides and a top, on the principle of the board drains. . . . Just about the close of the Civil War the "horseshoe" tile were replaced by flat-bottomed tile, which were continued in use for a period of fifteen or twenty years. They are familiar to most people of the county, and may still be excavated in repairing the older ditches. During the eighties round tile came into general use and since that time have been used almost exclusively in our covered ditches.[83]

Schramm's flat-bottom drainage tiles appear to have been similar to the extruded examples made by David Hockett of Randolph County, North Carolina, during the same period (see fig. 40). In the 1860 census for Hancock County, Beeson and his son John were listed as potters living in the same household. Isaac's son Mahlon had moved to Hancock County by then, although he was listed as a farmer.[84] In 1864 Isaac Beeson sold his pottery shop to the Society of Friends for the establishment of Western Grove Preparatory Meeting.[85]

The Hoggatt/Hockett Family

Oral tradition suggests that Philip Hoggatt (ca. 1687–1783) may have been a potter, but no documentary evidence pertaining to his trade has been found. He settled on Richland Creek, a tributary of the Deep River, in what is today southwestern Guilford County, North Carolina.[86] Philip had two sons, William and Joseph, whose descendants were unquestionably potters (fig. 30). William (1727–1772) and his family settled "on the Middle Fork of Polecatt, near the Head Waters of Deep River, about 3 Miles, North Of the Trading Path" in northern Randolph County, North Carolina.[87] Their arrival probably coincided with that of Peter Dicks (ca. 1720–1796).

An 1878 journal entry by William (now Hockett) III (1799–1880) indicates that his grandfather may have been a potter: "John Hockett son of

Figure 30 Hoggatt/Hockett Family of Potters. (Compiled by Hal Pugh and Eleanor Minnock-Pugh; artwork, Wynne Patterson.)

- ▦ Documented potter
- ▦ Undocumented potter claimed through family tradition
- ▦ Documented decorator

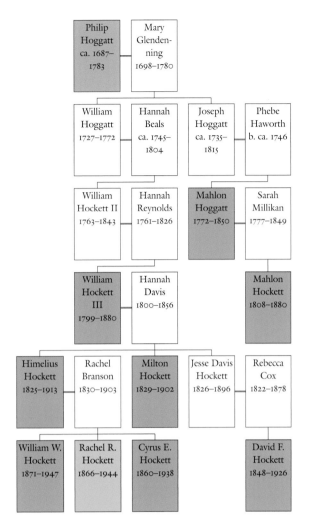

```
Philip Hoggatt ca. 1687–1783 ─── Mary Glendenning 1698–1780

William Hoggatt 1727–1772 ─── Hannah Beals ca. 1745–1804      Joseph Hoggatt ca. 1735–1815 ─── Phebe Haworth b. ca. 1746

William Hockett II 1763–1843 ─── Hannah Reynolds 1761–1826      Mahlon Hoggatt 1772–1850 ─── Sarah Millikan 1777–1849

William Hockett III 1799–1880 ─── Hannah Davis 1800–1856      Mahlon Hockett 1808–1880

Himelius Hockett 1825–1913 ─── Rachel Branson 1830–1903      Milton Hockett 1829–1902      Jesse Davis Hockett 1826–1896 ─── Rebecca Cox 1822–1878

William W. Hockett 1871–1947      Rachel R. Hockett 1866–1944      Cyrus E. Hockett 1860–1938      David F. Hockett 1848–1926
```

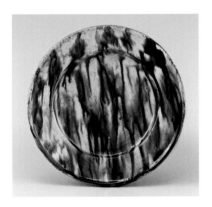

Figure 31 Dish, possibly made by a member of the Hoggatt/Hockett family of potters, northern Randolph/southern Guilford County, North Carolina, 1785–1820. Lead-glazed earthenware. D. 6½". (Private collection.) The rear profile of this dish is similar to that of Moravian examples, but it was removed from the wheel with a twisted cord—a technique not associated with Moravian work.

[William I] . . . was born the 16th day of the 2nd month 1771, and died about the 5th month 1772 by getting badly burned at the clay oven on the coals pulled out."[88] Tragically, John likely fell or crawled onto excess coals removed from the firebox during the firing of the kiln. Pottery kilns are still referred to as "clay ovens" by some longtime residents of Randolph and Guilford counties.

A small dish that descended through several generations of the Hockett family bears the pencil inscription "Made from Clay on Henry Clay Gregson's Farm" (fig. 31). Gregson's farm, which remains in his family today, was near William Hoggatt I's land grant. The double booge rear profile, heavy undercut rim, and decoration of the dish suggest that it dates from the eighteenth century. The maker coated the buff-colored body with white slip, then applied copper and manganese sponging. After the slip dried, he coated the front with a clear lead glaze. Migration of the glaze indicates that the dish stood on end during firing.

An earthenware bottle attributed to William Hockett III (fig. 32) bears the incised inscription "WM RR H 4-19-1879" (fig. 33). Presumably, "WM" signifies his first name, "RR" signifies the first and middle names of his thirteen-year-old granddaughter Rachel Rodema (1866–1944; fig. 34), and

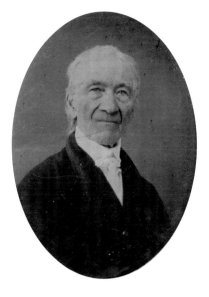

Figure 32 Photograph of William Hockett III (1799–1880). (Courtesy, Jane Coltrane Norwood.)

Figure 33 Bottle, attributed to William Hockett III, northern Randolph/southern Guilford County, North Carolina, 1879. Lead-glazed earthenware. H. 7¼". Inscribed on shoulder: "W̲M̲ RR H 4-19-1879." (Private collection).

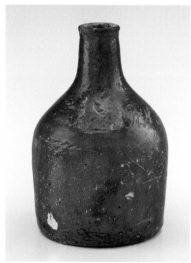
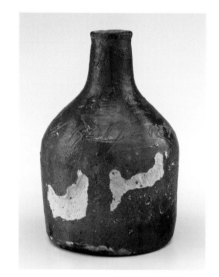

"H" signifies their last name (Hockett). According to family members, William III turned the bottle and Rachel decorated it with an incised design that seems to be a tree or a flower. Rachel was the daughter of potter Himelius Mendenhall Hockett (1825–1913) (fig. 35), who reputedly used it to store coffee beans.[89] Himelius married Rachel Branson (1830–1903), daughter of John and Jane Cox Branson, on May 6, 1852.[90]

Hockett family tradition maintains that the earthenware chest illustrated in figure 36 was made by William III as a gift for Himelius.[91] The maker rolled out slabs of clay and cut them into rectangles for the sides, back, and bottom, but turned the top on a potter's wheel. After cutting the top and adding a slab to its underside, he shaped the side peaks and feet, assembled the pieces, and inscribed the date, 1828, on the front. Although the potter probably used the same glaze for the lid and the case, the lid has a more unified green surface.

The 1850 census for Randolph County states that Himelius Hockett was a teacher living in the household of his father, William III.[92] In the census

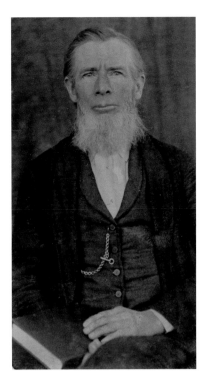

Figure 34 Photograph of Rachel Rodema Hockett (1866–1944), grand-daughter of William Hockett III and daughter of Himelius Mendenhall Hockett. (Courtesy, Jane Coltrane Norwood.)

Figure 35 Photograph of Himelius Mendenhall Hockett (1825–1913). (Courtesy, Jane Coltrane Norwood.)

Figure 36 Chest, attributed to William Hockett III, northern Randolph/southern Guilford County, North Carolina, 1828. Lead-glazed earthenware. H. 3⅜". (Private collection.) The chest is slab-built.

a decade later he is described as a farmer living with his wife, one child, and Harper Parson at residence number 725, which was near the home of Henry Watkins.[93] Harper Parson (b. ca. 1842) has been identified as a laborer in Himelius's pottery.[94] A November 1863 letter to Himelius from his daughter

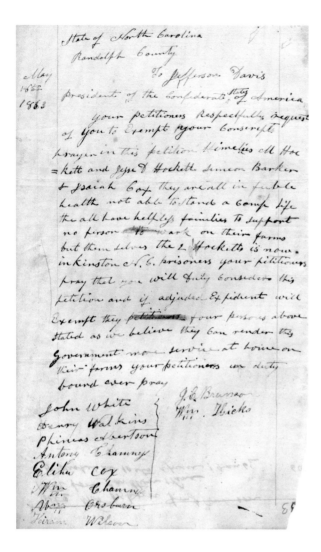

Figure 37 Petition from John Branson to Jefferson Davis, May 18, 1863, requesting the exemption of Himelius Hockett and others. The petition, written on an older account ledger page, was signed by ten neighbors, including potter Henry Watkins. (Courtesy, Friends Historical Collection, Guilford College.)

Figure 38 Reverse side of the petition illustrated in fig. 37. On this side, numbered page 34, is recorded an earthenware sale between John Branson and William Osborn: "Oct. 2 1842 Wm Osborn fr J Branson for Earthen Ware 5 dishes at 10 cts a piece 1 pan 6½."

Nancy Maria (b. 1858) and son Cyrus Elwood (b. 1860) reported on their mother caring for Watkins's ailing son:

> My Dear Pappy, as mother has sent thee [several letters] . . . I will try to send thee one to [tell] . . . thee what we are . . . [doing] at this time we are all well all though mother suffer a grate deal with her old complaint tho she is able to work all they time she is ___ go backerds and forward to H. Watkins to sit up with Franklin He is sick with the tyfoid fever an dont look like he will last the weak out.[95]

On April 4, 1862, Himelius and his brother Jesse Davis Hockett were conscripted into the Confederate Army. Because they would not bear arms, they were tortured and imprisoned at Kinston, North Carolina. John Branson, Himelius's father-in-law, sent a petition to Confederate President Jefferson Davis, requesting the release of the Hocketts and two other men (fig. 37).[96] Due to the scarcity of paper during the war, Branson used a page torn from an old account ledger recording the sale of earthenware pottery (fig. 38).[97] Himelius and his brother were discharged from the Confederacy, after the Society of Friends paid for their release.[98]

Himelius lost his vision in his later years, and his granddaughter Carrie Hockett Cox (b. 1899) remembered reading to him as a young girl: "I

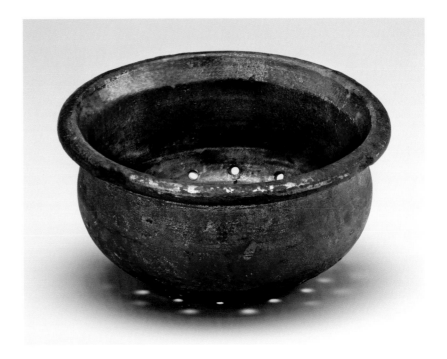

Figure 39 Colander, attributed to the William Hockett/Hoggatt family of potters, northern Randolph/southern Guilford County, North Carolina, ca. 1860. Lead-glazed earthenware. H. 4⅜". (Private collection.)

learned to read by reading to him. He couldn't see, you know, but he could tell me what chapter in the Bible to read." Cox thought her father, William Wilburforce Hockett (1871–1947), had also been a potter: "Way before I was born . . . I think he made a little . . . [but] he didn't burn it." She recalled a building referred to as the "potter shop," which was "across the old road in front of their house" and an old kiln where their chickens laid eggs. Cox also believed that "they made brick" in addition to "pottery . . . crocks . . . flower pots and things like that." The pottery was "nothing fancy . . . sort of like clay, brown" (fig. 39).[99]

Himelius Hockett's brother Milton (1829–1902), who lived north of Himelius's residence and shop, near the Randolph/Guilford County line, was also an earthenware potter.[100] Although there is no documentary evidence or oral tradition that their brother Jesse Davis Hockett was a potter as well, Jesse's son David Franklin Hockett (1848–1926) made brick, earthenware, and extruded earthenware drain tiles (fig. 40).[101]

Figure 40 Drain tile, David Franklin Hockett, Randolph County, North Carolina, ca. 1875. Unglazed earthenware. L. 6½". (Private collection.)

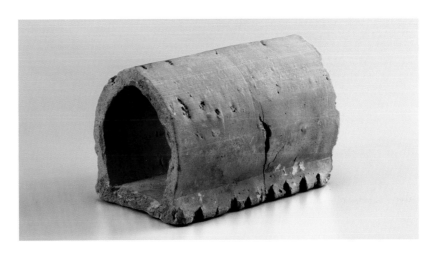

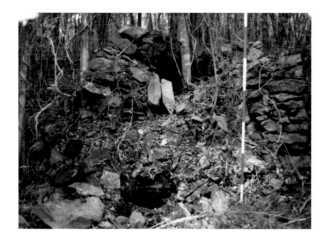 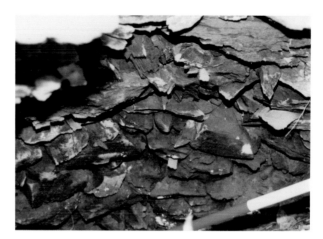

Figure 41 Exterior view of the David Franklin Hockett kiln, Randolph County, North Carolina, 1875–1910. (Photo, Hal Pugh.)

Figure 42 Interior view of the David Franklin Hockett kiln showing rock lining, Randolph County, North Carolina, 1875–1910. (Photo, Hal Pugh.)

Remnants of David Hockett's kiln are situated on the sloping south side of a hill and, at first glance, resemble a rock wall (fig. 41). The nearly square kiln, 10 by 9½ feet, was built into the hillside to provide insulation and structural support. The outer shell was made of local rock, and the interior lining was made of soft, fire-resistant, talceous schist—a stone occurring naturally in the region (fig. 42). Both the interior and the exterior rock surfaces appear to have been dry-stacked without the benefit of mortar. The rock was corbelled near the upper part of the kiln to close off the top. A single flue channel is visible running under the kiln remains and a piece of strap iron on the front wall indicates the location of an access opening. Local residents remembered the kiln being approximately seven feet tall with a firebox extending out the front and a smokestack made of clay or metal (fig. 43). One individual, who described the smokestack as a clay cylinder, also recalled seeing red clay pottery with the initials "DFH" scratched in the bottom near the site.[102] According to another neighbor, David Hockett's kiln was

> rock all the way over . . . there was a hole . . . in the center of it, maybe a foot across . . . it was a furnace looking thing, and I reckon that is what they had. They fired it from the outside . . . heat would expand up into it. There was a door, looked like about two and a half to three feet square. . . . I believe you went in over the firebox. . . . It set out facing the south there, the firebox, and the hole was right up over that firebox, I remember.[103]

In shape and size, Hockett's kiln was comparable to that built by William Dennis approximately three miles south (fig. 44).

Philip Hoggatt's son Joseph (ca. 1735–1815) remained in the vicinity in which his father had settled. He married Phebe Haworth on January 6, 1763, and had a son named Mahlon (1772–1850), who lived and made pottery within the present-day city limits of High Point, North Carolina. According to one descendant, Mahlon's shop was near the old Highland Cotton Mill: "[He] didn"t make fancy stuff . . . he preached and worked in the church, and just made [pottery] . . . when somebody wanted something. . . . [If] they told him they wanted a big pot, and he went out and made that for them."[104] Mahlon's son and namesake (1808–1880) was also a potter, as indicated in the 1850 census for Guilford County.[105] Mahlon II

Figure 43 Drawing of the David Franklin Hockett kiln, based on eyewitness accounts.

ACCESS

FIRING CHAMBER

FLUE

ACCESS

FIRE BOX

Figure 44 Overhead view of the partially excavated William Dennis kiln footprint, Randolph County, North Carolina, 1790–1832. (Photo, Linda F. Carnes-McNaughton.) It is similar in size and shape to the firing chamber of the David Franklin Hockett kiln.

is listed as a farmer in the 1860 census for Randolph County.[106] By 1880, however, he had moved to Indiana and was living in Ripley Township of Rush County, where he was listed as a farmer in the census for that year.[107]

The Mendenhalls
George Mendenhall was born on July 21, 1751, in Bradford, Pennsylvania (fig. 45). He moved to North Carolina with his parents, James Mendenhall (1718–1782) and Hannah Thomas Mendenhall (1717–1798), and later married Judith Gardner, whose birthplace was Nantucket, Massachusetts.

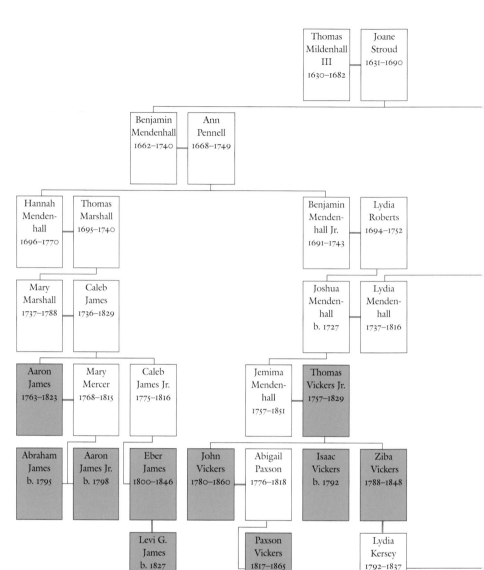

Thomas Mildenhall III 1630–1682 — Joane Stroud 1631–1690

Benjamin Mendenhall 1662–1740 — Ann Pennell 1668–1749

Hannah Mendenhall 1696–1770 — Thomas Marshall 1695–1740

Benjamin Mendenhall Jr. 1691–1743 — Lydia Roberts 1694–1752

Mary Marshall 1737–1788 — Caleb James 1736–1829

Joshua Mendenhall b. 1727 — Lydia Mendenhall 1737–1816

Aaron James 1763–1823 — Mary Mercer 1768–1815 — Caleb James Jr. 1775–1816

Jemima Mendenhall 1757–1851 — Thomas Vickers Jr. 1757–1829

Abraham James b. 1795 — Aaron James Jr. b. 1798 — Eber James 1800–1846 — John Vickers 1780–1860 — Abigail Paxson 1776–1818 — Isaac Vickers b. 1792 — Ziba Vickers 1788–1848

Levi G. James b. 1827

Paxson Vickers 1817–1865

Lydia Kersey 1792–1837

Figure 45 Mendenhall Family of Potters. (Compiled by Hal Pugh and Eleanor Minnock-Pugh; artwork, Wynne Patterson.)
■ Documented potter

Figure 46 Richard Mendenhall house, Jamestown, Guilford County, North Carolina, ca. 1811. (Courtesy, North Carolina State Archives.)

Mendenhall organized and laid out the town of Jamestown, North Carolina, which was named in honor of his father.[108] In 1794 George sent his fifteen-year-old son Richard (1778–1851) to Jesse Kersey (1768–1845) of Chester County, Pennsylvania, to learn the potter's trade; an older son, Stephen, went to York County, Pennsylvania, to apprentice as a tanner.[109] Kersey was a member of the Bradford Monthly Meeting, which accepted Richard Mendenhall's certificate from the Deep River Monthly Meeting in August 1794.[110] Kersey, who had apprenticed with Philadelphia potter John Thompson from 1784 to 1789, had just set up shop in Brandywine Township when Mendenhall arrived. Other workers at Kersey's pottery included Mendenhall's second cousin, Jonathan Howell Mendenhall, and Aaron Fraisure.[111] According to Richard Mendenhall, "Jonathan [Mendenhall] taught me all the Latin he could, and I repeated lessons while I was grinding clay."[112]

After Kersey sold his pottery shop and equipment in 1795, Richard Mendenhall "went to York[, Pennsylvania, and] learned tanning with Herman Updegraff . . . and . . . his son-in-law, and Jonathan [Mendenhall] continued at potting with Thomas Vickers," who worked at East Caln Township, Chester County.[113] Richard subsequently returned to Jamestown, operated a tannery, and built a brick store building across the road from his residence (figs. 46, 47). He apparently learned enough during his

Figure 47 Richard Mendenhall store, Jamestown, Guilford County, North Carolina, 1824. (Courtesy, North Carolina State Archives.) The store was situated across the road from the house illustrated in fig. 46.

apprenticeship with Kersey to establish a pottery on a one-half-acre lot he owned in Jamestown.[114] In 1842 Mendenhall sold the lot "known under the appellation of the potter Shop Lot together with all of the . . . appurtenances" to William Lamb for $125.[115] Noah Cude Jerrell (Jerrol) (1820–1909) and Isaac Potter (ca. 1787–1864) are thought to have been living at or near the shop.[116] Both men are listed as potters in southern Guilford County in the 1850 census.[117] Noah's residence was near that of William Hockett III, in the Centre Monthly Meeting area. Noah's sister Elizabeth Caroline was married to potter Samuel Vestal Barker (1814–1865), whose mother, Elizabeth, was the sister of potter Messor Amos Vestal (1812–1886), who married Richard Mendenhall's daughter, Rhoda. Samuel Barker is also listed as a potter in the 1850 census for southern Guilford County, but lived outside the Jamestown area.[118]

Born about 1787 in Somerset, Maryland, Isaac Potter, possibly a journeyman at Mendenhall's pottery, married Nancy Gossett in December 1814; she died eight years later. In 1819 he purchased a 165-acre tract adjoining Mendenhall's property from David Beard as well as two additional adjoining tracts, totaling slightly more than 138 acres, from James Talbert.[119] Presumably all those tracts were used for farming or animal husbandry. On January 16, 1827, Potter married Lois Kersey, Jesse Kersey's first cousin. Although tenuous, connections of this type lend credence to the theory that Isaac made pottery at Jamestown.[120]

Two other potters who were related to Richard Mendenhall through marriage may have been part of the Jamestown ceramic tradition. Hezekiah Clark (1797–1876) moved from Centre Monthly Meeting to Deep River Meeting in January 1817. Two years later he married Mendenhall's younger sister Abigail, who had been given several lots in Jamestown and was "by trade a bonnet and glove-maker, and before marriage, taught school."[121] Abigail and Hezekiah began attending New Garden Meeting in Guilford County after their marriage, but in 1823 returned to Centre Monthly Meeting.[122] According to a late-nineteenth-century history of Clinton County, Ohio,

> [Hezekiah] was a tanner by trade, and while in North Carolina, carried on a tanyard, blacksmith and potter shop, besides farming. He himself wagoned down through South Carolina and Georgia, hauling off leather and other goods, and attended different fairs that were held where he disposed of some of his stock. The tanshop was accidentally burned, when he sold out and moved to the then far West, with his family of nine children.[123]

Messor Amos Vestal (1812–1886), the son of Jesse Vestal, is another potter who might have worked in Richard Mendenhall's shop. Messor married Richard's daughter Rhoda on February 9, 1833. Because Messor was not a Quaker, the Deep River Meeting disowned Rhoda for marrying out of unity. Later that year, she condemned her marriage and was accepted back into Deep River Meeting. In 1835 Messor and Rhoda moved to Surry County, North Carolina, where she received a certificate of removal from Deep River Meeting to Deep Creek Meeting.[124] The 1850 census lists Messor Vestal as a merchant in Surry County.[125] In 1859 the Vestals moved

from the Surry (later Yadkin) County area to Maury County in central Tennessee, where they are recorded in the 1860 census.[126]

Messor's son, Tilghman Ross Vestal (b. 1844) was a potter by trade (fig. 48).[127] In February 1862 Tilghman was conscripted into the Confederate Army. After refusing to take up arms, he was offered the chance to buy his way out of service. He wrote that "the superintendent of the conscript said I could be exempt by paying $500 to the Treasurer of the Confederate States or hire a substitute this I new before I was first arrested but I did not

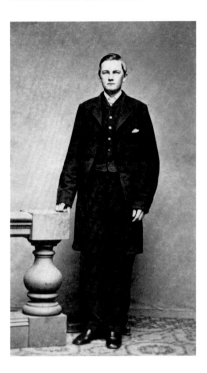

Figure 48 Tilghman Vestal, photo taken in 1866 by H. G. Pearce, Providence, Rhode Island. (Courtesy, Friends Historical Collection, Guilford College.)

choose to buy an exemption furnish a substitute or give ade to the war in any way and as $500 in the treasury would aid it I concluded to risk the consequences & submit to the penalty of the law."[128] Tilghman described his subsequent imprisonment and torture in vivid detail: "They began to pierce me with their bayonets I received 16 [wounds] . . . one of which was an inch deep the remainder about a quarter [inch deep] and still refused saying nothing could make me go to war I was then put on a dirt pile with a spade across my [knees]."[129] In November 1863 Vestal was sent to Castle Thunder—a tobacco warehouse that had been converted into a prison for civilians, spies, and political prisoners—in Richmond, Virginia. In a letter to John B. Crenshaw, a Quaker minister in Richmond, Tilghman stated that he was the grandson of Richard Mendenhall and would like to find an alternative to the service but "was reared in & now am of Friends faith and there by forbid from going into or buying an exemption from this war."[130] Vestal's aunt, Judith Mendenhall, and grandaunt, Delphina Mendenhall, also wrote to Crenshaw, and others, concerning Tilghman's case. Crenshaw suggested that alternative service in the pottery trade might be an acceptable option and proposed that idea to Assistant Secretary of War, Judge Campbell.[131]

Quaker potter David Parr agreed to take Tilghman as a journeyman in his manufactory at Richmond, and Vestal consented on condition that he did not have to make items for the war effort.[132] Parr and Sons Pottery was listed as an earthenware manufacturer, but the company also produced stoneware.[133] In a letter to his aunt, Vestal wrote that he liked Parr's pottery much better than his father's.[134] When military operations in Richmond forced Parr and Sons temporarily to close, Tilghman received permission to go to Guilford County during the interregnum.[135] When the manufactory resumed production, Delphina Mendenhall sent a letter to J. B. Crenshaw requesting that Vestal's place of service be transferred to Jamestown, which was in dire need of pottery (fig. 49).[136] Conscription for the war effort had left voids in all occupations. Richard Mendenhall's granddaughter, Mary Mendenhall Hobbs (b. 1852) recalled, "We can scarcely realize how quickly supplies diminished when they could not be replenished. Table ware and cooking utinsels as well as farmers' implements and Mechanics' tools became scarce."[137]

Delphina sent another letter requesting that Tilghman be sent to either Randolph County or Guilford County:

> We wrote last week the great need there is of the Potter's business being carried on here—next to the want of food & clothing, this country is suffering for want of vessels for domestic use. At [Tilghman's] . . . request I enclose a form of permission for him to work in the counties of Randolph & Guilford—If that is too indefinite, then he asks for a permit to work with Enoch Craven of Randolph County N.C.—The first much preferred because a change may become necessary in case of Craven's death, or other circumstances might render a change of location desirable.[138]

Vestal was unable to get transferred and eventually had to flee to Philadelphia to wait out the war's end. If he had decided to return to Parr and Sons, his term would have been short. The pottery was destroyed by fire when the Confederate Army evacuated Richmond on April 3, 1865.[139] After the war, Vestal moved to Maury County, Tennessee, where he is recorded as a teacher living with his father.[140]

During the war and Reconstruction, some potteries were established in the Jamestown area to help alleviate the need for utilitarian wares. Mary Mendenhall Hobbs recalled that "There were potteries established in which earthen dishes were made, rough, but serviceable and foundries which manufactured pots, skillets, and ploughs."[141] She also wrote of the need for fuel for lighting devices such as earthenware fat lamps (fig. 50):

> tallow and . . . bees-wax were often difficult to obtain, and in our part of the State pine knots, which furnished our eastern fellow citizens with light were wanting. It was rather pitiful to see father close his books and sit before the fire. He determined to have a light by some means and asked "Uncle" Tommy to join him in a 'possum hunt. 'Possums have a very oily fat, and he thought that if he could get this, he might use it in a lamp. At first mother protested, saying, "The bush-whackers will think you are conscript hunters and will shoot you." But when the time for the hunt came, and she saw the Nimrods preparing for the expedition, her anxiety turned to merriment, for two funnier looking persons never chased an Opossum. Both were tall men, father dressed in Quaker garb, plain coat and broad brimmed hat. "Uncle" Tommy always wore the Revolutionary Swallow tail. . . . As the two started out mother said, "When the 'possums see that outfit, I think they will come down." Nothing came of the hunt, and father was obliged to find other material for his lights. For a time he used a queer little grease lamp, which was shaped very much as the lamp in Greek pictures, a little shallow bowl with a handle at one end and a lip at the other, the wick lying in the oil in the bowl and hanging out at the lip where it was lighted.[142]

Figure 50 Fat lamp, attributed to the William Hockett/Hoggatt family of potters, northern Randolph/southern Guilford County, North Carolina, ca. 1860. Lead-glazed earthenware. H. 4". (Private collection.)

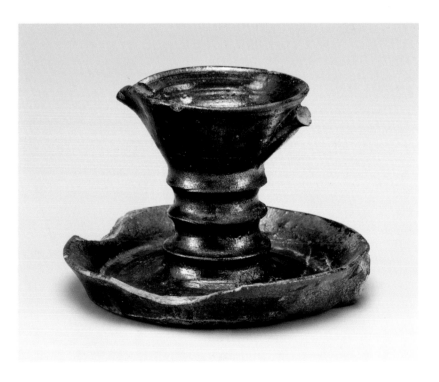

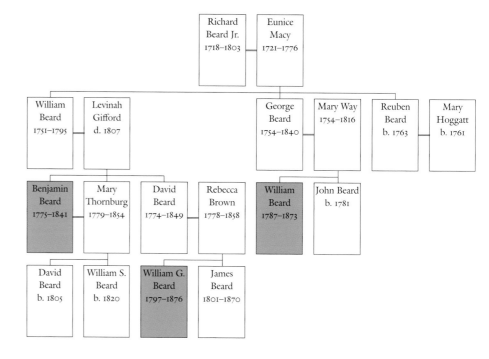

Figure 51 Beard Family of Potters. (Compiled by Hal Pugh and Eleanor Minnock-Pugh; artwork, Wynne Patterson.)
▨ Documented potter

The Beards

In 1772 Richard Beard Jr. (1718–1803), his wife, Eunice Macy, and their children moved from Nantucket Island, Massachusetts, to southwestern Guilford County, North Carolina. Together the couple had four sons and two daughters (fig. 51). Their son Reuben (b. 1763) married Philip Hoggatt's daughter Mary. Their sons William (1751–1795) and George (1754–1840) were associated directly and indirectly with the pottery trade. William's son Benjamin (1775–1841) was a potter, whose stamped signature has been found on the shoulder of a salt-glazed stoneware jar (figs. 52–54).[143] His pottery and clay pits were on land he inherited from his father (fig. 55).[144]

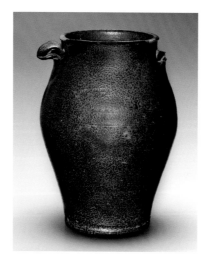

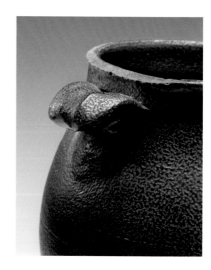

Figure 52 Jar, Benjamin Beard, Guilford County, North Carolina, 1810–1830. Salt-glazed stoneware. H. 9¹¹⁄₁₆". (Courtesy, Old Salem Museums & Gardens.)

Figure 53 Detail of the unusual pulled and pinched handle on the jar illustrated in fig. 52.

Figure 54 Detail of the impressed mark on the jar illustrated in fig. 52.

Figure 55 Deep River Friends Meeting, Deep River Community, Guilford County, North Carolina, 1873–1875. (Courtesy, Friends Historical Collection, Guilford College.) The meetinghouse was built using 133,000 bricks made of clay dug at Benjamin Beard's land.

Some members of the Beard family were connected to the potter Amor Hiatt. In June 1822 David Beard (1774–1849), Benjamin Beard's brother, was named as a trustee for his son William G. Beard (1797–1876), also a potter, concerning a loan to Amor Hiatt.[145] The terms of the agreement stated that Amor would pay back his debt of $90.70½ to William on or before the first day of September 1823. Hiatt moved to Milton, Indiana, where he established a pottery shop, near that date. In a letter written before 1839, David Beard wrote his son James: "And as for thy Brother William—the last account they were well and doing about like they used to do—William preaching some, making hats, some potterer. And still having children."[146]

George Beard had two sons, William and John. William (1787–1873) was a potter who married Rachael Pierson (Pearson) in Guilford County in September 1808. Eight years later William and his family moved to Union County, Indiana, where he lived until his death. A biographical and genealogical history published in 1899 states:

> In his youth [William Beard] . . . had learned the potter's trade, and this calling he followed . . . in connection with agriculture he was considered a man of much knowledge, and he not only practiced medicine for a period, but preached to congregations of the Society of Friends . . . for more than half a century.[147]

George Beard's son John (b. 1781) was a businessman but may also have been involved in the pottery trade. He married Hannah Elliot, whose sister Elizabeth was Henry Watkins's wife. Watkins purchased John Beard's property in Guilford County in 1837, and both men were listed as debtors in the inventory of potter Peter Dicks.[148] In a letter of February 14, 1842, John's first cousin David wrote: "George has left me—gone to John Beard's to care of shop for him, and it is said that John is broke and has made a general surrender of all of his property—gold mines and all. His debts it is said are $4000. While his worth is $12,100 if they break in upon him and sell him out."[149]

A Guilford County potter named Thomas Beard took Elliot Dison as an apprentice on December 15, 1809.[150] A Thomas Carson Beard (1768–1820) from Londonderry, Ulster Province, Ireland, married Elizabeth Dicks at Centre Monthly Meeting in March 1791.[151] Since Elizabeth was the sister of potter Peter Dicks, it seems likely that these Thomas Beards were one and the same. It should be noted that there were two separate Beard families in the Randolph/Guilford County area. Thomas Carson Beard was from a family that emigrated from Ireland to South Carolina and later moved to North Carolina.[152] He was not related to the Richard Beard Jr. family from Nantucket Island, Massachusetts.

The Quaker potters discussed in this article were accomplished craftsmen, entrepreneurs, and men of devout faith. Many were interrelated owing to the Quaker custom of marrying within the religion as well as their desire to preserve the secrets of their trade. Techniques, designs, and entrées into patronage networks were passed between family members and brethren, explaining some similarities between the work of Quaker potters in North Carolina and elsewhere. During the first half of the nineteenth

century, as slave-owning practices caused many Quakers to relocate, several potters left North Carolina and settled in the Midwest. Although opposition to slavery had extended the Quaker pottery tradition west, oral and written accounts indicate that the demand for utilitarian pottery grew during and immediately after the Civil War, reigniting the tradition in North Carolina, where Quaker potters found a market for their wares well into the early twentieth century.

1. Stephen B. Weeks, *Southern Quakers and Slavery: A Study in Institutional History* (Baltimore, Md.: Johns Hopkins University Press, 1896), p. 3.

2. *George Fox, an Autobiography*, edited by Rufus M. Jones (Philadelphia: Ferris and Leach, 1904), p. 125.

3. Weeks, *Southern Quakers and Slavery*, pp. 4–5.

4. Harrold E. Gillingham, "Pottery, China, and Glass Making in Philadelphia," *Pennsylvania Magazine of History and Biography* 54, no. 2 (1930): 98–102; Lura Woodside Watkins, *Early New England Potters and Their Wares* (Cambridge, Mass.: Harvard University Press, 1950), pp. 62–64.

5. *The Old Discipline, Nineteenth-Century Friends' Disciplines in America* (Glenside, Pa.: Quaker Heritage Press, 1999), p. 21.

6. Ibid., p. 419.

7. Mary Dennis, *Thomas Dennis and Some of His Descendants: Circa 1650–1979* (Dublin, Ind.: Print Press, 1979), pp. 1–2.

8. Hannah Benner Roach, "Philadelphia Business Directory, 1690," in *Colonial Philadelphians* (Philadelphia: Genealogical Society of Philadelphia, 1999), pp. 42–43.

9. Deed Book S, p. 387, Chester County Recorder of Deeds, West Chester, Pa.

10. William Wade Hinshaw, *Encyclopedia of American Quaker Genealogy*, 6 vols. (Baltimore, Md.: Genealogical Publishing Co., 1978), 1:536.

11. Will of Thomas Dennis II, written June 24, 1774, and proven in February 1775, Guilford County Wills, North Carolina State Archives (hereafter cited NCSA), Raleigh.

12. "Landgrant Entry No. 1560," NCSA. The land was described as "Containing three hundred Acres laying in the County aforesaid on bouth sides the Trading road and west side of Pole cat adjoining Joseph Hills Entry running for compliment, Including the Improvement of Thomas Dennis."

13. Thomas III appears in the Randolph County Tax List, 1779, NCSA; Deed Book 3, State Land Grant no. 319, p. 52, Randolph County Register of Deeds (hereafter cited RCRD), Asheboro, N.C.

14. Will of Thomas Dennis III, written November 11, 1795, and proven August 1803, NCSA. William Dennis had four siblings: Joseph, Sarah, Anne, and Elizabeth.

15. Dennis, *Thomas Dennis and Some of His Descendants*, p. 8.

16. Deed Book 7, p. 115, RCRD. William was issued by state land grant 60 acres in 1800 for a claim entered in 1799 (Deed Book 9, p. 447, RCRD).

17. Will of Thomas Dennis III.

18. Deed Book 13, p. 8, RCRD. Hinshaw, *Encyclopedia of American Quaker Genealogy*, 1:741.

19. "Minutes of the N.C. Manumission Society, 1816–1834," edited by H. M. Wagstaff, in *The James Sprunt Historical Studies Nos. 1–2* (Chapel Hill: University of North Carolina Press, 1934), p. 22. William's opposition to slavery may have prompted his move to Indiana in 1832.

20. Randolph County Original Apprentice Bonds and Records 1806–1829, NCSA.

21. Mary Mendenhall Hobbs, "Old Jamestown," p. 17, typed manuscript, Friends Historical Collection (hereafter cited FHC), Guilford College. Hobbs states that Richard Mendenhall was born on September 13, 1778, and at age fourteen was sent to Chester County, Pennsylvania, to learn the potter's trade. Deep River Monthly Meeting minutes indicate that Richard was granted his certificate to Bradford Monthly Meeting, Chester County, on August 4, 1794 (Hinshaw *Encyclopedia of American Quaker Genealogy*, 1:827). Based on that entry he would have been fifteen years old at the time of his departure.

22. Deed Book D, p. 493, Old Gloucester County Court House, Woodbury, N.J. *Patents and Deeds and Other Early Records of New Jersey 1664–1703*, edited by William Nelson (Baltimore, Md.: Genealogical Publishing Co., 1976), p. 432. Roach, "Philadelphia Business Directory," pp. 42–43. Thomas's Philadelphia lot was approximately 900 feet southeast of William

Crews's pottery, although no records of interaction between those men have been found. Beth A. Bower, "The Pottery-Making Trade in Colonial Philadelphia: The Growth of an Early Urban Industry," in *Domestic Pottery of the Northeastern United States, 1626–1850*, edited by Sarah Peabody Turnbaugh (Orlando, Fla.: Academic Press, Harcourt Brace Jovanovich Publishers, 1985), pp. 267–68; Roach, "Philadelphia Business Directory," p. 46.

23. Minutes of the Marlborough Monthly Meeting, pp. 133, 143, FHC.

24. J. A. Blair, *Reminiscences of Randolph County* (1890; repr., Asheboro, N.C.: Randolph County Historical Society, 1968), p. 50.

25. William Dennis owned 480 acres in 1815, according to *1815 Tax List of Randolph County, North Carolina*, edited by Winford Calvin Hinshaw (Raleigh, N.C.: WPG Genealogical Publication, 1957), p. 29. Five years later he is listed as owning 330 acres and two lots in New Salem in *1820 Tax List of Randolph County, North Carolina*, edited by Barbara N. Grigg and Carolyn N. Hager (Asheboro, N.C.: Randolph County Genealogical Society, 1978), p. 1; Deed Book 16, p. 39 and Deed Book 19, p. 194, RCRD. The William Dennis House remains standing today and is referred to as the Jarrell-Hayes House (Lowell McKay Whatley Jr., *Architectural History of Randolph County, N.C.* [Durham, N.C.: City of Asheboro, 1985], p. 114).

26. Deed Book 19, p. 90, RCRD.

27. Hinshaw, *Encyclopedia of American Quaker Genealogy*, 1:759.

28. Monthly Meeting Records, Springfield Monthly Meeting, First Friends Meeting Library, Richmond, Ind.

29. Deed Book 12, p. 317, RCRD. One hundred fourteen acres of this tract came from the northern part of the property granted by the state of North Carolina to Thomas's great-aunt, Rachel Dennis (widow of Edward), and her sons.

30. Birth, Death, and Marriage Records, Centre Monthly Meeting, p. 136, FHC.

31. *History of Wayne County, Indiana*, 2 vols. (Chicago: Interstate Publishing, 1884), 2:447.

32. Deed Book 14, p. 140, RCRD.

33. *History of Wayne County, Indiana*, 2:447.

34. Dennis, *Thomas Dennis and Some of His Descendants*, p. 14.

35. Andrew W. Young, *History of Wayne County, Indiana* (Cincinnati, Ind.: Robert Clarke and Co., 1872), pp. 375, 420. See also John T. Plummer, *A Directory to the City of Richmond* (Richmond, Ind.: R. O. Dormer and W. R. Holloway, 1857). Another former resident of Guilford County, Amor Hiatt, established a pottery near Milton, which was also in Wayne County, Indiana. (Luther M. Feeger, "Our History Scrapbook: Amor Hiatt Potter Shop Recalled in Early History about Milton," *Palladium Item* [Richmond, Ind.], January 30, 1956.)

36. Randolph County Apprentice Bonds, NCSA. Thomas Dennis "first located near Dublin, but the wolves being so troublesome he went to Perry Township, near Economy, where he wintered, purchasing during that time ninety acres on Green's Fork, one mile south of Washington, where he resided until Oct. 1, 1831." Young, *History of Wayne County, Indiana*, p. 447. If that account is accurate, he would not have been near either pottery long enough for employment.

37. Thomas acquired an adjoining 80 acres. He farmed this property and became tax assessor of a 108-square-mile area in Wayne County prior to his death. Young, *History of Wayne County, Indiana*, pp. 447–48.

38. Paul Heinegg, *Free African Americans of North Carolina, Virginia, and South Carolina from the Colonial Period to about 1820*, 4th ed., 2 vols. (Baltimore, Md.: Clearfield Publishing, 2001), 1:214. United States Federal Census, 1800, Randolph County, N.C.

39. James H. Craig, *The Arts and Crafts in North Carolina 1699–1840* (Winston-Salem, N.C.: Old Salem, Inc., 1965), pp. 90–91.

40. Randolph County Apprentice Bonds, NCSA.

41. *A Narrative of Some of the Proceedings of the North Carolina Yearly Meeting on the Subject of Slavery within Its Limits* (Greensboro, N.C.: Swaim and Sherwood, 1848), p. 23.

42. United States Federal Census, 1830, Wayne County, Ind.

43. United States Federal Census, 1840, 1850, Wayne County, Ind. Elliana is recorded as being thirteen years old.

44. Ebenezer Tucker, *History of Randolph County, Indiana* (Chicago: A. L. Kingman, 1882), p. 134.

45. United States Federal Census, 1850, Randolph County, Ind.

46. Real Estate Records: Appraisement List and Transfers of Real Estate, June 1, 1859, to June 1, 1864, Randolph County Recorder of Deeds, Winchester, Indiana. United States Federal Census, 1860, Randolph County, Ind.

47. Deed Book 19, p. 13, Randolph County Recorder of Deeds, Winchester, Ind.

48. United States Federal Census, 1870, Van Buren County, Mich.

49. Heinegg, *Free African Americans of North Carolina*, p. 214.

50. Orange County Apprentice Bonds and Records, 1780–1905, NCSA.

51. Craig, *Arts and Crafts in North Carolina*, pp. 90–91.

52. Hinshaw, *Encyclopedia of American Quaker Genealogy*, 1:691, 771.

53. Grigg and Hager, eds., *1820 Tax List of Randolph County*, p. 4.

54. Deed Book 20, p. 235, RCRD.

55. Craig, *Arts and Crafts in North Carolina*, p. 93. The date of birth on the indenture could be wrong, since the document was originally drawn up for another brother, William Watkins. William's name was crossed out and Joseph's name added with no change made to the birth dates. Randolph County Apprentice Bonds, NCSA.

56. Randolph County, N.C., Marriage Bonds, p. 179, RCRD.

57. Deed Book 17, p. 299, RCRD.

58. Deed Book 22, p. 343, RCRD.

59. Hinshaw, *Encyclopedia of American Quaker Genealogy*, 1:691; Deed Book 2B-27, pp. 89–90, Guilford County Register of Deeds (hereafter cited GCRD), Greensboro, N.C.

60. United States Federal Census, 1850, Guilford County, N.C.

61. United States Federal Census, 1860, Guilford County, N.C.

62. John B. Crenshaw Papers, C12, Digital Collections, FHC, www.guilford.edu/fhc.

63. Sarah Ester Ross and Mrs. Lewis Grigg, *Levin Ross and Thomas McCulloch with Related Families* (Asheboro, N.C.: Ross, 1973), p. 96.

64. Deed Book 3, p. 411, Rowan County Register of Deeds (hereafter cited RowRD), Salisbury, N.C.

65. Deed Book 5, p. 263, RowRD.

66. Charles G. Zug III, *Turners and Burners: The Folk Potters of North Carolina* (Chapel Hill: University of North Carolina Press, 1986), pp. 38–39.

67. Deed Book 8, p. 435, RCRD. See also Randolph County "Court of Pleas and Quarter Sessions," vol. 6, p. 200: "Ordered that Peter Dicks have leave to build a water grist mill on Deep River on his own land."

68. Randolph County Apprentice Bonds, NCSA.

69. Blair, *Reminiscences of Randolph County*, p. 50; *Laws of North Carolina 1818*, chap. 91, microfiche, State Library of North Carolina, Raleigh.

70. Deed Book 19, p. 90, RCRD.

71. Will Book 8, pp. 26–27, microfiche, Asheboro Public Library, Asheboro, N.C. (hereafter cited APL).

72. United States Federal Census, 1850, 1860, Guilford County, N.C.; R. R. Ross, "History of the Highway from Climax to Trinity," unpublished ms., 1927, APL.

73. Interview with Nettie Dicks Lamb, August 24, 1990.

74. Interview with Franklin and Ruby Cox, October 31, 1989; interview with Ann S. Turner, November 25, 2007.

75. Will Book 16, p. 299, microfiche, APL. Cornelius died three years later.

76. United States Federal Census, 1880, 1900, New Market Township, Randolph County, N.C. Nathan was probably working in his father's shop from the 1870s to the mid-1880s. He married Rodemia E. Millikan on November 25, 1877, but the 1880 census lists him as a widower. He married Nancy M. Chriscoe on July 14, 1880. See Ross and Grigg, *Levin Ross and Thomas McCulloch with Related Families*, p. 105.

77. United States Federal Census, 1910, Morehead Township, Guilford County, N.C.

78. Interview with Iro Trueblood Swaim, October 6, 1991. Swaim recalled that her family owned "pie dishes" made by Nathan Dicks.

79. Interview with Eleanor Hartley, 1980.

80. Young, *History of Wayne County, Indiana*, p. 325. Beeson served as town marshal in 1826. See John Plummer, "Reminiscences of Richmond History," in Plummer, *A Directory to the City of Richmond*.

81. United States Federal Census, 1850, Randolph County, Ind.

82. George J. Richman, *History of Hancock County, Indiana: Its People, Industries and Institutions* (Greenfield, Ind.: W. Mitchell Printing Co., 1916), p. 492.

83. Ibid., pp. 104–5.

84. United States Federal Census, 1860, Hancock County, Ind.

85. "The house and lot, consisting of two acres, were bought of Isaac Beeson for the sum of four hundred and fifty dollars. The house, which was a hewed-log building, was used for several years previous as a 'potter's shop,' and was known by that name for nearly nine years, when a committee, composed of Jonathan Jessup, John Hunt, Lewis G. Rule and Elihu Coffin, were appointed to solicit money and material for a new church building"; Richman, *History of Hancock County*, p. 509.

86. Sarah Myrtle Osborne and Theodore Edison Perkins, *Hocketts on the Move: The Hoggatt/Hockett Family in America* (Greensboro, N.C.: S. M. Osborne, 1982), pp. 19–21.

87. Ibid., p. 23.

88. Ibid., p. 246.

89. In 1990 the bottle still held an aroma of coffee. Interviews with Margaret Fields Coltrane, March 1990, and Jane Coltrane Norwood, February 24, 2007.

90. Osborne and Perkins, *Hocketts on the Move*, p. 210.

91. Coltrane interview, 1990; Norwood interview, 2007.

92. United States Federal Census, 1850, Guilford County, N.C.

93. United States Federal Census, 1850, 1860, Guilford County, N.C. Watkins lived at residence number 728 and is listed as a miller.

94. United States Federal Census, 1860, Guilford County, N.C. Interview with Winford Calvin Hinshaw, 1987.

95. Nancy M. Hockett and Cyrus Elwood Hockett to Himelius Hockett, November 4, 1863, transcribed and filed in Hockett Papers, FHC.

96. John B. Crenshaw Papers, C12, FHC. William Osborn also signed the petition to Jefferson Davis.

97. Ibid. Other account book pages used by Branson suggest that he was a merchant. The 1850 census lists him as a farmer and the owner of real estate valued at $5,000, a significant sum for the time. United States Federal Census, 1850, Guilford County, N.C.

98. John B. Crenshaw Papers, F11, FHC.

99. Interview with Carrie Hockett Cox, March 5, 1990. Cox described David Hockett visiting her grandfather Himelius: "I remember David. His wife died and he lived there by himself for a long time and he wore long whiskers, and he'd come over here once in awhile to see my grandfather . . . I just can remember him; I was a little girl." She said her parents inherited the home place from Himelius and looked after him when he was older. According to Cox, her mother "would crawl [into the kiln] . . . and get the eggs."

100. Interview with Winford Calvin Hinshaw, March 29, 1992. According to Hinshaw, Himelius and Milton Hockett made salt-glazed stoneware after 1860; it is known that Himelius's son Cyrus Elwood Hockett (1860–1938) also made salt-glazed stoneware.

101. Interview with Worth Everett Cox, March 5, 1990. Cox recalled the David Hockett pottery building and kiln:

> Now there was another crockery over there, the other side of the farm I lived on . . . they made crockery and I think and I wouldn't say, but I think the old building is there yet. . . . They cured it they had a rock wall that they cured it in, right across the branch. I believe they called that the David Hockett Place.

102. Interview with Butch Thompson, September 2, 1991. According to Thompson, David Hockett fired brick in his kiln about 1885 and used them to build the chimney of the latter's house.

103. Interview with Roy Coltrane, April 8, 1990.

104. Interview with Sarah Haworth, September 13, 1990. According to Haworth, her mother took a piece of Mahlon's pottery to the one-hundredth-anniversary celebration of the Springfield Monthly Meeting:

> [In] 1890, they celebrated the one-hundredth anniversary of the establishment of Springfield Monthly Meeting and my grandmother had a piece of Mahlon Hocketts pottery and she tried to get some of the folks to bring some, but everybody—it was after the war, you know—and the Quakers were poor and didn't have slaves or anything, and they were all using theirs and nobody brought any, so she was the only one who had a piece of Mahlon Hockett's pottery there.

105. United States Federal Census, 1850, Guilford County, N.C.

106. United States Federal Census, 1860, Randolph County, N.C.

107. United States Federal Census, 1880, Rush County, Ind.

108. Deed Book 11, p. 45, GCRD.

109. Hobbs, "Old Jamestown," p. 17.

110. Hinshaw, *Encyclopedia of American Quaker Genealogy*, 1:827.

111. Arthur Edwin James, *The Potters and Potteries of Chester County, Pennsylvania* (Exton, Pa.: Schiffer Publishing, 1978), pp. 107–9.

112. William Mendenhall and Edward Mendenhall, *History, Correspondence, and Pedigrees of the Mendenhalls in England and the United States* (Cincinnati, Ohio: Moore, Wilstach, and Baldwin, 1864), p. 35. Jesse Kersey started having health problems after Richard Mendenhall's arrival. His brother-in-law, Dr. Jesse Coates, prescribed a mixture of laudanum and brandy, which further debilitated Kersey. James, *Potters and Potteries of Chester County*, p. 109.

113. Vickers married Richard and Jonathan's cousin Jemima Mendenhall. Her son Ziba was a potter who subsequently married Jesse Kersey's daughter, Lydia. Mendenhall and Mendenhall, *History, Correspondence and Pedigrees of the Mendenhalls*, p. 35; James, *Potters and Potteries of Chester County*, pp. 166–71. Richard Mendenhall's brother, Stephen, died while apprenticing as a tanner; Mendenhall and Mendenhall, *History, Correspondence and Pedigrees of the Mendenhalls*, p. 35. Richard completed his apprenticeship as a tanner. In July 1800 he received a certificate of removal from York Monthly Meeting in Pennsylvania to Deep River Meeting. He had lived in Pennsylvania for six years. Mendenhall married Mary Pegg in Guilford County, North Carolina, on February 3, 1812. Hinshaw, *Encyclopedia of American Quaker Genealogy*, 1:828.

114. Deed Book 11, p. 45, GCRD. The pottery lot is shown on an 1812 plat map.

115. Deed Book 27, pp. 168–69, GCRD.

116. Michael Hill, "Pottery Fragments at the Shubal Coffin House, Jamestown, Guilford County," memorandum from Jerry Cashion to John Clauser, Raleigh, Archaeology Branch, Department of Cultural Resources, March 27, 1984.

117. United States Federal Census, 1850, Guilford County, N.C.

118. Henry Hart Beeson, *The Mendenhalls: A Genealogy* (Houston: H. H. Beeson, 1969), p. 94. See www.ancestry.com (search "Samuel V. Barker" and select North Carolina Marriage Collection 1741–2004). United States Federal Census, 1850, Guilford County, N.C.

119. Deed Book 14, pp. 184, 200, 203, GCRD.

120. Mary Browning, "The Potters of Jamestown," *Guilford Genealogist* 14, no. 3 (Spring 1987): 123–28.

121. Hinshaw, *Encylopedia of American Quaker Genealogy*, 1:804. The couple married on October 21, 1819. *The History of Clinton County Ohio* (Chicago: W. H. Beers and Co., 1882), p. 1122.

122. Hinshaw, *Encyclopedia of American Quaker Genealogy*, 1:804, 531.

123. Abigail and Hezekiah moved to Indiana in 1835. *History of Clinton County Ohio*, p. 1122.

124. Hinshaw, *Encyclopedia of American Quaker Genealogy*, 1:828, 842.

125. United States Federal Census, 1850, South Division, Surry County, N.C.

126. John B. Crenshaw Papers, Tilghman Vestal Documents, J32, FHC, available through Digital Collections, www.guilford.edu/fhc.

127. Ibid., J15.

128. Ibid., J32.

129. Ibid., J32.

130. Ibid., D1.

131. Ibid., J15.

132. Ibid., J17.

133. Robert Hunter, Kurt C. Ross, and Marshal Goodman, "Stoneware of Eastern Virginia," *The Magazine Antiques* 167, no. 4 (April 2005): 131.

134. John B. Crenshaw Papers, Tilghman Vestal Documents, J24, FHC. Vestal wrote: "I board with friend Parr. I and another journeyman have a room to our selves. I have not c[o]mmenced yet but expect to in the morning. John B. brought me here yesterday made arrangements with Parr and I turned some to see what I could do."

135. Ibid., J29.

136. Ibid., G8.

137. Mary Mendenhall Hobbs, "General Recollections of Conditions in North Carolina during and following the Civil War," personal papers of Grimsley T. Hobbs. The authors thank the Hobbs family for permission to quote this document.

138. John B. Crenshaw Papers, G9, FHC.

139. "Sufferers of the Late Fire," *Richmond Whig*, April 15, 1865.

140. United States Federal Census, 1870, Maury County, Tenn.

141. Hobbs, "General Recollections."

142. Mary Mendenhall Hobbs, "Recollections of Mary Mendenhall about Family Life and Times during the Civil War, with Particular Reference to Nereus Mendenhall," personal papers of Grimsley T. Hobbs. The authors thank the Hobbs family for permission to quote this document.

143. Edith M. Beard, "Beard Pedigree" (http://longislandgenealogy.com/barnabas/John Beard.htm.)

144. Benjamin's son William (b. 1820) made brick for a local schoolhouse in 1857, and William's brother David (b. 1805) was one of the masons involved in the construction. Glazed brick in the east gable formed the initials "D. B." Ruth Lindenberger, *Beard Family History and Genealogy* (privately printed, 1939), pp. 76–77. Clay from the same pits was used to make brick for the Deep River Friends Meeting in 1873. Cecil E. Haworth, *Deep River Friends: A Valiant People* (Greensboro: North Carolina Friends Historical Society and North Carolina Yearly Meeting, 1985), p. 52.

145. Deed Book 15, pp. 650–51, GCRD. David (1774–1849), son of William Beard (1751–1795), was a hatter and merchant who operated a store north of Jamestown. Lindenberger, *Beard Family History*, p. 26.

146. Lindenberger, *Beard Family History*, p. 29. James lived in Illinois. In 1819 William G. Beard married Martha Henley. By 1830 they had moved to Davidson County, North Carolina. In a letter to his son James dated February 14, 1842, David Beard wrote:

> [William] is following the same trade and preaching, and that is one of the most expensive families I know of. . . . I had thy brother William here all night last night before last. He came to get me to teach him how to dry deer skins for gloves. He says they have 50 pair bespoke.

Ibid., pp. 28, 31. Lindenberger states that William Beard's middle name was Ashbury, but census records for 1850–1870 consistently list him as "William G." or "W. G. Beard." William G. Beard is listed as a "hatter" in United States Federal Census, 1850, Northern Division, Davidson County, N.C. In the 1860 census, he is described as a "colporture" [*sic*], a purveyor of religious literature. The same record indicates that his wife, Martha, and three daughters were glove makers and a son was a farmer, all living in the same household. (United States Federal Census, 1860, Northern Division, Davidson County, N.C.) By 1870 William had moved to Kernersville, North Carolina, where he lived with his daughter Sarah, while working as a store clerk. (United States Federal Census, 1870, Kernersville Township, Forsyth County, N.C.)

147. *Biographical and Genealogical History of Wayne, Fayette, Union and Franklin Counties, Indiana* (Chicago: Lewis Publishing Company, 1899), p. 516.

148. Deed Book 2B-27, GCRD; Will Book 8, pp. 26–27, microfiche, APL.

149. Lindenberger, *Beard Family History*, p. 30. This would likely explain why John's name appeared under "Bad Debts" in Peter Dicks's estate inventory. Will Book 8, pp. 26–27, microfiche, APL.

150. Craig, *Arts and Crafts in North Carolina*, p. 91.

151. Hinshaw, *Encyclopedia of American Quaker Genealogy*, 1:674.

152. Personal communication with Nadine Holder, July 3, 2007.

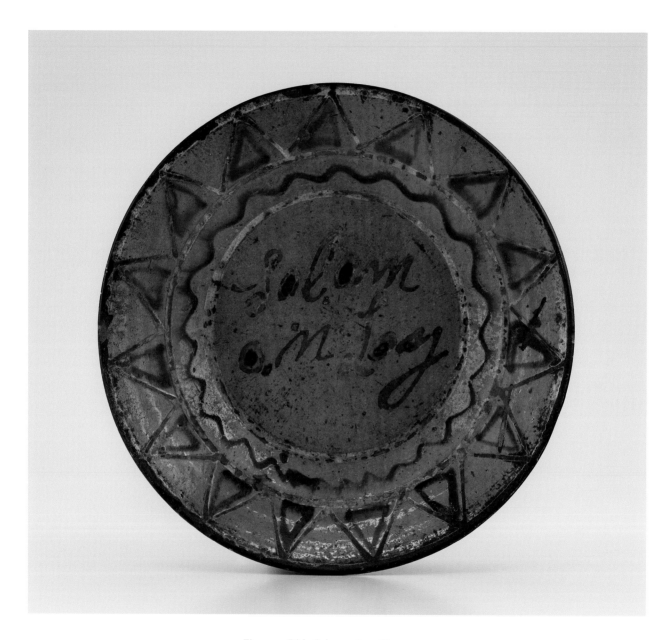

Figure 1 Dish, Solomon Loy, Alamance
County, North Carolina, 1825–1840. Lead-
glazed earthenware. D. 12". (Private collec-
tion; unless otherwise noted, photos by
Gavin Ashworth.)

Linda F. Carnes-McNaughton

Solomon Loy: Master Potter of the Carolina Piedmont

▼ S O L O M O N L O Y (1805–before 1865) emerged as a master potter during the second quarter of the nineteenth century—a period of technological and stylistic transition in North Carolina's ceramic industry. Although trained as an earthenware potter in a tradition distinguished by the use of polychrome slip decoration, Loy responded to demand for more durable forms with nonreactive coatings by making salt-glazed stoneware. Many of his salt-glazed vessels have trailed slip designs that relate to those on his earthenware as well as on pottery associated with earlier members of his extended family. To say Loy was born into a "clay clan" may be something of an understatement, as his father, father-in-law, uncles, brothers, and possibly his great-grandfather were potters. He also trained his son, nephew, grandsons, and neighbors, thus contributing to the longevity of what has been termed the "St. Asaph's tradition" (see in this volume "Slipware from the St. Asaph's Tradition" by Luke Beckerdite, Johanna Brown, and Linda F. Carnes-McNaughton).[1]

Several stoneware vessels documented to Loy survive, but an earthenware dish decorated with triangles on the marly is the only object in that medium bearing his full name (fig. 1). Documentary research and archaeology conducted after the publication of this dish in Charles Zug III's *Turners and Burners: The Folk Potters of North Carolina* (1986) have broadened our understanding of Loy's career and work.[2] This essay will present these new findings by examining the historical context of pottery making in the St. Asaph's district of Orange County (now southern Alamance County), analyzing kiln remains and earthenware fragments recovered at Loy's site, and using archaeological evidence to identify surviving examples of his work.

The Loy Family
When Solomon Loy began his career, pottery making in North Carolina was a cottage industry; production was often seasonal, makers sold directly to consumers, and bartered goods and services were common forms of payment. Craftsmen and their kin often intermarried with other potting families in order to protect trade secrets, maintain a labor force, and gain access to markets or natural resources.[3] The Loy family tree (fig. 2) illustrates how members of Solomon's family followed that pattern, although many connections have yet to be explored. Over the course of six generations, at least a dozen Loys worked as potters. Some married into the families of potters, like the Boggs and the Phillips; others married into the

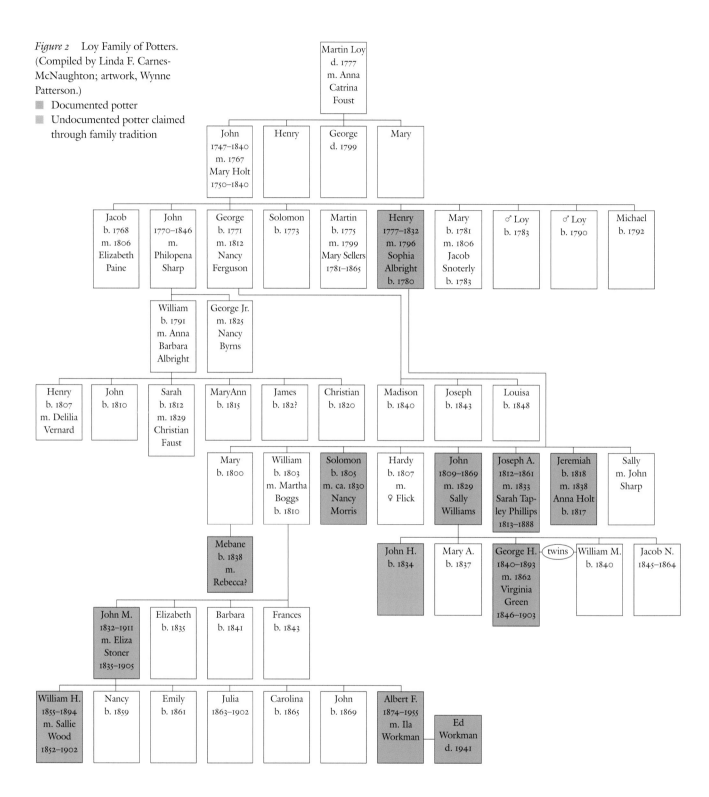

Figure 2 Loy Family of Potters. (Compiled by Linda F. Carnes-McNaughton; artwork, Wynne Patterson.)

▨ Documented potter

▨ Undocumented potter claimed through family tradition

families of prominent landowners, like the Holts and the Albrights. As was the case with Solomon Loy's great-grandfather Martin, the progenitors of several of these families had settled in Alamance County during the 1750s and 1760s and clustered in communities according to ethnicity (German and English) and religious affiliation (German Reformed/Lutheran and Quaker).

According to family tradition, the Loys were Huguenots who sought refuge in southwestern Germany following the revocation of the Edict of Nantes in 1685. Martin may have been born at Herzenhausen, Hessen, where his father, Johannes, worked as a tailor.[4] In 1729 Martin married Anna Margaretha Fechter in the German Reformed Church in Mussbach, and the couple eventually had three children.[5] What became of their progeny remains unclear, but port-of-entry records indicate that Martin and Anna Margaretha arrived in Philadelphia aboard the ship *St. Mark* on September 26, 1741.[6] Approximately two years later, Martin married Anna Catrina (also referred to as Catherenny) Foust, members of whose family had emigrated from Germany in 1733, settling first in Berks County, Pennsylvania, and later in southern Alamance County, North Carolina. Martin and Anna Catrina had four children: John, George, Henry, and Mary.[7]

Martin Loy and his family apparently moved to Augusta County, Virginia, before February 17, 1753, when his name appears on a bond with John and Ernest Sharp.[8] The relationship between these two families extended to Alamance County, where Martin's grandson John married Philopena Sharp, daughter of Isaac Sharp III.[9] Isaac was John and Ernest Sharp's brother.[10]

The Loy family apparently arrived in North Carolina before 1765, when Martin purchased 251 acres of land on Great Alamance Creek.[11] In 1769 he settled on a 112-acre tract farther south on Varnal's Creek, and later became a member of Stoner's Church, a German Reform congregation.[12] Martin died in 1777, and his will, probated two years later, lists his son George and his friend Jacob Albright Sr. as executors and Isaac Sharp III as witness.[13] Census records indicate that Anna Catrina remained on Martin's land until at least 1800 and that their sons John, George, and Henry were heads of households in the St. Asaph's district.

Although there is no documentary evidence that Martin Loy was a potter, circumstances suggest he was: he came from an area in Germany known for the production of slip-trailed and sgraffito-decorated earthenware; he settled in Berks County, Pennsylvania, where immigrant potters made comparable objects; and he was the progenitor of what became a clay clan. Even more significant, one of the earliest examples of slipware from the St. Asaph's district is a flask decorated with a cross with radiating fleur-de-lis, a motif found in French Protestant and Catholic iconography (fig. 3). Given the Loy family's Huguenot origins, Martin must be considered a possible source for this design.

Martin Loy's son John married Mary Holt in 1767.[14] Between 1768 and 1792 the couple had ten children. Their son Henry (1777–1832) was a potter who married Sophia Albright on September 6, 1796.[15] She was the daughter of Jacob Albright Jr. and Sally Wolf, who also came from a potting family.

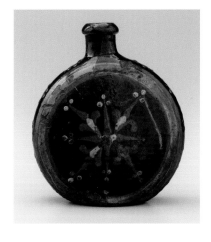

Figure 3 Flask, Alamance County, North Carolina, 1770–1790. H. 5⅜". (Courtesy, Old Salem Museums & Gardens.)

Jacob was listed as a potter in the 1800 tax list for the St. Asaph's district. "An Inventory and an Account of Sales of the Estate of Jacob Albright Dec^d," dated March 24, 1825, listed two potter's wheels, a glaze mill, a clay mill, a grindstone, a pipe mold, and a stove mold along with stock-in-trade.[16] The lack of household goods indicates that the contents of Albright's pottery were inventoried separately from his personal effects.[17]

Henry and Sophia had eight children: Mary (b. 1800); William (b. 1803); Solomon (b. 1805); Hardy (b. 1807); John (1809–1869); Joseph A. (1812–1861); Jeremiah (b. 1818); and Sally (birth date unknown). Solomon was apparently named after his uncle on his father's side. William was the only son who was not a potter, but he owned the land on which Solomon built his last two kilns and worked.[18] It is possible that this entire generation of Loy potters served apprenticeships with their father in the Henry Loy/Jacob Albright Jr. shop. William, Solomon, John, and Jeremiah remained in southern Alamance County, but Joseph moved to Person County after marrying Sarah Tapley Phillips in 1833.[19] Her father, John, was also a potter.[20]

About 1830 Solomon Loy married Nancy Morris (b. 1803), whose father was Henry Morris. The Morris and Loy families must have been close, since Solomon's father was the executor of Henry Morris's estate.[21] Solomon and Nancy had four children: John Mebane (1832–1911); Elizabeth (b. 1835); Barbara (b. 1841); and Frances (b. 1843). Census records indicate that Solomon died before 1865, but where he and Nancy are buried is not known.[22]

The next generation of Loy potters extended the family's craft tradition into the late nineteenth and early twentieth centuries. John Mebane Loy continued to produce stoneware at his father Solomon's site; William's son Mebane trained with Solomon and later set up his own shop nearby; and Joseph's son George Haywood made stoneware and earthenware in Person County.[23] Oral tradition maintains that Joseph's son John H. was also a potter, but neither his site nor any ware made by him has been identified. Another potter who can be considered part of this ceramic tradition is John Thomas Boggs, who came from a local potting family and served his apprenticeship with Solomon Loy.[24]

Early Site Discoveries

A 1986 archaeological survey of Alamance County, North Carolina, identified two pottery sites with kiln remains, 31AM191 and 31AM192.[25] Although both were subsequently linked to Solomon Loy, test trenches revealed that site 31AM192 had been compromised from modern landscaping. Recovered artifacts were limited to lead-glazed earthenware and kiln furniture, which suggests that 31AM192 predated 31AM191. The presence of lead-glazed earthenware in combination with salt-glazed stoneware suggests that 31AM191 came later and was occupied for a longer period. In the east-central piedmont region, the shift to stoneware production began in the late 1830s and continued into the early 1920s.

Sites 31AM192 (Solomon Loy's first kiln) and 31AM191 (his last two kilns) are located in southern Alamance County near Snow Camp, a Quaker

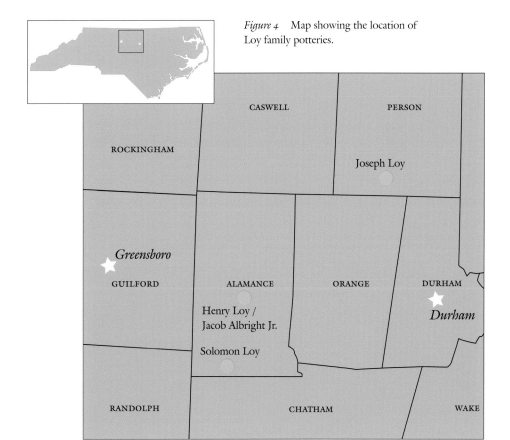

Figure 4 Map showing the location of Loy family potteries.

community settled in the mid-eighteenth century (fig. 4). During the period covered by Solomon's career, this community was part of Chatham County (formed in 1770), where Loy is listed on the tax rolls. It was not until 1897 that the northern edge of Chatham County became part of Alamance County. As was the case with many early Quaker settlements, Snow Camp and its sister community, Cane Creek, were located near waterways—essential for the establishment of mills. Germanic immigrants such as the Loys followed a similar pattern, although Lutheran and German Reformed churches, rather than Quaker meetings, served their communities.[26]

The 1986 survey and Zug's historical research also identified potteries operated by descendants of Solomon: his grandsons Albert Loy (31AM182) and William H. Loy; his brother or nephew John Loy; and his nephew Mebane Loy.[27] Another possible production site (31AM278) was recently discovered near Varnal's Creek in the St. Asaph's district, where Solomon's family originally settled. Fragments surface-collected there include lead-glazed earthenware with slip-trailed decoration, kiln furniture, English creamware, and wine-bottle glass. The locally made and imported artifacts suggest that the site may have been occupied from about 1780 to about 1820. Deeds indicate that the owner of the pottery was Jacob Albright Jr. He is described as a "potter" in the 1800 tax list for the St. Asaph's district, but it is unclear whether he worked in that trade or provided land and financing for his son-in-law, Henry Loy, which was not an uncommon practice at that time.[28]

The Solomon Loy Site

Site 31AM191 (fig. 5) is located in the middle of a farm. Several nineteenth-and twentieth-century buildings surround and partially cover the site, and human feet continue to traverse the yard where the detritus of previous activities is buried. Paved roads, utility lines, and a new brick house mask what was once a thriving pottery. Mature black walnut trees, an aging log barn, and a small log house are all that remain from two centuries past.

In 1980 Carl Lounsbury examined the farm complex as part of a county-wide architectural survey. He referred to the log dwelling as the "Teague/ Loy" house and postulated a date of 1880s, but the design of the stone and brick chimney suggests that the building could be earlier.[29] Some of the bricks had significant deposits of salt glaze on their surfaces and may have been recycled from an abandoned or reconstructed kiln.[30] The owner of the farm also reported that he found a pewter pipe mold in the chinking of the log house, and it appears to have been used to make some of the clay pipes recovered at the site. Deed research indicates that Solomon Loy's older brother William owned the land on which the pottery was located.[31] William's involvement in the business has not been fully explored, but family history maintains that he was not a potter.

Archaeology at the site began in 1986 with the excavation of a test unit near a standing smokehouse. The property owner had attempted to sink a fence post in that location and encountered an unknown buried feature. Recovered artifacts included earthenware and stoneware fragments, kiln furniture, and glaze debris along with large rock slabs located six inches below the surface. Expansion of the unit subsequently revealed two small postholes that had punched through the arched top of a tunnel-like structure located beneath the foundation stones. Because this feature appeared to be part of a semisubterranean groundhog kiln, work ceased until arrangements for additional time, help, and equipment could be made. Excavations resumed two years later, revealing the remains of two circular kiln foundations, each measuring seventeen feet in diameter; thousands of bisque-fired earthenware, lead-glazed earthenware, and salt-glazed stoneware fragments; tobacco pipe heads; several types of kiln furniture (props, saggers, wads, and coils); globs of glaze residue; and architectural debris from the furnaces.

One kiln was a downdraft type, complete with an underground transept flue (formerly thought to be the tunnel of a groundhog kiln) made of brick, but missing its exhaust chimney (likely dismantled and recycled into the chimney of the log house). The foundation walls, two-and-one-half feet thick, were made of local fieldstone and held together with clay mortar. The interior ware floor, which measured twelve feet in diameter, was covered with broken props and coils coated with crushed white quartz to prevent them from sticking to the pottery during firing. This kiln was used for the production of stoneware by Solomon Loy and later by his son John.[32]

Located about twenty feet downhill, the second kiln was an updraft design with four double-chambered fireboxes, situated equally distant, around the perimeter of the foundation (figs. 6, 7).[33] The foundation walls

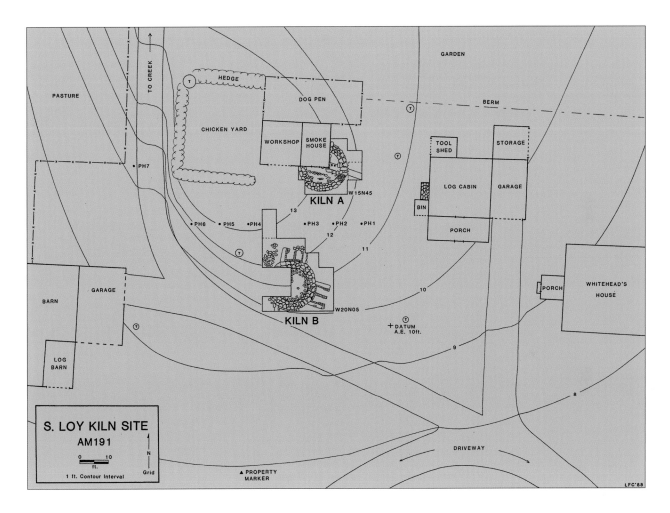

Figure 5 Drawing of site 31AM191 show-
ing the location of two circular kilns, a log
house, a barn, and other landscape features
following archaeological investigations.
(Artwork, Linda F. Carnes-McNaughton.)
The smokehouse covers 25 percent of the
foundation of the downdraft kiln (A). The
updraft kiln (B) was not entirely excavated
because of a fruit tree on top of the west
firebox.

were constructed just like those of the downdraft example: two feet thick, made of fieldstone, and mortared with clay. The interior, which encompassed 227 square feet, contained in situ kiln furniture and a floor of fine gravel (crushed quartz) on top of a dense clay layer that had turned deep red from multiple firings. Shelves, tiles, and props coated with lead glaze confirmed the use of this furnace for the manufacture of earthenware.[34]

Figure 6 Drawing of the updraft kiln after excavation. (Artwork, Linda F. Carnes-McNaughton.) Double-chambered, or "hob," fireboxes are located equidistant along the perimeter of the foundation wall. The interruption in the foundation stone was for a doorway.

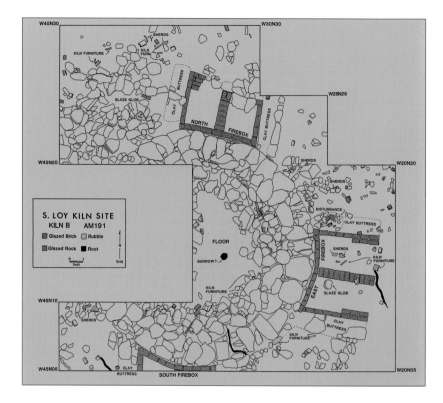

Figure 7 View of the updraft kiln during final stages of excavation. (Photo, Linda F. Carnes-McNaughton.)

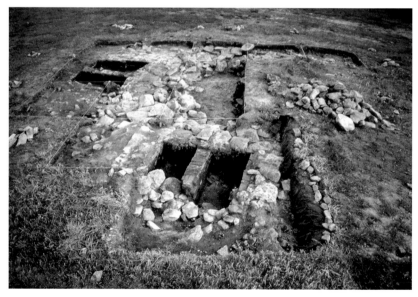

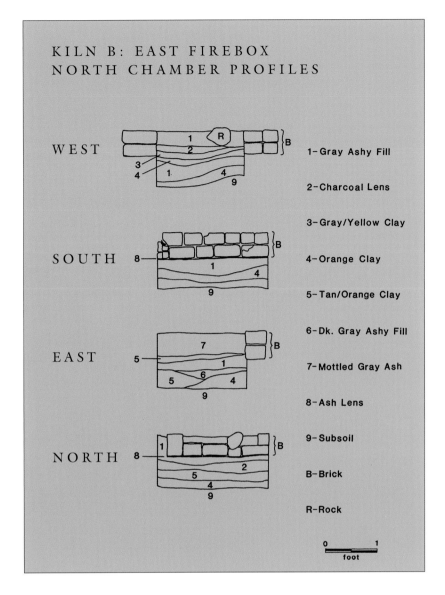

Figure 8 Profile drawings of the east firebox of the updraft kiln (B). (Artwork, Linda F. Carnes-McNaughton.)

KILN B: EAST FIREBOX
NORTH CHAMBER PROFILES

WEST

SOUTH

EAST

NORTH

1- Gray Ashy Fill

2- Charcoal Lens

3- Gray/Yellow Clay

4- Orange Clay

5- Tan/Orange Clay

6- Dk. Gray Ashy Fill

7- Mottled Gray Ash

8- Ash Lens

9- Subsoil

B- Brick

R- Rock

0 1
 foot

Figure 9 View of the east firebox following excavation. (Photo, Linda F. Carnes-McNaughton).

All of the excavated fireboxes were six feet long, four feet wide, and made of handmade brick laid in clay mortar (figs. 8, 9). The exterior walls were double coursed for additional support and buttressed with piles of whitish gray clay. The builder added an additional course of brick at the loading ends, which constricted the opening and thereby improved draft. A single course of brick served as the divider, or "hob," separating each firebox into smaller chambers measuring 1.8 feet in width and 3.5–4 feet from end to end. The fill in the east and north fireboxes consisted of alternating layers of ash, charcoal, and gray clay—evidence of repeated firings and cleanings. The back walls of the fireboxes, curved to abut the kiln's stone foundation, were mortared with clay.[35] Their design is similar to what kiln authority Daniel Rhodes describes as a "hob firebox."[36] Wood would have been arranged crosswise on the center support, allowing the bottom pieces to burn first, then drop down and ignite the timber stored in the lower chambers. Because it was relatively self-sustaining, a hob firebox could be left unattended until the wood supply was burned out.

It is not known whether Loy's updraft kiln was a beehive, dome, or bottle design, but the quantity of unglazed earthenware fragments and kiln furniture found on the interior floor suggests that the furnace may have had two stories, an upper chamber for bisque firing and a lower chamber for glaze firing. If that were the case, the kiln would have been more than thirty feet in height. Bricks were likely used to construct the upper portion of the kiln to provide better control for expansion and contraction during firing and cooling periods. Stones, while excellent for foundations, lack this elasticity.[37]

Loy was clearly as skilled in kiln design and construction as he was at turning and decorating pottery, and his two kilns were twice the size of that built by Philip Jacob Meyer at Mount Shepherd in nearby Randolph County.[38] The architecture of his kilns as well as the range of earthenware and stoneware fragments found nearby make Loy's site one of the most significant of its type in the state.

The Earthenware of Solomon Loy

The terms that backcountry potters like Solomon Loy used to describe their work and manufacturing processes remain something of a mystery. Daybooks, account books, and other documents pertaining to the day-to-day operation of their businesses are scarce, and formulas for clay mixtures and glazes were well-guarded secrets, most often transmitted through verbal communication and demonstration. Even when pottery-related terms are found in estate records or business accounts, interpretation and application often varied between maker, seller, and consumer and from one generation to the next. Nomenclature for vessel forms used in this article complies with a large body of research gathered over several decades and is consistent with that found in the companion volume of *Ceramics in America* published in 2009.

Excavations at site 31AM191 yielded a total of 16,731 artifacts: pottery fragments, kiln furniture, architectural debris, glaze waste, and other historic and prehistoric objects. Quantifiable attributes used to group ceramics were body composition (earthenware, stoneware, or intermediate ware), surface finish (unglazed, glazed, location of glaze, and Munsell color equivalent for glaze), decoration (type, use, and composition), maker's marks (stamped, slipped, incised), vessel form (food or non-food related), percent of vessel represented, paste (Munsell color equivalent), portion of vessel represented, condition (burned, overfired, underfired, warped), and count. Food-related vessels produced at the site included crocks, jars, jugs, pitchers, churns, plates, saucers, bowls, mugs, and cups. Non-food ceramic items included flowerpots, tiles, candlesticks, grave markers, and smoking pipes.[39]

Fragments of 1,168 identifiable earthenware vessels were recovered at Loy's site: 525 jars (including crocks), 313 bowls, 283 dishes (including plates and saucers), 18 pitchers, 17 jugs, and 12 mugs/cups. Loy also made earthenware pipe heads with glazed and unglazed surfaces, as well as fluted and anthropomorphic bowls (fig. 10). His transition to salt-glazed stoneware,

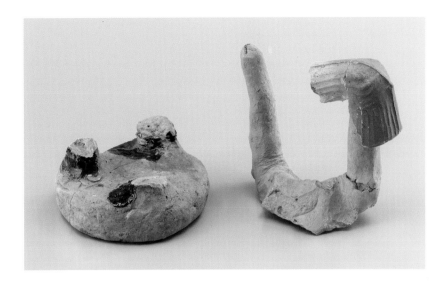

Figure 10 Pipe and kiln furniture recovered at Solomon Loy's pottery site, Alamance County, North Carolina, 1825–1840. Bisque-fired earthenware and high-fired clay. (Courtesy, Research Labs of Archaeology, UNC-Chapel Hill.) The pipes and supports would have been placed in a sagger. Fragments of thirteen pipe heads were recovered during excavations, six of which were in the updraft kiln. Five fragments were unglazed earthenware, two were lead-glazed, and six were salt-glazed stoneware. The unglazed earthenware examples are fluted, and one has a face at the outer elbow joint. The fluted examples matched a pewter pipe mold found in the chinking of the log house on the site.

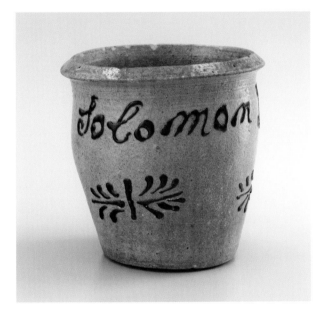 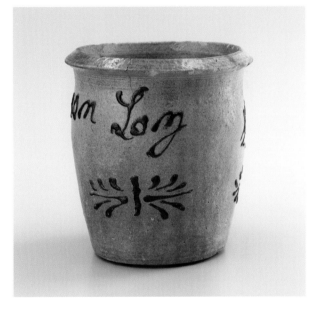

Figure 11 Jar, Solomon Loy, Alamance County, North Carolina, 1830–1850. Salt-glazed stoneware. H. 6⅞". (Courtesy, Old Salem Museums & Gardens.) This jar bears the maker's full name. Solomon also used stamps and incising to mark his ware. A large cobalt-decorated stoneware crock and a unique salt-glazed stoneware grave marker dated 1834 have square floral stamps. Fragments of large crocks bearing the mark of Solomon's son John M. Loy were recovered at Solomon's site (31AM191). Some had debased cruciform motifs, like those on this example.

which occurred during the mid- to late 1830s and continued into the 1880s, was marked by a dramatic increase in the production of storage containers (fig. 11) and a decline in the manufacture of tableware.[40]

The dish and plate fragments from 31AM191 have consistent rim, back, and base profiles. Morphologies cited in John Bivins's *The Moravian Potters in North Carolina* are problematic for comparative purposes, because many of the dishes and plates he studied were actually made in southern Alamance County. Indeed, most of the features Bivins assigned to the "second part of the middle period" of Moravian production—squared rim, concave back, lack of a foot—are characteristic of Loy's work (figs. 12, 13) as well as that of other potters from the St. Asaph's tradition.[41]

Loy's bowls are distinguished by having relatively steep sides and rims that are slightly concave at the top and gently rolled at the back (fig. 14). All of the surviving examples display moderate outward flare from bottom to top, but are not coved in rear profile (figs. 15, 16). Loy decorated the rims

Figure 12 Dish, attributed to Solomon Loy, Alamance County, North Carolina, 1825–1840. Lead-glazed earthenware. D. 12". (Private collection.) Loy's dishes are generally lighter and thinner than those made by Moravian potters in Bethabara and Salem, North Carolina. He used green, orange, brown, and black slips to decorate earthenware, and brown and blue slips to decorate stoneware.

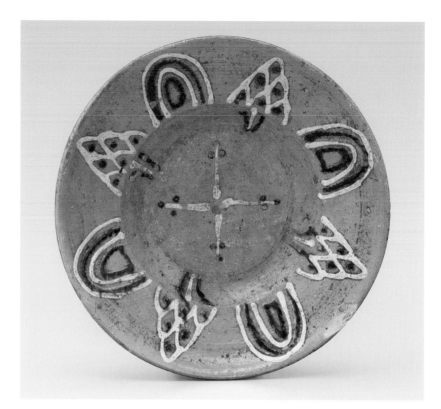

Figure 13 Detail of the back of the dish illustrated in fig. 12. Some late Moravian dishes have concave backs, but they do not flare as dramatically as those associated with Loy.

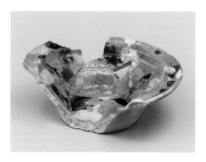

Figure 14 Fragmentary bowl recovered at Solomon Loy's pottery site, Alamance County, North Carolina, 1825–1840. Lead-glazed earthenware. (Courtesy, Research Labs of Archaeology, UNC-Chapel Hill.)

of bowls with evenly spaced small dots or in more random patterns reminiscent of the so-called dotted Staffordshire slipwares made in the eighteenth century. One bowl (location unknown) has precisely applied dots in the concave section of the rim, a detail found on bowl fragments from Loy's site (fig. 17).

The mugs illustrated in figures 18 and 19 are attributed to Loy based on their decoration and handle and base profiles, which relate closely to those of fragments recovered at Loy's site (fig. 20). Both mugs have bodies that taper slightly below the rim, simple molded lips and feet, and handles that are feathered into the body at the top and reinforced with finger impressions at the bottom. The rim and lip moldings were generated with a rib; the detailing on the handle was probably done with a cylindrical tool or smooth stick. There is no evidence that Loy used an extruder to produce handles.

A fat lamp (fig. 21), an unusual cylindrical container (fig. 22), and a small cream jug (fig. 23) represent other surviving forms associated with Loy.[42] Antique dealer Joe Kindig Jr. of York, Pennsylvania, purchased the lamp prior to 1935 and illustrated it in *The Magazine Antiques* along with several other pieces of North Carolina earthenware.[43] He was at the forefront of southern pottery scholarship and handled many important examples of Loy's work. The cylindrical container has a more specific provenance, having been purchased at an estate sale at the farm where Loy worked.[44] The pewter pipe mold found in the chinking of the log house on that property has the same history.[45]

Loy's earthenware can be interpreted as the final chapter of a ceramic tradition introduced by potters who emigrated from southwestern Germany

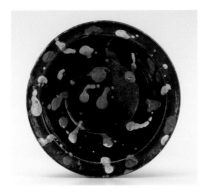

Figure 15 Bowl, attributed to Solomon Loy, Alamance County, North Carolina, 1825–1840. Lead-glazed earthenware. D. 6³⁄₁₆". (Private collection.)

Figure 16 Detail of the back of the bowl illustrated in fig. 15.

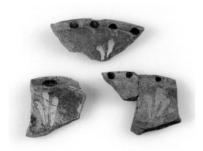

Figure 17 Bowl fragments recovered at Solomon Loy's pottery site, Alamance County, North Carolina, 1825–1840. Lead-glazed earthenware. (Courtesy, Research Labs of Archaeology, UNC-Chapel Hill.) Tripartite stylized leaves like those on these fragments are common on slipware attributed to Loy.

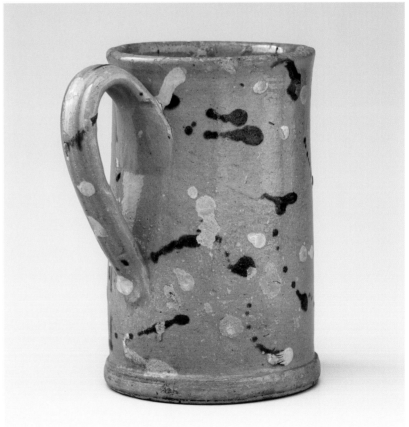

Figure 18 Mug, attributed to Solomon Loy, Alamance County, North Carolina, 1825–1840. Lead-glazed earthenware. H. 6³⁄₈". (Courtesy, Old Salem Museums & Gardens.)

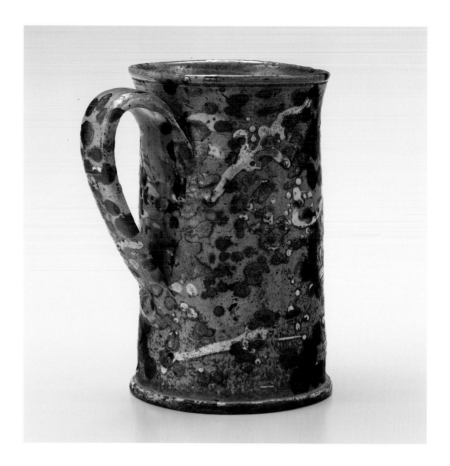

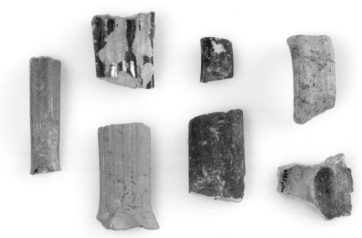

to Berks County, Pennsylvania, then relocated to southeastern Guilford County and southern Alamance County during the 1760s. As suggested in "Slipware from the St. Asaph's Tradition" in this volume, familial and religious ties between craftsmen and consumers in those areas contributed to the longevity of the St. Asaph's tradition. Nearly all of the motifs used by Loy have antecedents in Alamance County pottery dating from the last quarter of the eighteenth century if not earlier.

Like his predecessors in the St. Asaph's tradition, Loy applied his decoration directly on the clay body or on white, orange, and black slip grounds,

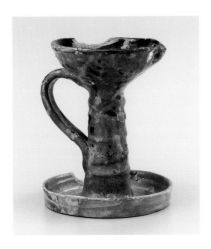

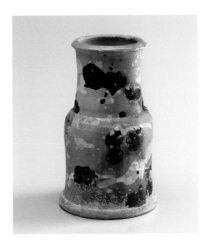

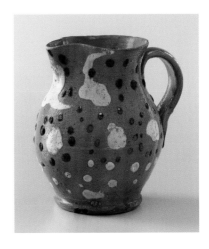

Figure 21 Fat lamp, attributed to Solomon Loy, Alamance County, North Carolina, 1825–1840. Lead-glazed earthenware. H. 6⅝". (Courtesy, Old Salem Museums & Gardens.)

Figure 22 Container, attributed to Solomon Loy, Alamance County, North Carolina, 1825–1840. Lead-glazed earthenware. Dimensions not recorded. (Private collection.) The foot of this object is similar to those on the mugs illustrated in figs. 18 and 19.

Figure 23 Cream jug, attributed to Solomon Loy, Alamance County, North Carolina, 1825–1840. Lead-glazed earthenware. H. 4". (Private collection.) The decoration on this cream jug is related to that on dish and hollow-ware fragments recovered at Loy's site (see fig. 31).

Figure 24 Bowl, dish, and handle fragments recovered at Solomon Loy's pottery site, Alamance County, North Carolina, 1825–1840. Lead-glazed earthenware. (Courtesy, Research Labs of Archaeology, UNC-Chapel Hill.)

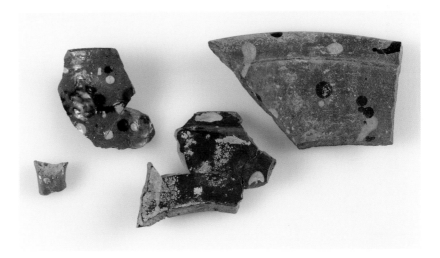

often referred to as engobes. Few American earthenware potters outside the St. Asaph's tradition used black grounds. Loy trailed most of his designs (see fig. 12), but several objects attributed to him have dripped decoration (figs. 24–26). Both types of ware were bisque-fired to harden the body and slip, then burned a second time to mature and bond the lead glaze. Proper firing was critical in the production of decorated earthenware because temperature and kiln atmosphere influenced the final color of slips and glazes.

Bisque and glazed fragments recovered at Loy's site indicate that his decorative vocabulary included lunettes (fig. 27), stylized leaves (fig. 28), imbricated (fig. 29) and "nested" (fig. 30) triangles, jeweled circles (fig. 31), and stylized crosses with dots representing *pommettes* (fig. 32). Surviving examples of his work also feature interlinked cymas, lobate designs filled with dots, and, in one instance, a fylfot. Loy's trailing on these archaeological

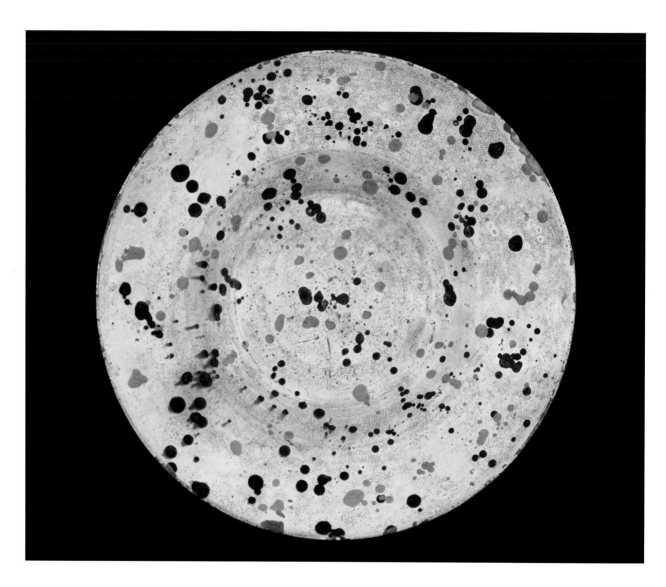

Figure 25 Dish, attributed to Solomon
Loy, Alamance County, North Carolina,
1825–1840. Lead-glazed earthenware. D. 15".
(Private collection.) This monumental
dish is the largest example attributed
to Loy.

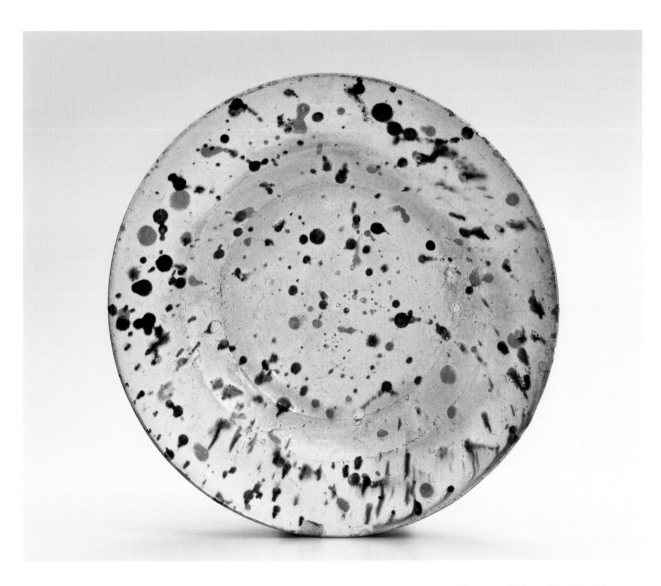

Figure 26 Dish, attributed to Solomon
Loy, Alamance County, North Carolina,
1825–1840. Lead-glazed earthenware.
D. 13½". (Private collection.)

and intact wares is competent (figs. 33, 34), but not as bold as that of earlier potters in the St. Asaph's tradition (figs. 35, 36).

Dishes are the most ornately decorated objects associated with Loy. Four have combinations of lunettes, imbricated triangles, and stylized leaves on the marly and cruciform motifs in the center (figs. 12, 33, 37, 38). The example illustrated in figure 38 is the most refined, with three colors of slip on a white ground, interconnected cymas encircling the cavetto, and a stylized cross with rays extending from the center. Loy also used a somewhat crude version of this cruciform motif on salt-glazed stoneware (see fig. 11). While Loy's crosses are less complex than those of earlier potters in the St. Asaph's tradition, they are among the most persistent motifs in his work (fig. 39).

Figure 27 Dish fragments recovered at Solomon Loy's pottery site, Alamance County, North Carolina, 1825–1840. Bisque-fired earthenware. (Courtesy, Research Labs of Archaeology, UNC-Chapel Hill.)

Figure 28 Dish fragments recovered at Solomon Loy's pottery site, Alamance County, North Carolina, 1825–1840. Bisque-fired and lead-glazed earthenware. (Courtesy, Research Labs of Archaeology, UNC-Chapel Hill.) The trailing on the fragment on the left is similar to that in the center of the dish illustrated in fig. 48, whereas the leaf motif on the right fragment relates to that in the cavetto of the example shown in fig. 44.

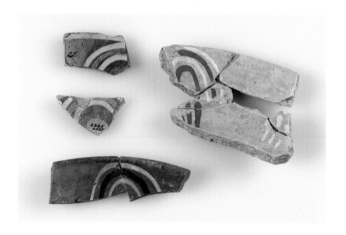

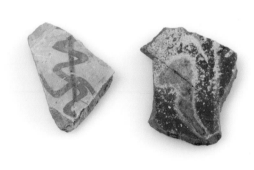

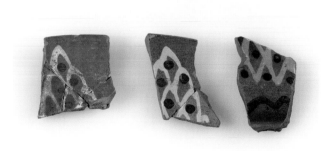

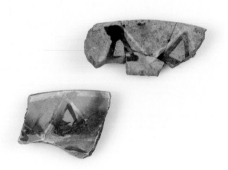

Figure 29 Dish fragments recovered at Solomon Loy's pottery site, Alamance County, North Carolina, 1825–1840. Bisque-fired earthenware. (Courtesy, Research Labs of Archaeology, UNC-Chapel Hill.)

Figure 30 Dish fragments recovered at Solomon Loy's pottery site, Alamance County, North Carolina, 1825–1840. Bisque-fired earthenware. (Courtesy, Research Labs of Archaeology, UNC-Chapel Hill.) Nested triangles occur on several paint-decorated chests from Berks County, Pennsylvania. As was the case with Martin Loy, many early Alamance County settlers had previously lived in Berks County.

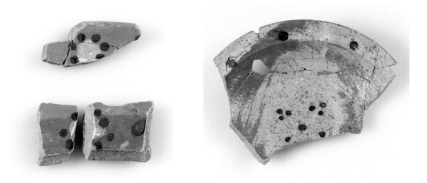

Figure 31 Hollow-ware fragments recovered at Solomon Loy's pottery site, Alamance County, North Carolina, 1825–1840. Bisque-fired earthenware. (Courtesy, Research Labs of Archaeology, UNC-Chapel Hill.)

Figure 32 Bowl fragment recovered at Solomon Loy's pottery site, Alamance County, North Carolina, 1825–1840. Lead-glazed earthenware. (Courtesy, Research Labs of Archaeology, UNC-Chapel Hill.)

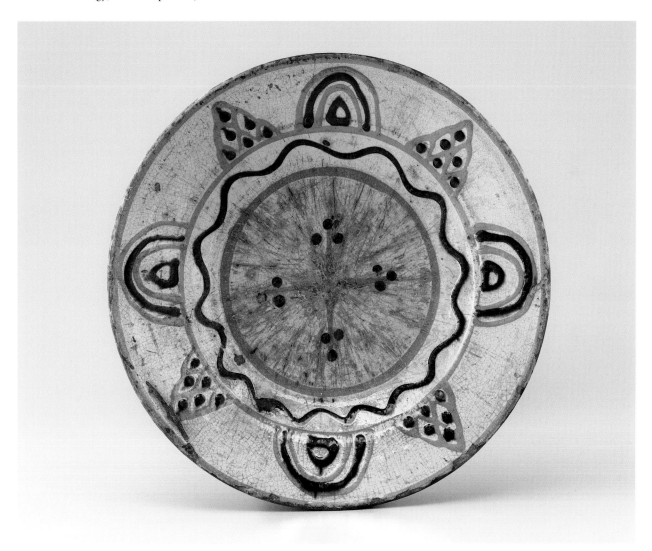

Figure 33 Dish, attributed to Solomon Loy, Alamance County, North Carolina, 1825–1840. Lead-glazed earthenware. D. 10¾". (Courtesy, The Barnes Foundation.)

Figure 34 Detail of the decoration on the marly of the dish illustrated in fig. 33.

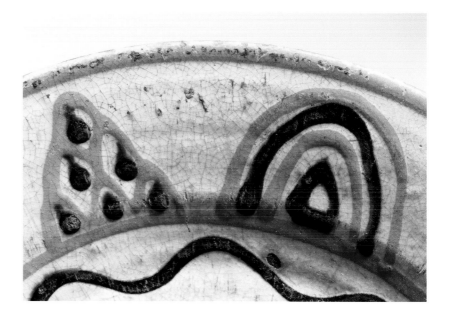

Figure 35 Dish, Alamance County, North Carolina, 1790–1820. Lead-glazed earthenware. D. 10". (Courtesy, Old Salem Museums & Gardens.)

Figure 36 Detail of the decoration on the marly of the dish illustrated in fig. 35.

Several of Loy's dishes have stylized plants in the cavetto, including a pair marked "E+K" on the back (figs. 40, 41). As is the case with other, similarly marked examples of slipware from the St. Asaph's tradition (see figs. 35, 42), the letters were cut into the clay after firing. Variations of the cavetto decoration on these dishes occur on other examples from Alamance County, some possibly by Loy and others by related potters of his generation (figs. 42, 43).

Continuities within the St. Asaph's tradition can make attributions difficult. The dish illustrated in figure 44 has stylized leaves on the marly and triangles encircling the cavetto—motifs that occur on fragments from Loy's site (figs. 30, 45)—but its coved rear profile is sharper than that on

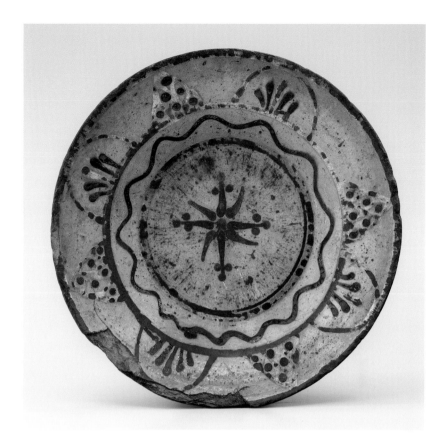

Figure 37 Dish, Alamance County, North Carolina, 1800–1835. Lead-glazed earthenware. D. 10½". (Private collection.) This dish and the example illustrated in fig. 38 may be by Solomon Loy. If so, they probably date from the beginning of his career but no earlier than ca. 1825.

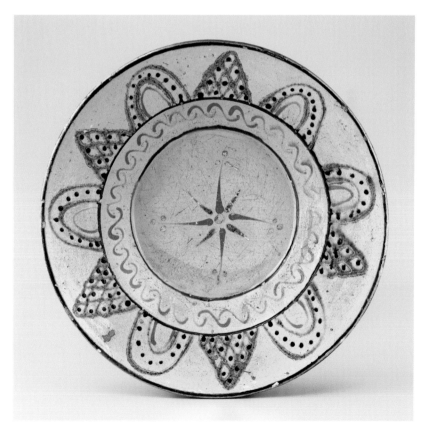

Figure 38 Dish, Alamance County, North Carolina, 1800–1835. Lead-glazed earthenware. D. 11⅝". (Courtesy, The Barnes Foundation.)

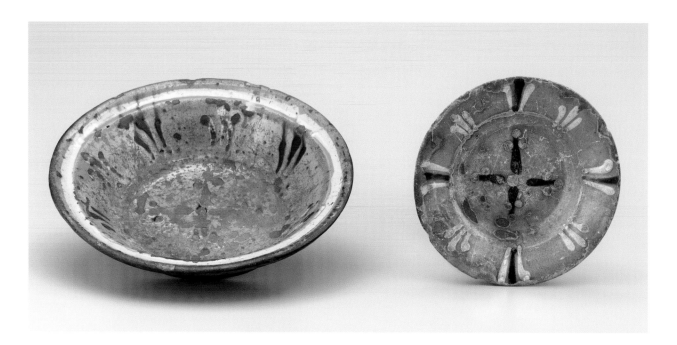

Figure 39 Bowl and saucer, attributed to Solomon Loy, Alamance County, North Carolina, 1825–1840. Lead-glazed earthenware. Dimensions not recorded. (Private collection.)

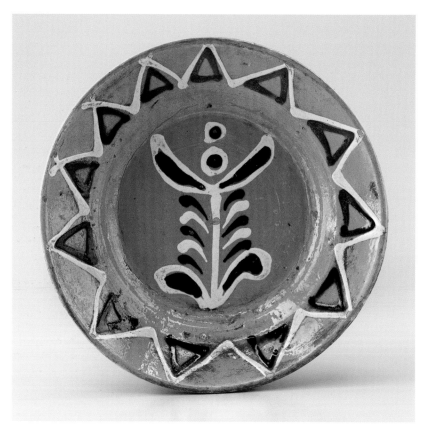

Figure 40 Dish, attributed to Solomon Loy, Alamance County, North Carolina, 1825–1840. Lead-glazed earthenware. D. 9¾". (Courtesy, The Barnes Foundation.)

other examples attributed to him (figs. 13, 46). If this dish is by Loy, it most likely dates from the beginning of his career. The same can be said of the example shown in figure 47, which has a cavetto design related to that on an earlier dish by a different hand (see fig. 35). The presence of other potters at Loy's site could explain some variations in form and decoration among surviving examples. A dish with black and yellow slip applied on an orange ground (figs. 48, 49) has several features that suggest it is from his pottery; the stylized grass motifs on the marly and overlapping lines (straight and wavy) in the center of the cavetto are similar to those on excavated fragments (see figs. 17, 28), and the fine jeweling in large lobes on the marly relates to the precisely applied dots on other objects attributed to Loy. At the same time, this object has a gently rolled rim—a common feature on Loy's bowls but not on dishes attributed to him. No other Alamance County slipware with jeweled, lobate motifs is known, but the design is often seen on paint-decorated furniture from southeastern Pennsylvania.

Because of the sheer number of artifacts recovered at Solomon Loy's site, his work is a benchmark for understanding earlier and later pottery in the

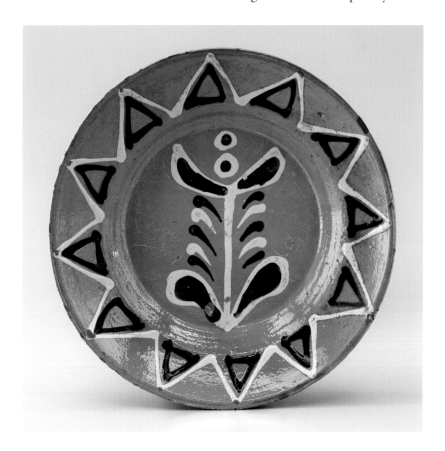

Figure 41 Dish, attributed to Solomon Loy, Alamance County, North Carolina, 1825–1840. Lead-glazed earthenware. D. 9⅞". (Courtesy, The Barnes Foundation.)

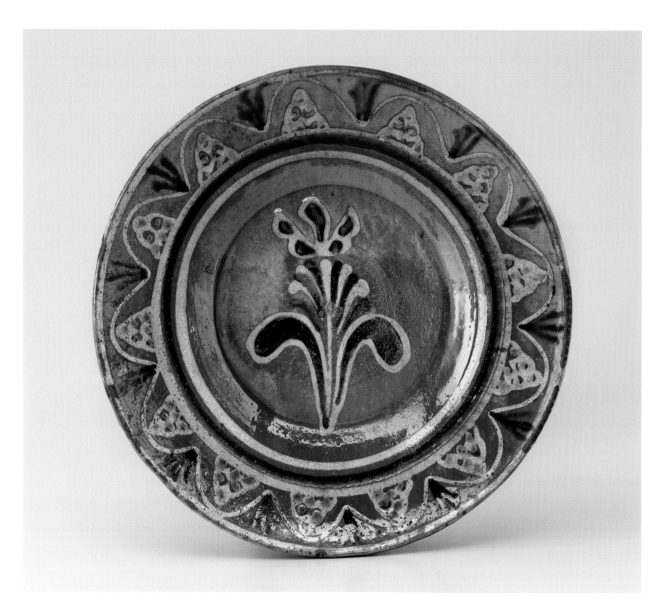

Figure 42 Dish, Alamance County,
North Carolina, 1800–1835. Lead-glazed
earthenware. D. 10⅝". (Courtesy, The
Barnes Foundation.) The back of this
dish has post-firing marks similar to
those on the examples illustrated in
figs. 40 and 41.

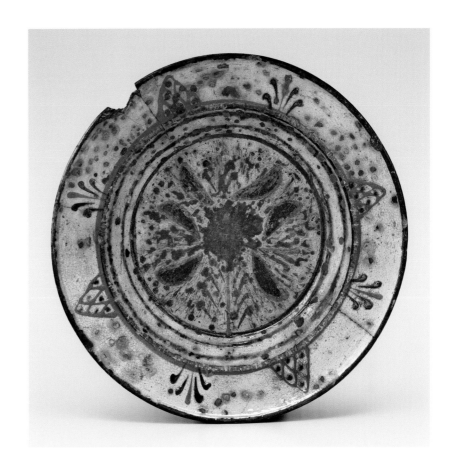

Figure 43 Dish, Alamance County, North Carolina, 1800–1835. Lead-glazed earthenware. D. 11¾". (Private collection.) This dish and the examples illustrated in figs. 44, 47, and 48 may be by Solomon Loy. If so, they date no earlier than 1825.

Figure 44 Dish, Alamance County, North Carolina, 1800–1835. Lead-glazed earthenware. D. 11". (Courtesy, Old Salem Museums & Gardens.) The plant motif in the center is a debased version of that found on dishes and hollow-ware forms decorated by earlier potters in the St. Asaph's tradition.

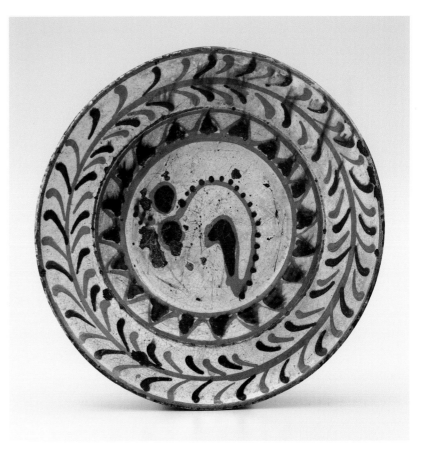

Figure 45 Dish fragments recovered at
Solomon Loy's pottery site, Alamance
County, North Carolina, 1825–1840.
Bisque-fired earthenware. (Courtesy,
Research Labs of Archaeology, UNC-
Chapel Hill.)

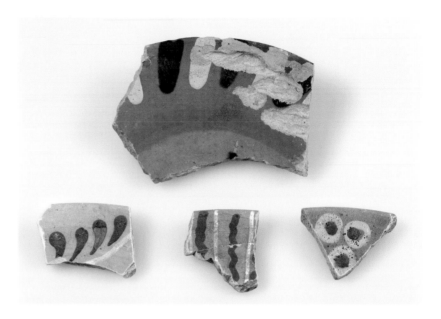

Figure 46 Detail of the back of the dish
illustrated in fig. 44.

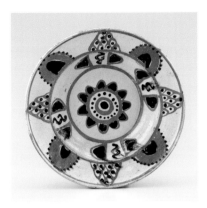

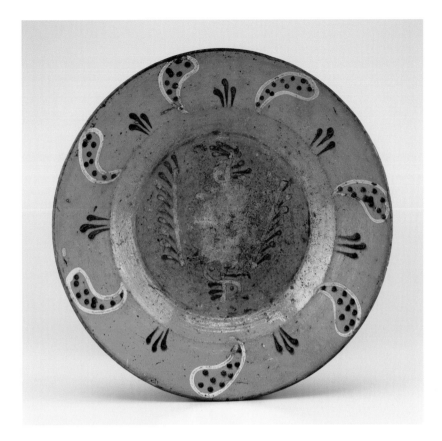

Figure 48 Dish, Alamance County, North Carolina, 1800–1835. Lead-glazed earthenware. D. 12¾". (Courtesy, Old Salem Museums & Gardens.)

Figure 47 Dish, Alamance County, North Carolina, 1800–1835. Lead-glazed earthenware. D. 11½". (Courtesy, Old Salem Museums & Gardens.)

Figure 49 Detail of the back of the dish illustrated in fig. 48.

St. Asaph's tradition. This is particularly true of artifacts associated with sites occupied by his father, Henry, and brother Joseph. Collectively, these objects show that the decorative vocabulary of Alamance County potters was codified by the end of the eighteenth century if not earlier.

The Joseph Loy Site
Joseph probably learned the pottery-making trade from his father and older brothers, then went into business with his father-in-law when he relocated to Person County, North Carolina. Joseph's site (31PR59) was discovered in 1992, owing to the diligent efforts of his descendants Allen and Hugh Campbell.[46] With the help of volunteers, fifteen small test units were excavated in a single day that yielded hundreds of artifacts—mostly lead-glazed earthenware fragments and kiln furniture, as well as datable European ceramics and glass. A partial kiln wall made of local fieldstone was found just below plow zone; the kiln was likely an updraft furnace used to burn earthenware.

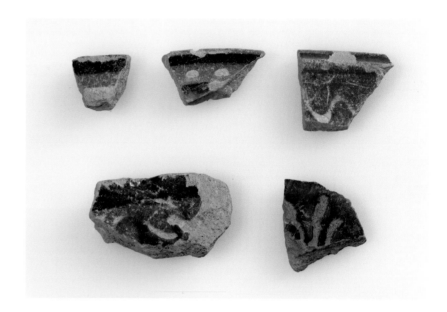

Figure 50 Slipware fragments recovered at Joseph Loy's pottery site, Person County, North Carolina, ca. 1833. Lead-glazed earthenware. (Courtesy, Research Labs of Archaeology, UNC-Chapel Hill.)

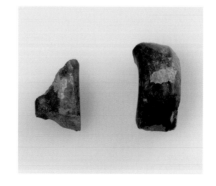

Figure 51 Handle fragments recovered at Joseph Loy's pottery site, Person County, North Carolina, ca. 1833. Lead-glazed earthenware. (Courtesy, Research Labs of Archaeology, UNC-Chapel Hill.) Joseph used copper oxide to produce a green glaze. His son George Haywood produced similar wares well into the 1860s.

Figure 52 Marble and candlestick fragment recovered at Joseph Loy's pottery site, Person County, North Carolina, ca. 1833. Bisque-fired and lead-glazed earthenware. (Courtesy, Research Labs of Archaeology, UNC-Chapel Hill.)

There is no evidence that Joseph Loy made stoneware at this site, but later his sons John Henry and George Haywood each had salt-glaze kilns located elsewhere.[47] A few pieces of lead-glazed earthenware marked with

Figure 53 Handle fragment recovered at Joseph Loy's pottery site, Person County, North Carolina, ca. 1833. Lead-glazed earthenware. (Courtesy, Research Labs of Archaeology, UNC-Chapel Hill.)

George Haywood's name survive in private collections. Letters from him to his uncle John A. Loy provide a glimpse at pottery making during this era. He wrote that he had returned to "pottering" because severe rains had destroyed his crops and he needed to make money. He asked his uncle for information about "glazing with copper and how to mix it" and requested that the formula be sent quickly so he could "glaze some greenware in the kiln that is nearly ready to burn."[48] This indicates George Haywood was producing lead-glazed earthen forms into the 1860s and that formulas for glazes were passed between family members.

Excavations at Joseph Loy's site revealed several interesting pieces of slip-decorated earthenware, among them fragments with green glazes and those representing dishes, plates, large pitchers, cups, and baluster candlesticks (figs. 50–52). Hand-formed clay marbles, glazed and unglazed pieces of kiln furniture, and a few fragments of pottery with dark grounds and polychrome slip decoration in floral and geometric patterns rounded out the assemblage (fig. 53). The trailed fragments are consistent in design and palette with those recovered at other Loy family pottery sites.

The Henry Loy/Jacob Albright Jr. Site

The Henry Loy/Jacob Albright Jr. site (31AM278) is potentially the most significant archaeological find relating to earthenware production in Alamance County.[49] Surface examinations yielded hundreds of lead-glazed earthenware fragments, many of which have elaborate slip-trailed decoration (fig. 54); a large quantity of kiln furniture (mostly stacking shelves or slabs and props); and an unusual anthropomorphic object, possibly intended for use as a pipe head prop (fig. 55). Solomon Loy made similar props by rolling out pieces of clay, attaching them to a base, and firing the assembled piece

Figure 54 Slipware fragments recovered at Jacob Albright Jr.'s pottery site, Alamance County, North Carolina, 1795–1825. Lead-glazed earthenware. (Courtesy, Research Labs of Archaeology, UNC-Chapel Hill.)

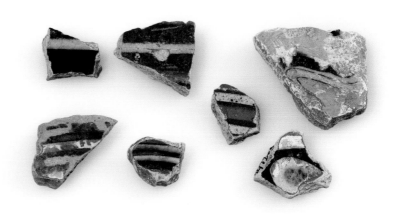

Figure 55 Pipe prop and anthropomorphic object recovered at Jacob Albright Jr.'s pottery site, Alamance County, North Carolina, 1795–1825. High-fired clay. (Courtesy, Research Labs of Archaeology, UNC-Chapel Hill.)

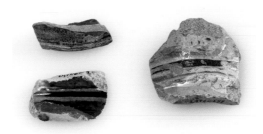

Figure 56 Mug fragments recovered at Jacob Albright Jr.'s pottery site, Alamance County, North Carolina, 1795–1825. Lead-glazed earthenware. (Courtesy, Research Labs of Archaeology, UNC-Chapel Hill.) Some of the mug bases from Albright's site are similar to those associated with Solomon Loy.

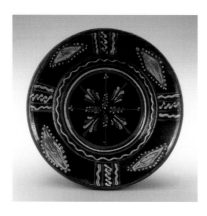

Figure 57 Dish, Alamance County, North Carolina, 1790–1820. Lead-glazed earthenware. D. 11". (Courtesy, Colonial Williamsburg Foundation.) Jacob Albright Jr.'s pottery produced slipware with marbleizing like that in the lozenges on the marly of this dish.

(see fig. 10). Relationships between decorated fragments from the Henry Loy/Jacob Albright Jr. and Loy family sites suggest that the Loy/Albright shop was the principal training ground for early-nineteenth-century artisans in the St. Asaph's tradition. This pottery shop clearly produced earthenware with polychrome slip on dark grounds and vessel forms that relate to those represented by fragments from the Solomon and Joseph Loy sites (fig. 56). Fragments from the Loy/Albright site also relate very closely to such contemporaneous pottery as the dish illustrated in figure 57.

A Legacy in Clay

Folklorist Henry Glassie could have been describing members of the Loy family when he wrote, "the potter manages the transformation of nature, building culture while fulfilling the self, serving society, and patching the world together with pieces of clay that connect the past with the present, the useful with the beautiful, the material with the spiritual."[50] The Loys were more than skillful potters and thoughtful teachers of their craft—they were vital participants in communities linked by language, religion, marriage, migration, and settlement. The documentary record reveals a great deal about the lives and careers of the Loy potters, but as much is gleaned from the surviving wares and archaeological investigations. All of these artisans, whose history was largely written in clay, deserve to be acknowledged as premier potters. The craft and legacy of Solomon Loy, however, earn him special rank as master potter of the Carolina piedmont.

1. For more on Loy, see Linda F. Carnes-McNaughton, "Transitions and Continuity: Earthenware and Stoneware Pottery Production in Nineteenth-Century North Carolina" (Ph.D. diss., University of North Carolina at Chapel Hill, 1997).

2. Charles G. Zug III, *Turners and Burners: The Folk Potters of North Carolina* (Chapel Hill: University of North Carolina Press, 1986), p. 235.

3. Ibid., pp. 238–43.

4. Marriages, Evangelisch-Reformierte Kirche, Mussbach, film 488536; Hasslock Baptisms, film 1418010.

5. Ibid.

6. The website www.progenealogists.com/palproject/pa/1741smark.htm lists both Martin and Anna Margaretha as passengers.

7. Howard M. Faust, *Faust-Foust Family in Germany & America*, rev. and expanded ed. (Baltimore, Md.: Gateway Press, 1984), D1–D5. Most genealogies of the Faust family do not include Anna Catrina Foust, who was twenty-one when she arrived on the ship *Elizabeth*; see www.olivetreegenealogy.com/ships/pal_eliz1733.shtml, where she is listed as Anna Catrina Foust. Anna Catrina may have been the daughter of Johan Peter Foust and his first wife, Magdalena Adams, who died in 1713, shortly after giving birth to their son Peter.

8. The following year Loy purchased 230 acres of land on Tom's Creek, adjacent to property owned by George Sharp; Lyman Chalkley, *Chronicles of the Scotch-Irish in Virginia, Extracted from the Original Court Records of Augusta County, 1745–1800*, 3 vols. (1912; repr., Baltimore, Md.: Genealogical Publishing Co., 1965), 3:73, 321. All three volumes are available online at www.rootsweb.ancestry.com/~chalkley/ (accessed June 1, 2009).

9. Isaac Sharp III and his wife, Philopena Graves, moved from Pennsylvania to Botetourt County, Virginia, before relocating to Alamance County, North Carolina. See http://genforum.genealogy.com/sharp/messages/5893.html (accessed July 30, 2010). The only other evidence of a kiln with a "hob"-style firebox like that used by Solomon Loy was excavated in Botetourt County. Kurt Russ, "The Fincastle Pottery (44BO304): Salvage Excavations at a Nineteenth-Century Earthenware Kiln Located in Botetourt County, Virginia," *Technical Report Series No. 3* (Richmond, Va.: Department of Historic Resources, 1990), pp. 11–23.

10. http://genforum.genealogy.com/sharp/messages/5893.html (accessed July 30, 2010).

11. A December 1755 date is cited, without a source, at www.voiceuniverse.com/family/genealogy/ (search last name LOY, first name MARTIN, select person ID I903; accessed June 5, 2009). This date might not be correct, since *Register of Orange County North Carolina Deeds, 1752–1768 and 1793*, transcribed by Eve B. Weeks (Danville, Ga.: Heritage Papers, 1984), n.p., refers to Martin's purchase of 251 acres of land in Orange (now Alamance) County from Henry McCulloh in 1765.

12. For the 1803 membership roll of Stoner's Church, see www.rootsweb.ancestry.com/~ncalaman/stoners.html (accessed March 17, 2010).

13. *Orange County, NC Wills*, transcribed by Laura Willis, 13 vols. (Melber, Ky.: Simmons Historical Publications, 1997–), 2:13–14.

14. John and Mary named their children Jacob, John, George, Solomon, Martin, Henry, Mary, and Michael. The names of two further male children are unknown. David Isaac Offman, "Albright Family Records," Alamance County Historical Association, 1975.

15. Brent Holcomb, *Marriages of Orange County, North Carolina, 1779–1868* (Baltimore, Md.: Genealogical Publishing Co., 1983), p. 186.

16. The contents of Albright's pottery were listed in "An Inventory and an Account of Sales of the Estate of Jacob Albright Dec^d.," North Carolina State Archives (hereafter cited NCSA), Raleigh, and sold on March 24, 1825. His stock-in-trade included 255 crocks, 62 basins, 20 dishes, 9 pitchers, 7 jugs, 2 cream pots, 2 pans, 2 "P pots," and 1 sugar pot.

17. According to deed research, the site AM278 is currently located on a 30-acre parcel that has been in this family's possession since the mid-1890s. Prior to that it was owned by Cobles, Boyds, Holts, Isleys, and Browns back into the earlier recorded deed of 1803, originally all Orange County. Then the deeds are less specific and include larger tracts of land. One such large tract is listed as Joseph Albright to Andrew Albright (August 13, 1815, for 110 acres) and prior to this deed was Jacob Albright to his son Joseph, dated May 13, 1778, for 150 acres, indicating that the portion of the land where the Henry Loy/Jacob Albright kiln site is located was once on a larger tract of land. Other adjoining tracts of the 1770s were owned by Adam Marly, John Haney, Martin Hurdle (who moved to Person County), and Joel Moody.

18. Jeremiah, John, and Solomon are listed as potters in Chatham County in the 1850 and 1860 censuses. Carnes-McNaughton, "Transitions and Continuity," pp. 46–52. William may have received this land from his father (Register of Orange County, North Carolina, Deed Book 25, p. 18, NCSA). Jeremiah's site has not been located, and it is possible that he worked with one of his brothers. He married into the Holt family, as had his grandfather, thus securing some property, which Joseph most likely farmed. William Loy, the eldest son of Henry and Sophia, married Martha Boggs, who was also from a pottery family in Snow Camp. The Boggs kiln site (31AM199) is approximately one mile from that of Solomon Loy. Historical records indicate that the shop and groundhog kiln were built by John Thomas Boggs and later operated by his son, Timothy. See "The Potters of Alamance County," in Jane Madeline McManus, Ann Marie Long, and Linda F. Carnes-McNaughton, *Alamance County Archaeological Survey Project, Alamance County, North Carolina* (Chapel Hill: Research Laboratories of Anthropology, University of North Carolina, 1986), pp. 115–22 (appendix A); and Zug, *Turners and Burners*, pp. 58, 354, 437. Timothy Boggs' future brother-in-law Joseph Vincent also worked at the pottery. When Timothy died of tuberculosis, Joseph ran the shop until 1910 with help from his sons, Cesco and Turner. John Thomas Boggs trained with Solomon Loy. Pottery associated with members of the Boggs family is documented in South Carolina. For related history in Tennessee, see Samuel D. Smith and Stephen T. Rogers, *A Survey of Historic Pottery Making in Tennessee*, Research Series No. 3 (Nashville: Division of Archaeology,

Tennessee Department of Conservation), p. 16; in Georgia, John A. Burrison, *Brothers in Clay: The Story of Georgia Folk Pottery* (Athens: University of Georgia Press, 1983), pp. 310–11; and in Alabama, Joey Brackner, *Alabama Folk Pottery* (Tuscaloosa: University of Alabama Press, 2006), pp. 218–19. William Loy's son, Mebane (born 1838), trained alongside his cousin John M. and neighbor J. T. Boggs, all under Solomon Loy. Mebane later opened his own shop nearby (site recorded but not tested).

19. Will of John Phillips, Person County, Records, Wills, Inventories, Sales of Estates, Taxables, 1835–1837, pp. 153–54, CR078.801.13, NCSA.

20. John Phillips is listed as a potter in the 1820 Census of Commerce and Manufacturers for North Carolina.

21. M. D. Chiarito, "Summary of Alamance County, North Carolina 1850 Census," unpublished, NCSA, n.d., pp. 194–95.

22. Solomon's wife and son John M. are buried at Flint Ridge Cemetery nearby, and other Loys are buried at Mt. Herman Methodist Church farther north. Carnes-McNaughton, "Transitions and Continuity," p. 102.

23. Indirect evidence for John Mebane Loy working at Solomon Loy's site is suggested by fragments recovered at 31AM191 including those marked "SGSW" and "ME." The letters ME appear to be the beginning of a name. Alamance County census records for 1860 and 1880 list John Mebane Loy as a potter. George Haywood Loy is listed as a potter in Hurdles Mills, Person County, in the 1860 census. Information about Solomon's grandsons Albert F. Loy and William H. Loy is largely based on family tradition, their surviving wares, and their pottery sites. Albert's sites were recorded in 1986 (McManus, Long, and Carnes-McNaughton, "Potters of Alamance County," pp. 114–48 [appendix A]). Discussion of marked John M. and J. M. Loy pieces excavated at site 31AM191, as well as census records and family history, indicate John Mebane Loy remained at this pottery shop after his father died. The presence of George Haywood Loy working in Person County is also based on census records and family history. For further description, see Carnes-McNaughton, "Transitions and Continuity."

24. No records of formal apprenticeship of the Boggs potters working at Solomon Loy's shop exist, however; this assessment is based on oral tradition, the nearby proximity of the Boggs land and shop, the intermarriage of the two families, and the fact that John Mebane Loy and John Thomas Boggs were contemporaries. Calvin Hinshaw, noted regional historian, also stated that the Boggses worked at the Loy shop until they built their own kiln, which Timothy Boggs operated until his death. Timothy Boggs married into another pottery family, the Vincents.

25. McManus, Long, and Carnes-McNaughton, "Potters of Alamance County," appendix A.

26. Zug, *Turners and Burners*, p. 30. The annexed portion of Alamance County (i.e., Newlin and Patterson townships) consisted of a 2¾-mile-wide strip, which maintained its strong Quaker character as well as a "distinctive, self-contained tradition" of pottery manufacturing.

27. For more on the ownership of these sites, see Carnes-McNaughton, "Transitions and Continuity," pp. 51–54.

28. "A List of Taxables & Taxable Property within Orange Co. for the Year 1800," NCSA. The contents of Albright's pottery were sold on March 24, 1825 and listed in "An Inventory and an Account of Sales of the Estate of Jacob Albright Decd." Henry Loy died in 1832. Among the items listed in the inventory of his property were "1 pair pipe molds" valued at 12¢, "1 turning wheel" valued at 10½¢, and "1 mill" valued at 5¢. The pipe molds were purchased by Henry's son John ("Sale of Property of Henry Loy, Dec^d.," March 24, 1832, loose estate papers in the Henry Loy file, NCSA). The absence of pottery in the inventory suggests that Henry had either ceased production or transferred his stock-in-trade to another party, possibly one or more of his sons. Land transactions recorded between 1826 and 1839 involving Henry's sons William and Solomon show they were purchasing land and perhaps were relocating the pottery in the years prior to their father's death. Carnes-McNaughton, "Transitions and Continuity," pp. 49–54.

29. Carl Lounsbury, *Alamance County Architectural Heritage* (Burlington, N.C.: Alamance County Historic Properties Commission, 1980), p. 130.

30. Carnes-McNaughton, "Transitions and Continuity," p. 48.

31. Ibid., pp. 49, 86.

32. Ibid., pp. 114–16. For more details on the design of the kiln used for firing stoneware, see ibid., pp. 65–68, 115–17, and 225–26.

33. Interiors of the north and east fireboxes were excavated. The south and west fireboxes were left intact in order to preserve a peach tree and provide undisturbed strata for future research.

34. An interruption in the circular foundation wall was interpreted as a possible threshold

for a doorway into the kiln. Bricks on the interior were coated with a thick deposit of glaze.

35. Only the lower two courses of brick remained intact in the east firebox; the north firebox, located slightly farther uphill, was deeper (1.3 feet), with more of its original brick courses in place. Excavation of the west firebox was avoided.

36. On the use and design of hob fireboxes, see Daniel Rhodes, *Kilns: Design, Construction, and Operation* (Radnor, Pa.: Chilton Book Company, 1968), pp. 60–61.

37. If Loy's kiln was a beehive design, it may have been only about 8–10 feet high. The Virginia kiln with a hob firebox was recorded during a salvage archaeology project in Botetourt County, Virginia. Roadway construction had destroyed the kiln foundation, but the remains of one double-chambered firebox were found in the embankment adjacent to the road. Russ, "Fincastle Pottery (44BO304)," pp. 11–23.

38. Alain Outlaw, "The Mount Shepherd Pottery Site, Randolph County, North Carolina," in *Ceramics in America*, edited by Robert Hunter and Luke Beckerdite (Hanover, N.H.: University Press of New England for the Chipstone Foundation, 2009), pp. 165–67.

39. Carnes-McNaughton, "Transitions and Continuity," pp. 160–64. Architectural byproducts included bricks, foundation stones, mortar samples, gravel floor samples, and glaze waste. Kiln furniture included coils, slab/shelf pieces, saggers, trivets, props, draw trials, and pipe head holders.

40. Fragments of crocks and jars (86%), jugs (9%), plates (1%), bowls (1%), and mugs (1%) were examined for diagnostic attributes related to the top, middle, and basal portions, with appropriate descriptors for parts per vessel form: lip of a cup; rim of a crock; cavetto of a plate; base of a jar; spout for a pitcher; shoulder of a jug or jar; neck of a jug; collar of a churn; recessed lip to seat a lid; strap handle; lug handle; footring; finial of lid. Capacity indicators, decorations, maker's stamp or signature, and embellishments were added to the earthenware vessels in the areas of greatest visibility, typically the exterior of hollow ware or inside flatware.

41. John Bivins Jr., *The Moravian Potters in North Carolina* (Chapel Hill: University of North Carolina Press for Old Salem, Inc., 1972), p. 283. More useful is the recent study by Hal E. Pugh on the decorative plates found in the Quaker community of New Salem located near Randleman, North Carolina (Pugh, "The Quaker Ceramic Tradition in the North Carolina Piedmont: Documentation and Preliminary Survey of the Dennis Family Pottery," *The Southern Friend, Journal of the North Carolina Friends Historical Society* 10, no. 2 [1988]: 12–13).

42. Luke Beckerdite has attributed the lamp to Loy.

43. Joe Kindig Jr., "A Note on Early North Carolina Pottery," *The Magazine Antiques* 27, no. 1 (January 1935): 14–15. This article was reprinted with annotations in *The Art of the Potter*, edited by Diana Stradling and J. Garrison Stradling (New York: Main Street/Universe Books, 1977), pp. 26–27. The advertisement is illustrated in Beckerdite and Hunter, "Collectors and Scholars of North Carolina Earthenware," p. 7, fig. 9, in this volume.

44. This information was provided by William Ivey.

45. When I first photographed this vase, ca. 1986, it was owned by someone else who had no provenance data regarding the Loy farm purchase. The pipe mold apparently did come from the Whiteheads log house, however, and was sold to William Ivey. I thank Bill Ivey for sharing the history of the container.

46. Field notes and map from Allen Campbell and Hugh Campbell on the Joseph Loy Site (31PR59), Office of State Archaeology, State Site Files, Raleigh, North Carolina, 1992. Joseph's site is in a large, open field near the community of Hurdle Mills. It was located using historical maps and oral tradition, then verified with ground-penetrating radar and archaeological investigation. Carnes-McNaughton, "Transitions and Continuity," pp. 150–51.

47. Joseph and his wife, Sarah, had five children: John Henry, Mary A., George Haywood, William M., and Jacob N. The eldest, John Henry, eventually moved back to Alamance County, served in the Civil War, and died after being wounded in 1863. George Haywood received his father's land and home from his mother in 1866. Correspondence between the author and Barry Loy (citing private family papers), 2006 and 2007.

48. Correspondence between the author and Barry Loy (citing private family papers of George Haywood Loy), 2006 and 2007.

49. In 1998 an amateur archaeologist discovered this site and subsequently brought it to my attention. I received permission to record the site and surface-collect artifacts between cultivation cycles in the field. The site is about eight miles north of Snow Camp and within one-half mile of the graveyard for Stoner's Church, where members of the Loy family worshiped.

50. Henry Glassie, *The Potter's Art* (Bloomington: Indiana University Press, 1999), p. 116.

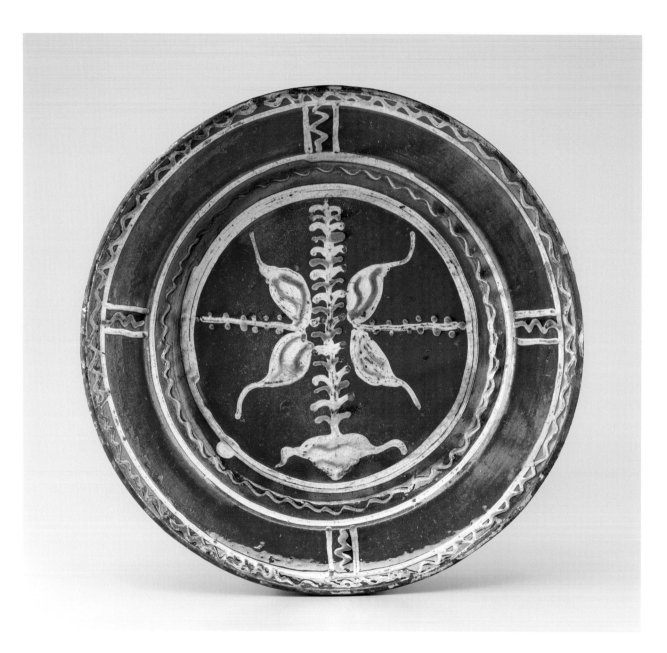

Figure 1 Dish, attributed to the William Dennis pottery, New Salem, North Carolina, 1790–1832. Lead-glazed earthenware. D. 13⅜". (Courtesy, The Barnes Foundation; unless otherwise noted, photos by Gavin Ashworth.) Antique dealer Joe Kindig Jr. of York, Pennsylvania, purchased this dish prior to April 1935, when he advertised it along with other southern earthenware in *The Magazine Antiques* 27, no. 4 (April 1935): 121.

Hal E. Pugh and Eleanor Minnock-Pugh

The Dennis Family Potters of New Salem, North Carolina

Figure 2 Map showing the location of the William Dennis and Thomas Dennis pottery sites. (Artwork, Wynne Patterson.)

▼ THE CONTRIBUTION OF Quaker potters to North Carolina's ceramic history has been sadly neglected owing to the absence of identifiable production sites, insufficient knowledge of those involved in the pottery trade, and scarcity of signed and attributed wares. The belief that Quakers eschewed ornament in their daily life has led to the assumption that their decorative arts were largely unadorned. The discovery of the William Dennis site and the pottery associated with it changes that supposition (fig. 1).

History

In 1766 Thomas Dennis II (ca. 1700–ca. 1775) arrived in what is now northern Randolph County, North Carolina, having moved from his 263-acre farm in East Fallowfield Township in Chester County, Pennsylvania.[1] With the patriarch came his wife, their sons Thomas III (1724–1803) and Edward (b. ca. 1726), and the young men's families.[2] In their move south, the Dennises followed kin and other members of the Society of Friends who had been migrating from Pennsylvania to the central piedmont region of North Carolina since the 1750s. The families of Thomas II and Thomas III settled on a 300-acre tract of land that sat astride the colonial trading road, an advantageous location for the establishment of pottery making that came later (fig. 2). Like many migrants from Pennsylvania, the Dennises probably followed that route from Petersburg, Virginia, into the North Carolina piedmont.

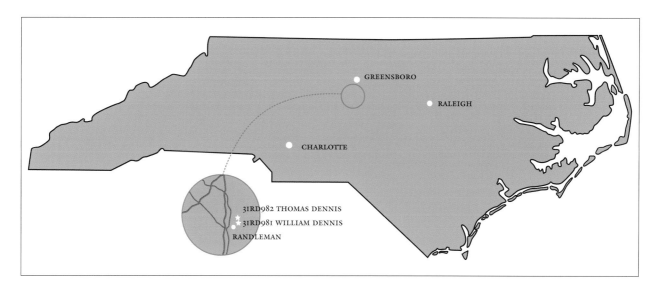

GREENSBORO

RALEIGH

CHARLOTTE

31RD982 THOMAS DENNIS

31RD981 WILLIAM DENNIS

RANDLEMAN

Upon the death of Thomas Dennis II, in 1775, his property passed by will to his wife, Sarah, and eldest son, Thomas III.[3] Thomas III was a devout Quaker who adhered to his pacifist beliefs during the American Revolution. His land and house were confiscated after he refused to fight and swear the oath of allegiance against the king of Great Britain and his successors, which was required by North Carolina law in 1778.[4] On April 19, 1779, Robert and William Rankin received a land grant for the confiscated property "Containing three hundred Acres laying in the County aforesaid on bouth sides the Trading road and west side of Pole cat adjoining Joseph Hills Entry running for Compliment, Including the Improvement of Thomas Dennis."[5] Thomas III was forced to buy his property back,

Figure 3 Indenture of George Newby, Randolph County, North Carolina, May 3, 1813. (Courtesy, North Carolina State Archives.)

receiving a grant in his name in 1786.[6] When he died, in 1803, his property passed by will to his son, William Dennis (1769–1847).[7]

As Quakers, the Dennises believed that the souls of men had an inner light that could illuminate God's will and guide the conscience. This spiritual connection was a foundation of the sect's adherence to tenets of equality and nonviolence, beliefs that played a major role in William Dennis's taking an African American child named George Newby (ca. 1801–ca. 1870) as an apprentice in the pottery trade in 1813.[8] The Disciplines of the Society of Friends recommended that members "in their several neighbourhoods advise and assist such of the black people as are at liberty, in the education of their children, and common worldly concerns."[9] Newby's indenture is the earliest documentary evidence of pottery production at the Dennis site (fig. 3).[10] The apprenticeship bound him until the age of twenty-one, which meant he would have completed his term about 1822. It is probable that William also taught his eldest son, Thomas (1791–1839), the pottery trade. According to a late-nineteenth-century history, "[Thomas] . . . followed farming until he was near twenty years of age, when he commenced to learn the potter's trade, which he followed . . . until his removal to Wayne County, Ind., landing Oct. 1, 1822."[11] Although this account suggests that Thomas's apprenticeship commenced in 1811, it is far more likely that he began working with his father as a child, completed his training at the age of twenty, and supplemented his trade with farming like most rural craftsmen. In 1812 Thomas purchased 164 acres of land adjoining his father's property and established his own pottery.[12] Part of Thomas's tract had belonged to William Dennis's aunt Rachel, who was the widow of Edward Dennis. That land contained extensive beds of clay suitable for the manufacture of pottery. Early histories and deeds show that Thomas probably operated a pottery there from 1812 through 1821, when he sold his property to Edward Bowman prior to moving to Indiana.[13]

The technically accomplished wares associated with the William Dennis site suggest that he learned his trade from an experienced and knowledgeable potter. At present one can only hypothesize as to the identity of his master. It is possible that William's father, Thomas III, was also a potter, but at present farming is the only occupation that can be documented to the elder Dennis. This does not eliminate him from consideration, since both William and his son Thomas combined pottery making with farming. It appears that William's earlier male lineage was involved in the farming and shoemaking trades. His grandfather Thomas II was listed as a yeoman in his will, which was probated in North Carolina in 1775, and as a cordwainer on a New Jersey deed registered in 1728.[14] William's great-grandfather Thomas I (who emigrated from an area near Athlone, Ireland, to New Jersey in 1682) was listed as a shoemaker in 1684, while in Gloucester County, New Jersey, and in 1692, in Philadelphia.[15]

Quakers often apprenticed their children to other members of their faith. The Disciplines of the Society of Friends "advised [brethren] to bring up their children to habits of industry, placing them with sober and exemplary members of the society, for instruction in such occupations as are consistent with our religious principles and testimonies."[16] At the age of fifteen,

Figure 4 Mendenhall and Dicks family tree. (Compiled by Hal Pugh and Eleanor Minnock-Pugh; artwork, Wynne Patterson.) John Mendenhall married Elizabeth Maris (b. 1665) in 1685; in 1708 he married Esther Maddock Dicks, the widow of Peter Dicks.

Richard Mendenhall (1778–1851) of southern Guilford County, North Carolina, was sent to Chester County, Pennsylvania, to serve an apprenticeship with his second cousin's husband, potter Jesse Kersey (fig. 4).[17] It is possible that William Dennis learned the potter's trade in a similar way. His second cousin once removed, Hannah Webb, was married to Nathan Pusey, a potter in Chester County.[18] This relationship was through his mother's side of the family, and her maiden name was Elizabeth Webb (fig. 5); however, no connection has yet been documented between Pusey and Dennis.

It is equally plausible that William learned his trade locally. Members of the Hoggatt (Hockett) and Dicks families, who lived five miles north of the Dennises, were potters and attended the Centre Friends Meeting in southern Guilford County, where William worshiped. Peter Dicks (1771–1843) moved to the New Salem area of northern Randolph County in 1804 and had established a pottery by 1806, when he took Isaac Beeson as an appren-

Esther Maddock 1661–1709 — Peter Dicks 1654–1704

Nathan Dicks 1694–1765 — Deborah Clark ca. 1690

Peter Dicks 1696–1760 — Sarah Hayes ca. 1700–1749

James Mendenhall 1718–1782 — Hannah Thomas 1717–1798

Zachariah Dicks 1736–1812 — Ruth Hiatt b. 1735

Peter Dicks ca. 1720–1796

Elizabeth d. 1799

Nathan Dicks Jr. 1727–1765

Mary Ballinger 1729–1790

Esther Dicks 1730–1804 — John Darlington ca. 1727–1813

George Mendenhall 1751–1805 — Judith Gardner 1754–1831

Elizabeth C. Vestal 1769–after 1830

Peter Dicks 1768–after 1830 — Mary Lindley 1774–ca. 1805

James Dicks ca. 1748–1830 — Rachel Beals ca. 1750–1827

Zillah Darlington 1769–1844 — Jonathan Cope 1762–1840

Richard Mendenhall 1778–1851 — Mary Pegg 1788–1867

Abigail Mendenhall 1795–1867

Hezekiah Clark 1797–1876

Peter Dicks 1771–1843 — Ann Hodson 1780–1850

William Dicks 1773–1839 — Esther Williams 1777

Elizabeth Dicks 1775–1816

Thomas C. Beard 1768–1820

Darlington Cope 1815–1888 — Ann Cope 1824–1905

Rhoda Mendenhall 1815–1892

Messor Amos Vestal 1812–1886

Nathan Dicks 1794–ca. 1834 — Eleanor Leonard 1794–1860

Wilmer Cope 1864–1943

Caleb Cope 1867–1957

Tilghman Vestal 1844

Cornelius Dicks 1818–1894 — Eunice Blackburn 1822–1892

Nathan Dicks 1855–1918

Mary Dicks 1842–1920

- Documented potter
- Undocumented potter claimed through family tradition
- Documented maker of clay smoking pipes

tice in that trade.[19] In 1816 Dicks, William Dennis, and three other Quakers were appointed commissioners to lay out the town of New Salem into lots on both sides of the Trading Road.[20] Four years later William purchased lot number 4, built a home, and moved half a mile west of his pottery and former residence.[21] Dennis and Dicks were evidently good friends, as they traveled together to Tennessee and Indiana in 1825–1826. Before moving to

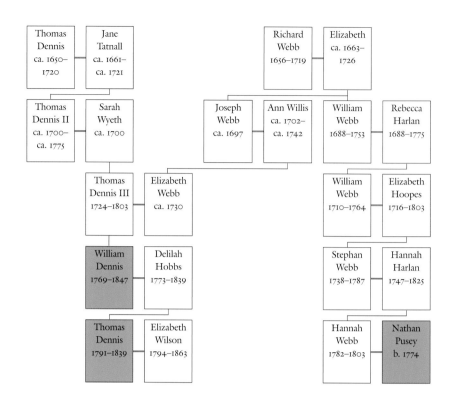

Figure 5 Dennis and Webb family tree. (Compiled by Hal Pugh and Eleanor Minnock-Pugh; artwork, Wynne Patterson.)

▨ Documented potter

Indiana permanently in 1832, William sold Peter a 140-acre tract of land that included William's former residence, pottery shop, and clay beds.[22]

Biographical and historical accounts indicate that at various times between 1806 and 1837 at least four Quaker potteries were in operation within 1½ miles of New Salem. All of the potters knew one another, attended the same meeting, and interacted socially and commercially on a regular basis. Since many were related, it is logical to assume that their ceramic forms, decorative techniques, kiln architecture, and kiln furniture were similar. Given that their patronage networks were also basically the same, one can postulate congruencies in other aspects of their business as well.[23]

Archaeology
Archaeology at the William Dennis site indicates that the production of pottery there predates documentary evidence. In 1997 the late Tom Hargrove volunteered to conduct geophysical surveys on the William Dennis house and pottery sites to determine subsurface integrity.[24] After Hargrove located the kiln feature, Linda F. Carnes-McNaughton partially excavated that site, revealing the footprint of a ten-foot-square kiln with two-foot-thick rock walls (fig. 6). Many contemporary earthenware potters used beehive or bottle-shaped kilns, but square examples are evident in the Quaker pottery tradition.[25] The kiln architecture and artifacts recovered at the site strongly suggest that the pottery was in operation during the last quarter of the eighteenth century.[26] Similarities between the excavated fragments and those from datable Germanic and English pottery sites in North Carolina and elsewhere in the United States indicate that William Dennis was making pottery by the time of his marriage to Delilah Hobbs, in 1790.[27]

Figure 6 View of the William Dennis kiln after partial excavation, Randolph County, North Carolina, 2001. (Photo, Linda F. Carnes-McNaughton.) The kiln measures 10' by 10' and had 2'-thick rock walls.

Potters and Pottery: The William Dennis Site

Variations in turning, decoration, and other technical and stylistic attributes of fragments recovered from the William Dennis site document the presence of three different potters. Ranging from bold to subtle, these disparities belie the notion that this assemblage of artifacts is the product of a single potter whose work changed over time.

Dish fragments, which account for the highest percentage of artifacts found thus far, can be divided into groups based on shared features and techniques. One group of plain and decorated fragments has heavy, flat-topped rims with tooled outer edges (fig. 7). While these dishes were turning on the wheel, the maker used a wooden tool with a rounded notch to press against the outside bottom edge of the rim in order to give it curvature (fig. 8). A closer examination of these fragments reveals the impression left

Figure 7 Dish rim fragments recovered at the William Dennis pottery site, New Salem, North Carolina, 1790–1832. Lead-glazed and bisque-fired earthenware. (Private collection.) The extrapolated diameters of these dishes are 11¾"–12".

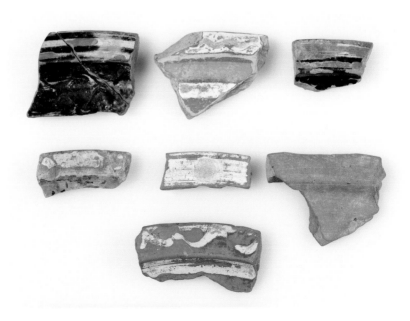

Figure 8 Notched wooden tool with a rim fragment recovered at the William Dennis pottery site, New Salem, North Carolina, 1790–1832. (Private collection.)

Figure 9 Dish rim fragments recovered at the William Dennis pottery site, New Salem, North Carolina, 1790–1832. Bisque-fired earthenware. (Private collection.) The impression left in the clay by the potter's notched wooden tool is clearly visible on the edges of these rims, particularly the one at the upper left.

Figure 10 Mug fragments recovered at the William Dennis pottery site, New Salem, North Carolina, 1790–1832. Lead-glazed earthenware. (Private collection.) The concentric tooling on these mugs appears to have been generated with a multitoothed rib.

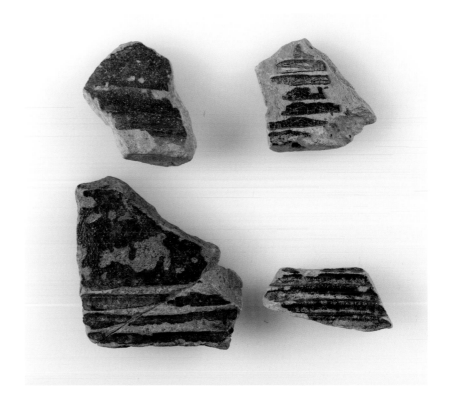

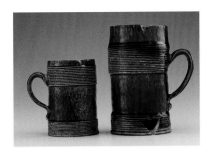

Figure 11 Mugs, Staffordshire, England, 1700–1720. Lead-glazed earthenware. (Courtesy, James Glenn Collection.)

Figure 12 Dish rim fragments recovered at the William Dennis pottery site, New Salem, North Carolina, 1790–1832. Bisque-fired earthenware. (Private collection.) The extrapolated diameters of these dishes are, from top to bottom, 11¾", 12", and 13".

by the edge of the tool in the clay near the upper outside edge of the rims (fig. 9). The majority of rims associated with this potter have an intentionally sharp interior edge between the rim and cavetto. Similarities also can be observed in this potter's application of slip. He often used a brown engobe on the interiors of dishes and a white slip to cover the flat rims. The rim of one dish is decorated with large, ⅝-inch slip dots reminiscent of those on late-seventeenth- and early-eighteenth-century slipware from the Staffordshire area of England. Fragments from the bottoms and sides of mugs (fig. 10) attributed to this potter also have details found on early Staffordshire mugs with multigrooved tooling (fig. 11) and on comparable examples made by New England potters of English descent.[28] To produce broad bands of concentric grooves, this potter pressed a rib with multiple teeth against the sides of his mugs while they were turning on the wheel (see fig. 10). Mug fragments by this potter also exhibit glazes in three separate colors—black, green, and a manganese/iron purple.

The potter responsible for another group of dish fragments recovered at the William Dennis site excelled at both turning and slip-trailing (fig. 12). These pieces have a rounded edge on the rim interior and lack the tooled outer edge shared by the examples illustrated in figure 9. They resemble the undercut and rolled rims of many North Carolina dishes made at the beginning of the nineteenth century. Several dish fragments made by this exceptionally skilled hand have engobes that were intentionally darkened

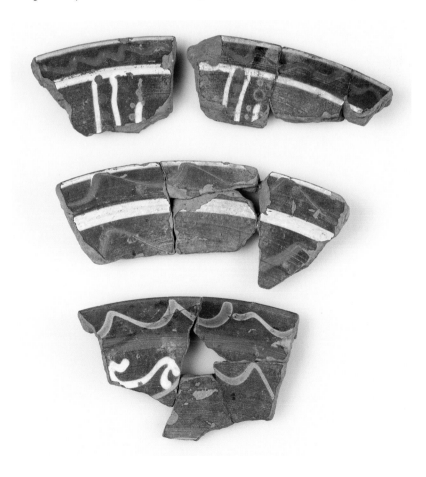

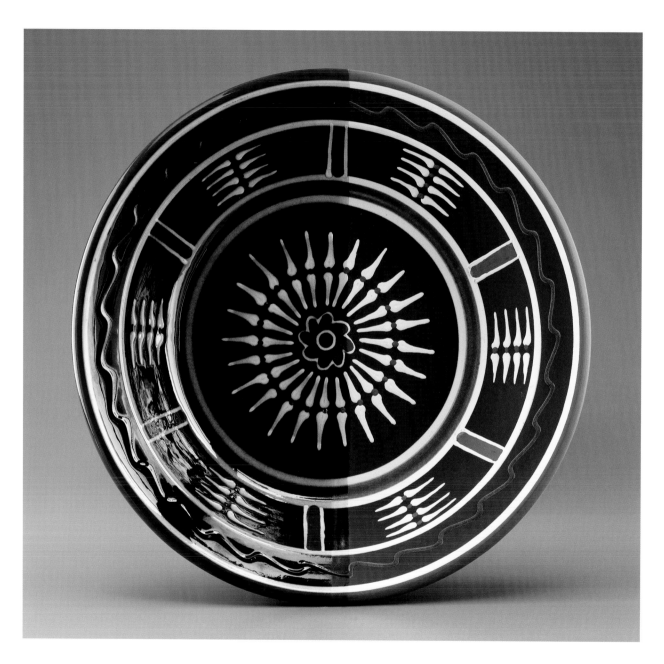

Figure 13 Reproduction dish, based
on fragments from the William Dennis
pottery. D. 12″. Lead-glazed earthenware.
(Private collection.)

to create a dark brown to black background. A reproduction dish based on fragments from the Dennis site shows how the engobe looks in the bisque and glaze stages (fig. 13). Several fragments attributed to this potter are decorated with an unusual winged motif in the form of a dot with an attenuated teardrop abutting each side (fig. 14). The reproduction dish and reassembled fragments illustrated in figure 14 show repetitive use of that winged device to create a circular motif around a flower-shaped design. Related decoration occurs on contemporary Quaker samplers from the Ackworth School in Yorkshire, England (fig. 15), and Westtown School in Chester County, Pennsylvania.[29] Fragments from the Dennis site also indicate that the winged motif was applied directly on the clay body of some dishes. On two surviving examples, the decoration was applied in patterns that appear almost skeletal (see figs. 16, 17). The dish illustrated in figure 16 has a recovery history in Randleman, North Carolina, where New Salem and the William Dennis site are located.[30] On that object and the related examples shown in figures 1 and 17, the marlys are partitioned with vertical lines, squiggles, and dots. As the fragments and reproduction dish suggest, partitioning devices are common on slipware from the Dennis site. Another technique used by this potter was outlining geometric and floral motifs with contrasting slip lines and/or dots (jeweling) (fig. 18). A slip-decorated dish bearing the date 1812 has stylized petal motifs with jeweled perimeters (fig. 19) that match those on fragments from the Dennis site (fig. 20) and

Figure 14 Dish fragments recovered at the William Dennis pottery site, New Salem, North Carolina, 1790–1832. Bisque-fired earthenware. (Private collection.) The reproduction dish illustrated in fig. 13 was based on these and other related fragments.

Figure 15 Detail of the upper left corner of a sampler by Ann Grimshaw, Ackworth School, Yorkshire, England, 1818. (Courtesy, Philadelphia Museum of Art.)

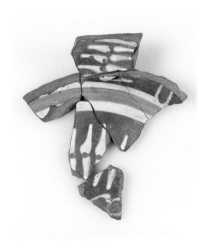

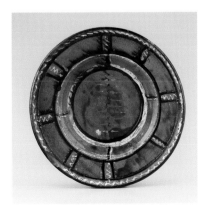

Figure 16 Dish, attributed to the William Dennis pottery, New Salem, North Carolina, 1790–1832. Lead-glazed earthenware. D. 13". (Courtesy, Old Salem Museums & Gardens.) The decoration in the cavetto of this dish is closely related to that on the fragments illustrated in fig. 14.

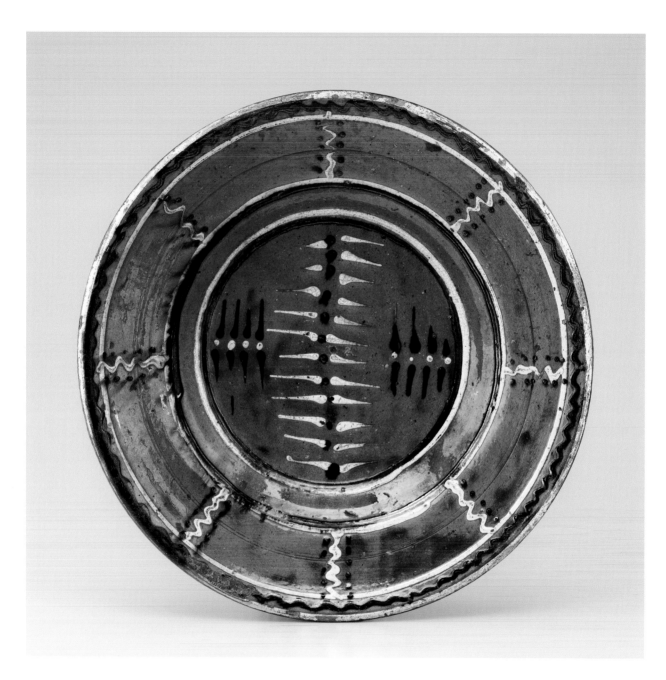

Figure 17 Dish, attributed to the William
Dennis pottery, New Salem, North Caro-
lina, 1790–1832. Lead-glazed earthenware.
D. 13¼". (Courtesy, The Barnes Founda-
tion.)

Figure 18 Dish fragments recovered at the William Dennis pottery site, New Salem, North Carolina, 1790–1832. Bisque-fired earthenware. (Private collection.) All of these fragments have petal-shaped motifs with contrasting slip outlines and jeweling.

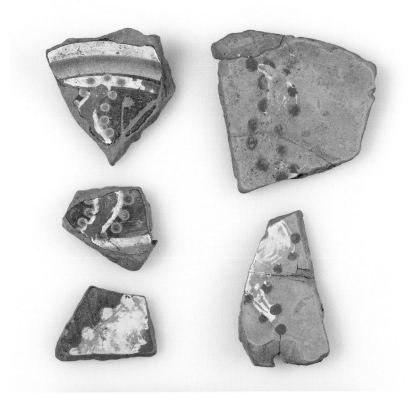

Figure 19 Dish, attributed to the William Dennis pottery, New Salem, North Carolina, 1812. Lead-glazed earthenware. D. 13⅛". (Courtesy, Old Salem Museums & Gardens.)

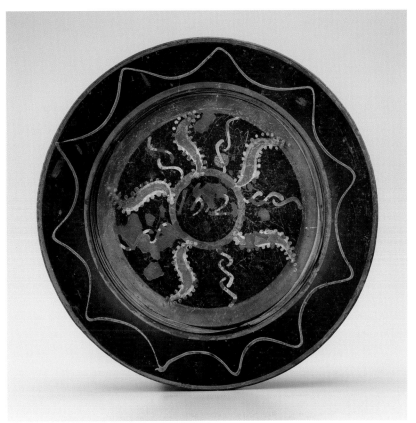

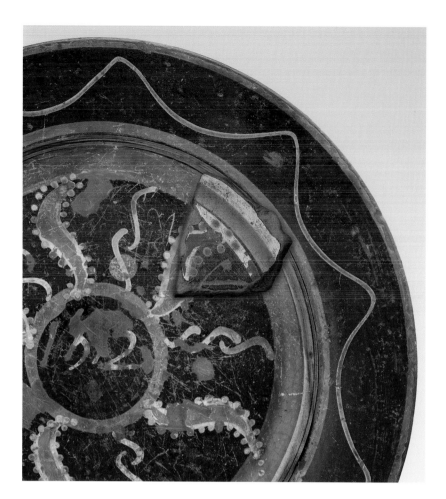

Figure 20 Detail of the dish illustrated in fig. 19, with a cavetto fragment recovered at the William Dennis pottery site. The background engobe and slip decoration on the fragment would have matched those on the fired dish. The beige jeweling and concentric banding on the fragment would have burned green during the glaze firing.

Figure 21 Dish, attributed to the William Dennis pottery, New Salem, North Carolina, 1790–1832. Lead-glazed earthenware. D. 13⅞″. (Private collection.)

Figure 22 Detail of the marly of the dish illustrated in fig. 21.

the marly of a fragmentary dish found in Randleman, North Carolina, where the Dennis sites are located (figs. 21, 22).[31] One of the fragments with this petal device is from the cavetto of a dish removed from the potter's wheel with a twisted wire or cord. The marks on the back match those on the underside of the 1812 dish (fig. 23).

The third group of dish fragments, with bottoms ranging from ⅛″ to ³/₁₆″ in thickness (fig. 24), displays masterful turning. To produce these wares, the potter used buff clay that was finer in quality than the more common reddish variety used at the Dennis site. Surprisingly, the slip

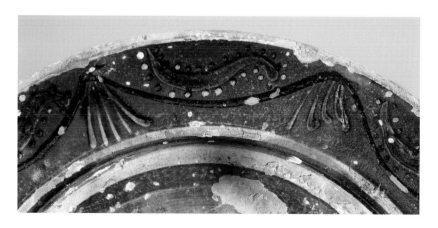

Figure 23 Detail of the underside of the dish illustrated in fig. 19 with a fragment from the William Dennis pottery site, New Salem, North Carolina, 1790–1832.

decoration on some of the Dennis pottery is not well executed. The stiffness and rigidity of his trailing suggests that his techniques and work habits were not fully developed in that arena. Archaeological evidence indicates that pottery was made with various shades of green, brown, yellow, red, and white slip applied in annular and undulating lines, either directly on the clay body or on a brown engobe (fig. 25). This potter also used motifs similar to the winged device favored by the decorator of the fragments illustrated in figure 14. Sherds recovered at the Dennis site indicate that the

Figure 24 Dish fragments recovered at the William Dennis pottery site, New Salem, North Carolina, 1790–1832. Bisque-fired and lead-glazed earthenware. (Private collection.) The extrapolated diameter of the middle dish fragment on the left is 11¾"; the extrapolated diameter of the dish fragment at the lower left is 10½".

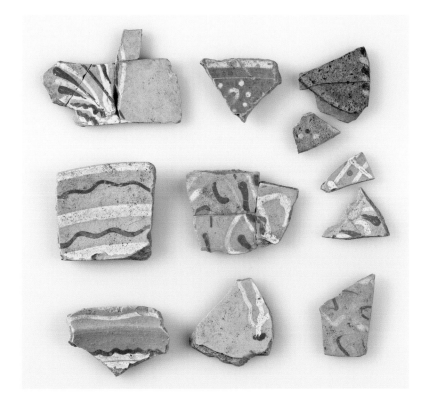

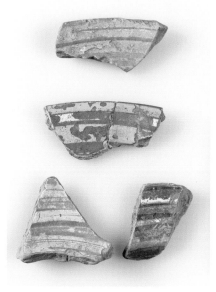

Figure 25 Dish fragments recovered at the William Dennis pottery site, New Salem, North Carolina, 1790–1832. Bisque-fired earthenware. (Private collection.)

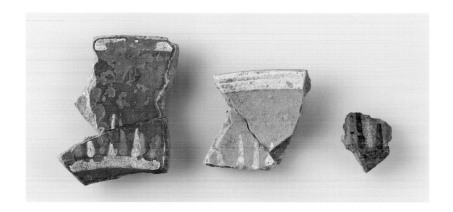

Figure 26 Dish fragments recovered at the William Dennis pottery site, New Salem, North Carolina, 1790–1832. Bisque-fired and lead-glazed earthenware. (Private collection.) The repetitive trailed slip device creates a flame or sunburst pattern.

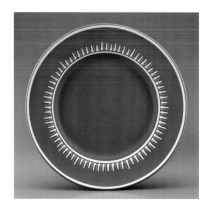
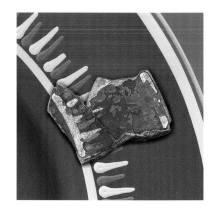

Figure 27 Reproduction dish, based on fragments recovered at the William Dennis pottery site. Bisque-fired earthenware. D. 12⅛". (Private collection.)

Figure 28 Detail of the dish illustrated in fig. 27, with a marly fragment recovered at the William Dennis pottery site, New Salem, North Carolina, 1790–1832. The Dennis potters made engobes ranging from brown to purple-black by grinding iron/manganese nodules with scale produced during the forging of iron.

potter often arranged his motifs to produce flame or sunburst patterns on the marlys of dishes. The patterns were executed in alternating red and white slip on a light brown engobe, alternating white and brown slip on a plain background, or white slip on a plain background (figs. 26–28).

Despite the differences among these groups of fragments, all the slip decoration associated with the William Dennis site was thinner in viscosity than that used by contemporary Moravians and other North Carolina potters of Germanic descent. The Dennis pottery craftsmen also shared a diverse stylistic vocabulary that included a variety of floral and geometric designs (fig. 29).

Potters and Pottery: The Thomas Dennis Site
Many of the artifacts recovered at the Thomas Dennis site are similar to those found at his father's pottery. Both men used nearly identical finger-grooved slabs of fired clay as setting tiles. These tiles vary in thickness from ¹/₂" to 1", and some are fused together with glaze (fig. 30). The slips, glazes, extrapolated forms, and trailed decoration of fragments from Thomas's site also display parallels with those shown above. The products of Thomas Dennis's pottery were well turned and decorated, supporting the theory that he trained with William and established his own business about 1812.

Although the slip decoration is dissimilar, a dish fragment from Thomas's site is closely related in form and profile to an example from William's pottery (fig. 31). Similarly, a slip-decorated dish fragment from Thomas's site has a dark-brown trailed design on the rim, a detail executed in green slip

Figure 29 Dish, attributed to the
William Dennis pottery, New Salem,
North Carolina, 1790–1832. Lead-glazed
earthenware. D. 13¼". (Private collection.)
Bearing the initials "AH," this dish
reputedly belonged to Quaker Abraham
Hammer.

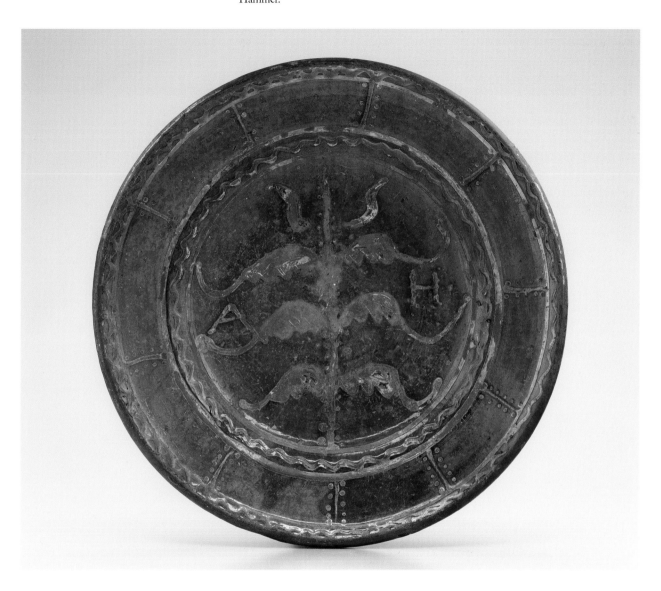

Figure 30 Kiln tiles recovered at the
Thomas Dennis pottery site, New Salem,
North Carolina, 1812–1821. High-fired clay.
(Private collection.) The tiles on the right
are fused together with glaze.

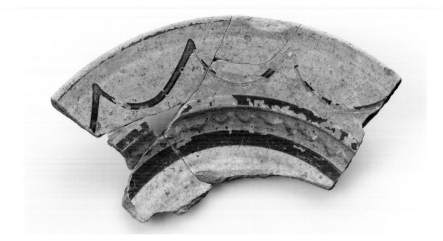

Figure 31 Dish fragments recovered at the William Dennis pottery site, New Salem, North Carolina, 1790–1832 (left) and the Thomas Dennis pottery site (right). Lead-glazed earthenware. (Private collection.) The form and profile of these pieces are very similar.

Figure 32 Dish fragment recovered at the Thomas Dennis pottery site, New Salem, North Carolina, 1812–1821. Lead-glazed earthenware. (Private collection.) The extrapolated diameter is 11½".

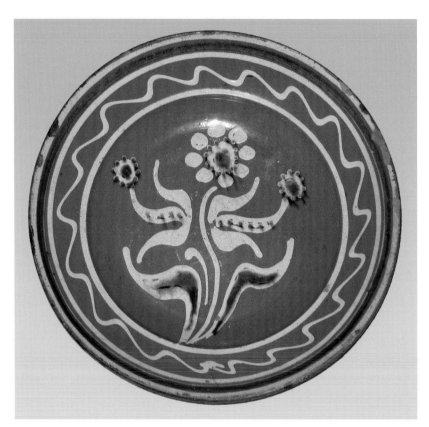

Figure 33 Dish, attributed to the Dennis potteries, New Salem, North Carolina, 1790–1832. Lead-glazed earthenware. D. 13¼". (Courtesy, Winterthur Museum.)

on the marly of the 1812 dish (figs. 20, 32). This draping slip design is common on fragments and intact examples (figs. 22, 34) from both sites. The light green engobe used to cover the interior of the dish fragment illustrated in figure 32 does not occur on any other fragments recovered at either site. Although that color could have been intentional, it is equally possible that the decorator inadvertently mixed green slip with white slip.

Distinctive Techniques and Materials
The majority of handle fragments found at both Dennis sites had been pulled to the appropriate size, then attached by pressing them into place at

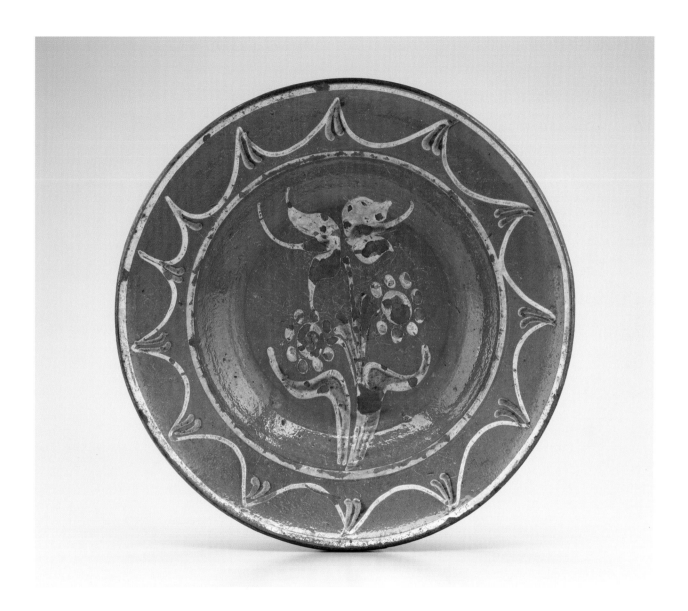

Figure 34 Dish, attributed to the Dennis potteries, New Salem, North Carolina, 1790–1832. Lead-glazed earthenware. D. 13½". (Courtesy, North Carolina Pottery Center.)

the upper and lower terminal. Often a finger indention was used at the lower terminal to help secure the handle and as a decorative element, and on one fragment the indentation is highlighted with slip dots (fig. 35). Ninety-five percent of the handle fragments from both potteries have molded upper surfaces (figs. 36, 37). They look extruded but actually were pulled by the conventional hand method, laid on a board (fig. 38), and fluted with a small round stick. Drawing the stick down the length of the handle produced carefully regulated parallel grooves that gave the illusion that the handles were pushed through a die.[32]

Figure 35 Handle fragment recovered at the William Dennis pottery site, New Salem, North Carolina, 1790–1832. Lead-glazed earthenware. (Private collection.) This fragment is the lower terminal.

Figure 36 Handle fragments recovered at the William Dennis pottery site, New Salem, North Carolina, 1790–1832. Lead-glazed earthenware. (Private collection.) On the fragments at the upper and lower right, the potter applied the green on a white engobe, which produced a light apple-green color.

Figure 37 Handle fragments recovered at the William Dennis pottery site, New Salem, North Carolina, 1790–1832. Bisque-fired and lead-glazed earthenware. (Private collection.)

Figure 38 Front and back views of a handle fragment recovered at the William Dennis pottery site, New Salem, North Carolina, 1790–1832. Lead-glazed earthenware. (Private collection.)

The clay used for most of the earthenware made at these potteries probably came from the Dennis family's original 300-acre land grant and the property owned by William's aunt Rachel (wife of Edward Dennis) and subsequently by William's son Thomas. When fired, this clay ranged in color from light orange to terracotta. Another type of clay, used less frequently at both sites, was buff-colored when bisque-fired and yellow when glazed. This same clay would have been used in the formulation of slip that fired to a yellow color. Firing temperature, the amount of carbon in the kiln atmosphere, the placement in saggars, and the length of firing time all affected the color of clay and glazes.

The Dennis clay was of such high quality that James Madison Hays used material from the same sources to make salt-glazed stoneware. Between 1871 and 1874 he purchased lot number 4, which included William Dennis's house, and 140 acres of the Dennis family's land grant.[33] The clay beds on that large tract sustained Hays's pottery for at least thirty-five years. His buff clay contained less iron than the red variety and came from a source one mile west of Thomas and William's sites. Hays mixed the buff clay material with earthenware clay to improve the plasticity and increase the firing range of his stoneware.[34] For his press-molded pipes, Hays used white clay from a source half a mile south of the William Dennis pottery. William's buff clay and his and Thomas's white clay probably came from the same sources. The Dennises also used white clay for their pipes as well as for slip.[35]

A disturbed area near the William Dennis pottery yielded an abundance of iron-manganese nodules typically ranging from $^1/_4$" to 1" in diameter (fig. 39). Originally thought to have been a clay pit, this area apparently was mined for those metallic oxides, which were integral components of certain slips and glazes used by the Dennises. Testing revealed that the nodules are very soft and easily ground to the proper consistency. By experimenting with different proportional quantities of these nodules, the authors made a

Figure 39 Iron-manganese nodules recovered at the William Dennis pottery site, New Salem, North Carolina, 1790–1832. (Private collection.)

brown engobe that matched the color and texture of that used by potters at the William Dennis site (see fig. 27). To produce the dark-brown to black engobe found on dish fragments from that site, the potters likely varied the amount of iron scale, which is a source of black iron oxide. Formed around the blacksmith's anvil as a result of forging iron, this easily obtained oxide could be ground together with the iron-manganese nodules. The authors followed that procedure to produce a dark brown/black engobe matching that of the Dennises (see fig. 13).[36]

The slips used by both Dennis potteries are similar in color to the white, yellow, red, brown, and green found on earthenware from other late-eighteenth- and early-nineteenth-century potteries in the piedmont region of North Carolina. The only exception is the light green engobe on a dish

fragment from the Thomas Dennis site, but, as previously mentioned, that color might not have been intentional. As was the case at every pottery, accidents, experimentation, and alteration occasionally led to the production of idiosyncratic objects. On the dish illustrated in figure 40, the decorator changed his design by covering a concentric, wavy line of white slip with a broad band of green.

Trailed fragments from forty-three separate dishes were studied from the William Dennis site. Of these, 56 percent have a brown to dark brown/black slip engobe, 9 percent have a white engobe, and 2 percent have a red engobe. The fact that 67 percent are covered in some form of slip coating

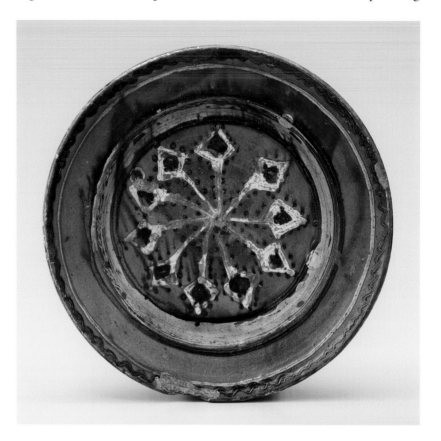

Figure 40 Dish, attributed to the Dennis potteries, New Salem, North Carolina, 1790–1832. Lead-glazed earthenware. D. 10½". (Courtesy, Old Salem Museums & Gardens.)

is significant, as the application of an engobe over leather-hard clay required an extra, labor-intensive step. The potter had to wait for the engobe to dry before applying his decoration, as opposed to simply trailing his designs directly onto the plain clay ground. White engobe occurs on the interiors and exteriors of several teacup fragments, some having a wall thickness of only ⅛". Turning such thin wares and coating their delicate bodies with engobe required considerable skill.

Engobes were used on the front of dishes and on the interior and/or exterior of hollow ware. The desired glaze color often dictated the placement and color of the engobe. If he wanted to produce a bright apple green, the potter would apply a copper-bearing lead glaze over a white engobe (fig. 41). A similar green glaze applied over a red clay body without the white engobe would fire dark green to almost black.

Figure 41 Hollow-ware fragment recovered at the William Dennis pottery site, New Salem, North Carolina, 1790–1832. Lead-glazed earthenware. (Private collection.) The light apple-green color of this fragment was achieved by applying a green lead glaze over a white engobe.

A small percentage of earthenware fragments from the William Dennis pottery have slip marbling, which was applied in combinations of green, brown, and white; green and brown; and yellow and red. The most intriguing artifact from that site is a bisque-fired fragment from a coggle-edged dish with a marbled interior (fig. 42) recovered near the kiln feature. The

Figure 42 Dish fragment recovered at the William Dennis pottery site, New Salem, North Carolina, 1790–1832. Bisque-fired earthenware. (Private collection.) Marbled in a flattened buff and red slip, the dish from which this fragment came appears to have been drape-molded; it would have been similar in appearance to the example illustrated in fig. 43.

very flat and smooth buff and red marbling indicates that the potter pressed the dish onto a drape mold after applying the slip. The dish would have been very similar in form, color, and marbleized pattern to a coggle-edged dish found at Franklin Court in Philadelphia (fig. 43). It is reasonable to assume that experimentation with drape molding occurred at the Dennis pottery site. This technique could have been passed through family members who were interrelated with potters living in Chester County, Pennsylvania, some having apprenticed in Philadelphia (see figs. 4, 5).

Figure 43 Dish, Philadelphia, Pennsylvania, ca. 1780. Lead-glazed earthenware. D. 7½". (Courtesy, Independence Hall, National Park Service.)

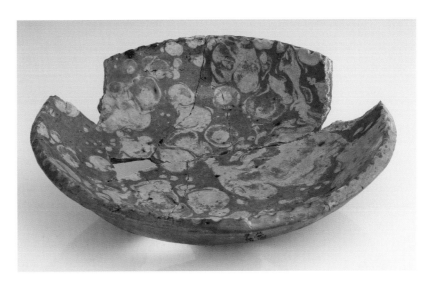

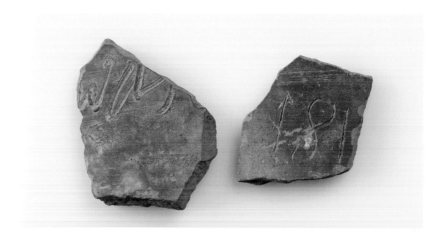

Figure 45 Kiln tile recovered at the William Dennis pottery site, New Salem, North Carolina, 1790–1832. High-fired clay. (Private collection.) This finger-grooved tile is 11½" x 4" and varies in thickness from ½" to 1".

Several fragments at the William Dennis site exhibit script writing and designs that were incised in the clay when it was leather-hard. Script writing appears on the sides of hollow ware and saggar fragments, and indecipherable designs or writing appear on the bases of fragments whose forms cannot be extrapolated. "WM" is incised on the exterior wall of one saggar fragment in script resembling that of William Dennis (see fig. 3), while the partial date "181[]" appears on another (fig. 44). Some of the setting tiles recovered at his site were whittled with a knife while in the leather-hard state, and one is randomly punched with holes from a sharp tool. A large fragment of a finger-grooved setting tile has notched edges likely produced with a gouge and triangular indentations running down the center (fig. 45). William and Delilah Dennis had seven boys and three girls, most of whom probably worked in his pottery at one time or another. Those children may have been responsible for some of the more naive marks on the fragments from his site.

The ceramic assemblages from the William and Thomas Dennis sites reveal that New Salem's Quaker farmer-potters were not just making nondescript earthenware to fulfill everyday utilitarian needs but were experimenting in the production of a variety of decorated wares, including those with rib-generated tooling and geometric and floral slip motifs. The Dennises produced a wide range of designs within their own tradition, experimented with new procedures and techniques, and imitated pottery from other areas. Many of their techniques were labor-intensive and technically demanding, requiring a thorough understanding of the art and craft of pottery making and the ability to apply that knowledge in a distinctive and artistic way.

The only written sources identifying members of the Dennis family as potters are George Newby's indenture and the biography of William's son Thomas. Without evidence from their pottery sites, these talented craftsmen would merely be names on a long list of earthenware potters working in North Carolina from the mid-eighteenth to the mid-nineteenth century. As the essays in this volume of *Ceramics in America* attest, considerable progress has been made in identifying the work of those potters. Nevertheless, most of the earthenware surviving from the piedmont region remains anonymous, only a few production sites have been located, and even fewer

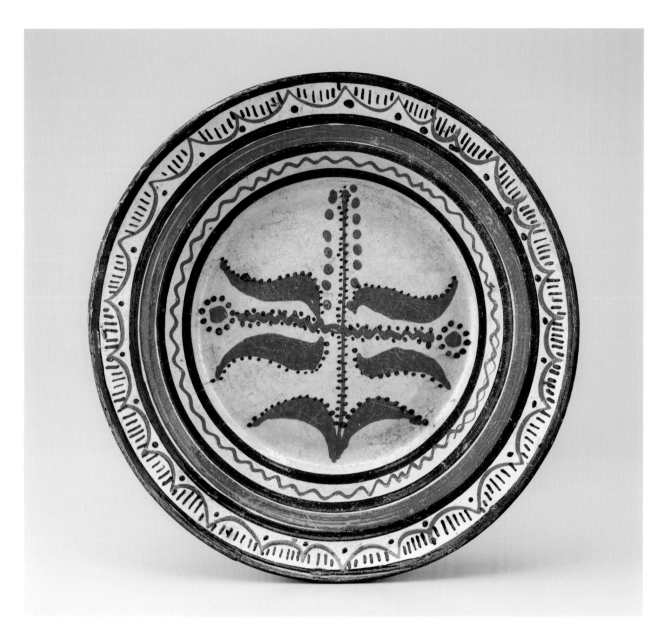

sites have been excavated. As a consequence, attributions are subject to change as new information emerges about these potters and their interaction with one another and their communities.

The Quaker pottery tradition in the central piedmont region extended beyond the confines of New Salem, where at least four potters and three apprentices worked circa 1790–1837. In Randolph County and neighboring Guilford County, members of the Dicks, Mendenhall, Hoggatt/Hockett, Hiatt, Beard, and other families produced earthenware and/or salt-glazed stoneware (fig. 46). Collectively, these families represent a Quaker pottery tradition that lasted from the third quarter of the eighteenth century through the first quarter of the twentieth century. The William and Thomas Dennis sites represent a starting point in the study of that tradition. Regrettably, many of these ancillary sites are in metropolitan areas and their suburbs and are in danger of being lost forever. The legacy of these early Quaker

potters, which represents a integral facet of North Carolina's ceramic history, can be preserved only by locating, protecting, and researching their sites.

ACKNOWLEDGMENTS For assistance with this article, the authors thank Gavin Ashworth, Luke Beckerdite, Johanna M. Brown, and Wesley Stewart. Special thanks are due to Linda F. Carnes-McNaughton, for her many hours of volunteer work at the William Dennis site; Thomas and Mary Dennis, for sharing their family history and personal insights; Gwen Gosney Erickson, for her assistance at the Friends Historical Collection, Guilford College, North Carolina; and W. C. Hinshaw, for sharing his knowledge of early Quakers in North Carolina.

1. Deed Book S, p. 387, Chester County Recorder of Deeds, West Chester, Pa. William Wade Hinshaw, *Encyclopedia of American Quaker Genealogy*, 6 vols. (Baltimore, Md.: Genealogical Publishing Co., 1978), 1:536.

2. Hinshaw, *Encyclopedia of American Quaker Genealogy*, 1:536.

3. Will of Thomas Dennis II, written June 24, 1774, and proven in February 1775, Guilford County Wills, North Carolina State Archives (hereafter cited NCSA), Raleigh.

4. *The State Records of North Carolina*, vols. 11–26, edited by Walter Clark (Goldsboro, N.C.: Nash Brothers, 1907), 22:168. Attached to the oath of allegiance was the warning "all persons being quakers, Moravians, Menomists & dunkards & under the circomstances above mentioned in Law, shall make the following affirmation or depart the State."

5. Grant #319, Secretary of State's Office Records, 1663–1959, bk. 59, p. 361, NCSA.

6. Deed Book 3, State Land Grant no. 319, p. 52, Randolph County Register of Deeds (hereafter cited RCRD), Asheboro, N.C.

7. Will of Thomas Dennis, III, written Nov. 11, 1795, and proven August 1803, NCSA.

8. Randolph County Apprentice Bonds, NCSA.

9. *The Old Discipline: Nineteenth-Century Friends' Disciplines in America* (Glenside, Pa.: Quaker Heritage Press, 1999), p. 92.

10. Apprenticeship indenture for George Newby, 1813, Randolph County Apprentice Bonds, 1806–1813, CR.081.101.2, NCSA.

11. *History of Wayne County, Indiana,* 2 vols. (Chicago: Inter-state Publishing, 1884), 2:447.

12. Deed Book 12, p. 29, RCRD.

13. *History of Wayne County*, 2:447.

14. Will of Thomas Dennis II, Deed Book D, p. 493, Old Gloucester County Court House, Woodbury, N.J.

15. Mary Wright Dennis, *Thomas Dennis and Some of His Descendants: Circa 1650–1979* (Dublin, Ind.: Prinit Press, 1979), pp. 1–2.

16. *The Old Discipline*, p. 99.

17. William Mendenhall and Edward Mendenhall, *History, Correspondence, and Pedigrees of the Mendenhalls of England and the United States* (Cincinnati, Ohio: Moore, Wilstach, and Baldwin, 1865), pp. 34–35. Jesse Kersey had finished his apprenticeship five years earlier, under Quaker potter John Thompson of Philadelphia, when he took Richard as an apprentice in 1794.

18. According to Arthur Edwin James, *The Potters and Potteries of Chester County, Pennsylvania* (Exton, Pa.: Schiffer Publishing, 1978), pp. 141, 202, Nathan Pusey (1748–1832) was a potter in East Caln Township from 1796 to 1800 and in London Grove Township from 1801 to 1812.

19. Apprenticeship indenture for Isaac Beeson, 1806, Randolph County Apprentice Bonds 1806–1813, NCSA. The terms of the indenture stated that Beeson was to be taught the trade of potter until 1809, when he turned twenty-one.

23. A timeline of Quaker potters in the New Salem area, based on historical and biographical accounts, can be posited as follows:

1806–1809	Peter Dicks takes Isaac Beeson as an apprentice in the pottery trade.
1811–1821	Thomas Dennis, son of William, active in the pottery trade.
1813–1822	William Dennis takes George Newby as an apprentice.
1821	Henry Watkins takes Joseph Watkins as an apprentice.

1821	Thomas Dennis sells property to Edward Bowman.
1822	Thomas Dennis moves to Indiana.
1830	George Newby is living in Indiana.
1832	William Dennis sells property with pottery shop to Peter Dicks and moves to Indiana.
1837	Henry Watkins moves to southern Guilford County.
1837	Peter Dicks advertises his land for sale in New Salem after moving to southwestern Randolph County.
1843–1844	Peter Dicks's son James purchases "1 pair pipes moles [sic]" and "1 potters lathe and glaseing mill" at his father's estate sale.

24. Tom Hargrove, "Geophysical Surveys in North Carolina Archaeology," *North Carolina Archaeological Society Newsletter* 9, no. 2 (Summer 1999): 1–2. Hargrove conducted a fluxgate gradiometer (magnetometer) survey and a resistivity survey at both sites.

25. Linda F. Carnes-McNaughton and Hal E. Pugh, "Arsenic and Old Lead: Recent Excavations at the William Dennis Pottery Site 31RD981," paper presented at the annual conference of the Society for Historical Archaeology, January 4–9, 2000, Quebec. A second kiln, of similar square design, construction, and dimensions, has been located approximately three miles to the north of the William Dennis site and is also of Quaker origin, being built and used by a member of the Hoggatt/Hockett family of potters.

26. Carnes-McNaughton and Pugh, "Arsenic and Old Lead." A perforated, 1774 Spanish one-half real coin found in the northwest wall of the kiln during excavation supports that assertion, while setting a date for the structure above where it was found as no earlier than 1774.

27. Hal E. Pugh, "The Quaker Ceramic Tradition in the North Carolina Piedmont: Documentation and Preliminary Survey of the Dennis Family Pottery," *The Southern Friend, Journal of the North Carolina Friends Historical Society* 10, no. 2 (Autumn 1988): 1–26.

28. Lura Woodside Watkins, *Early New England Potters and Their Wares* (1950; repr., Hamden, Conn.: Archon Books, 1968), pp. 55, 237; Steven R. Pendery, "Changing Redware Production in Southern New Hampshire," in *Domestic Pottery of the Northeastern United States, 1625–1850,* edited by Sarah Peabody Turnbaugh (Orlando, Fla.: Academic Press, 1985), pp. 109, 112.

29. Ackworth, a Quaker school for boys and girls, was founded in Yorkshire, England, in 1779. During the late eighteenth and early nineteenth centuries, girls at Ackworth stitched samplers to develop needlework skills. The Philadelphia Yearly Meeting founded the Westtown School in Chester County, Pennsylvania, in 1799 and based its curriculum on that of Ackworth. Samplers made at the two schools are very similar.

30. The history is recorded on the accession card for dish 89-17, Museum of Early Southern Decorative Arts, Winston-Salem, N.C.

31. The authors thank William Ivey for information on the recovery of the dish illustrated in figs. 21 and 22.

32. On a large handle fragment from the William Dennis site, the pressing of grooves in the front of the handle created indentions from the edges of a board on its reverse side. The potter left these indentions in the back of the handle and utilized it in the design.

33. James Madison Hays purchased 70 acres of the former 140-acre Dennis/Dicks tract from Noah Jarrell and wife in 1871. Noah Jarrell was listed as a potter in the 1850 Federal Census for the southern division of Guilford County, North Carolina. It has not been determined whether Jarrell continued the trade after moving to New Salem and purchasing the aforementioned property in 1852.

34. Robert S. Hayes, grandnephew of J. M. Hays; Virginia Wall Hayes, married to Charles Hayes, grandnephew of J. M Hays; and Roy Hayes, grandson of J. M. Hays, interviews by Hal E. Pugh, July 1966.

35. Ibid. The white pipe clay pit got its name, Deer Lick, from deer repeatedly pawing and licking the clay in search of minerals or salts. Unfortunately, this clay pit was destroyed when the property was graded for a housing development.

36. The color of iron-saturated engobe also depends on the firing temperature; the higher the temperature, the darker the engobe. Also, with a high content of iron in the slip, the lead glaze will interact and partially melt and darken the slip. In some instances where the engobe is thin, the lead glaze will melt the slip enough to cause transparency. When slipware dishes are stood on edge in the kiln, the lead glaze can interact with the iron slip and cause it to run. This is also very apparent when copper is used as a colorant. Occasionally, it will wash out of the white slip base altogether.

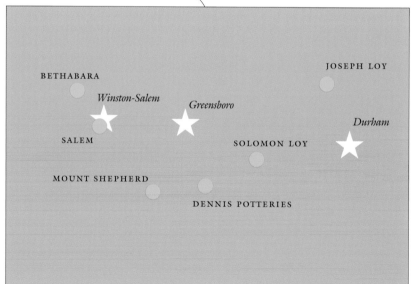

Figure 1 Map showing in yellow the locations of the pottery sites in the North Carolina piedmont that were studied as part of the project. Analysis of the data for the Dennis pottery is forthcoming.

J. Victor Owen and John D. Greenough

Mineralogical and Geochemical Characterization of Eighteenth-Century Moravian Pottery from North Carolina

▼ THE MORAVIANS WERE members of a Protestant sect centered at Herrnhut, east of Dresden, Germany. Persecuted in their home country, during the eighteenth century they established several towns in North American colonies, from the southern states to the northern coast of Labrador. An initial outpost in Georgia was unsuccessful, so in 1741 they founded Bethlehem, the first Moravian town in Pennsylvania. The Moravian theology dictated that each member of the faith contribute to the material well-being as well as spiritual growth of their communities.[1] As such, when planning future town sites, the Moravians considered which trades were likely to be the most successful. The abundance of clay in the middle colonies (later in the century high-quality kaolin deposits were also discovered in Georgia and the Carolinas) ensured that making pottery would become a Moravian tradition in America.[2]

In 1753 a group of Moravians migrated from Bethlehem to the piedmont region of central North Carolina, where they owned a 100,000-acre tract of land purchased from Lord Granville. By the following year, the residents of this nascent community, named Bethabara, petitioned church leaders to establish a pottery there. Master potter Gottfried Aust, a thirty-three-year-old Silesian, arrived in 1755 and immediately sought local sources of clay and flint for use in his potworks. By the spring of 1756 he had conducted firing experiments on these materials, and in August he built a larger kiln in which he fired earthenware.[3]

Aust stayed in Bethabara until 1771, whereupon he moved to the Moravians' newly built town of Salem (fig. 1) and served as master of the pottery there until his death, in 1788. During his tenure, he trained several apprentices, among them John Heinrich Beroth (who later established a pottery in Salisbury in Rowan County), Rudolph Christ (who established his own pottery at Bethabara in 1786 and became master at Salem after Aust died), Gottlob Krause (who took over the Bethabara pottery when Christ moved back to Salem), and Jacob Meyer (who left Salem and established a pottery at Mount Shepherd in Randolph County, North Carolina).[4]

In terms of slipware production, the greatest competition faced by the Moravians came from potters working in southern Alamance County east of Salem, and there is evidence to suggest that members of the Loy family were responsible for much of the work that has survived. The progenitor of the line was Martin Loy, descended from Huguenots who had left France after the revocation of the Edict of Nantes in 1685 and settled in the Palatinate. Martin emigrated from Mussbach, Germany, in 1741 and lived

in Berks County, Pennsylvania, before relocating to Alamance between 1755 and 1769. The wares of two of his great-grandsons Joseph and Solomon, who operated potworks in separate locations in the North Carolina piedmont, were analyzed for the study presented here.[5]

This paper reviews compositional data used to characterize selected samples excavated from six North Carolina potworks (see fig. 1): Mount Shepherd, while operated by Jacob Meyer (seven sherds, including one fired clay sample); Solomon and Joseph Loy (four sherds); Bethabara (eight sherds); Salem (six sherds); Dennis (eight sherds; analyses not yet available); and Heinrich Schaffner (six sherds, including three fired clay samples). A comparison is then made of the compositions of red earthenware Moravian sherds selected from this sample suite and those of pottery sherds from the Moravian settlement in Bethlehem.[6] Exploratory statistical techniques have been utilized to determine the extent to which samples from the various production sites differ from one another. Brief sample descriptions and the approximate dates of operation of these potworks are provided in Appendix 1.

ANALYTICAL METHODS

Using a diamond trim saw, a slice was taken from each sherd presented for analysis and mounted with epoxy on glass. The slices were then polished to a high finish with a fabric lap in preparation for analysis by electron microprobe. The instrument used is a JEOL Superprobe 8200 equipped with five wavelength-dispersive (WD) spectrometers and an Oxford Link eXL energy dispersive (ED) system. The WD system was used in the present study. The beam current was 15 nA; the accelerating voltage was 15 kV. Count time was 420 s. Phases were analyzed using a tightly focused (\sim1 μm) beam. The standards used for calibration purposes included jadeite (Al, Si, Na), hornblende (Ca, Ti, Fe, Mg), sanidine (K), pyrolusite (Mn), apatite (P), and galena (Pb, S). Detection limits are in the order of \sim0.1 wt.%. Data were reduced using Link's ZAF matrix correction program.

Another piece of each remaining sherd was removed with the trim saw. The saw marks were ground off using emery paper, and each piece was washed with distilled water before being powdered in a ceramic shatter box for bulk-sample analysis. Depending on sample size, major elements were determined by X-ray fluorescence (XRF; larger samples [>5 g powder]) or ICP-optical emission spectrometry (ICP-OES; smaller samples [\leq5 g powder]). The former analyses were undertaken at the Regional Geochemical Center at Saint Mary's University, Halifax, Nova Scotia, using a Phillips PW2400 x-ray fluorometer. This instrument is equipped with a PW2510 102 position sample changer. Calibration curves were initially established using forty rock standards and are checked against these standards every few years. During routine runs, a single rock standard suitable for the unknown samples being analyzed is reviewed to confirm that the calibration equations still apply; small corrections are undertaken where necessary. The sample powders were prepared as fused disks made by adding 1 g of crushed sample to 5 g lithium tetraborate, 0.3 g LiF and 0.035 LiBr. This mixture was

melted at about 1050°C in crucibles (95% platinum, 5% gold) using a Claisse Fluxy fusion device. The ICP-OES analyses were undertaken at Acme Labs in Vancouver following lithium tetraborate fusion and dilute nitric acid digestion. Trace elements were determined by ICP-MS, also at Acme Labs. Sample powders were dissolved by acid digestion in a closed beaker.

RESULTS

Mineralogy

Collectively, the North Carolina sample suite comprises a variety of wares. Red earthenware is predominant, but pottery with white, pale brown, gray, pink, and yellow bodies is also represented. Some sherds have thin (1 mm or less scale) yellow and pink bands, and in that case were classified according to the predominant color. In terms of Munsell colors, most of the so-called red earthenware falls within the light brown to reddish yellow color range, although it should be noted that the differences between light brown, pink, and even pale yellow can be very subtle.[7] As a result, the identification of what most archaeologists and ceramists would recognize as redware is highly subjective. As already noted, raw clay from Mount Shepherd (one sample) and the Schaffner pottery (three samples) was kiln-fired before being analyzed. In contrast to the North Carolina samples, all of the Pennsylvania samples were red earthenware. Mineral compositions were determined by electron microprobe only in the North Carolina samples, but, as will be seen, the bulk compositional data help identify accessory minerals in the Pennsylvania and North Carolina sherds, since many of these common albeit volumetrically insignificant minerals are essentially the sole or principal reservoirs of some trace elements (for example, Zr and Hf in zircon).

The North Carolina potsherds contain fine silt to very fine sand-sized grains (i.e., ~3–60 μm) of quartz and typically, but not invariably, alkali feldspar, and various combinations of epidote, titanite, plagioclase, calcic amphibole, chlorite, ilmenite, and muscovite. Based on a limited number (~230) of microprobe spot analyses that focused on minerals with high molecular weights (i.e., those generating bright backscattered electron images) and visual estimates of their concentrations, the abundance of these diverse phases differs in the samples from the various pottery sites.

The sherds from the Mount Shepherd and Loy sites appear to be the most mineralogically diverse. Epidote is the most ubiquitous of the minor minerals in these samples. Expressed in terms of its ferric iron/aluminum ratios ($Fe^{3+}/[Fe^{3+} + Al]$, traditionally referred to as the pistacite content), the epidote in sherds from these sites have overlapping compositions.[8] For the Mount Shepherd samples, the average pistacite content was 22.6 (average of fourteen analyses), whereas for the Joseph and Solomon Loy samples it was 21.7 (ten) and 24.1 (seventeen), respectively. As a result, the composition of this phase cannot be used to distinguish products of these factories. However, its abundance in these sherds could potentially help distinguish Mount Shepherd and Loy pottery from that produced at the other pottery sites considered here. It also accounts, of course, for the rel-

TABLE 1 Bulk chemical composition of
Moravian pottery from various production sites
in the piedmont of North Carolina

| | MOUNT SHEPHERD | | | | | | | SALEM | | | |
	MS-1	MS-2	MS-3	MS-4	MS-5	MS-6	MS-8	SALEM-1	SALEM-2	SALEM-3	SALEM-4
SiO2 (wt%)	60.5	76.07	61.19	72.14	60.25	72.06	56.71	56.97	57.59	62	58.33
TiO2	1.2	1.49	1.73	1.4	0.95	0.9	1.5	1.53	1.7	1.77	1.65
Al2O3	22.62	13.98	26.18	13.15	21.64	15.55	22.93	27.74	29.7	26.04	28.42
Fe2O3	5.38	5.82	4.24	5.71	9.63	5.24	5.83	7.42	5.94	3.75	6.36
MgO	0.71	0.25	0.61	0.19	0.5	1.13	0.64	0.8	0.67	0.57	0.6
MnO	0.05	0.08	0.03	0.07	0.07	0.06	0.04	0.04	0.04	0.02	0.03
Na2O	0.68	0.05	0.29	0.06	0.07	0.6	0.35	0.35	0.2	0.39	0.28
CaO	0.71	0.16	0.41	0.12	0.08	0.83	0.47	0.27	0.3	0.44	0.26
K2O	2.75	0.66	1.44	0.65	2.01	1.28	1.78	1.93	1.71	2.02	1.87
P2O5	0.08	0.03	0.07	0.03	0.09	0.06	0.17	0.08	0.1	0.13	0.09
Cr2O3	0.011	0.007	0.013	0.006	0.008	0.01	0.017	0.015	0.016	0.018	0.016
TOT/C	0.36	0.04	0.16	0.07	0.16	0.17	0.87	0.1	0.05	0.1	0.05
LOI	5	1.3	3.6	6.4	4.5	2.1	9.3	2.6	1.8	2.6	1.8
Total	100.05	99.94	99.96	100.00	99.96	99.99	100.61	99.85	99.82	99.85	99.76
Ba (ppm)	985	227	415	246	472	387	622	557	572	684	570
Rb	93.4	37.3	84.2	37.1	66.3	61.9	117.4	118	108.4	126.6	115.7
Sr	327	16.5	64.3	15.1	16	62.5	71.3	46.9	50.5	67.1	49.6
Y	28.2	14.8	35.3	16.6	20.2	31.4	35.8	54.4	66.7	62.4	70.8
Zr	472.2	189.3	335.2	183.3	207.3	200.8	345.4	405.6	314.3	418.2	376.1
Nb	18.6	11.7	23.8	11.5	14.1	10.3	26.8	29.9	30.1	32.3	30.2
Ga	26.7	16.3	28.4	15.6	23.8	17.9	27.9	34.2	36.5	32.3	35.1
V	85	146	142	171	99	115	147	183	119	112	121
Cu	21.8	10.1	25.6	54.4	53.3	6.7	23	25.4	9.7	22.7	7
Pb	17.1	156.2	56.7	184.9	218.8	47.3	112.2	93.2	115.9	41.6	110.8
Zn	17	6	30	33	28	6	92	8	9	20	3
Be	3	1	2	1	2	1	4	4	4	4	4
Co	15.2	13.7	10.4	11.5	5.9	14.4	12.8	14.1	14.5	10.1	13
Ni	27	24	37	26	33	34	41	51	60	52	56
Sc	16	29	29	27	34	29	24	28	33	28	30
Sn	2	2	4	4	3	2	4	7	6	6	6
W	0.6	1.3	2.1	1.3	1.3	1.2	2.8	3	3.3	4	3.2
Cs	3.2	3.6	6.4	3.8	3	4.7	9.4	12.1	12.2	12.8	11.8
Hf	13.1	5.3	9.5	5.4	6.5	5.8	9.6	11.9	9.5	12.2	11.2
La	69.2	12.9	34.7	14.2	17.6	23.9	39.2	48	67.8	63.1	66.9
Ce	143.3	36.4	64.5	37.9	55.9	50.7	74.7	92.5	127	110.3	116.5
Pr	16.7	3.25	8.46	3.63	4.79	6.19	10.19	11.95	16.94	15.3	16.67
Nd	62.7	11.3	32.1	14.1	18.9	24.9	38.3	46.1	64.7	57.4	63.9
Sm	9.75	2.61	6.25	2.78	3.99	5.17	7.36	9.17	12.89	11.23	12.57
Eu	2.28	0.61	1.41	0.67	0.81	1.23	1.58	1.77	2.76	2.38	2.62
Gd	6.77	2.39	5.86	2.53	3.26	5.11	6.64	8.49	11.64	10.7	12.16
Tb	0.97	0.43	1.06	0.47	0.58	0.86	1.16	1.56	2	1.86	2.08
Dy	4.96	2.47	5.96	2.82	3.41	5	6.5	8.9	11.1	10.26	11.63
Ho	0.93	0.55	1.21	0.6	0.75	1.07	1.29	1.83	2.21	2.09	2.32
Er	2.57	1.73	3.35	1.9	2.31	3.28	3.6	5.51	6.24	5.88	6.67
Tm	0.4	0.28	0.53	0.28	0.43	0.52	0.57	0.82	0.95	0.9	1
Yb	2.46	2.08	3.34	2.1	3.09	3.41	3.64	5.18	5.97	5.5	6.4
Lu	0.4	0.32	0.5	0.34	0.52	0.55	0.52	0.76	0.86	0.81	0.94
Ta	1.3	0.8	1.7	0.8	0.9	0.7	2	2.5	2.4	2.6	2.5
Th	20.3	5.5	11.5	4.8	14.1	6.7	14.7	20.2	18.4	18	18.9
U	8	1.7	4.1	1.6	2.7	1.9	6.2	7.8	7.3	7.5	7.2

| | SALEM-6 | SALEM-7 | SCHAFFNER | | | | | | BETHABARA | | |
			SP CLAY-1	SP CLAY-2	SP CLAY-3	SP-5	SP-6	SP-8	BP-1	BP-3	BP-4
	59.5	58.23	59.47	64.29	67.41	57.22	57.02	67.02	61.06	59.51	60.71
	1.65	1.53	1.76	1.4	1.27	1.43	1.54	1.11	1.58	1.5	1.56
	27.72	28.41	29.92	23.06	20.89	28.34	27.96	22.04	23.07	25.88	24.02
	5.88	6.33	3.59	6.83	5.49	7.2	5.73	3.86	6.7	6.31	6.29
	0.67	0.67	0.56	0.6	0.55	0.7	0.67	0.58	0.94	0.97	0.99
	0.03	0.03	0.02	0.06	0.05	0.02	0.03	0.02	0.03	0.06	0.03
	0.26	0.31	0.27	0.38	0.31	0.39	0.34	0.57	0.43	0.34	0.56
	0.29	0.24	0.72	0.34	0.39	0.25	0.43	0.27	0.56	0.5	0.42
	1.72	1.9	1.73	1.75	1.56	2.01	1.83	2.19	1.83	1.73	1.75
	0.1	0.08	0.09	0.06	0.12	0.07	0.3	0.06	0.18	0.2	0.13
	0.016	0.015	0.015	0.013	0.012	0.014	0.015	0.01	0.019	0.019	0.02
	0.06	0.06	0.02	<0.02	0.02	0.06	0.2	0.05	0.17	0.15	0.63
	1.9	2	1.6	1	1	2.1	3.9	2.1	3.4	2.7	3.3
	99.80	99.81	99.77	99.78	99.07	99.80	99.97	99.88	99.97	99.87	100.41
	541	564	694	514	503	526	596	526	621	586	562
	108.9	112.5	109.1	111.8	96.4	111.8	105.2	113	95.4	104.5	88.7
	48.5	43	61.9	44.8	49.7	46.9	80.1	48.5	73.3	62	66.1
	65.5	68.6	49.9	49.8	50.6	56	43.5	68.5	37.8	47.1	38.6
	335.4	345	256	500.3	384.6	401.2	370.5	437	431.3	328.7	402.5
	29.8	29.2	30.7	27	22.4	27.6	28.9	21.8	27	26.7	26.7
	34.2	34.4	35	29.1	26	34.5	33.7	27.8	28.2	31.2	29.4
	104	125	154	160	117	91	115	84	98	89	104
	4.9	6.4	4.1	5.3	13.6	7.2	23.5	8.1	12	6.9	5.9
	110.5	283.9	6.9	26.3	382.8	124.6	219.3	38.4	232	677	270.5
	7	5	3	3	5	15	70	14	20	7	9
	5	4	3	3	3	4	4	4	4	3	3
	14.1	11.8	10.2	21.2	10.9	10.5	11.5	7.7	15.1	16.3	14.9
	52	53	53	39	36	46	49	35	52	56	55
	30	30	30	23	20	25	25	18	23	27	24
	7	6	6	54	19	7	6	7	5	6	4
	3.1	2.8	3.7	3.2	2.6	2.9	3.6	2.4	2.6	3	2.5
	12.5	10.7	11.7	9.8	8.4	10.7	11.3	8.3	8.9	9.6	9.2
	10.3	10	7.3	14.5	10.7	11.7	10.7	12.2	12.4	9.4	11.4
	64.1	67.5	59.7	39	51.3	48.9	39.8	55.9	38.9	51.1	40.2
	114.5	111.6	104.3	131.6	102.9	98.4	83.4	109.6	76	104.7	85.6
	16.06	16.66	14.31	10.4	13.11	12.84	10.33	14.37	9.91	12.92	10.29
	60.9	62.4	54.2	40	50.8	52.1	42.2	57.4	38.5	48.8	40.4
	12.08	12.67	10.29	8.35	9.54	10.72	8.58	11.89	7.34	9.3	7.75
	2.57	2.67	2.26	1.52	1.68	1.94	1.72	2.24	1.56	2.1	1.71
	11.21	11.93	9.31	7.7	8.66	10	8.01	11.99	6.63	8.66	6.79
	1.93	2.04	1.61	1.43	1.54	1.74	1.43	2.13	1.13	1.45	1.2
	10.9	11.06	8.81	8.33	8.83	9.66	8.09	11.97	6.16	7.81	6.51
	2.18	2.24	1.72	1.71	1.77	2.05	1.64	2.56	1.3	1.61	1.37
	6.02	6.34	4.83	5.08	5.02	5.78	4.65	7.47	3.78	4.53	3.9
	0.9	0.95	0.7	0.81	0.78	0.92	0.71	1.16	0.57	0.7	0.59
	5.84	5.97	4.31	5.19	4.91	5.83	4.71	7.33	3.7	4.38	3.8
	0.86	0.89	0.62	0.79	0.73	0.9	0.71	1.13	0.59	0.67	0.59
	2.5	2.2	2.3	2.3	1.9	2.3	2.6	1.9	2.3	2.2	2.3
	17.4	18.3	16.4	18.9	17.3	19.6	18.2	15.6	12.6	14.3	13.7
	7	6.9	5.5	7.3	6	7.2	7.3	6.6	6.3	7.3	6.9

Figure 2 Simplified bedrock geology of part of the piedmont of North Carolina, showing the locations of potworks. (Source: http://z.about.com/d/geology/1/o/f/z/northcarolinabig.jpg.)

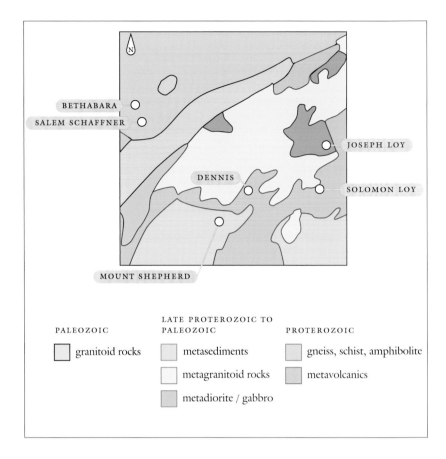

atively high bulk lime content (>0.5% CaO) of some of this pottery (for example, Mount Shepherd samples MS1 and MS6; Table 1).

Granite clasts were noted in a sample of Solomon Loy slipware (SL2). Granitoid plutons, however, crop out throughout much of the North Carolina piedmont (fig. 2), so these clasts provide only a loose constraint on the source of some of the temper-size grains in this sample. Furthermore, it is unclear whether these grains were deliberately added to the clayey paste of these wares (i.e., represent temper) or were an accidental ingredient originating as erosional detritus in the original clay source that survived levigation during the preparation of ceramic pastes. We assume here that the bulk of aplastic mineral grains in Moravian pottery are temper, but this inference will be substantiated only when the clay sources exploited by these potters have been identified and their mineralogy investigated.

The alkali feldspar in sherds (fig. 3) from most of the sites typically has a low albite content, but this phase is greatly enriched in this component in some of the Salem samples; some even have ternary compositions (i.e., with >5mol.% of each feldspar endmember). The compositionally distinct alkali feldspars found in many of the Salem sherds suggest that this potworks made use of a different source of temper—if indeed these grains are temper—than the other potteries described here. The albite-rich nature of these feldspars suggests that they were derived from the weathering of relatively high-temperature source rocks.

Plagioclase feldspar is a very minor constituent of the North Carolina pottery, but this mineral was detected in a few samples from the Mount Shepherd, Bethabara, and Salem potteries. It corresponds to calcic oligoclase to sodic andesine (see fig. 3).

Amphiboles were found in a few samples (Mount Shepherd samples MS3, MS6, and MS8); they may occur in others, but were not detected during microprobe analysis of silt- and fine-sand-sized grains. The amphiboles span a wide range of compositions, but all are calcic, have low titanium contents (<0.1 Ti ions per formula unit [pfu], based on 23 oxygens), and sodium and potassium contents approaching but not attaining concentrations diagnostic of edenitic amphiboles (A-site Na+K is <0.5 ions pfu). The amphiboles typically coexist with epidote. Although there is no evidence that these phases equilibrated during kiln firing, it is quite likely that many of the amphiboles and epidotes originated in the same source rocks. If correct, this provides a reasonable mineralogical guideline for selecting the most suitable recalculation scheme for estimating the ferric iron content of these amphiboles (in this case, 13exCNK).[9] Using the classification scheme of B. E. Leake (1978) the calcic amphiboles in Moravian pottery (including prepared clay from the Schaffner site) span actinolite to tschermakite (fig. 4).[10]

Figure 3 Compositions of alkali and plagioclase feldspars in Moravian pottery from the Mount Shepherd, Salem, and Bethabara sites, and prepared clay from the Schaffner potworks. (Artwork, Nicole Drgan.)

Figure 4 Classification of calcic amphiboles in Moravian pottery (red circles). The open circle denotes hornblende from prepared clay from the Schaffner potworks. Total iron is assumed to be in the ferrous state. The number of silicon ions is based on an oxygen basis of 23.

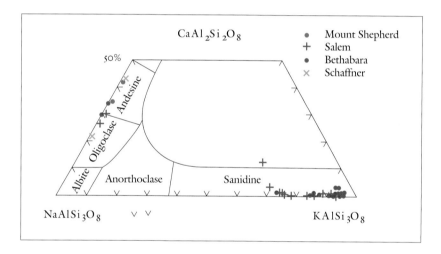

The former likely originated in low-grade metabasites, but the magnesio-hornblendes and tschermakites could be derived from higher-grade meta-morphic rocks or from intermediate igneous rocks such as diorite. Both are common in the piedmont of North Carolina.

The three clay samples from the Schaffner site were retrieved from clay stockpiles found on the site, so they might have been tempered in prepara-tion for use. The samples were fired before being prepared for analysis. They contain fine silt-size particles of quartz, K feldspar, and subordinate epidote, hornblende, ilmenite, and plagioclase. The compositions of the solid solution minerals overlap those in the pottery sherds. K feldspar con-tains up to 14% albite, plagioclase is oligoclase to andesine (An_{22}, An_{43}), the pistacite content of epidote averages 20%, the amphibole is a magnesio-hornblende, and ilmenite contains up to 0.8% MnO. The single fired clay sample analyzed from Mount Shepherd (MS5) contains aluminum- and iron-rich phyllosilicates, but analyses of this phase are considered to be only semi-quantitative.

Glazes

Glaze compositions from selected samples are listed in Table 2. All are lead-rich, with between 45% and 61% PbO. Alumina contents (3%–10% Al_2O_3) and femic components (~1%–3% FeO_T) are highly variable. Alkalis and lime are present in low concentrations (<1% Na_2O, K_2O, CaO). An insuffi-

TABLE 2 Chemical composition of glazes on Moravian pottery from various sites in the piedmont of North Carolina

	SL1	JL1	L2	MS6	BP4	BP6	Salem 1	Salem 4
SiO_2	39.1	29.0	31.5	34.8	31.9	29.6	30.7	30.5
TiO_2	1.0	0.8	1.2	0.4	0.6	0.5	0.6	0.8
Al_2O_3	10.4	6.7	7.9	8.1	3.3	2.9	3.1	5.0
FeO_T	2.9	2.8	3.3	2.2	0.9	0.7	0.8	1.7
MnO	0.0	0.6	0.3	0.8	0.8	0.4	0.6	2.3
MgO	0.3	0.4	0.3	0.4	0.3	0.2	0.2	0.3
CaO	0.5	0.5	0.4	0.3	0.5	0.6	0.5	0.8
Na_2O	0.1	0.2	0.4	0.1	0.3	0.4	0.4	0.2
K_2O	0.2	0.2	0.3	0.4	0.4	0.6	0.5	0.5
PbO	45.5	58.5	54.2	52.2	57.1	60.6	58.9	54.3
P_2O_5	0.0	0.1	0.1	0.0	0.1	0.2	0.1	0.1
SO_3	0.0	0.3	0.2	0.0	0.2	0.3	0.3	0.2
Total	100.0	100.0	100.0	99.8	100.0	100.0	100.0	100.0

cient number of glazed sherds was analyzed to determine whether there are consistent differences in the compositions of glazes used at different North Carolina piedmont potworks.

Bulk Compositions

The sample suite has a wide range of compositions—as expected, given the color variation of their pastes. Rather than attempting side-by-side comparison of the analytical data for each group of sherds, we subjected the data to multidimensional scaling (MDS). This exploratory statistical

method essentially uses all of the available analytical data rather than individual elements to plot the distances or relationships between the objects being investigated. MDS diagrams can be thought of as "maps" that show "distances" between samples or chemical constituents. Samples or chemical constituents that are similar, or that behaved similarly, plot close together. Points on opposite sides of an MDS diagram represent samples or chemical constituents that are dissimilar or behaved in an antithetic manner. Calculations were performed using SYSTAT software.[11]

To avoid subdividing the dataset into unduly small numbers of samples based on paste type, we used MDS to compare the data for all the samples from each potworks with those from other sites. Duplicate attempts were made to distinguish pottery from the different sites, first by using logged data, then by using non-logged data. The symbols representing sherds from individual potworks sites (figs. 5, 6, 9) are color-coded to represent paste type (per paste color); while the MDS results are based solely on composition, clearly there is a relationship between bulk composition and sample color. This color-coding reveals the paste type's contribution to the scatter of samples from particular sites. As will be seen, differences among the compositions of wares from the various potworks are greater than the similarities of pastes of specific color (for example, red earthenware; figs. 5, 6). This type of statistical treatment of bulk compositional data therefore holds promise in provenance studies of particular types of Moravian earthenware.

Figure 5 shows that the logged analytical data for the pottery from the five sites plot in fairly coherent albeit overlapping fields. Data for the Salem pottery, in particular, cluster together. Except for one outlier (a white earthenware sample, BP6), the data for Bethabara do too, but they plot close to Salem and Schaffner samples. The Loy samples from Alamance County plot near the bottom of the diagram. There is an insufficient number of samples to distinguish between the products of different generations of this family of potters, so the same symbol is used for Loy pottery on figures 5 and 6, although individual sherds from both Loy sites are distinguished by their sample numbers. The Mount Shepherd sherds plot as a broad, coherent field across the central part of the diagram.

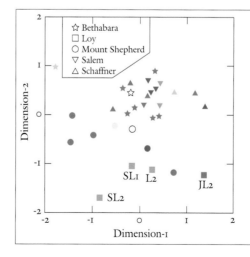

Figure 5 MDS diagram comparing the bulk compositions of Moravian pottery from North Carolina. Symbol colors mirror those of the potsherds; the red earthenware is represented by the red and brown symbols. To create the diagram, data were logged (base 10), elements were z-scored, and a matrix of sample-versus-sample Pearson correlation coefficients calculated and used by the MDS algorithms.

Use of non-logged data helps to distinguish the Bethabara sherds from the Salem and Schaffner sherds (fig. 6). Except for two outliers corresponding to white ware and yellow ware, the Bethabara data plot near the bottom of the diagram. In general, sample chemistry is primarily tied to locality/producer, but color variations from a single producer seem to correlate with chemistry.

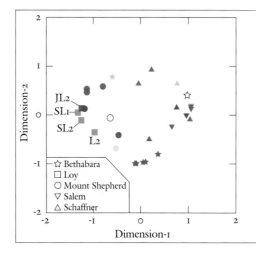

Figure 6 MDS diagram comparing the bulk compositions of Moravian pottery from North Carolina. Symbol colors mirror those of the potsherds; the red earthenware is represented by the red and brown symbols. Calculations used non-logged data.

In order to better understand mineralogical controls on the composition of the sample suite, non-logged data were used to generate a MDS plot of individual components. The result (fig. 7) shows that silica plots on the opposite (left) side of the diagram from most of the trace elements other than those tied to specific temper grains. (For example, Fe, Ti, V, and Sc are associated with ilmenite [$FeTiO_3$]; twenty-nine elements cluster near alumina.) This strongly suggests that quartz and clay minerals largely control the composition of this pottery, with the clay minerals adsorbing many of the trace elements not associated with temper grains other than quartz. The separation of P and Sr, components expected to be associated with apatite, from Ca suggests that the latter component is largely controlled not by the phosphate (apatite) but by various silicate minerals such as plagioclase and calcic amphibole, where present.

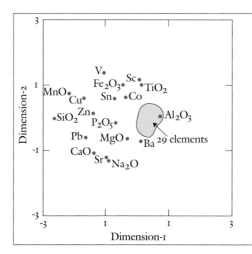

Figure 7 MDS plot of major, minor and trace elements in Moravian pottery from North Carolina. Most components (29 elements; Table 1) cluster in the outlined, gray field that also encloses alumina, indicating their adsorption on clay (see text). Calculations used non-logged data.

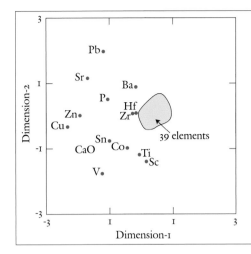

Figure 8 MDS plot of trace elements (including Ti and P) in Moravian pottery from North Carolina. Most trace elements (n = 39) cluster in the outlined, gray field, indicating they are controlled by clays. Other trace elements can be linked to particular, silt- and fine-sand-size mineral grains in the pottery (see text). Calculations used non-logged data.

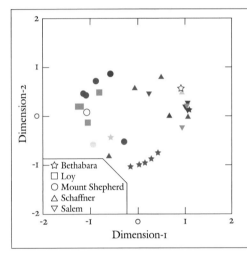

Figure 9 MDS diagram comparing the trace element (plus Ti and P) contents of Moravian pottery from North Carolina. Symbol colors mirror those of the potsherds; the red earthenware is represented by the red and brown symbols. Calculations used unlogged data. Elements were z-scored, and a matrix of element-versus-element Pearson correlation coefficients calculated and used by the MDS algorithms.

To eliminate the effect of temper grains other than ilmenite and apatite, we eliminated from the dataset all major elements other than Ti and P and reran the data. The results (fig. 8) confirm the role of clays in controlling trace elements other than those specifically tied to specific temper grains, some of which can clearly be identified on this diagram. For example, Zr and Hf plot as nearly contiguous points, consistent with the inferred presence of zircon in the pottery, and ilmenite and apatite control the trace elements already mentioned. The only surprise concerns the base metals (Cu, Zn, Pb) that are usually associated with sulphide minerals: none was detected by microprobe analysis. These minerals are highly unstable in secondary (that is, oxidizing) environments and would not be expected to survive for long at the Earth's surface. It is not known which minerals control their concentrations in Moravian pottery, but clearly clay does not. An MDS plot based on trace element (plus Ti and P) data (fig. 9) shows the degree of clustering of sherds from particular producers to be similar to that generated by a file using all elements.

COMPARISON WITH PENNSYLVANIAN MORAVIAN POTTERY
The dataset for analyzed Moravian pottery from North Carolina hints at some mineralogical and hence compositional differences between sherds

TABLE 3 Bulk chemical compositions of
Moravian pottery from Bethlehem, Pennsyl-
vania

	PA-1323	PA-1341	PA-1353	PA-1426	PA-1731	PA-2626
SiO_2 (wt.%)	70.61	73.81	70.41	70.3	72.18	71.15
TiO_2	0.85	0.881	0.89	0.87	0.99	0.865
Al_2O_3	16.49	15.43	16.16	16.37	14.95	16.71
Fe_2O_3	5.02	3.39	4.93	4.65	5.06	5.17
MnO	0.036	0.04	0.032	0.037	0.036	0.027
MgO	1.36	1.48	1.32	1.36	0.71	0.59
CaO	0.41	0.83	0.38	0.4	0.74	1.02
Na_2O	0.28	0.44	0.29	0.3	0.93	1.26
K_2O	2.74	2.29	2.93	2.89	2.86	2.49
P_2O_5	0.209	0.306	0.149	0.139	0.06	0.048
LOI	1.18	1.19	1.00	1.39	0.82	0.76
Total	99.19	100.09	98.49	98.71	99.34	100.09
Ba(ppm)	656	540	598	584	685	825
Rb	106.4	107.1	117.4	116.4	84.2	72.4
Sr	56.0	133.8	54.8	53.2	100.7	121.4
Y	52.4	49.6	50.8	48.2	43.1	34.9
Zr	310.2	355.3	343.6	323.9	477.8	318.8
Nb	17.0	18.0	18.0	17.2	19.9	14.6
Ga	21.0	18.0	20.2	19.7	19.3	17.5
V	84	83	97	92	76	61
Cu	4.4	5.5	4.7	7.1	2.1	2.1
Pb	44.2	22.1	105.4	24.1	23.8	11.7
Zn	11	10	12	6	9	3
Be	3	2	3	3	1	2
Co	15.2	10.5	14.2	13.5	8.6	6.0
Ni	2.4	2.1	4.1	2.9	1.3	2.0
Sn	4	3	4	4	4	3
W	3.1	2.4	3.2	2.9	3.8	3.0
Cs	6.4	6.3	6.1	5.7	4.2	1.8
Hf	8.4	10.2	9.5	9.3	12.7	8.7
La	61.5	55.2	56.1	55.7	48.9	32.4
Ce	123.6	115.6	109.4	108.3	100.5	65.1
Pr	15.39	13.90	13.66	13.52	12.65	8.25
Nd	59.1	52.2	53.4	51.4	47.6	32.2
Sm	10.50	9.04	9.01	8.72	8.71	6.16
Eu	2.22	1.89	1.87	1.83	1.73	1.43
Gd	9.51	8.04	8.47	8.06	7.86	5.80
Tb	1.62	1.37	1.42	1.37	1.35	1.02
Dy	8.85	7.54	7.85	7.45	7.40	5.89
Ho	1.77	1.55	1.58	1.51	1.56	1.24
Er	4.97	4.51	4.56	4.46	4.52	3.64
Tm	0.69	0.65	0.66	0.65	0.65	0.56
Yb	4.38	4.26	4.30	3.93	4.20	3.58
Lu	0.68	0.66	0.66	0.62	0.67	0.56
Ta	1.1	1.3	1.2	1.3	1.3	1.0
Th	13.9	15.8	14.2	13.4	13.1	7.3
U	5.2	3.7	4.7	4.6	6.6	2.6

PA-2942	PA-2989	PA-3055	PA-3083	PA-3246	PA-3590
68.37	70.86	70.36	70.24	71.11	70.42
0.86	0.895	0.886	0.913	0.888	0.765
15.58	15.94	15.88	15.52	16.06	13.85
5.71	5.87	5.84	5.74	5.11	6.96
0.035	0.036	0.038	0.032	0.032	0.04
1.85	1.86	1.86	1.64	1.35	1.55
0.4	0.43	0.43	0.5	0.38	0.48
0.35	0.36	0.38	0.44	0.32	0.32
3	3.07	3.02	2.97	2.85	3.49
0.091	0.093	0.089	0.112	0.115	0.072
2.68	0.89	0.88	1.75	2.16	1.95
98.93	100.30	99.66	99.86	100.38	99.90
608	600	587	606	603	581
136.3	135.1	129.1	121.7	104.5	116.1
47.5	48.0	49.4	58.5	51.4	50.6
51.2	48.5	47.8	50.6	50.1	45.1
304.7	314.4	308.9	332.7	315.6	324.5
17.0	16.6	16.5	17.4	16.9	15.2
20.2	19.6	18.9	19.9	19.6	17.1
98	93	91	94	88	76
2.6	3.3	2.9	5.2	5.1	2.2
116.6	19.9	12.3	43.9	18.0	4.4
5	7	9	35	25	3
3	2	2	2	3	2
16.1	15.7	15.1	16.6	14.5	16.9
4.1	4.8	5.9	13.5	9.5	2.6
3	2	3	2	3	3
4.0	2.5	2.1	2.7	2.7	3.3
6.9	6.7	6.7	6.0	5.9	5.9
8.3	7.7	8.8	9.3	9.5	9.4
55.7	55.6	55.0	56.9	59.0	47.5
111.3	113.1	109.8	115.1	118.8	95.1
14.46	14.45	13.81	14.64	14.79	11.95
57.1	56.7	54.0	54.5	56.3	44.5
9.96	10.14	9.74	9.83	9.78	8.21
2.12	2.13	2.04	2.13	2.08	1.71
9.21	9.22	8.74	9.12	8.95	7.91
1.51	1.52	1.45	1.52	1.52	1.29
8.42	8.64	7.87	8.18	8.26	7.18
1.60	1.65	1.59	1.68	1.65	1.48
4.81	4.69	4.54	4.78	4.55	4.28
0.68	0.68	0.66	0.71	0.67	0.67
4.34	4.27	4.30	4.52	4.25	4.05
0.69	0.66	0.65	0.69	0.64	0.63
1.3	1.2	1.2	1.3	1.3	1.0
14.8	13.8	14.5	14.9	13.9	13.0
5.0	5.0	4.7	4.7	4.8	4.0

from different factory sites, but the range of material is too diverse and the initial number of samples of each pottery type too small to allow consistent, reliable distinctions to be made in provenance studies of unsourced pottery. However, the sample suite already described here is supplemented by twelve pieces of earthenware from Bethlehem, where the Moravians established a pottery industry in about 1743. The bulk compositions of these samples are reported in Table 3. We have used MDS to evaluate the possibility that this Pennsylvanian Moravian earthenware is compositionally distinct from its North Carolina counterparts, as represented by a sixteen-sample subset of the material described here—four samples from Mount Shepherd, five from Bethabara, four from the Schaffner pottery (including fired clay samples), one from Salem, and one from each of the two Loy sites. Classification of individual samples as "redware" was done prior to the final description of the potsherds in terms of Munsell colors. Trace element data determined by ICP-OES were not available for the Pennsylvania samples, so trace elements (Ba, Sc, Ni, Cr) more reliably determined by this method (as opposed to ICP-MS) were not included in our comparison of the two data sets. Analytical data at or below detection limits for both the North Carolina and Pennsylvania samples were also omitted and are not reported here.

The results (fig. 10) show that the Pennsylvanian samples are significantly different from the analyzed North Carolina earthenware sherds, which cluster into two fields (Mount Shepherd + Loy; Bethabara + Schaffner + Salem). Given their geographic proximity to one another (see figs. 1, 2), the compositional similarity of Schaffner, Bethabara, and Salem earthenware is not surprising, but the Mount Shepherd and Loy pottery sites are more widely spaced. Clearly, identifying the sources of raw materials used by these potters is crucial to understanding differences and similarities in the compositions of their wares.

Probabilities (p-values < 0.05) on univariant F-statistics indicate that the Pennsylvania and North Carolina earthenware samples can be distinguished on the basis of major (Si, Ti, Al, Mn, Mg, K) as well as trace

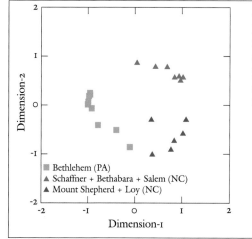

Figure 10 MDS diagram comparing Moravian earthenware from North Carolina and Pennsylvania. The North Carolina pottery clusters into two distinct groupings. Calculations used non-logged data.

Figure 11 Discrimination diagrams distinguishing Moravian earthenware from that made in North Carolina and Pennsylvania. Future work will focus on establishing compositional criteria to distinguish earthenware from particular North Carolina potworks.

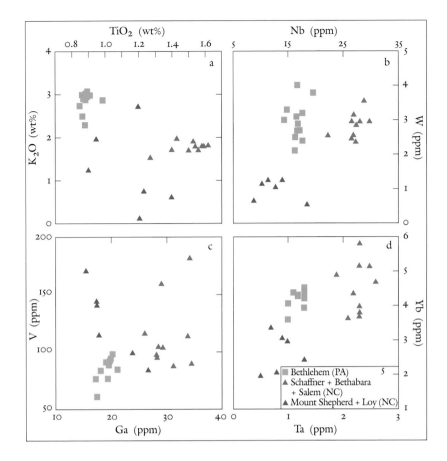

elements (Rb, Cs, Be, Y, Zr, Hf, Nb, Ta, U, Ga, V, Sn, W, Cu, Pb and the Rare Earth elements). Consequently, discrimination diagrams can be constructed using pairs of these various components. Four examples are given here (fig. 11), but of course many more could also be used.

Although the mineralogy of the Bethlehem ceramics has not yet been determined (thin sections were not available at the time of this writing), the bulk compositional data provide clues about the phases controlling the composition of these samples. Feldspar components cluster together on one side of a MDS plot (fig. 12) for this material, whereas other elements are scattered across the middle of the diagram or are concentrated on the other side of the diagram, suggesting that they are variably diluted by feldspar. Titanium, Nb, and Ta cluster together, away from Fe, indicating that they are controlled by rutile (or another TiO_2 polymorph) rather than ilmenite. Phosphorous plots separately from Ca, so it appears that plagioclase controls the latter component, and that apatite is a minor constituent of the Pennsylvania samples. The tight elemental concentration field on the right side of figure 12 is dominated by the Rare Earths. It is unclear which minerals govern the distribution of these elements, but, unlike the North Carolina samples (see fig. 7), it is unlikely to be clay, because they do not plot close to Al.

The significant differences in the distribution of elements on the elemental MDS plots (see figs. 8, 12) suggest differences in the proportion (relative to clay) and composition of temper used in the manufacture of

Figure 12 MDS plot of major, minor, and trace elements in Moravian pottery from Bethlehem, Pennsylvania. Many components (18 elements; Table 3) cluster in the outlined, gray field that plots away from alumina, indicating they are not controlled by adsorption on clay (see text). Calculations used non-logged data.

North Carolina and Pennsylvania earthenware. The distribution of components on figure 12 suggests that, compared with its Carolinian counterparts, the Bethlehem earthenware made use of a relatively high proportion of feldspar-rich temper.

DISCUSSION

The use of analytical data in the investigation of historical ceramics has flourished over the past few decades. These data provide an objective means of characterizing particular wares, of comparing the products of individual producers over time, and of different contemporaneous potworks.[12] Coupled with a careful assessment of the historical record, the results of an analytical approach to ceramic scholarship can overturn ideas that have long been entrenched in the literature.[13]

This methodology is particularly well suited to the study of Moravian pottery, because the forms of these wares, like those of Germanic tradition in general, changed little over time.[14] The main concern here centers on the possibility that similarities in form are matched by similarities in paste compositions, particularly in a closely knit industry centered in a relatively restricted area like the piedmont of North Carolina. Moreover, it is to be expected that the raw materials used in the pottery industry would tend to be rather uniform in such production centers, which would have been situated close to clay sources. Since processes such as transportation and deposition tend to mix fine-grained sediments, it can be challenging to distinguish these media (and hence pottery) on compositional and mineralogical grounds. The present study, however, demonstrates that even if the side-by-side comparison of analytical data points to broad similarities in the composition of wares produced at various production sites, the exploratory statistical treatment of such data can highlight their differences. The long-term objective of this type of study is, of course, to provide compositional criteria by which unprovenanced pottery examples can be attributed to specific North Carolina potworks.

To highlight the potential of this approach, the comparison of earthenwares from North Carolina and Pennsylvania presented here shows how

profound these differences can be. We are presently expanding our database for North Carolina earthenware. Additional samples from the potworks described here, along with others from the North Carolina piedmont (including some newly acquired samples from the Thomas Dennis and William Dennis sites), will be analyzed and the data statistically evaluated to identify the elements or element ratios that best serve to distinguish these wares. Even if there is some overlap in the compositions of the earthenware produced at some of these sites, then at least these data can exclude some of the potworks at which individual ceramic artifacts might have been made. With the recent development of nondestructive analytical tools such as portable x-ray fluorescence (XRF), the data required for this objective means of sourcing pottery can now be safely acquired for intact, loosely identified objects residing in many private and public collections.

The use of analytical data to characterize archaeological artifacts extends well beyond attribution and authentication purposes. These data can also be used to better understand the technologies used to create early wares, from determining the sources of raw materials to placing constraints on kiln firing conditions. The variety of pastes—as indicated by color—represented by the sherds described here suggests that different types of clay were used by Moravian potters, but the extent that the kiln atmosphere (oxygen fugacity) and temperature also influenced the color of these samples also needs to be determined. Expert potters have already re-created some of the forms made famous by the Moravians.[15] Once the sources of clay exploited by the Moravians have been identified, and their non-clay mineralogy and granulometry documented, the levigation methods of the Moravians and the extent to which they deliberately tempered their wares can be determined. Once this is established, compositionally and mineralogically accurate facsimiles of their pastes can be mixed. These pastes can then be fired under controlled conditions until the oxygen fugacity and most appropriate temperature-time profile to emulate Moravian wares have been established.

ACKNOWLEDGMENTS Background information concerning the Moravian and St. Asaph's traditions in North Carolina was kindly provided by Luke Beckerdite. The North Carolina sherds were made available through the generosity of several individuals: Michael O. Hartley provided the samples from the Salem, Bethabara, and Heinrich Schaffner pottery sites; Linda F. Carnes-McNaughton provided samples from the Loy family pottery sites; Alain Outlaw provided samples from the Mount Shepherd pottery site; Hal Pugh and Eleanor Minnock-Pugh provided samples from the William and Thomas Dennis Pottery sites that will be analyzed in the future as part of this ongoing project; and the Bethlehem (Pennsylvania) samples were provided by Bonnie Stacy, Curator of Collections and Exhibitions, Historic Bethlehem Partnership. This study was supported by grants to J. Victor Owen from the Natural Sciences and Engineering Research Council of Canada Discovery and the Chipstone Foundation. The authors are grateful to both agencies for their generosity.

DESCRIPTION OF THE POTTERY SAMPLES
SELECTED FOR ANALYSIS

SAMPLE DESIGNATION	DESCRIPTION	MUNSELL COLOR DESIGNATION
MOUNT SHEPHERD (1793–1800)		
MS-1	hard-fired slipware	Hue 7.5YR 7/6 reddish yellow
MS-2	greenish/yellow glazed base fragment	Hue 7.5YR 7/6 reddish yellow
MS-3	white clay pipes	Hue 10YR 8/1 white
MS-4	slipware from kiln slipware pit	Hue 5YR 6/8 reddish yellow
MS-5	red fired clay	Hue 5YR 6/8 reddish yellow
MS-6	glazed jar rim	Hue 10YR 7/4 very pale brown
MS-8	unglazed tile fragment	Hue 10YR 7/2 light gray (edge); Hue 2.5YR N6/ gray (core)
JOSEPH LOY (ca. 1833–1850)		
JL-2	unglazed earthenware	Hue 7.5YR 7/6 reddish yellow
L-2	unglazed earthenware	Hue 10YR 8/3 very pale brown (rim); Hue 5YR 7/4 pink (core)
SOLOMON LOY (1825–1840)		
SL-1	lead-glazed earthenware	Hue 5YR 8/4 pink (glazed side); Hue 10YR 8/4 (unglazed side)
SL-2	bisque slipware sherd	Hue 7.5YR8/4 pink
BETHABARA (1760–1800)		
BP-1	brown-glazed base sherd	Hue 7.5YR 6/6 reddish yellow
BP-3	brown/green glazed red earthenware	Hue 5YR 7/8 reddish yellow
BP-4	tortoise saucer fragment dark glaze exterior	Hue 5YR 7/6 reddish yellow
BP-5	surface slip dish	Hue 10YR 8/4 very pale brown
BP-6	tortoise over white body	No Munsell match; very pale yellow
BP-7	green-glazed whiteware	Hue 10YR 8/2 white
BP-8	handle white slip over pink body	Hue 7.5 7/8 reddish yellow
BP-9	base sherd white slip	Hue 5YR 7/6 reddish yellow
BETHLEHEM (Pennsylvania; 1741–ca. 1780)		
PA-1341	glazed, ribbed tile	Hue 7.5YR 6/6 reddish yellow
PA-2942	glazed, ribbed vessel or tile	Hue 5YR 6/6 reddish yellow
PA-1353	glazed, ribbed vessel	Hue 7.5YR 6/6 reddish yellow
PA-3246	unglazed vessel	Hue 7.5YR 6/4 light brown
PA-1323	glazed vessel	Hue 5YR 7/8 reddish yellow
PA-3083	unglazed vessel	Hue 5YR 6/6 reddish yellow
PA-2989	unglazed vessel	Hue 5YR 6/6 reddish yellow
SCHAFFNER (post-1834)		
SPclay1	gray clay from well	Hue 10YR 8/3 very pale brown
SPclay2	yellow clay from feature 5	Hue 5YR 7/8 reddish yellow
SPclay3	green clay fired sample	Hue 5YR7/8 reddish yellow
SP-5	glazed red earthenware	Hue 7.5YR 7/6 reddish yellow
SP-6	unglazed red earthenware	Hue 7.5YR 7/6 reddish yellow
SP-8	pipe saggar base	Hue 10 YR 8/3 yellow
SALEM (ca. 1771–ca. 1810)		
Salem-1	green-glazed rim sherd	Hue 5YR 7/8 reddish yellow
Salem-2	slip-trailed sherd; overglaze absent	Hue 10YR 8/3 very pale brown
Salem-3	slip-trailed sherd	Hue 7.5YR 8/4 pink
Salem-4	green exterior, yellow interior rim	Hue 10YR 8/4 very pale brown (core); Hue 7.5YR Hue 5YR 8/4 pink (rim)

1. For more on the Moravians and their North Carolina potteries, see Luke Beckerdite and Johanna Brown, "Eighteenth-Century Earthenware from North Carolina: The Moravian Tradition Reconsidered," in *Ceramics in America*, edited by Robert Hunter and Beckerdite (Hanover, N.H.: University Press of New England for the Chipstone Foundation, 2009), pp. 2–67.

2. W. Ross H. Ramsay, Anton Gabszewicz, and E. Gael Ramsay, "'Unaker' or Cherokee Clay and Its Relationship to the 'Bow' Porcelain Manufactory," *Transactions of the English Ceramic Circle* 17, pt. 3 (2001): 474–99.

3. Beckerdite and Brown, "Eighteenth-Century Earthenware from North Carolina," pp. 4–7.

4. Ibid., pp. 15, 26, 33–47. See also Alain C. Outlaw, "The Mount Shepherd Pottery Site, Randolph County, North Carolina," in *Ceramics in America*, edited by Robert Hunter and Luke Beckerdite (Hanover, N.H.: University Press of New England for the Chipstone Foundation, 2009), pp. 161–89.

5. See in this volume Luke Beckerdite, Johanna Brown, and Linda F. Carnes-McNaughton, "Slipware from the St. Asaph's Tradition," pp. 14–65.

6. The Bethlehem samples were selected by Brenda Heidl-Hornsby, Lois F. McNeil Fellow at the Winterthur Program in American Material Culture.

7. *Munsell Soil Color Charts* (Baltimore, Md.: Munsell Color, 1975).

8. Thomas Armbruster et al., "Recommended Nomenclature of Epidote-Group Minerals," *European Journal of Mineralogy* 18, no. 5 (2006): 551–67.

9. Based on a 23-oxygen unit cell, all cations other than Ca, Na, and K are normalized to 13. See Peter Robinson, Barry L. Doolan, and John C. Schumacher, "Phase Relations of Metamorphic Amphiboles: Natural Occurrence and Theory," in *Amphiboles: Petrology and Experimental Phase Relations*, Reviews in Mineralogy 9B, edited by David R. Veblen and Paul H. Ribbe (Mineralogical Society of America, 1985).

10. Bernard E. Leake et al., "Nomenclature of Amphiboles," *Mineralogical Magazine* 42 (1978): 533–63.

11. Leland Wilkinson et al., *SYSTAT for Windows, Version 5: Statistics* (Evanston, Ill.: SYSTAT, 1992); *Munsell Soil Color Charts*. For further discussion of the method, see Ingwer Borg and Patrick Groenen, *Modern Multidimensional Scaling: Theory and Applications,* Springer Series in Statistics (New York: Springer, 1997), pp. 1–14. For its application to rocks, see John D. Greenough, Jaroslav Dostal, and Leanne M. Mallory-Greenough, "Incompatible Element Ratios in French Polynesia Basalts: Describing Mantle Component Fingerprints," *Australian Journal of Earth Sciences* 54, no. 7 (2007): 947–58. For its application to wine, see John D. Greenough, Leanne M. Mallory-Greenough, and Brian J. Fryer, "Regional Trace Element Fingerprinting of Canadian Wines" (Geology and Wine Series 9), *Geoscience Canada* 32, no. 3 (2005): 129–37. For its application to glass, see J. Victor Owen and John D. Greenough, "Influence of Potsdam Sandstone on the Trace Element Signatures of Some 19th-Century American and Canadian Glass: Redwood, Redford, Mallorytown, and Como-Hudson," *Geoarchaeology* 23, no. 5 (2008): 587–607.

12. For comparison of products of individual producers over time, see J. Victor Owen, "The Geochemistry of Worcester Porcelain from Dr. Wall to Royal Worcester: 150 Years of Innovation," *Historical Archaeology* 37, no. 4 (2003): 84–96; W. Ross H. Ramsay and E. Gael Ramsay, "A Classification of Bow Porcelain from First Patent to Closure c. 1743–1774," *Proceedings of the Royal Society of Victoria* 119, no. 1 (2007): 1–68. For those of different contemporaneous potworks, see J. Victor Owen and Maurice Hillis, "From London to Liverpool: Evidence for a Limehouse-Reid Porcelain Connection Based on the Analysis of Sherds from the Brownlow Hill (c. 1755–67) Factory Site," *Geoarchaeology* 18, no. 8 (2003): 851–82.

13. W. Ross H. Ramsay and E. Gael Ramsay, "A Case for the Production of the Earliest Commercial Hard-Paste Porcelains in the English-speaking World by Edward Heylyn and Thomas Frye in about 1743," *Proceedings of the Royal Society of Victoria* 120, no. 1 (2008): 236–56.

14. Outlaw, "The Mount Shepherd Pottery Site."

15. Robert Hunter and Michelle Erickson, "Making a Moravian Faience Ring Bottle," *Ceramics in America*, edited by Hunter and Luke Beckerdite (Hanover, N.H.: University Press of New England for the Chipstone Foundation, 2009), pp. 190–99.

Mary Farrell

Making
North Carolina
Earthenware

▼ I CANNOT REMEMBER when I first began to love early earthenware, often referred to incorrectly as "redware" even though it fires to various shades of white, buff, and red. Whether in its raw state or in the form of finished pottery that we used in our family household, reddish, iron-bearing clays were all around me as a child growing up in North Carolina. I began to make pottery as a teenager and soon became interested in historic ceramics. My husband, David, had followed a similar path, so when we first opened Westmoore Pottery in 1977 in the Seagrove area of North Carolina, it was only natural that earthenware formed an important part of our production.

David and I trained in an academic environment, and both of us had served apprenticeships with working potters. With those skill sets, we began studying traditional pottery forms, styles, and decoration. We had even taught ourselves slip-trailing methods before we met. (The wonderful books about slip-trailing that exist today were not yet written.)

By the time David and I began our business, we were very familiar with a portion of the state's pottery legacy—that of the late 1800s through the 1950s. Much of the published information related either to stoneware or to earthenware of the twentieth century. North Carolina pottery made before the mid-nineteenth century remained relatively unknown to us. We wanted to learn more about historical pottery, but running a new business consumed most of our time. Nevertheless, we used every resource we could find in the time we could spare. We visited museums with late-eighteenth- and early-nineteenth-century pottery, even those that had only a handful of pieces. The Greensboro Historical Museum and the North Carolina Museum of History both have small collections that were informative. We quickly came to treasure and closely study the holdings of the Museum of Early Southern Decorative Arts and its parent organization, Old Salem Museums & Gardens, which are the primary repositories of early North Carolina earthenware. Of course, we also eagerly studied the few relevant publications we could find, such as *The Moravian Potters in North Carolina* by John Bivins Jr.[1]

While museum collections contained elaborately decorated examples of North Carolina earthenware, most of the simpler variants were privately owned, and we are fortunate that so many individuals were kind enough to grant us access to their collections. Of the numerous collectors who "took us under their wing," we are particularly grateful to Bill Ivey—one of our first and best instructors on piedmont North Carolina pottery. His

collection, which reflects his appreciation of North Carolina earthenware made before 1840, changes constantly as new pieces come in and redundant examples go out. Countless times over the years he has called or stopped by our shop to say, "Mary, I've got a new piece I know you'll want to look at!" He has an excellent memory, a discerning eye, and the ability to be far less influenced than most collectors by what he *wants* a piece to be.

Thirty years ago almost every elaborately decorated example of North Carolina earthenware was attributed to the Moravian potters at Bethabara and Salem. This assumption was in some ways strengthened when research by L. McKay Whatley showed that another production site for decorated wares—the Mount Shepherd kiln site in Randolph County—was an offshoot of the Moravian tradition and the workplace of Jacob Meyer, whose persistent bad behavior got him banished from Salem.[2]

In the 1970s and early 1980s, I began to puzzle over contradictions within the group of wares that were said to be Moravian.[3] Among the pieces attributed to Rudolph Christ, there was greater variation in shape than seemed likely in the work of one potter: dish shapes varied considerably, as did rim profiles, and hollow ware ranged from very crude to very fine. As a potter, I can shift easily from one shape to another or one rim profile to another, but I wondered why a craftsman in the eighteenth and early nineteenth centuries would bother to do so. Most potters' wares from that time are remarkably consistent.

Even more inexplicable were differences in slip-trailing, a technique almost as distinctive as handwriting. Copying the trailing style of another potter (or changing one's own) is like trying to forge someone's signature: the process is consciously deliberate rather than natural. After attempting to replicate many old North Carolina dishes, several of which had been attributed by the academic community to Christ, I became certain that those objects represented the work of multiple hands.

So whose work was I replicating? One possibility was that there were more Moravian potters working at Bethabara and Salem than heretofore believed or that the Moravians hired separate decorators, but neither of those theories is supported by that sect's meticulous records. On the pages of my old copies of Bivins's book I penciled in more and more notations such as: "No way could Christ have made this" or "I don't think this is really Moravian." Furthermore, the family and recovery histories of several examples of slipware in Bill Ivey's collection led him to question certain Moravian attributions and reinforced my skepticism.

Now, fast-forwarding more than thirty years, knowledge about North Carolina earthenware is vastly improved. Thanks to those who do primary research in the field, we have documentation for more than fifty-five non-Moravian earthenware potters working in North Carolina in the eighteenth and nineteenth centuries.[4] Of those, there are some to whom no known pottery can be attributed, and of existing pottery much remains anonymous. We do know for certain that several non-Moravian potters were doing highly decorative work.

Pots that have descended in families often offer clues to their place of origin, but much of the surviving earthenware lacks provenance. Archaeological research has identified a few early earthenware potteries in the piedmont, although much work remains to be done before that region's earthenware traditions can be comprehensively brought to light.[5] Great progress is being made, however, and many of the pots that I used to puzzle over can now be attributed with certainty to various non-Moravian potters, or at least to a particular region of North Carolina.

Exploring North Carolina Potting Techniques
In our first year at Westmoore Pottery, we began to make replicas of early North Carolina earthenware, a way to learn about historic ceramics and work methods that is often vastly underestimated. Replicating an old pot is an excellent way to "get inside" the original potter's head and better understand his or her world. In trying to duplicate the hand motions of the original potter, methods become obvious that are not apparent from just looking at a piece.

Since the central or piedmont region of North Carolina has abundant naturally occurring clay, North Carolina's early potters tended to settle there. These early earthenware potters in the piedmont region were from families that had emigrated from Germany or England and entered our state via the Virginia border, coming from states to the north.

Early North Carolina potters all worked primarily on the wheel. The Moravians were the only potters who made press-molded hollow ware, but that work was limited to fine table- and tea wares, flasks, and figural forms. The use of rounded drape, or hump, molds, which was common in Europe and Pennsylvania, has been documented at only one North Carolina site (see Hal E. Pugh and Eleanor Minnock-Pugh, "The Dennis Family Potters of New Salem, North Carolina," p. 163, fig. 42, in this volume). Almost all North Carolina earthenware potters kept the vessel shape that came off the wheel as the finished form (fig. 1), although occasionally there was a little trimming of a foot or rounding of a ring bottle. (Extraneous elements, such as handles, legs, and so forth, were of course added later.) In the final stages of the wheel work, most North Carolina potters seemed to have finished their wares with a rib, known locally as a chip and usually made of wood, leaving the surface very smooth (fig. 2). Moravian hollow wares are unique in the extent to which specially cut wooden and metal ribs were used in their formation (fig. 3). After turning a pot on the wheel, the maker pushed a rib specific to that form against the piece (figs. 4, 5). If the rib had grooves, it produced raised moldings. This was a simple way to add a decorative touch. Though many vessel bottoms are smooth where they were cut from the wheel, some have marks from a rough multistrand string (fig. 6). The Moravian potters also used ribbed extruded handles on their most refined ware (fig. 7). Handle terminals vary, some with elaborate curls at the end, some with thumb impressions (fig. 8).

Beyond general similarities, many differences among North Carolina wares emerge during a close examination of the specific techniques used in

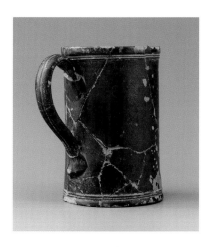

Figure 1 Mug, Salem, North Carolina, 1774–1786. Lead-glazed earthenware. H. 5⅛". (Courtesy, Old Salem Museums & Gardens; unless otherwise noted, photos by Gavin Ashworth.)

Figure 2 When turning has been completed, finger grooves are apparent on both the outside and the inside of the body. On the outside, use of a rib creates a very smooth surface.

Figure 3 Ribs, Salem, North Carolina, 1820–1860. Copper (left) and brass (right). (Courtesy, Old Salem Museums & Gardens.)

Figure 4 Procedural sequence showing the initial stages of turning an eighteenth-century Moravian-style mug on the wheel. A specified amount of clay is first centered and then raised using only the hands and fingers to form the cylinder.

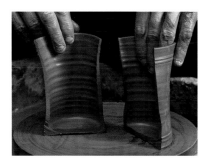
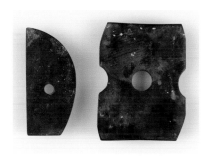
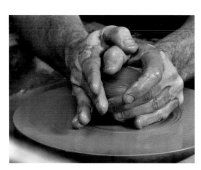
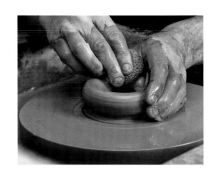
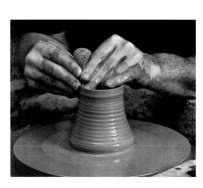
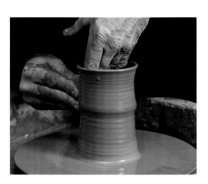
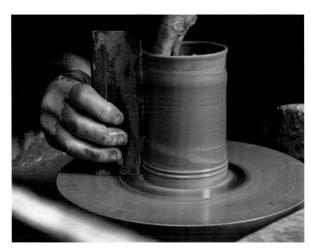
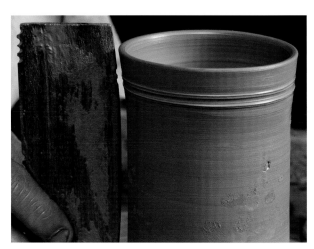

Figure 5 Once the form of the mug is raised, a grooved rib unique to each size and shape of mug is placed against the surface to produce moldings. Evidence of this technique is found on many Moravian mugs.

creating them: variations in the color and type of clay as well as in the style of the forms; a wide range in the skill level of the makers; differing rim treatments; the diameters of the plate bases, which range from very wide to very small; and the array and quality of decorative elements, which range from very fine slip-trailed representations of flowers to simple but elegant zigzags and lines to seemingly random swipes of brushed slip.

Many North Carolina pots made in the period under discussion are decorated either with slips or with oxides (typically iron, copper, or manganese) mixed with water. Slips are clays to which water has been added. For slip-trailing or painting, the consistency should be similar to yogurt that has been vigorously stirred with a spoon; for pouring or dipping a background surface, a slightly thinner slip is better. The naturally occurring clays in North Carolina can yield slips in shades of white, cream, yellow, orange, and red. Adding iron or manganese, or both, can produce a very dark brown or purple-black slip. Mixing copper oxide with a white or

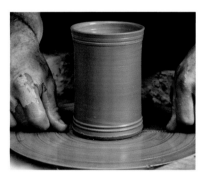

Figure 6　Some North Carolina pottery was cut from the wheel with a heavy string, leaving a shell pattern on the bottom of the mug if the wheel was moving at the time, or a striped pattern if the wheel was not turning. Although David Farrell is demonstrating this technique on a Moravian-style mug, Salem and Bethabara examples usually have smooth bottoms.

Figure 7　Molded handles hanging from an extruder, ready to cut to length and attach. This modern extruder is a bit more technologically advanced than the simple hand-pushed extruders used by Moravians and other North Carolina potters, but the principle is exactly the same.

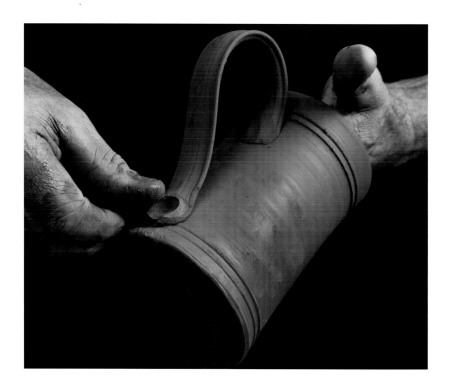

Figure 8 Various handle terminal treatments were used on eighteenth- and nineteenth-century North Carolina earthenware. A simple thumbprint terminal is shown here, although this technique was not widely used by the Moravians.

cream slip makes green slips. North Carolina pots from the 1770s to 1840 are often decorated with multiple colors on a single piece.

Slip-trailing was apparently one of the most widespread decorating techniques employed by North Carolina potters. Early craftsmen used a fired-clay slip cup equipped with reeds or quills (fig. 9). We still use these in our business, although I often rely on a rubber bulb aspirator for trailing slip. Many dishes with simple trailed decoration have turned up in Randolph and lower Guilford counties (fig. 10). These examples were thrown and decorated, while still on the wheel, with bands and zigzags, most often with only a dark brown or almost black slip (figs. 11–15). Since the darkest slips are a purplish black rather than a true black, they probably contain heavy concentrations of manganese, along with some iron, rather than any cobalt. If the potters had easy access to cobalt, we would expect to find some evidence of blue slip-trailing. The Randolph County plates also range so much in skill level, both in wheelwork and in decoration, that I suspect they are the work of more than one potter. The ones that appeal most to me include zigzags as well as concentric and spiraling lines, all applied before the plate was taken off the wheel (fig. 16).

As one begins to compare the highly decorated slipwares made by various North Carolina potters, many specific differences emerge. Most potters seem to have made some variation of the plate or dish, usually a double-booge shape and almost always with a thickened rim. The rim was turned over and attached to the underside rather than simply left thickened (as evidenced in fragment cross sections), which makes the dish somewhat less prone to warping and much sturdier in daily use. Variations in the rims, profiles, and feet (if present) are common when comparing the work of different potters.

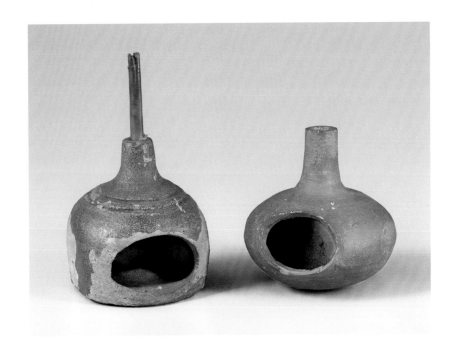

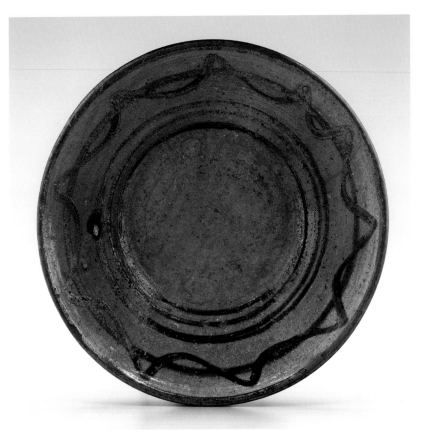

Figure 9 Slip cups, Salem, North Carolina, 19th century. *Left:* Lead-glazed earthenware. H. 2⅝". *Right:* Bisque-fired earthenware. (Courtesy, Old Salem Museums & Gardens.) These cups are typical of the form used by slipware potters in America and Europe. A quill has been inserted into the cup on the left.

Figure 10 Dish, Randolph County, North Carolina, 1800–1850. Lead-glazed earthenware. Dimensions not recorded. (Private collection.)

Figure 11 Only the hands are used in the beginning stages of turning a plate or dish. The clay is centered, then opened into a wide cylinder.

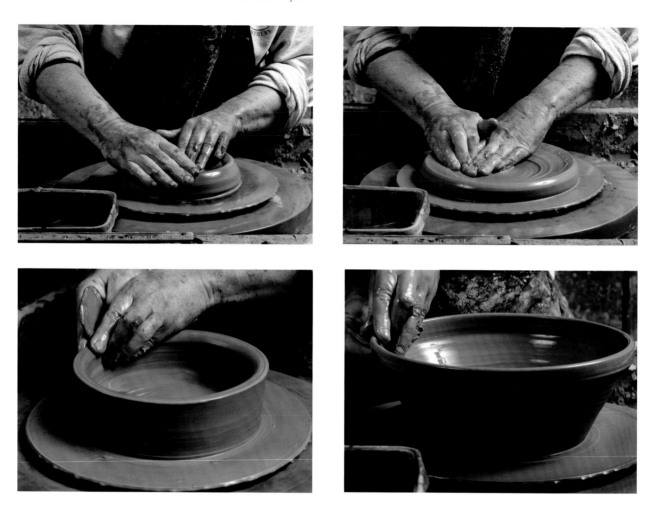

Figure 12 After the initial cylinder is raised, a flat or curved rib is used to form the plate or dish shape.

For the purposes of this article, two elaborately decorated slipware dishes were re-created to illustrate different potting and decorating techniques in North Carolina. One dish was probably made at the Salem pottery during Christ's tenure as master, and the other is attributed to a potter from the St. Asaph's tradition of Alamance County. Many dishes from the Moravian and St. Asaph's traditions are ornately decorated with multiple colors of slip (typically green, reddish orange, and cream-yellow), often applied on a cream, red, or brown ground. The use of dark grounds, ranging from brown to purple-black, is much more common in the St. Asaph's tradition.

The shape of dishes made by the Moravian potters is quite flat, with a very wide bottom in proportion to the marly and a short, curved transition

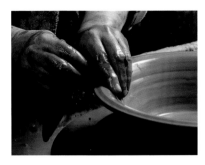

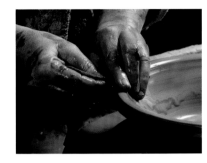

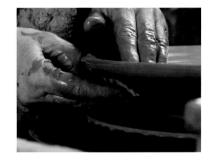

Figure 13 Period Randolph County dishes have a distinctive type of rolled rim. The stages of flipping over the edge of the rim are shown here.

Figure 14 The broad, flat marly is shaped and finished using the rib.

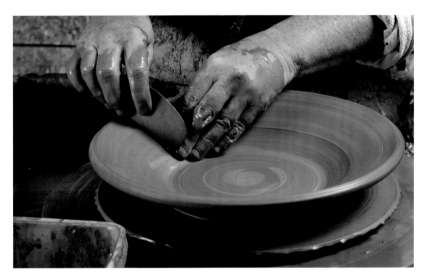

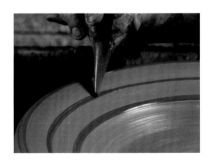

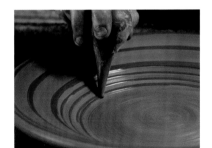

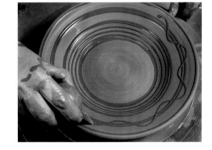

Figure 15 After the dish is turned and shaped, it is allowed to dry to a leather-hard state. The simple slip-trailing is accomplished using a very dark brown—almost black—slip. The wheel is slowly rotated while the concentric bands are applied, then rotated even more slowly while zigzags and the spiraling lines are slip-trailed. As on period dishes by this potter, the zigzags often do not meet up evenly. The decoration is applied with a modern rubber bulb aspirator.

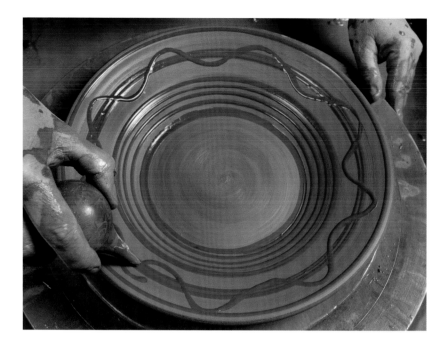

Figure 16 The completed slip-trailed Randolph County–style plate in the wet state.

from the bottom to the marly (fig. 17). Because the marlys are slightly concave, I frequently form them with a curved rib (figs. 18–21). A fairly generous portion of clay is turned over at the edge and smoothed underneath, giving the underside of the rim a rounded shape. Though joined to the clay underneath it, there is a definite demarcation on the reverse side of the plate between the rim edge and the rest of the plate below it. The top edge of the rim comes to something of a point. Despite their curved shape, the marlys of Moravian dishes are very horizontal, so much so that some seem to defy the effect gravity would have had on a piece of wet clay. They almost appear to have been wheel-made with a shaped bat underneath the clay while working, but, if that were the case, those bats should have been included among the many potter's tools and implements collected by the Wachovia Historical Society at the beginning of the nineteenth century.

Replicating the Moravian technique of slip decoration begins with covering the upper surface of the dish or plate with a background slip. This could have been done by pouring on a base slip, but our research suggests that the Moravians applied their engobes with a brush (fig. 22). After the background slip is applied, trailing of the decoration begins (fig. 23). The concentric lines on the marly are applied using a banding wheel so the dish is easily rotated. The slip-trailing of Moravian potters was loose and flowing, with extensive use of floral motifs in the center of the dishes. Lines and zigzags were typically used on the marlys framing the central compositions.

The lines of slip defining the floral or geometric elements come next, followed by filling in of the leaves and petals with different color slips. The completed dish has to dry completely before being bisque-fired (fig. 24). After this initial firing, the dish is covered in a glaze before the final firing. Many of the Moravian plates were fired on edge, so that copper and manganese colorants washed out of the slips in one direction.

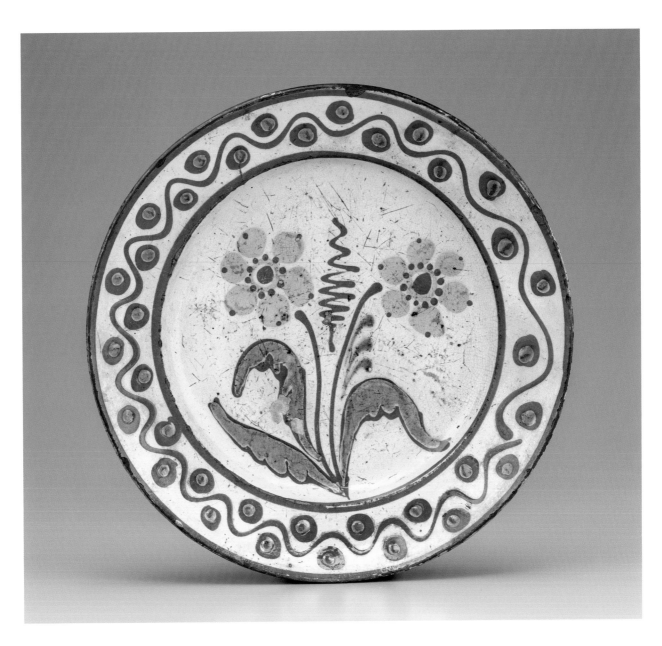

Figure 17 Dish, probably made during
Rudolph Christ's tenure as master of the
pottery at Salem, North Carolina, 1790–
1810. Lead-glazed earthenware. D. 12½".
(Courtesy, Old Salem Museums &
Gardens.)

Figure 18 The process of forming a Moravian-style dish begins on the wheel with the raising of a broad cylinder. The contours of the piece are shaped with a combination of hands and a rib.

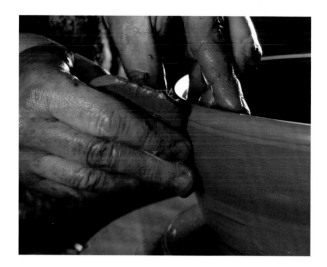

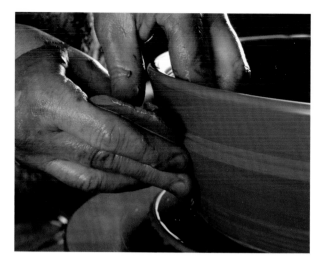

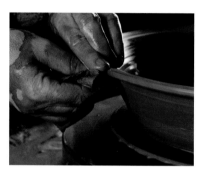

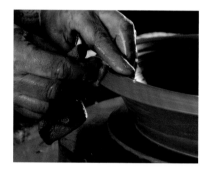

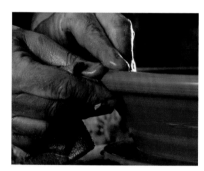

Figure 19 The original Moravian dish has a very distinctive rolled rim, a diagnostic trait on antique examples. This procedural sequence shows such a rim being created, by folding over a substantial amount of clay at the top. The edge comes to a peak before being rolled and rounded.

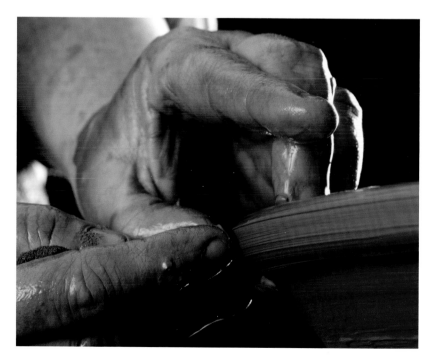

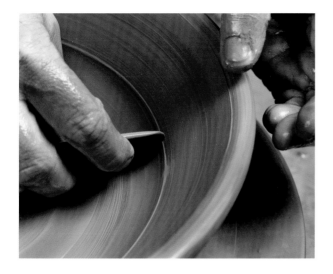

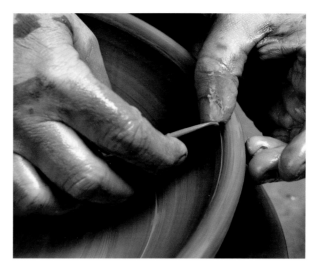

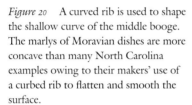

Figure 20 A curved rib is used to shape the shallow curve of the middle booge. The marlys of Moravian dishes are more concave than many North Carolina examples owing to their makers' use of a curbed rib to flatten and smooth the surface.

Figure 21 The finished thrown and shaped dish.

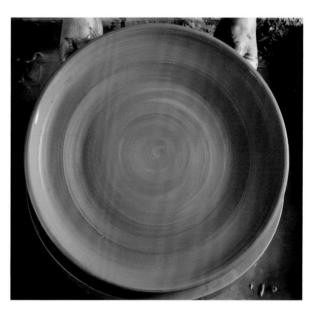

Figure 22 After the dish has dried to a leather-hard state, a base coat of cream-colored slip is applied with a brush. Four coats of the base slip are used, with very short drying time between each coat, in order to have a solid base color.

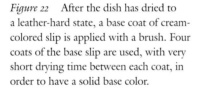

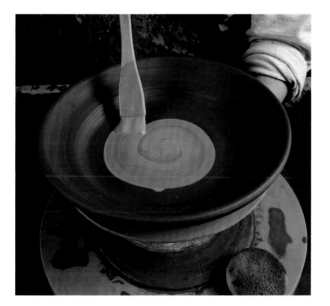

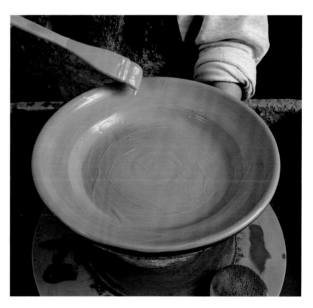

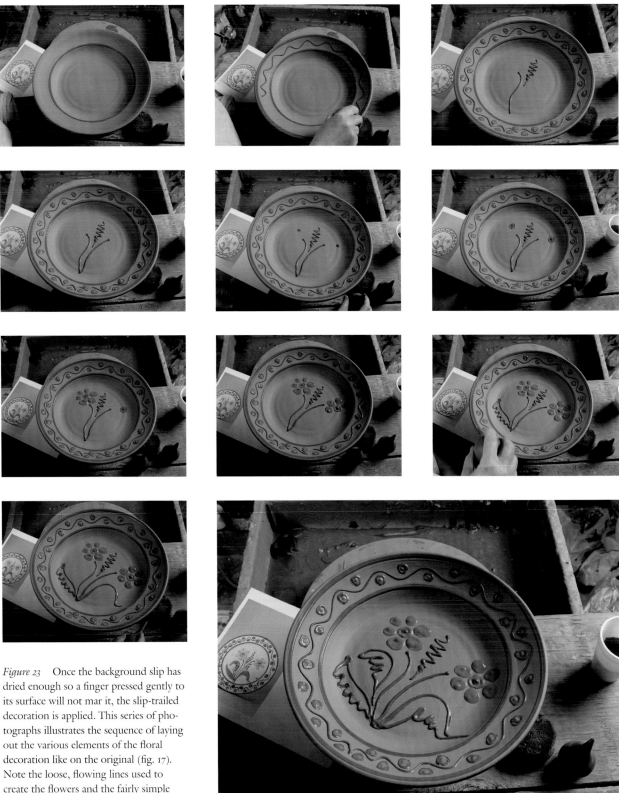

Figure 23 Once the background slip has dried enough so a finger pressed gently to its surface will not mar it, the slip-trailed decoration is applied. This series of photographs illustrates the sequence of laying out the various elements of the floral decoration like on the original (fig. 17). Note the loose, flowing lines used to create the flowers and the fairly simple rim pattern. The application of the slip is sketchlike and can be completed in a matter of minutes.

Figure 24 The replica Moravian plate, shown next to a photograph of the original, is left to dry before being bisque-fired. After being coated with lead glaze, the dish is given a final firing.

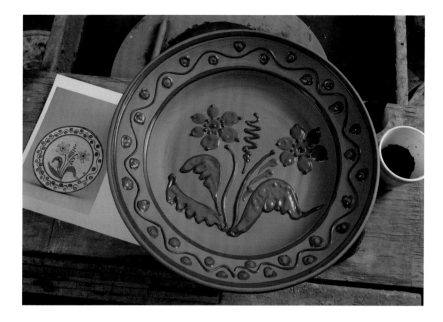

The slip-decorated dish illustrated in figure 25 has a purple-black ground, which is typical of late-eighteenth- and early-nineteenth-century work from the St. Asaph's tradition. The body is thrown on the wheel and, as in the Moravian tradition, the rim turned over, though using a smaller amount of clay (fig. 26). The rolled rims on dishes by this St. Asaph's potter are not as undercut as those on most Moravian examples. When seen from the side, his rims also have a straighter edge.

The interior profile of many Alamance County dishes is bowl-like, with a gradual but continual curve between the bottom and marly (fig. 27). Dishes by the potter responsible for figure 25 have a double booge, but their profiles differ from those of comparable Moravian examples. The bottom of his dish is small, with a large section leading up to the marly, and the proportion of plate bottom to marly size is much smaller than in Moravian work. The marlys of dishes by this potter are also not as curved as those made by the Moravians, although they do turn upright at the edge. When forming the marlys of dishes like the example illustrated in figure 25, I use

Figure 25 Dish, Alamance County, North Carolina, 1790–1820. Lead-glazed earthenware. D. 10½". (Colonial Williamsburg Foundation.)

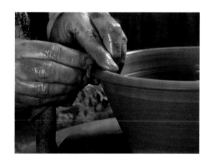
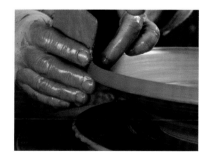

Figure 26 Procedural sequence showing the formation of the marly and rim on a replica of the Alamance County dish illustrated in fig. 25. A fairly small amount of clay is folded over and sealed against the underside of the plate. The rim has a relatively straight profile, and on the top surface only the edge curls up slightly.

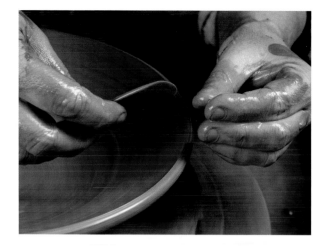

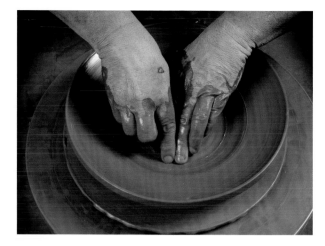

Figure 27 The Alamance County dish had a small base, a fairly large and steep middle booge, and an upper rim with a curve just at the top edge. The base-to-upper-rim proportion is small.

Figure 28 The inside is coated with black slip. The distinctive shape of this potter's dishes can be readily seen in this photograph.

a relatively flat rib, and right at the end I curve the edge using my fingers and the rib.

Once the dish is thrown and completely formed, the dark background slip is applied. This engobe is poured into the interior of the dish and the excess poured off (fig. 28). Evidence for this can be found in the drip runs on the back of the dish illustrated in figure 25 and on other Alamance County examples. The slip-trailing on this Alamance County potter's work is done with short strokes (fig. 29), making it appear less flowing than some work by the Moravians. The marlys on his dishes are usually elaborate (fig. 30), and this example has the highly unusual addition of marbleized lozenges (figs. 31, 32).

Like their Moravian counterparts, the St. Asaph's dishes were fired twice (fig. 33). Several Alamance County examples appear to have been fired upside down with a post in the center, which leaves a central scar and outward radiating washes of copper and manganese colorants from the slips. This is most visible on the marlys.

Figure 29 Concentric lines of slip are applied to the replica Alamance County dish after the background slip has been allowed to dry somewhat.

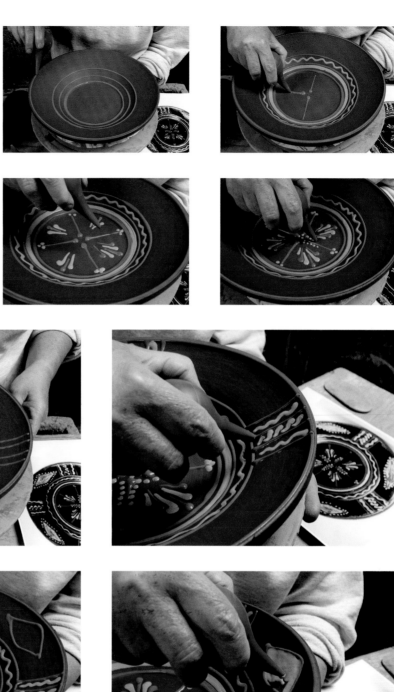

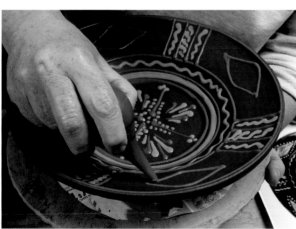

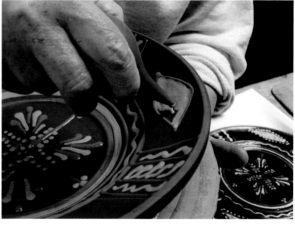

Figure 30 The Alamance County potter whose work is being replicated here typically used more elaborate marly decoration than his Moravian contemporaries. He apparently began trailing in the center, then worked his way out. The lozenge-shaped elements are laid out in red slip then filled with white slip.

Simple yet effective decorative techniques are also manifest in Alamance County earthenware. Some examples have crude, seemingly random brush swipes of slips and oxides, a free-form technique that enhances their charm. The level of skill and artistic vision vary so much within this group of wares that it is almost certainly the work of several potters.

Figure 31 Dots of red slip are placed systematically on the white ground of the lozenges.

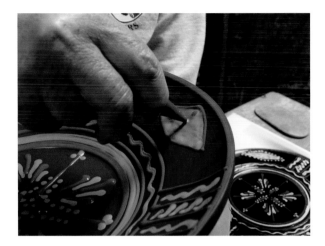
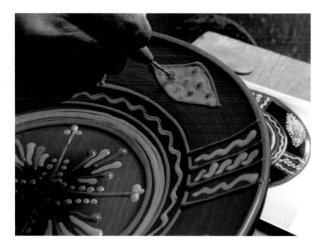

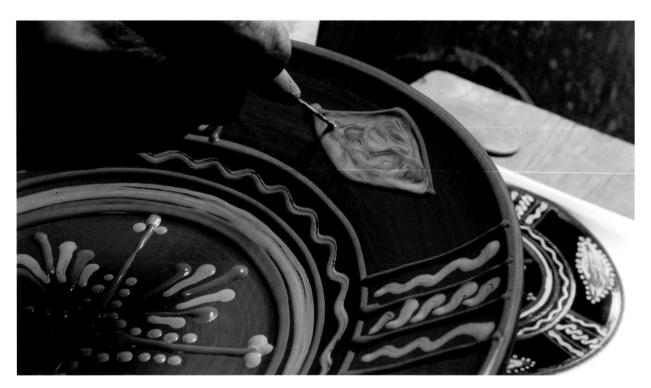

Figure 32 A needle tool is used to create the marbled effects by swirling the dots of red slip into the wet white ground.

One distinctive technique documented in use by Alamance County potter Solomon Loy consisted of dripping polychrome slip directly on the clay body or on black or cream-white slip backgrounds. Several antique specimens of this type of decoration survive, including small bowls, mugs, saucers, dishes, a vase, and a fat lamp. For demonstration purposes, a small bowl attributed to Solomon Loy was selected for replication (fig. 34). This thrown bowl has a purple-black engobe, which was applied by pouring

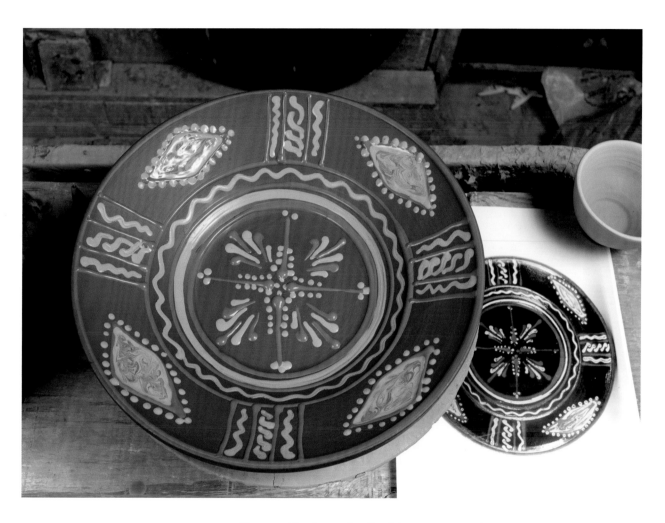

Figure 33 The decorated replica dish, shown next to a photograph of the original, is left to dry before being bisque-fired. After being coated with lead glaze, the dish is given a final firing. The heat from the firing and the addition of lead glaze will change the colors of the slips close to those of the original dish illustrated in fig. 25.

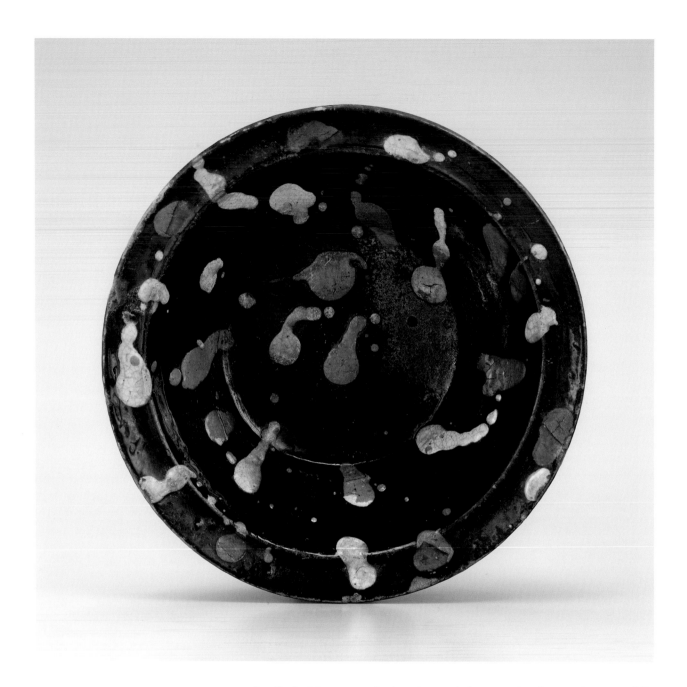

Figure 34 Bowl, attributed to Solomon Loy, Alamance County, North Carolina, 1825–1840. Lead-glazed earthenware. D. 6¼". (Private collection.)

the slip inside to coat the interior, and then pouring it out (fig. 35). While the ground slip was still wet, drops of various colored slips were applied to the surface (fig. 36). The result is a very abstract pattern of colors and shapes, creating a decorative treatment that appears almost modern (fig. 37). While the pattern seems somewhat random, Loy was able to control the application of the slips to create an aesthetic that must have been valued by his customers and continues to be admired by today's collectors.

The orientation of wares during the process of slip-trailing often varied from form to form or hand to hand. On some vessels a portion of the decoration was applied with the piece upright and a portion with it upside down, a combination that becomes evident when replicating old wares. Since it is difficult to maintain the gravitational flow of trailed slip on an

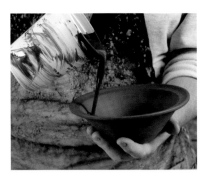

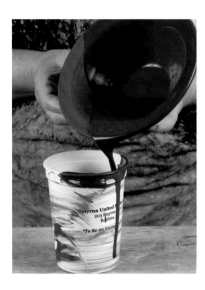

Figure 35 Slip is poured inside the leather-hard bowl to coat the surface, then the excess is poured out.

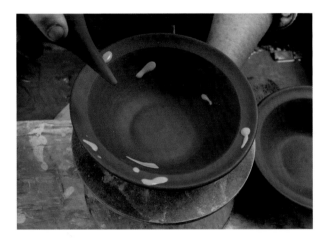

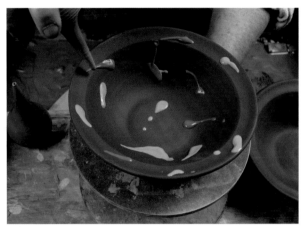

Figure 36 Dripping various colors of slip is a technique associated with Solomon Loy. This process takes only a few seconds.

Figure 37 On some period examples, it is apparent that the piece was rotated slowly during the application of the slip, which gave the drops a slight curve.

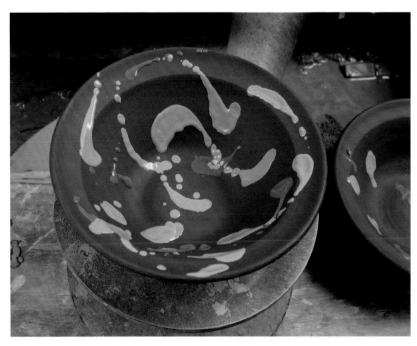

Figure 38 Bowl, Alamance County,
North Carolina, 1790–1820. Lead-glazed
earthenware. H. 3". (Private collection.)

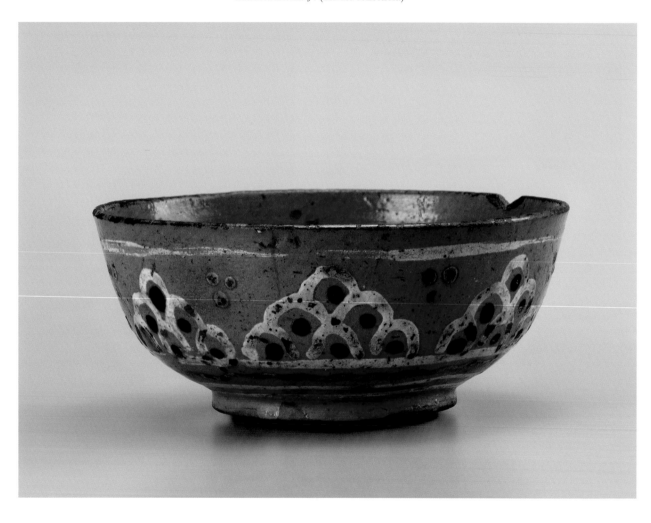

undercut, some bowls were decorated upside down. A good example of this is the small Alamance County bowl shown in figure 38. In replicating the bowl, the interior and exterior are first covered in an orange slip (fig. 39). The bowl is then turned upside down on a banding wheel to have the trailed decoration applied (figs. 40, 41).

In this brief discussion of decorating styles on North Carolina pottery, I have included examples of slip-trailing directly on the clay body, slip-trailing on engobes, and the dripping of slips. Other techniques that appear in the North Carolina repertoire include sponging of slips and oxides and, on a small group of dishes, sgraffito. Teabowl fragments from the Mount Shepherd pottery site illustrate several of these decorative finishes (fig. 42). From this fragmentary example, we were able to determine

Figure 39 A bowl, still damp, is dipped in orange slip that is only slightly different in color from the clay the piece is made from. The bowl is then allowed to dry a bit before being slip-trailed.

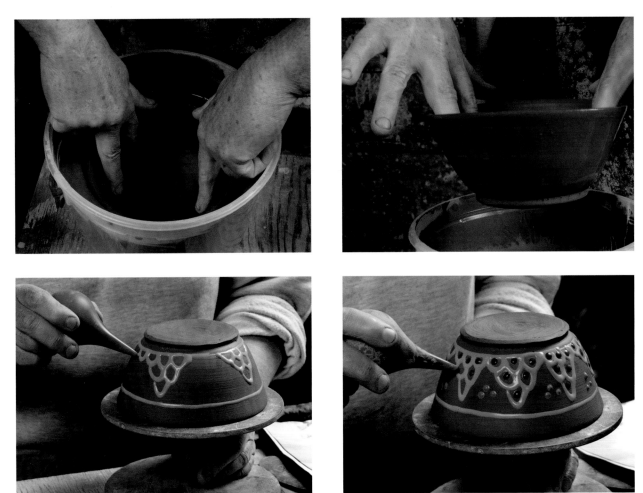

Figure 40 The bowl is placed upside down on a banding wheel and decorated with cream, green, and dark brown slips. By trial and error, we realized the original bowl (fig. 38) was slip-trailed while upside down rather than right side up.

Figure 41 The replica bowl, just after
being slip-trailed. When the piece is dry, it
will be bisque-fired, then covered with a
clear-firing lead glaze for the final burning.

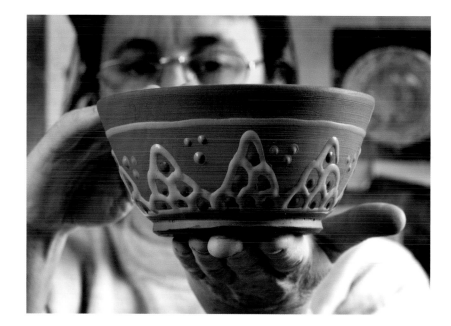

Figure 42 Teabowl fragments recovered
at the Mount Shepherd pottery site, Ran-
dolph County, North Carolina, 1793–1800.
Lead-glazed earthenware. (Courtesy,
Mount Shepherd Collection, Mount
Shepherd Retreat Center.)

that this red-bodied teabowl was dipped on both the interior and the
exterior with a white-colored slip (figs. 43, 44). Unlike the other objects
presented in this article, the slip on the teabowl had to dry before the
additional oxides were both sponged and brushed onto the surface
(figs. 45, 46). The finish on this teabowl is very unusual for North Carolina
pottery and undoubtedly was intended to mimic English teabowls done in
the style of Thomas Whieldon (1719–1795). Similar techniques were
employed by the Salem and Bethabara potters in their versions of these
"finewares."[6]

All early North Carolina slipware was allowed to dry after having been
decorated, then bisque-fired before being covered in a lead glaze. The

Figure 43 Light-colored slip is poured into a Mount Shepherd–style teabowl while it is still damp. Excess slip is poured out and wiped off the exterior. The wet slip makes the bowl very moist, which could cause the form to collapse, so the bowl is allowed to dry somewhat before the exterior slip is applied.

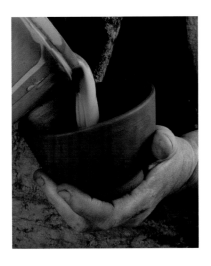

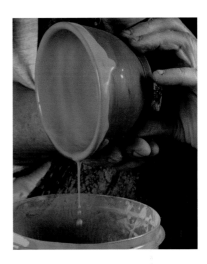

Figure 44 After a period of drying, the outside of a Mount Shepherd–style teabowl is dipped in the light-colored slip.

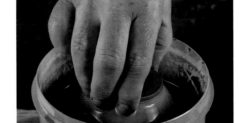

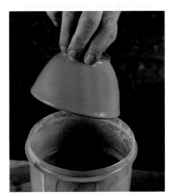

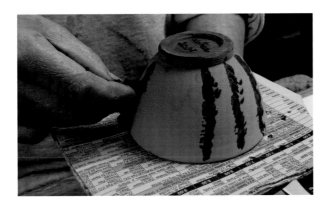

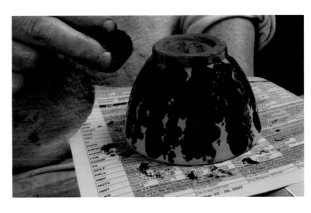

Figure 45 On the Mount Shepherd-style teabowl, the slip background is allowed to air-dry completely before the initial decoration is sponged onto the surface in alternating bands. This ensures that the applied copper and manganese oxides will be properly absorbed into the surface.

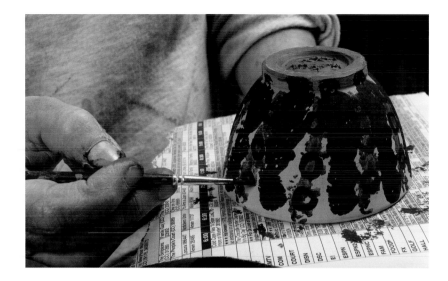

Figure 46 Once the sponging is completed, a brush is used to apply small circles of manganese oxide and water over the copper oxide bands, as seen on the original specimen.

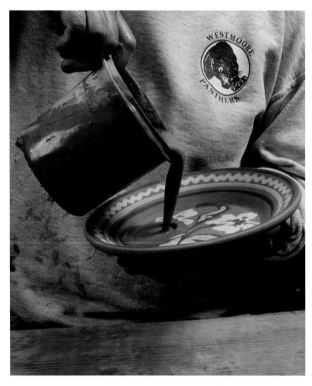

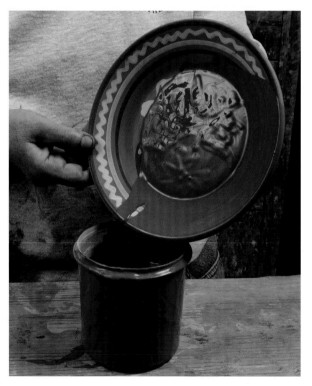

Figure 47 After the decorated wares are bisque-fired, the final glaze is applied by pouring and/or dipping. During the second firing, this glaze will melt to form a clear glass, allowing the decoration underneath to show through. Unlike period examples, the glaze being applied here is lead-free, so the finished piece can be used safely with food.

glaze, consisting of slip and lead oxides, was applied in liquid form by either pouring or dipping, creating an opaque covering (fig. 47). During firing, the glaze converts to a layer of glass, which fuses to the body. (In the interest of safety and usability, we have developed a lead-free glaze for all of our pieces at Westmoore Pottery.)

With these few replicated examples, some insights into the production and decorating techniques used by North Carolina piedmont potters can be gained. Ceramic historians often describe technical aspects of pottery that they might be ill equipped to understand. Through the actual process of replication, working potters can make valuable contributions to our understanding of historical pottery.

North Carolina has played an important role in the history of American pottery for many years. Potters who worked in North Carolina from the 1750s to the mid-nineteenth century, some highly skilled and some less so, have left us a great legacy. The best of their surviving wares certainly hold their own when compared with pottery from any region of our country. Even pots made by less skilled hands can teach us something about those potters, their lives, and the lives of their neighbors. My learning about this pottery has been ongoing for more than thirty years—a study made with my eyes and my hands, and very dependent on the research of others. I look forward to the knowledge I will gain with each year ahead.

ACKNOWLEDGMENTS Much of my education over the years has come from conversations with many people, among them Luke Beckerdite, John Bivins, Johanna Brown, Linda Carnes-McNaughton, Ron and Gwen Griffith, William Ivey, Paula Locklair, and Hal Pugh and Eleanor Minnock-Pugh.

1. John Bivins Jr., *The Moravian Potters in North Carolina* (Chapel Hill: University of North Carolina Press for Old Salem, Inc., 1972).

2. L. McKay Whatley, "The Mount Shepherd Pottery: Correlating Archaeology and History," *Journal of Early Southern Decorative Arts* 6, no. 1 (May 1980): 21–57.

3. Bivins, *Moravian Potters in North Carolina*.

4. Linda F. Carnes-McNaughton, "Transitions and Continuity: Earthenware and Stoneware Pottery Production in Nineteenth-Century North Carolina" (Ph.D. diss., University of North Carolina at Chapel Hill, 1997).

5. Hal E. Pugh, "The Quaker Ceramic Tradition in the North Carolina Piedmont: Documentation and Preliminary Survey of the Dennis Family Pottery," *The Southern Friend* 10, no. 2 (Autumn 1988): 1–26; and Carnes-McNaughton, "Transitions and Continuity."

6. See Robert Hunter, "Staffordshire Ceramics in Wachovia," in *Ceramics in America*, edited by Hunter and Luke Beckerdite (Hanover, N.H.: University Press of New England for the Chipstone Foundation, 2009), pp. 81–104.

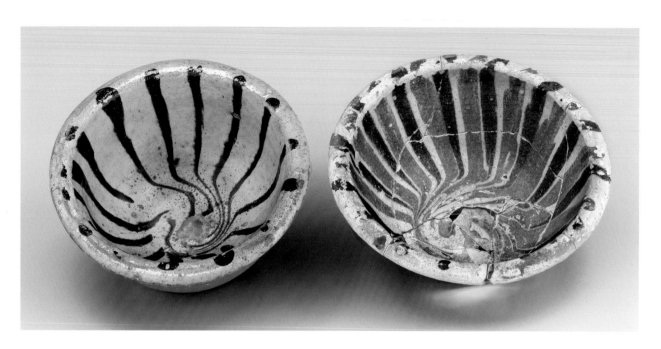

Figure 1 Slipware bowls, North Carolina. Lead-glazed earthenware. *Left*: Bethabara or Salem, 1770–1790. D. 6". (Private collection.) *Right*: recovered at the site of the gunsmith's shop at Bethabara, 1787–1789. (Courtesy, Historic Bethabara Park; unless otherwise noted, photos by Gavin Ashworth.)

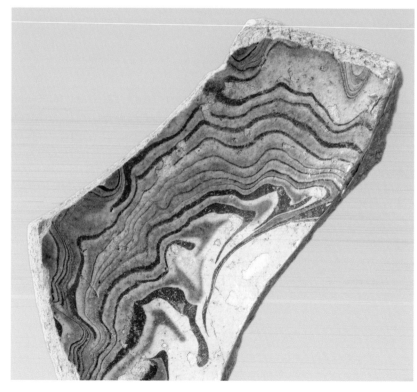

Figure 2 Slipware bowl fragment recovered at Gottlob Krause's pottery site, Bethabara, North Carolina, 1790–1800. Bisque-fired earthenware. (Courtesy, Historic Bethabara Park.)

Michelle Erickson
and Robert Hunter

Making a Marbled
Slipware Bowl

▼ O N E O F T H E M O S T distinctive decorated vessel types asso-
ciated with eighteenth-century Moravian pottery is a small, deep-sided
bowl with marbleized decoration made using two or more colors of con-
trasting slips. The best surviving prototype is a nearly complete example
excavated from the gunsmith's site in the Bethabara community (fig. 1).
The shape of the thrown form is unlike English examples of the period and
must relate to a Germanic bowl type. Fragments of these slip-decorated
bowls have been excavated from the pottery sites in both Bethabara and
Salem (fig. 2).[1] Most important, perhaps, is the discovery of fragments of
nearly identical bowls at the Mount Shepherd pottery of Philip Jacob
Meyer, a former apprentice of Gottfried Aust (fig. 3).[2]

The appearance of these slip-decorated bowls stands in pronounced con-
trast to the carefully trailed floral designs characteristic of the Moravian
decorative oeuvre. The deep-sided bowls are distinguished by the use of
alternating bands of colored slip poured over a white slip that run downward
from the lip of the rim and flow into the bottom. The bowl is then moved
in a swirling motion to create a marbled pattern from the free-flowing slips.
The use of two or more colors of slip to simulate marble patterning has its
origins in antiquity, and British and European potters made great use of
the technique in the seventeenth and eighteenth centuries.[3] European par-
allels for creating a marbled slipware pattern abound, and the decorative style
exemplified by the Moravian bowl has definite Germanic/Netherlandish

Figure 3 Slipware bowl fragments,
recovered at the Mount Shepherd pottery
site, Randolph County, North Carolina,
1793–1800. (Courtesy, Mount Shepherd
Collection, Mount Shepherd Retreat
Center.) These marbleized fragments are
nearly identical to those excavated at
Bethabara.

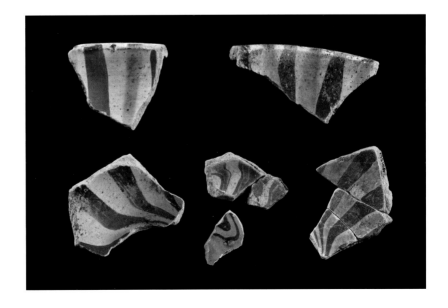

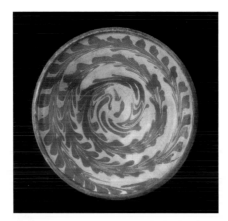

Figure 4 Dish, Netherlands, late-seventeenth century. Lead-glazed earthenware. D. 12¾". (Courtesy, Chipstone Foundation.) This example shows the use of slip with a technique similar to that used at the William Rogers pottery in Yorktown, Virginia.

Figure 5 Fragmentary dish recovered at the William Rogers pottery site, York-town, Virginia, 1720–1745. Lead-glazed earthenware. D. approx. 13". (Courtesy, National Park Service, Colonial National Historical Park, Yorktown Collection.) Among several large fragments recovered from the Rogers site is this partially reassembled dish. The technique used to create the marbled pattern is similar to that used by the North Carolina Moravian potters.

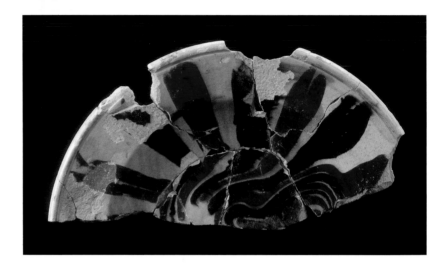

traits (fig. 4). Yet a surprising American precedent for this pattern is found at the William Rogers kiln site at Yorktown, Virginia (fig. 5).

The Rogers pottery produced earthenware and stoneware in the English style from about 1720 to about 1745. Some of the artifacts found there, including stove tiles and, more specifically, Germanic-style slipwares, suggest that Rogers employed potters with that training. No historical evidence has been found regarding the identity or nationality of Rogers's potters, however, and the making of Germanic-style stove tiles and marbled slipware in Yorktown some twenty years or more before the settlement of Bethabara remains a mystery. It does, however, underscore the popularity of decorative marbling in utilitarian slipware.

The recent reevaluation of Moravian slipware decoration has revealed a connection between the floral motifs used and the religious sect's cosmology.[4] In fact, new research suggests that the slip-trailed techniques used by Moravian potters might have been restricted to plates and dish forms made primarily for display rather than daily use. The marbled bowl, however, is radically different from such carefully drawn floral chargers, as are the colors and clays used to form it.

The symbolic significance of the marbled decoration to the Moravians is unknown, though the exuberantly styled bowls probably served a utilitarian

function. Marbelized fragments excavated at Bethabara indicate that Gottfried Aust might have been responsible for introducing the technique into the Moravian workshops. Comparable fragments found in Salem and Bethabara demonstrate that he and/or his apprentices were also making these bowls there from about 1771 into the early 1800s. In addition, Philip Jacob Meyer, a former Aust apprentice who worked at Salem from 1786 through 1788, used an identical technique at his pottery, in Randolph County, North Carolina (fig. 3).

Previous explanations of the process utilized to decorate these bowls have suggested that the slip lines were "combed" by dragging bristles or a stylus through them, a description that is both inaccurate and misleading.[5] In fact, the marbling is achieved solely with the potter's skill and the effects of gravity, as will be demonstrated by our re-creation.

The bowls from Bethabara, Salem, and Mount Shepherd are steep-sided, thrown on the wheel in a buff-colored clay with a slightly rounded rim and a flat bottom, having been cut directly from the wheel. The bowls would have been thrown in batches, perhaps several dozen at a sitting, and allowed to dry to a leather-hard state (fig. 6).

Figure 6 The deep-sided bowls are thrown on the wheel in a white earthenware and allowed to dry to a leather-hard state.

Figure 7 White slip is poured into the interior of a leather-hard bowl and then poured off, leaving a wet coating on the surface.

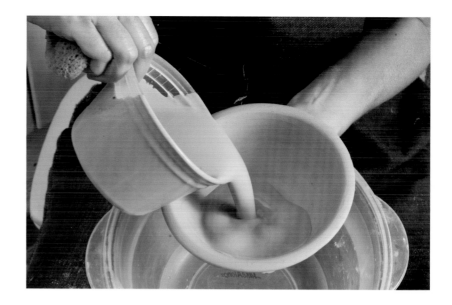

Although the marbled pattern looks random, in fact it requires carefully prepared batches of slip and a measure of control by the potter. The essential element of creating marbled decoration is the viscosity of the various colored slips—too thin and the mixtures are uncontrollable, too thick and the slips will not flow.

The interior of the leather-hard bowl is first coated with a fine white ground slip (fig. 7). In addition to the white ground, slips of two colors were normally used on the Moravian examples: a reddish brown and a green made from copper oxides. For demonstration purposes, a red slip and a dark brown slip were used for this article.

While the ground slip coating is very wet, colored slips are dropped from the rim and allowed to flow naturally to the bottom of the bowl. The first color is applied around the perimeter of the rim at intervals (fig. 8), then the second color is dropped between the previously applied lines (fig. 9).

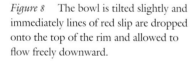

Figure 8 The bowl is tilted slightly and immediately lines of red slip are dropped onto the top of the rim and allowed to flow freely downward.

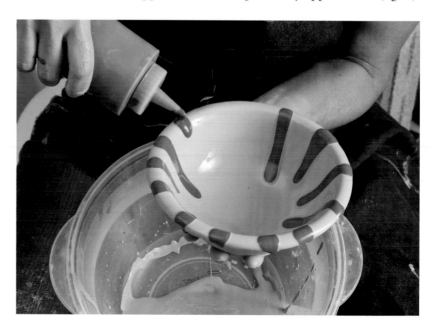

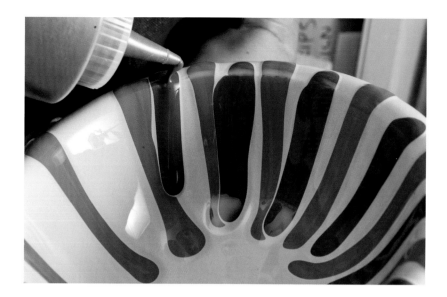

Figure 9 A second series of brown slip lines are placed between the red slip lines.

The application of the slip lines is necessarily a quick procedure, since gravity is utilized to create the lines, not any action by the potter.

The bottom of the bowl is now saturated with three colors of slip: the white ground and the brown and red lines (fig. 10). At this point, the potter

Figure 10 All of the red and brown lines have been dropped. The white-colored ground slip and the slip lines are still quite wet and fluid.

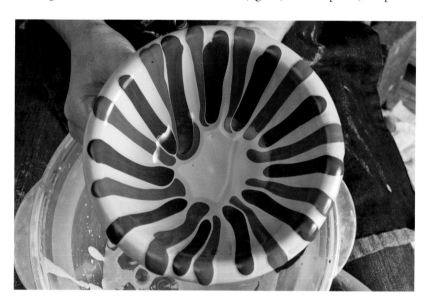

Figure 11 The bowl is tipped and rotated to swirl the slip lines at the bottom of the bowl. This must be done before the slips become too dry to flow easily.

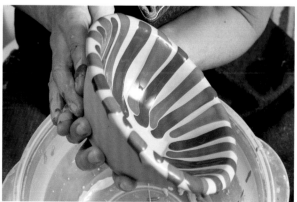

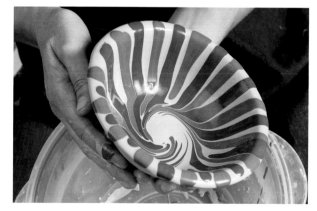

retakes control of the patterning by rotating and tipping the bowl to permit the slips to swirl around the bottom of the bowl (fig. 11). The swirling process takes place in a matter of seconds as the slips begin to dry (fig. 12). The two intact antique bowls illustrated in figure 1 as well as the replications show that the potter could make the swirling go in either a clockwise or a counterclockwise direction (fig. 13).

Figure 12 When the marbling effect is complete, the bowl is allowed to dry thoroughly before the bisque firing.

Figure 13 A group of marbled bowls in the wet state surrounds the archaeological specimen recovered from Bethabara illustrated in fig. 1. There is inherent variation in all these examples, including the clockwise and counterclockwise swirl of the slip lines. This technique is a quick but effective means of creating repetitive yet individualized decoration.

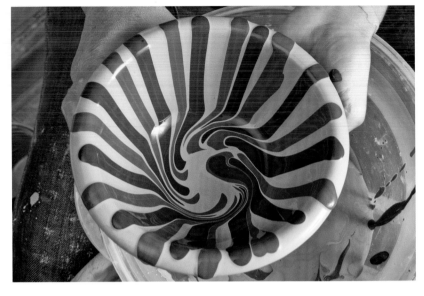

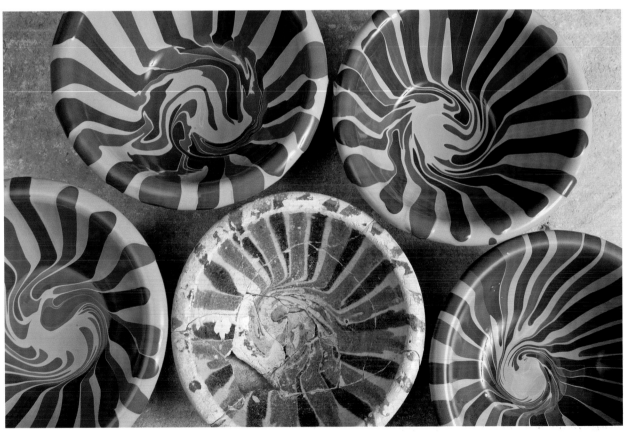

Once the slip decorating is completed, the bowls are air-dried, bisque-fired, and then covered in a lead glaze for the final gloss-firing.

It is hoped that the demonstration of the marbled slip decorating technique used by the Moravian potters will help future researchers recognize and better understand new examples that might arise from archaeological contexts or in the antiques market. Thus far, this technique—in the Moravian context—has been found only on very specific bowl forms and used only on the interior surface, although it also would have worked well on flat plates and dishes, as exemplified on the earlier examples made at the William Rogers pottery in Yorktown. Why the marbling technique was limited to the Moravian bowl forms remains an unanswered question.

Also unknown is how these bowls functioned in the Moravian community. Were they simply decorative utilitarian vessels? Perhaps they were intended for very specific kinds of foods, such as desserts or puddings. Whatever the case, a great deal of preparation went into creating such graphically appealing products.

1. Stanley South, *Historical Archaeology in Wachovia: Excavating Eighteenth-Century Bethabara and Moravian Pottery* (New York: Kluwer Academic/Plenum Publishers, 1999), pp. 226–34; John Bivins Jr., *The Moravian Potters in North Carolina* (Chapel Hill: University of North Carolina Press for Old Salem, Inc., 1972), pp. 220–23.

2. L. McKay Whatley, "The Mount Shepherd Pottery: Correlating Archaeology and History," *Journal of Early Southern Decorative Arts* 6, no. 1 (May 1980): 21–57.

3. Michelle Erickson and Robert Hunter, "Dots, Dashes, and Squiggles: Early English Slipware Technology," in *Ceramics in America*, edited by Hunter (Hanover, N.H.: University Press of New England for the Chipstone Foundation, 2001), pp. 94–114; Mary Wondrausch, *Mary Wondrausch on Slipware: A Potter's Approach* (London: A&C Black, 1986); Erickson and Hunter, "Dots, Dashes, and Squiggles," pp. 107–13.

4. Luke Beckerdite and Johanna Brown, "Eighteenth-Century Earthenware from North Carolina: The Moravian Tradition Reconsidered," in *Ceramics in America*, edited by Robert Hunter and Beckerdite (Hanover, N.H.: University Press of New England for the Chipstone Foundation, 2009), pp. 2–67.

5. See South, *Historical Archaeology in Wachovia*, p. 233; Bivins, *Moravian Potters in North Carolina*, p. 221; and Whatley, "Mount Shepherd Pottery," p. 28.

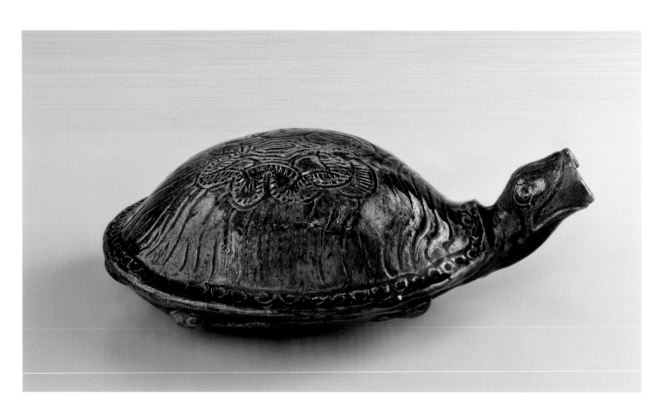

Figure 1 Turtle bottle, Salem, North
Carolina, 1800–1820. Lead-glazed earthen-
ware. L. 8½". (Courtesy, Old Salem
Museum & Gardens; unless otherwise
noted, photos by Gavin Ashworth.)
Rudolph Christ, the second master potter
of the Moravian settlement at Salem,
North Carolina, began making press-
molded figural bottles about 1800, the
year "turtles," first appear on the annual
pottery inventory.

Johanna Brown

A Recently Discovered Moravian Turtle Bottle

▼ THE PRESS-MOLDED figural bottles made in the Moravian pottery at Salem, North Carolina, in the nineteenth century are among the most iconic of American ceramics. Sold by the thousands in their own time, these objects continue to appeal to scholars and collectors today.[1] In 2009 Old Salem Museums & Gardens aquired a previously unrecorded example of a rare turtle bottle that reputedly came from the Poe family of Alamance County, North Carolina, about fifty miles east of Salem (fig. 1).

The Salem pottery made at least two types of turtle bottles in a variety of sizes.[2] The first type of molded bottle used an actual turtle shell as a model (fig. 2). The one extant mold and surviving bottles of this type show the plates from the turtle's shell clearly delineated. The size and domed profile of the shell—with a ridge along the center top—suggest that an Eastern box turtle served as the model.

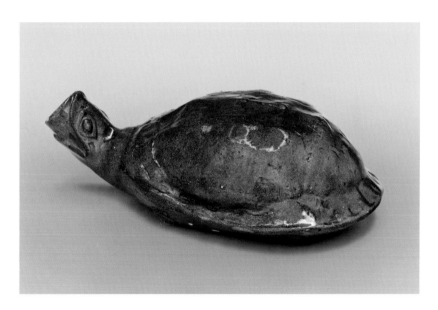

Figure 2 Turtle bottle, Salem, North Carolina, 1800–1850. Lead-glazed earthenware. L. 7¼". (Courtesy, Wachovia Historical Society.)

The second type of turtle bottle made by Salem potters was stylized after a pond slider or river cooter. The back of the shell has a carefully carved design reminiscent of some Native American representations of sun circles, with wavy lines radiating from a concentric central design, although the back plates of river cooters and some pond sliders exhibit similar markings (fig. 3). The bottom of the shell is much more flattened than that of an actual turtle and shows an exaggerated depiction of the turtle's nails (fig. 4). Until the discovery of the Poe family example, only three Moravian

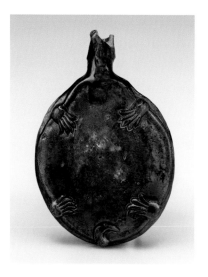

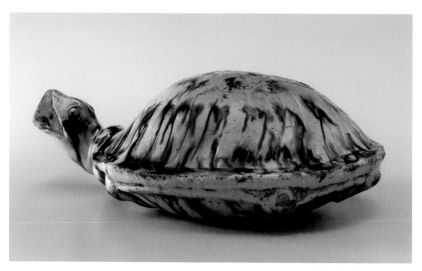

Figure 4 Detail of the bottom of the bottle illustrated in fig. 1.

Figure 5 Turtle bottle, Salem, North Carolina, 1800–1820. Lead-glazed earthenware. L. 8½". (Private collection.)

turtle bottles of this style were known: one other with a green glaze and two with a mottled glaze (fig. 5).

Collectors generally refer to Moravian press-molded bottles as flasks, although most are not glazed on the interior, precluding their use for holding liquid. Yet this new example is indeed glazed on the interior, suggesting it could have functioned for the storage of some type of liquid.

Old Salem Museums & Gardens has the most comprehensive collection of figural bottles and the molds from which they were made. With its family association and its history of having remained in North Carolina, not to mention its excellent condition and the clear, crisp design on its back and underside, this press-molded earthenware turtle is an important addition to the collection.

1. Johanna Brown, "Tradition and Adaptation in Moravian Press-Molded Earthenware," *Ceramics in America*, edited by Robert Hunter and Luke Beckerdite (Hanover, N.H.: University of New England Press for the Chipstone Foundation, 2009), pp. 105–38.

2. Inventory of the Pottery in Salem, April 30, 1800. Inventories for the years 1772–1829 are in file R701 at the Moravian Archives, Southern Province, Winston-Salem, North Carolina. Translations of most of the inventories are available in the Museum of Early Southern Decorative Arts Research Center, Winston-Salem.

Luke Beckerdite

A Unique Slip-
ware Barrel and
Related Dish:
Recent Finds from
the St. Asaph's
Tradition

▼ T H E 2 0 0 9 A N D 2 0 1 0 issues of *Ceramics in America* have
shown that North Carolina's earthenware tradition was far more diverse
than previously thought. Before the publication of those volumes, the slip-
decorated barrel illustrated in figure 1 would have been ascribed, with great

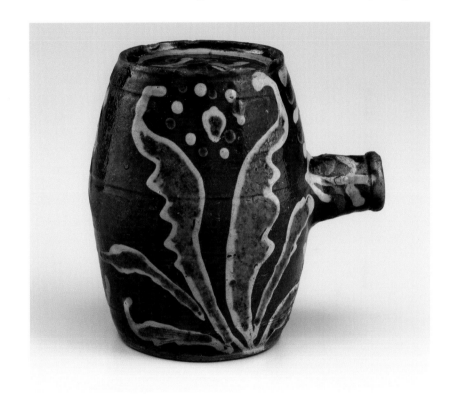

Figure 1 Front and side views of a barrel,
Alamance County, North Carolina,
1790–1820. Lead-glazed earthenware.
H. 6½". (Private collection; unless other-
wise noted, photos by Gavin Ashworth.)

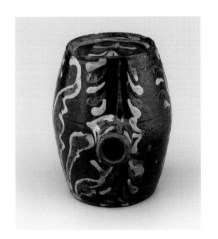
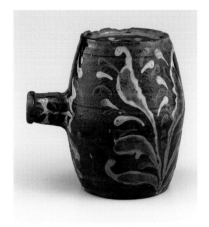

Figure 2 Dish, Alamance County, North Carolina, 1790–1820. Lead-glazed earthenware. D. 15¼". (Courtesy, Old Salem Museums & Gardens.)

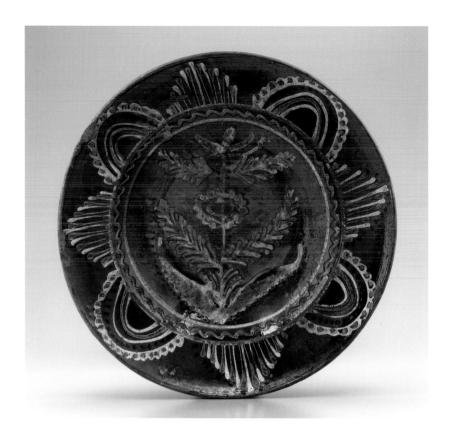

confidence, to Moravian potters, whose primary production sites were Bethabara and Salem. Indeed, a dish that may be by the same hand (fig. 2) was formerly attributed to Rudolph Christ, who served as master of the Bethabara pottery from 1786 to 1789 and master of the Salem pottery from 1789 to 1821.[1] Recent research indicates that these objects are part of a subgroup from the St. Asaph's tradition, which flourished in and around southern Alamance County from the mid-eighteenth to the mid-nineteenth century.

The barrel is the only known North Carolina example with slip trailing. Like the dish, it has a brown ground and polychrome designs that range from somewhat naturalistic to abstract. Both objects have leaves with serrated edges that are outlined with yellow slip and filled in with green. The barrel and dish also have motifs accented with jeweling, but the use of dot accents is much more extensive on the latter. The jeweling on the dish seems almost compulsive, running below the lower leaves on the cavetto and on either side of the stem above.

Although the dish and barrel could have had utilitarian functions, it is more likely that they were primarily decorative. If the barrel had been used as a container, it may have held dry goods rather than spirits, as the form would suggest. A smaller, undecorated barrel made in Salem contained pieces of tobacco when found.[2]

1. John Bivins Jr. attributed the dish to Christ in *The Moravian Potters in North Carolina* (Chapel Hill: University of North Carolina Press for Old Salem, Inc., 1972), p. 247, fig. 255.
2. Ibid., p. 122.

Hal E. Pugh and Eleanor Minnock-Pugh

The "Hannah" Dish

Figure 1 Dish, attributed to the Dennis potteries, New Salem, North Carolina, 1790–1832. Lead-glazed earthenware. D. 13". (Private collection; unless otherwise noted, photos by Gavin Ashworth.)

▼ ATTACHED TO THE dish illustrated in figure 1 is a note written by genealogist and historian W. C. Hinshaw and dated March 27, 1959, in which the object's descent through six generations of a North Carolina Quaker family is cited. The original owner appears to have been Hannah Piggott Davis (1774–1812), wife of Charles Davis (1771–1850) and daughter of Benjamin Piggott (1732–1818) and Mary Hadley (1739–1810). According to tradition, the dish was to be given to the next child named Hannah in the family.[1]

Hannah Piggott Davis and her family attended Cane Creek Friends Meeting in present-day Alamance County, North Carolina. Before her death in 1812, she presumably gave the dish to her daughter Hannah Davis (1804–1881), who in 1822 married Stephen Hinshaw (1797–1877), a member of Holly Springs Meeting, in Randolph County, North Carolina. Hannah Davis Hinshaw subsequently gave the dish to her daughter Hannah Hinshaw Bean (1842–1881). Upon Hannah Bean's death, the dish passed to her niece Hannah Cox Phillips (1847–1922).[2]

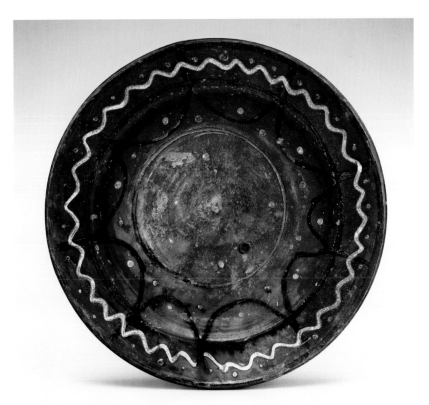

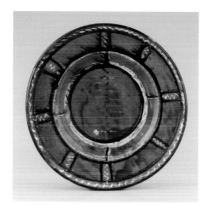

Figure 2 Dish, attributed to the William Dennis pottery, New Salem, North Carolina, 1790–1832. Lead-glazed earthenware. D. 13″. (Courtesy, Old Salem Museums & Gardens.)

The Hannah dish is lead-glazed and decorated with brown, white, and green slip. The most unusual feature is the brown slip swag that extends from the edge of the rim, crosses the marly, drapes down into the cavetto, then rises back in nine repeats. The swag was applied first, followed by the brown concentric lines, then the white wavy line and green and white dots. The dish is coated with a lead glaze containing iron and/or manganese, which, where the glaze is thin, produced a matte purplish tint. Where the glaze is thickest, the surface is glossy and a mottled honey color. Similar glazing can be observed on dishes from the Dennis potteries in New Salem, North Carolina, the likely production site for this remarkable find (fig. 2).[3]

1. Calvin Hinshaw, "The 'Hannah' Dish," March 27, 1959, typed card, private collection. William Wade Hinshaw, *Encyclopedia of American Quaker Genealogy*, 6 vols. (Baltimore, Md.: Genealogical Publishing Co., 1978), 1:349, 362.

2. Hinshaw typed card. Hinshaw, *Encyclopedia*, 1:468, 475, 484, 673.

3. See Hal E. Pugh and Eleanor Minnock-Pugh, "The Dennis Family Potters of North Carolina," pp. 140–67 in this volume.

Art in Clay:
Masterworks of North
Carolina Earthenware

1. Shop sign made during Gottfried Aust's tenure as master of the pottery at Salem, North Carolina, 1773. Lead-glazed earthenware. D. 21¾". (Wachovia Historical Society.)

2. Jug recovered at Gottfried Aust's pottery site, Bethabara, North Carolina, 1756–1770. Bisque-fired earthenware. H. 8¾". (Historic Bethabara Park.)

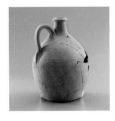

3. Dish recovered at Gottfried Aust's pottery site, Bethabara, North Carolina, 1756–1770. Lead-glazed earthenware. D. 12¼". (Old Salem Museums & Gardens.)

4. Dish fragments recovered at Gottfried Aust's pottery site, Bethabara, North Carolina, 1756–1770. Bisque-fired earthenware. (Historic Bethabara Park.)

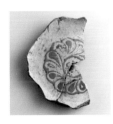

5. Dish fragments recovered at Gottfried Aust's pottery site, Bethabara, North Carolina, 1756–1770. Bisque-fired earthenware. (Historic Bethabara Park.)

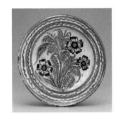

6. Dish, probably made during Gottfried Aust's tenure as master of the pottery at Salem, North Carolina, 1775–1785. Lead-glazed earthenware. D. 13¾". (Old Salem Museums & Gardens.)

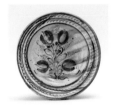

7. Dish, Salem, North Carolina, 1775-1795. Lead-glazed earthenware. D. 13". (Old Salem Museums & Gardens.)

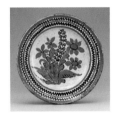

8. Dish, probably made during Gottfried Aust's tenure as master of the pottery at Salem, North Carolina, 1775–1785. Lead-glazed earthenware. D. 13¾". (Old Salem Museums & Gardens.)

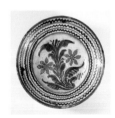

9. Dish, probably made during Gottfried Aust's tenure as master of the pottery at Salem, North Carolina, 1775–1785. Lead-glazed earthenware. D. 14⅛". (High Museum of Art.)

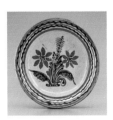

10. Dish, Salem, North Carolina, 1780–1800. Lead-glazed earthenware. D. 11⅝". (Old Salem Museums & Gardens.)

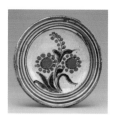

11. Dish, Salem, North Carolina, 1780–1800. Lead-glazed earthenware. D. 13¾". (Old Salem Museums & Gardens.)

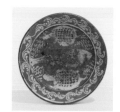

17. Dish, probably made during Gottfried Aust's tenure as master of the pottery at Salem, North Carolina, 1775–1785. Lead-glazed earthenware. D. 13". (The Henry Ford.)

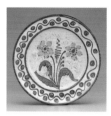

12. Dish, probably made during Rudolph Christ's tenure as master of the pottery at Salem, North Carolina, 1790–1810. Lead-glazed earthenware. D. 12½". (Wachovia Historical Society.)

18. Bowl recovered at the site of the gunsmith's shop at Bethabara, North Carolina, 1786–1789. Lead-glazed earthenware. D. 6". (Old Salem Museums & Gardens.)

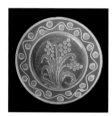

13. Dish, probably made during Rudolph Christ's tenure as master of the pottery at Salem, North Carolina, 1790–1810. Lead-glazed earthenware. D. 14". (Private collection.)

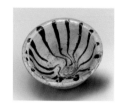

19. Bowl, Salem or Bethabara, North Carolina, 1780–1790. Lead-glazed earthenware. D. 6". (Private collection.)

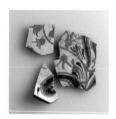

14. Dish fragments recovered at Gottlob Krause's pottery site, Bethabara, North Carolina, 1790–1800. Bisque-fired earthenware. (Historic Bethabara Park.)

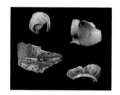

20. Waster fragments, John Bartlam, Cain Hoy, South Carolina, 1765–1770. Bisque-fired and lead-glazed earthenware. (South Carolina Institute of Archaeology and Anthropology.)

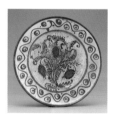

15. Dish, probably made during Rudolph Christ's tenure as master of the pottery at Salem, North Carolina, 1790–1810. Lead-glazed earthenware. D. 13½". (Old Salem Museums & Gardens.)

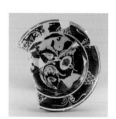

16. Fragmentary dish, Salem, North Carolina, 1790–1810. Lead-glazed earthenware. D. 9¼". (Old Salem Museums & Gardens.)

26. Sprig mold marked "RC" for Rudolph Christ, Salem, North Carolina, ca. 1780. High-fired clay. L. 2". (Old Salem Museums & Gardens.)

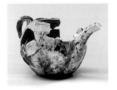

21. Teapot, Salem, North Carolina, 1774–1786. Lead-glazed earthenware. L. 7". (Old Salem Museums & Gardens.)

27. Plate fragments, Salem, North Carolina, 1774–1800. Lead-glazed earthenware. (Old Salem Museums & Gardens.)

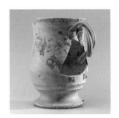

22. Mug, Salem, North Carolina, 1774–1786. Bisque-fired earthenware. H. 5⅞". (Old Salem Museums & Gardens.)

28. Plate fragment, Salem, North Carolina, 1774–1800. Lead-glazed earthenware. (Old Salem Museums & Gardens.)

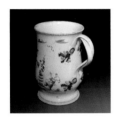

23. Mug, Staffordshire, England, 1770–1780. Lead-glazed earthenware. H. 5³⁄₁₆". (Colonial Williamsburg Foundation.)

29. Teapot fragments, Salem, North Carolina, 1774–1786. Lead-glazed earthenware. (Old Salem Museums & Gardens.)

24. Mug fragment adhered to a kiln prop, Salem, North Carolina, 1774–1786. Bisque-fired earthenware. (Old Salem Museums & Gardens.)

30. Teapot, Staffordshire, England, 1755–1775. Lead-glazed earthenware. H. 4½". (Old Salem Museums & Gardens.)

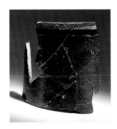

25. Mug fragment, Salem, North Carolina, 1774–1786. Lead-glazed earthenware. (Old Salem Museums & Gardens.)

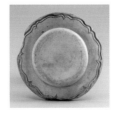

31. Mold inscribed "RC" for Rudolph Christ, Bethabara, North Carolina, 1789. Plaster. D. 10⅞". (Wachovia Historical Society.)

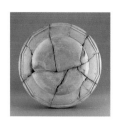

32. Mold inscribed "R.C. [for Rudolph Christ]/ Bethabara / Jan. 6 / 1789," Bethabara, North Carolina, 1789. Plaster. D. 10⅞". (Wachovia Historical Society.)

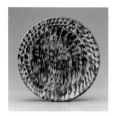

33. Dish recovered at Rudolph Christ's pottery site, Bethabara, North Carolina, 1786–1789. Lead-glazed earthenware. D. 9¾". (Historic Bethabara Park.)

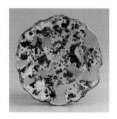

34. Dish, Salem or Bethabara, North Carolina, 1772–1800. Lead-glazed earthenware. D. 13". (Old Salem Museums & Gardens.)

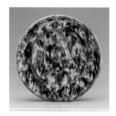

35. Saucer, Salem or Bethabara, North Carolina, 1772–1800. Lead-glazed earthenware. D. 6¼". (Old Salem Museums & Gardens.)

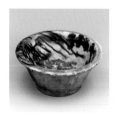

36. Bowl, Salem or Bethabara, North Carolina, 1772–1800. Lead-glazed earthenware. D. 6¼". (Old Salem Museums & Gardens.)

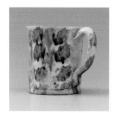

37. Mug, Salem or Bethabara, North Carolina, 1780–1800. Lead-glazed earthenware. H. 3½". (Old Salem Museums & Gardens.)

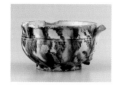

38. Porringer, Salem or Bethabara, North Carolina, 1780–1800. Lead-glazed earthenware. H. 3½". (Private collection.)

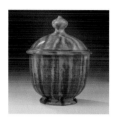

39. Sugar bowl, Salem or Bethabara, North Carolina, 1780–1800. Lead-glazed earthenware. H. 6". (High Museum of Art.)

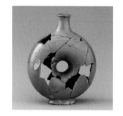

40. Ring bottle, Salem, North Carolina, 1793–1800. Tin-glazed earthenware. H. 8". (Old Salem Museums & Gardens.)

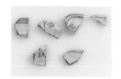

41. Plate fragments, Salem, North Carolina, 1793–1800. Tin-glazed earthenware. (Old Salem Museums & Gardens.)

42. Hollow-ware fragments, Salem, North Carolina, 1793–1800. Tin-glazed earthenware. (Old Salem Museums & Gardens.)

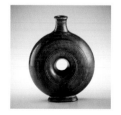

43. Ring bottle, Salem, North Carolina, 1795–1810. Lead-glazed earthenware. H. 5½". (Private collection.)

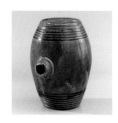

44. Barrel, Salem, North Carolina, 1790–1825. Lead-glazed earthenware. H. 8⅝". (Wachovia Historical Society.)

50. Lady bottle, Salem, North Carolina, 1806–1830. Lead-glazed earthenware. H. 7¾". (Private collection.)

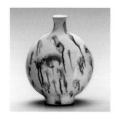

45. Bottle, Salem, North Carolina, 1790–1820. Lead-glazed earthenware. H. 6½". (Old Salem Museums & Gardens.)

51. Lady bottle, Salem, North Carolina, 1806–1830. Lead-glazed earthenware. H. 5½". (Old Salem Museums & Gardens.)

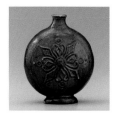

46. Bottle, Salem, North Carolina, 1800–1830. Lead-glazed earthenware. H. 6½". (Old Salem Museums & Gardens.)

52. Lady bottle, Salem, North Carolina, 1806–1830. Lead-glazed earthenware. H. 6¾". (Private collection.)

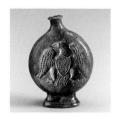

47. Eagle bottle, Salem, North Carolina, 1819–1830. Lead-glazed earthenware. H. 5½". (Old Salem Museums & Gardens.)

53. Turtle bottle, Salem, North Carolina, 1800–1820. Lead-glazed earthenware. L. 8½". (Private collection.)

48. Eagle bottle mold, Salem, North Carolina, 1819–1830. Plaster. H. 6½". (Wachovia Historical Society.)

54. Turtle bottle, Salem, North Carolina, 1800–1820. Lead-glazed earthenware. L. 8½". (Private collection.)

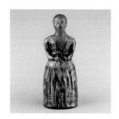

49. Lady bottle, Salem, North Carolina, 1806–1830. Lead-glazed earthenware. H. 9¼". (Old Salem Museums & Gardens.)

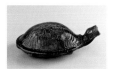

55. Turtle bottle, Salem, North Carolina, 1800–1820. Lead-glazed earthenware. L. 8½". (Old Salem Museums & Gardens.)

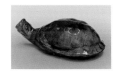

56. Turtle bottle, Salem, North Carolina, 1800–1820. Lead-glazed earthenware. L. 7¼". (Wachovia Historical Society.)

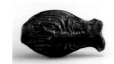

62. Crayfish bottle, Salem, North Carolina, 1801–1840. Lead-glazed earthenware. L. 4¼". (Old Salem Museums & Gardens.)

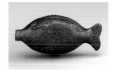

57. Fish bottle, Salem, North Carolina, 1801–1829. Lead-glazed earthenware. L. 9¾". (Old Salem Museums & Gardens.)

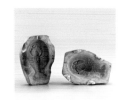

63. Crayfish bottle mold, Salem, North Carolina, 1801–1830. Plaster. L. 7½". (Wachovia Historical Society.)

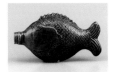

58. Fish bottle, Salem, North Carolina, 1801–1829. Lead-glazed earthenware. L. 6". (Old Salem Museums & Gardens.)

64. Squirrel bottle, Salem, North Carolina, 1804–1829. Lead-glazed earthenware. H. 8¼". (Private collection.)

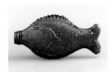

59. Fish bottle, Salem, North Carolina, 1801–1829. Lead-glazed earthenware. L. 4¾". (Old Salem Museums & Gardens.)

65. Squirrel bottle, Salem, North Carolina, 1804–1829. Lead-glazed earthenware. H. 8½". (Old Salem Museums & Gardens.)

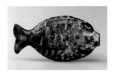

60. Fish bottle, Salem, North Carolina, 1801–1829. Lead-glazed earthenware. L. 8". (Private collection.)

66. Squirrel bottle, Salem, North Carolina, 1804–1829. Lead-glazed earthenware. H. 8¼". (Wachovia Historical Society.)

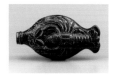

61. Crayfish bottle, Salem, North Carolina, 1801–1840. Lead-glazed earthenware. L. 6½". (Private collection.)

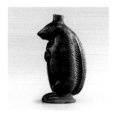

67. Squirrel bottle, Salem, North Carolina, 1804–1829. Lead-glazed earthenware. H. 8¼". (Old Salem Museums & Gardens.)

68. Squirrel bottle, Salem, North Carolina, 1820–1850. Lead-glazed earthenware. H. 6¼". (Old Salem Museums & Gardens.)

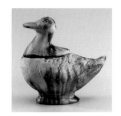

74. Duck tureen or sauceboat, Salem, North Carolina, 1819–1840. Lead-glazed earthenware. L. 7". (Old Salem Museums & Gardens.)

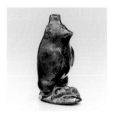

69. Bear bottle, Salem, North Carolina, 1810–1830. Lead-glazed earthenware. H. 6¾". (Old Salem Museums & Gardens.)

75. Chicken caster, Salem, North Carolina, 1810–1850. Lead-glazed earthenware. H. 4". (Old Salem Museums & Gardens.)

70. Fox caster, Salem, North Carolina, 1810–1830. Lead-glazed earthenware. H. 5½". (Old Salem Museums & Gardens.)

76. Bird figure, Salem, North Carolina, 1810–1820. Lead-glazed earthenware. L. 2¾". (Wachovia Historical Society.)

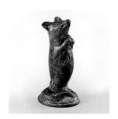

71. Fox caster, Salem, North Carolina, 1810–1830. Lead-glazed earthenware. H. 5½". (Private collection.)

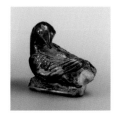

77. Bird figure, Salem, North Carolina, 1810–1820. Lead-glazed earthenware. L. 2½". (Old Salem Museums & Gardens.)

72. Owl bottle, Salem, North Carolina, 1804–1840. Lead-glazed earthenware. H. 7¾". (Old Salem Museums & Gardens.)

78. Wing mold for bird figure, Salem, North Carolina, 1810–1820. Plaster. L. 2¾". (Wachovia Historical Society.)

73. Owl bottle, Salem, North Carolina, 1804–1840. Lead-glazed earthenware. H. 5½". (Private collection.)

79. Leaf dish, Salem, North Carolina, 1807–1829. Lead-glazed earthenware. L. 8¾". (Colonial Williamsburg Foundation.)

80. Leaf dish mold, Salem, North Carolina, 1807–1829. Plaster. L. 9¾". (Wachovia Historical Society.)

86. Dish, probably Salem, North Carolina, 1775–1800. Lead-glazed earthenware. D. 11". (Old Salem Museums & Gardens.)

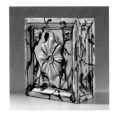

81. Flowerpot, Heinrich Schaffner, Salem, North Carolina, 1834–1860. Lead-glazed earthenware. H. 5". (Private collection.)

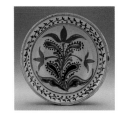

87. Dish, Friedrich Rothrock, Forsyth County, North Carolina, 1793–1800. Lead-glazed earthenware. D. 11⅝". (Old Salem Museums & Gardens.)

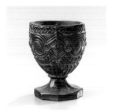

82. Stove tile, Salem or Bethabara, North Carolina, 1760–1800. Lead-glazed earthenware. H. 8⅝". (Old Salem Museums & Gardens.)

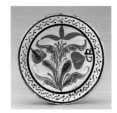

88. Dish, Friedrich Rothrock, Forsyth County, North Carolina, 1793–1800. Lead-glazed earthenware. D. 11". (Private collection.)

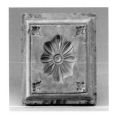

83. Stove tile mold, Salem or Bethabara, North Carolina, 1760–1800. High-fired clay. H. 9½". (Wachovia Historical Society.)

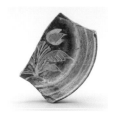

89. Dish fragment, Salem, North Carolina, 1780–1800. Lead-glazed earthenware. (Old Salem Museums & Gardens.)

84. Inkwell, John Holland, Salem, North Carolina, 1810–1813. Lead-glazed earthenware. W. 5". (Old Salem Museums & Gardens.)

90. Dish fragments recovered at the Mount Shepherd pottery site, Randolph County, North Carolina, 1793–1800. Lead-glazed earthenware. (Mount Shepherd Retreat Center.)

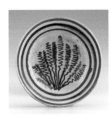

85. Dish, probably Salem, North Carolina, 1775–1800. Lead-glazed earthenware. D. 11". (Old Salem Museums & Gardens.)

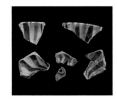

91. Bowl fragments recovered at the Mount Shepherd pottery site, Randolph County, North Carolina, 1793–1800. Lead-glazed earthenware. (Mount Shepherd Retreat Center.)

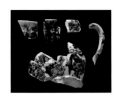

92. Porringer fragments recovered at the Mount Shepherd pottery site, Randolph County, North Carolina, 1793–1800. Lead-glazed earthenware. (Mount Shepherd Retreat Center.)

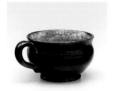

93. Porringer, Salem or Bethabara, North Carolina, 1780–1800. Lead-glazed earthenware. H. 3½". (Private collection.)

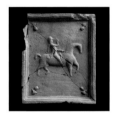

94. Stove tile, recovered at the Mount Shepherd pottery site, Randolph County, North Carolina, 1793–1800. Bisque-fired earthenware. 8⅝"(Mount Shepherd Retreat Center.)

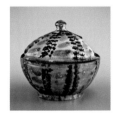

95. Sugar bowl, possibly Mount Shepherd pottery, Randolph County, North Carolina, 1793–1800. Lead-glazed earthenware. H. 5⅞". (Private collection.)

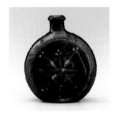

96. Flask, Alamance County, North Carolina, 1770–1790. Lead-glazed earthenware. D. 5⅜". (Old Salem Museums & Gardens.)

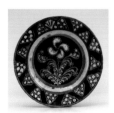

97. Dish, Alamance County, North Carolina, 1770–1790. Lead-glazed earthenware. D. 12½". (Old Salem Museums & Gardens.)

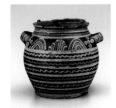

98. Sugar pot, Alamance County, North Carolina, 1770–1790. Lead-glazed earthenware. H. 8¼". (Old Salem Museums & Gardens.)

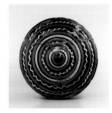

99. Sugar pot lid, Alamance County, North Carolina, 1770–1790. Lead-glazed earthenware. D. 7". (Old Salem Museums & Gardens.)

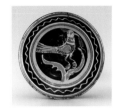

100. Dish, Alamance County, North Carolina, 1775–1795. Lead-glazed earthenware. D. 14⅞". (The Henry Ford.)

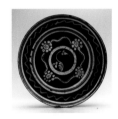

101. Dish, Alamance County, North Carolina, 1775–1795. Lead-glazed earthenware. D. 15½". (Old Salem Museums & Gardens.)

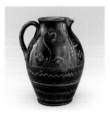

102. Pitcher, Alamance County, North Carolina, 1785–1810. Lead-glazed earthenware. H. 10". (Old Salem Museums & Gardens.)

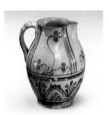

103. Pitcher, Alamance County, North Carolina, 1790–1820. Lead-glazed earthenware. H. 10½". (The Henry Ford.)

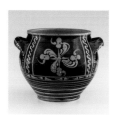

104. Sugar pot, Alamance County, North Carolina, 1785–1810. Lead-glazed earthenware. H. 7½". (Old Salem Museums & Gardens.)

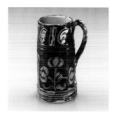

105. Tankard, Alamance County, North Carolina, 1785–1810. Lead-glazed earthenware. H. 9". (The Henry Ford.)

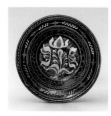

106. Dish, Alamance County, North Carolina, 1785–1810. Lead-glazed earthenware. D. 12½". (The Henry Ford.)

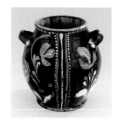

107. Sugar pot, Alamance County, North Carolina, 1790–1810. Lead-glazed earthenware. H. 6¼". (Colonial Williamsburg Foundation.)

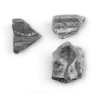

108. Dish fragments recovered at Jacob Albright Jr.'s pottery site, Alamance County, North Carolina, 1795–1820. Bisque-fired earthenware. (Research Labs of Archaeology, UNC-Chapel Hill.)

109. Dish fragments recovered at Jacob Albright Jr.'s pottery site, Alamance County, North Carolina, 1795–1820. Lead-glazed earthenware. (Research Labs of Archaeology, UNC-Chapel Hill.)

110. Dish fragment recovered at Jacob Albright Jr.'s pottery site, Alamance County, North Carolina, 1795–1820. Lead-glazed earthenware. (Research Labs of Archaeology, UNC-Chapel Hill.)

111. Mug fragments recovered at Jacob Albright Jr.'s pottery site, Alamance County, North Carolina, 1795–1820. Lead-glazed earthenware. (Research Labs of Archaeology, UNC-Chapel Hill.)

112. Handle fragment recovered at Joseph Loy's pottery site, Person County, North Carolina, ca. 1833. Lead-glazed earthenware. (Research Labs of Archaeology, UNC-Chapel Hill.)

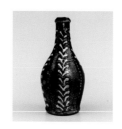

113. Bottle, Alamance County, North Carolina, 1790–1820. Lead-glazed earthenware. H. 6". (Private collection.)

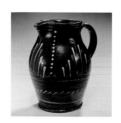

114. Pitcher, Alamance County, North Carolina, 1790–1820. Lead-glazed earthenware. H. 10". (High Museum of Art.)

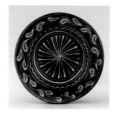

115. Dish, Alamance County, North Carolina, 1790–1820. Lead-glazed earthenware. D. 10⅞". (Old Salem Museums & Gardens.)

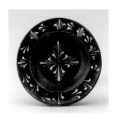

116. Dish, Alamance County, North Carolina, 1790–1820. Lead-glazed earthenware. D. 10⅜". (Old Salem Museums & Gardens.)

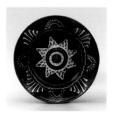

117. Dish, Alamance County, North Carolina, 1790–1820. Lead-glazed earthenware. D. 10". (Old Salem Museums & Gardens.)

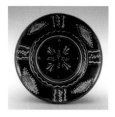

118. Dish, Alamance County, North Carolina, 1790–1820. Lead-glazed earthenware. D. 11". (Colonial Williamsburg Foundation.)

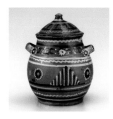

119. Sugar pot, Alamance County, North Carolina, 1790–1810. Lead-glazed earthenware. H. 10". (Old Salem Museums & Gardens.)

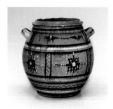

120. Sugar pot, Alamance County, North Carolina, 1790–1820. Lead-glazed earthenware. H. 10½". (Private collection.)

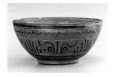

121. Punch bowl, Alamance County, North Carolina, 1790–1810. Lead-glazed earthenware. D. 5¾". (Private collection.)

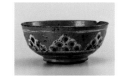

122. Bowl, Alamance County, North Carolina, 1790–1820. Lead-glazed earthenware. H. 3". (Private collection.)

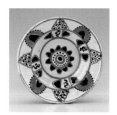

123. Dish, Alamance County, North Carolina, 1800–1835. Lead-glazed earthenware. D. 11½". (Old Salem Museums & Gardens.)

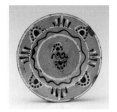

124. Dish, Alamance County, North Carolina, 1800–1835. Lead-glazed earthenware. D. 11½". (Old Salem Museums & Gardens.)

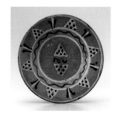

125. Dish, Alamance County, North Carolina, 1800–1835. Lead-glazed earthenware. D. 10⅞". (Private collection.)

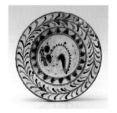

126. Dish, Alamance County, North Carolina, 1800–1835. Lead-glazed earthenware. D. 11". (Old Salem Museums & Gardens.)

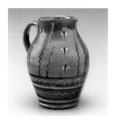

127. Pitcher, Alamance County, North Carolina, 1800–1835. Lead-glazed earthenware. H. 10". (Private collection.)

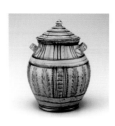

128. Sugar pot, Alamance County, North Carolina, 1795–1820. Lead-glazed earthenware. H. 10". (Old Salem Museums & Gardens.)

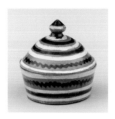

129. Condiment pot, Alamance County, North Carolina, 1795–1820. Lead-glazed earthenware. H. 5". (Old Salem Museums & Gardens.)

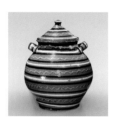

130. Sugar pot, Alamance County, North Carolina, 1790–1820. Lead-glazed earthenware. H. 13". (The Henry Ford.)

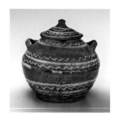

131. Sugar pot, Alamance County, North Carolina, 1800–1820. Lead-glazed earthenware. H. 8". (Private collection.)

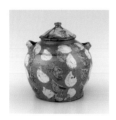

132. Sugar pot, Alamance County, North Carolina, 1800–1830. Lead-glazed earthenware. H. 8". (Old Salem Museums & Gardens.)

133. Sugar pot, Alamance County, North Carolina, 1800–1830. Lead-glazed earthenware. H. 8". (Old Salem Museums & Gardens.)

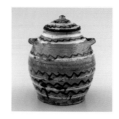

134. Sugar pot, Alamance County, North Carolina, 1800–1830. Lead-glazed earthenware. H. 10". (Private collection.)

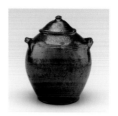

135. Sugar pot, Alamance County, North Carolina, 1800–1830. Lead-glazed earthenware. H. 10". (Private collection.)

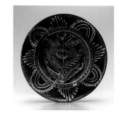

136. Dish, Alamance County, North Carolina, 1790–1820. Lead-glazed earthenware. D. 15¼". (Old Salem Museums & Gardens.)

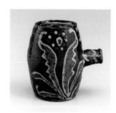

137. Barrel, Alamance County, North Carolina, 1790–1820. Lead-glazed earthenware. H. 6½". (Private collection.)

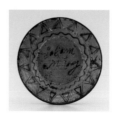

138. Dish, Solomon Loy, Alamance County, North Carolina, 1825–1840. Lead-glazed earthenware. D. 12". (Private collection.)

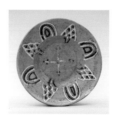

139. Dish, attributed to Solomon Loy, Alamance County, North Carolina, 1825–1840. Lead-glazed earthenware. D. 12". (Private collection.)

140. Dish fragments recovered at Solomon Loy's pottery site, Alamance County, North Carolina, 1825–1840. Bisque-fired earthenware. (Research Labs of Archaeology, UNC-Chapel Hill.)

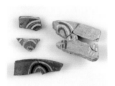

141. Dish fragments recovered at Solomon Loy's pottery site, Alamance County, North Carolina, 1825–1840. Bisque-fired earthenware. (Research Labs of Archaeology, UNC-Chapel Hill.)

142. Dish fragments recovered at Solomon Loy's pottery site, Alamance County, North Carolina, 1825–1840. Bisque-fired earthenware. (Research Labs of Archaeology, UNC-Chapel Hill.)

143. Bowl fragment recovered at Solomon Loy's pottery site, Alamance County, North Carolina, 1825–1840. Lead-glazed earthenware. (Research Labs of Archaeology, UNC-Chapel Hill.)

144. Cream jug, attributed to Solomon Loy, Alamance County, North Carolina, 1825–1840. Lead-glazed earthenware. H. 4". (Private collection.)

145. Hollow-ware fragments recovered at Solomon Loy's pottery site, Alamance County, North Carolina, 1825–1840. Bisque-fired earthenware. (Research Labs of Archaeology, UNC-Chapel Hill.)

146. Dish, attributed to Solomon Loy, Alamance County, North Carolina, 1825–1840. Lead-glazed earthenware. D. 15". (Private collection.)

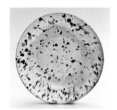

147. Dish, attributed to Solomon Loy, Alamance County, North Carolina, 1825–1840. Lead-glazed earthenware. D. 13½". (Private collection.)

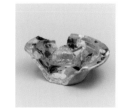

148. Fragmentary bowl recovered at Solomon Loy's pottery site, Alamance County, North Carolina, 1825–1840. Lead-glazed earthenware. (Research Labs of Archaeology, UNC-Chapel Hill.)

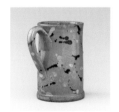

149. Mug, attributed to Solomon Loy, Alamance County, North Carolina, 1825–1840. Lead-glazed earthenware. H. 6⅜". (Old Salem Museums & Gardens.)

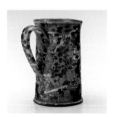

150. Mug, attributed to Solomon Loy, Alamance County, North Carolina, 1825–1840. Lead-glazed earthenware. H. 6½". (Old Salem Museums & Gardens.)

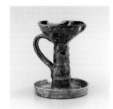

151. Fat lamp, attributed to Solomon Loy, Alamance County, North Carolina, 1825–1840. Lead-glazed earthenware. H. 6⅝". (Old Salem Museums & Gardens.)

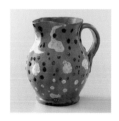

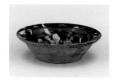

152. Bowl, attributed to Solomon Loy, Alamance County, North Carolina, 1825–1840. Lead-glazed earthenware. D. 6³⁄₁₆". (Private collection.)

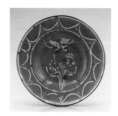

158. Dish, attributed to the Dennis potteries, New Salem, North Carolina, 1790–1832. Lead-glazed earthenware. D. 13½". (North Carolina Pottery Center.)

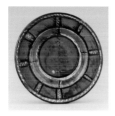

153. Dish, attributed to the William Dennis pottery, New Salem, North Carolina, 1790–1832. Lead-glazed earthenware. D. 13". (Old Salem Museums & Gardens.)

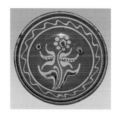

159. Dish, attributed to the Dennis potteries, New Salem, North Carolina, 1790–1832. Lead-glazed earthenware. D. 13¼". (Winterthur Museum.)

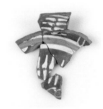

154. Dish fragments recovered at the William Dennis pottery site, New Salem, North Carolina, 1790–1832. Bisque-fired earthenware. (Private collection.)

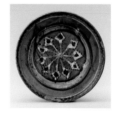

160. Dish, attributed to the Dennis potteries, New Salem, North Carolina, 1790–1832. Lead-glazed earthenware. D. 10½". (Old Salem Museums & Gardens.)

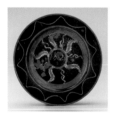

155. Dish, attributed to the William Dennis pottery, New Salem, North Carolina, 1812. Lead-glazed earthenware. D. 13⅛". (Old Salem Museums & Gardens.)

156. Dish fragment recovered at the Thomas Dennis pottery site, New Salem, North Carolina, 1812–1821. Lead-glazed earthenware. (Private collection.)

157. Dish fragment recovered at the William Dennis pottery site, New Salem, North Carolina, 1790–1832. Bisque-fired earthenware. (Private collection.)

Selected References

1815 Tax List of Randolph County, North Carolina. Edited by Winford Calvin Hinshaw. Raleigh, N.C.: WPG Genealogical Publication, 1957.

1820 Tax List of Randolph County, North Carolina. Edited by Barbara N. Grigg and Carolyn N. Hager. Asheboro, N.C.: Randolph County Genealogical Society, 1978.

Armbruster, Thomas, et al. "Recommended Nomenclature of Epidote-Group Minerals." *European Journal of Mineralogy* 18, no. 5 (2006): 551–67.

Barber, Edwin Atlee. *Pottery and Porcelain of the United States: An Historical Review of American Ceramic Art*. Reprint. Watkins Glen, N.Y.: Century House Americana, 1971.

Beckerdite, Luke. "The Life and Legacy of Frank L. Horton: A Personal Recollection." In *American Furniture*, edited by Beckerdite. East Hampton, Mass.: Antique Collectors' Club for the Chipstone Foundation, 2006. Pp. 9–12.

———, and Johanna Brown. "Eighteenth-Century Earthenware from North Carolina: The Moravian Tradition Reconsidered." In *Ceramics in America*, edited by Robert Hunter and Beckerdite. Hanover, N.H.: University Press of New England for the Chipstone Foundation, 2009. Pp. 2–67.

Beeson, Henry Hart. *The Mendenhalls: A Genealogy*. Houston: H. H. Beeson, 1969.

Biographical and Genealogical History of Wayne, Fayette, Union and Franklin Counties, Indiana. Chicago: Lewis Publishing Company, 1899.

Bivins, John, Jr. *The Moravian Potters in North Carolina*. Chapel Hill: University of North Carolina for Old Salem, Inc., 1972.

———. "Slip-Decorated Earthenware in Wachovia: The Influence of Europe on American Pottery." *American Ceramic Circle Bulletin* 1 (1970–71): 93–106.

———, and Paula Welshimer. *Moravian Decorative Arts in North Carolina*. Winston-Salem, N.C.: Old Salem, Inc., 1981.

Blacker, J. F. *The ABC of Collecting Old English Pottery*. 4th ed. London: Stanley Paul and Co., 1900.

Blair, J. A. *Reminiscences of Randolph County*. Reprint. Asheboro, N.C.: Randolph County Historical Society, 1968.

Borg, Ingwer, and Patrick Groenen. *Modern Multidimensional Scaling: Theory and Applications*. Springer Series in Statistics. New York: Springer, 1997.

Bower, Beth A. "The Pottery-Making Trade in Colonial Philadelphia: The Growth of an Early Urban Industry." In *Domestic Pottery of the Northeastern United States, 1626–1850*. Edited by Sarah Peabody Turnbaugh. Orlando, Fla.: Academic Press, Harcourt Brace Jovanovich Publishers, 1985.

Brackner, Joey. *Alabama Folk Pottery*. Tuscaloosa: University of Alabama Press, 2006.

Brown, Johanna. "Tradition and Adaptation in Moravian Press-Molded Earthenware." In *Ceramics in America*, edited by Robert Hunter and Luke Beckerdite. Hanover, N.H.: University of New England Press for the Chipstone Foundation, 2009. Pp. 105–38.

Browning, Mary. "The Potters of Jamestown." *Guilford Genealogist* 14, no. 3 (Spring 1987): 123–28.

Burrison, John A. *Brothers in Clay: The Story of Georgia Folk Pottery*. Athens: University of Georgia Press, 1983.

Carnes-McNaughton, Linda F. "Transitions and Continuity: Earthenware and Stoneware Pottery Production in Nineteenth-Century North Carolina." Ph.D. diss. University of North Carolina at Chapel Hill, 1997.

Chalkley, Lyman. *Chronicles of the Scotch-Irish Settlement in Virginia: Extracted from the Original Court Records of Augusta County, 1745–1800*. 3 vols. Reprint. Baltimore, Md.: Genealogical Publishing Co., 1965–74.

Clark, Walter, ed. *The State Records of North Carolina*. Vols. 11–26. Goldsboro, N.C.: Nash Brothers, 1886–1907.

Clement, Arthur W. "Ceramics in the South." *The Magazine Antiques* 137, no. 2 (February 1951): 136–37.

Craig, James H. *The Arts and Crafts in North Carolina 1699–1840*. Winston-Salem, N.C.: Old Salem, Inc., 1965.

Dennis, Mary Wright. *Thomas Dennis and Some of His Descendants: Circa 1650–1979*. Dublin, Ind.: Prinit Press, 1979.

Erickson, Michelle, and Robert Hunter. "Dots, Dashes, and Squiggles: Early English Slipware Technology." In *Ceramics in America*, edited by Hunter. Hanover, N.H.: University Press of New England for the Chipstone Foundation, 2001. Pp. 94–114

Fabian, Monroe H. *The Pennsylvania-German Decorated Chest*. Reprint. Atglen, Pa.: Schiffer Publishing for the Heritage Center of Lancaster County and the Pennsylvania German Society, 2004.

Faust, Howard. *Faust-Foust Family in Germany & America*. Revised and expanded ed. Baltimore, Md.: Gateway Press, 1984.

Feeger, Luther M. "Our History Scrapbook: Amor Hiatt Potter Shop Recalled in Early History about Milton." *Palladium Item* (Richmond, Ind.), January 30, 1956.

Fogleman, Aaron Spencer. *Hopeful Journeys: German Immigration, Settlement, and Political Culture in Colonial America, 1717–1775*. Philadelphia: University of Pennsylvania Press, 1996.

Fries, Adelaide L. "The Wachovia Historical Society." In *Literary and Historical Activities in North Carolina, 1900–1905*, edited by William Joseph Peale. Raleigh: North Carolina Department of Archives and History, 1907.

———, comp. *Diary of George Stolle*. Raleigh, N.C.: Department of Archives and History, 1968.

Garvan, Beatrice B. *The Pennsylvania German Collection*. Philadelphia: Philadelphia Museum of Art, 1982.

———, and Charles F. Hummel. *The Pennsylvania Germans: A Celebration of Their Arts, 1683–1850*. Philadelphia: Philadelphia Museum of Art, 1982.

Gillingham, Harrold E. "Pottery, China, and Glass Making in Philadelphia." *Pennsylvania Magazine of History and Biography* 54, no. 2 (1930): 98–102.

Glassie, Henry. *The Potter's Art*. Bloomington: Indiana University Press, 1999.

Greenough, John D., Jaroslav Dostal, and Leanne M. Mallory-Greenough. "Incompatible Element Ratios in French Polynesia Basalts: Describing Mantle Component Fingerprints." *Australian Journal of Earth Sciences* 54, no. 7 (2007): 947–58.

———, Leanne M. Mallory-Greenough, and Brian J. Fryer. "Regional Trace Element Fingerprinting of Canadian Wines." Geology and Wine Series 9. *Geoscience Canada* 32, no. 3 (2005): 129–37.

Gustafson, Eleanor. "Endnotes: A Turtle's Tale." *The Magazine Antiques* 177, no. 2 (March 2010): 88.

Häberlein, Mark. "German Migrants in Colonial Pennsylvania: Resources, Opportunities, and Experience." *William & Mary Quarterly* 50, no. 3 (July 1993): 555–60.

Hargrove, Tom. "Geophysical Surveys in North Carolina Archaeology." *North Carolina Archaeological Society Newsletter* 9, no. 2 (Summer 1999): 1–2.

Haworth, Cecil E. *Deep River Friends: A Valiant People*. Greensboro: North Carolina Friends Historical Society and North Carolina Yearly Meeting, 1985.

Heinegg, Paul. *Free African Americans of North Carolina, Virginia, and South Carolina from the Colonial Period to about 1820*. 4th ed. 2 vols. Baltimore, Md.: Clearfield Pub., 2001.

Hinshaw, William Wade. *Encyclopedia of American Quaker Genealogy*. 6 vols. Baltimore, Md.: Genealogical Publishing Co., 1978.

The History of Clinton County Ohio. Chicago: W. H. Beers and Co., 1882.

History of Wayne County, Indiana. 2 vols. Chicago: Inter-state Publishing, 1884.

Holcomb, Brent. *Marriages of Orange County, North Carolina, 1779–1868*. Baltimore, Md.: Genealogical Publishing Co., 1983.

Hunter, Robert. "Staffordshire Ceramics in Wachovia." In *Ceramics in America*, edited by Hunter and Luke Beckerdite. Hanover, N.H.: University Press of New England for the Chipstone Foundation, 2009. Pp. 81–104.

———, and Michelle Erickson. "Making a Moravian Faience Ring Bottle." In *Ceramics in America*, edited by Hunter and Luke Beckerdite. Hanover, N.H.: University Press of New England for the Chipstone Foundation, 2009. Pp. 190–99.

———, Kurt C. Ross, and Marshal Goodman. "Stoneware of Eastern Virginia." *The Magazine Antiques* 167, no. 4 (April 2005): 126–33.

James, Arthur Edwin. *The Potters and Potteries of Chester County, Pennsylvania*. Exton, Pa.: Schiffer Publishing, 1978.

Jones, Rufus M., ed. *George Fox, an Autobiography*. Philadelphia: Ferris and Leach, 1904.

Kamil, Neil. *Fortress of the Soul: Violence, Metaphysics, and Material Life in the Huguenots' New World, 1517–1751*. Baltimore, Md.: Johns Hopkins University Press, 2005.

———. "Hidden in Plain Sight: Disappearance and Material Life in Colonial New York." In *American Furniture*, edited by Luke Beckerdite and William N. Hosley. Hanover, N.H.: University Press of New England for the Chipstone Foundation, 1995. Pp. 233–41.

Kindig, Joe, Jr. "A Note on Early North Carolina Pottery." *The Magazine Antiques* 27, no. 1 (January 1935): 14–15.

Leake, Bernard E., et al. "Nomenclature of Amphiboles." *Mineralogical Magazine* 42 (1978): 533–63.

Lindenberger, Ruth. *Beard Family History and Genealogy*. Privately printed, 1939.

Lounsbury, Carl. *Alamance County Architectural Heritage*. Burlington, N.C.: Alamance County Historic Properties Commission, 1980.

Mashburn, Rick. "Collecting Moravian Antiques." *Early American Life* 19, no. 3 (June 1988): 18–23.

Mendenhall, William, and Edward Mendenhall. *History, Correspondence, and Pedigrees of the Mendenhalls of England and the United States*. Cincinnati, Ohio: Moore, Wilstach, and Baldwin, 1865.

Mérot, Alain. *French Painting in the Seventeenth Century*. New Haven: Yale University Press, 1995.

A Narrative of Some of the Proceedings of the North Carolina Yearly Meeting on the Subject of Slavery within Its Limits. Greensboro, N.C.: Swaim and Sherwood, 1848.

The Old Discipline: Nineteenth-Century Friends' Disciplines in America. Glenside, Pa.: Quaker Heritage Press, 1999.

Orange County, NC Wills. Transcribed by Laura Willis. 13 vols. Melber, Ky.: Simmons Historical Publications, 1997–.

Osborne, Sarah Myrtle, and Theodore Edison Perkins. *Hocketts on the Move: The Hoggatt/Hockett Family in America*. Greensboro, N.C.: S. M. Osborne, 1982.

Otterness, Philip. *Becoming German: The 1709 Palatine Migration to New York*. Ithaca, N.Y.: Cornell University Press, 2004.

Outlaw, Alain C. "The Mount Shepherd Pottery Site, Randolph County, North Carolina." In *Ceramics in America*, edited by Robert Hunter and Luke Beckerdite. Hanover, N.H.: University Press of New England for the Chipstone Foundation, 2009. Pp. 161–89.

Owen, J. Victor. "The Geochemistry of Worcester Porcelain from Dr. Wall to Royal Worcester: 150 Years of Innovation." *Historical Archaeology* 37, no. 4 (2003): 84–96.

———, and John D. Greenough. "Influence of Potsdam Sandstone on the Trace Element Signatures of Some 19th-Century American and Canadian Glass: Redwood, Redford, Mallorytown, and Como-Hudson." *Geoarchaeology* 23, no. 5 (2008): 587–607.

———, and Maurice Hillis. "From London to Liverpool: Evidence for a Limehouse-Reid Porcelain Connection Based on the Analysis of Sherds from the Brownlow Hill (c. 1755–67) Factory Site." *Geoarchaeology* 18, no. 8 (2003): 851–82.

Patents and Deeds and Other Early Records of New Jersey 1664–1703. Edited by William Nelson. Baltimore, Md.: Genealogical Publishing Co., 1976.

Pendery, Steven R. "Changing Redware Production in Southern New Hampshire." In *Domestic Pottery of the Northeastern United States, 1625–1850*, edited by Sarah Peabody Turnbaugh. Orlando, Fla.: Academic Press, 1985.

Peters, Genevieve E. *Know Your Relatives: The Sharps, Gibbs, Graves, Efland, Albright, Loy, Miller, Snoderly, Tillman, and Other Related Families*. Arlington, Va.: G. Peters, 1953. Micro-reproduction of typescript. North Carolina State Library, Raleigh.

Plummer, John T. *A Directory to the City of Richmond*. Richmond, Ind.: R. O. Dormer and W. R. Holloway, 1857.

"The Potters of Alamance County." In Jane Madeline McManus, Ann Marie Long, and Linda F. Carnes-McNaughton, *Alamance County Archaeological Survey Project, Alamance County, North Carolina*. Chapel Hill: Research Laboratories of Anthropology, University of North Carolina, 1986. Pp. 115–22.

Pugh, Hal E. "The Quaker Ceramic Tradition in the North Carolina Piedmont: Documentation and Preliminary Survey of the Dennis Family Pottery." *The Southern Friend, Journal of the North Carolina Friends Historical Society* 10, no. 2 (Autumn 1988): 1–26.

Pursell, Brennan C. *The Winter King: Frederick V of the Palatinate and the Coming of the Thirty Years' War.* Burlington, Vt.: Ashgate Publishing, 2003.

Ramsay, W. Ross H., and E. Gael Ramsay. "A Case for the Production of the Earliest Commercial Hard-Paste Porcelains in the English-speaking World by Edward Heylyn and Thomas Frye in about 1743." *Proceedings of the Royal Society of Victoria* 120, no. 1 (2008): 236–56.

———, and E. Gael Ramsay. "A Classification of Bow Porcelain from First Patent to Closure c. 1743–1774." *Proceedings of the Royal Society of Victoria* 119, no. 1 (2007): 1–68.

———, Anton Gabszewicz, and E. Gael Ramsay. "'Unaker' or Cherokee Clay and Its Relationship to the 'Bow' Porcelain Manufactory." *Transactions of the English Ceramic Circle* 17, pt. 3 (2001): 474–99.

Rauschenberg, Bradford L. "Carl Eisenberg's Introduction of Tin-Glazed Ceramics to Salem, North Carolina, and Evidence for Early Tin-Glaze Production Elsewhere in North America." *Journal of Early Southern Decorative Arts* 31, no. 1 (Summer 2005): 45–103.

———. "Escape from Bartlam: The History of William Ellis of Hanley." *Journal of Early Southern Decorative Arts* 17, no. 2 (November 1991): 80–102.

Records of the Moravians in North Carolina. 11 vols. Raleigh, N.C.: Edwards and Broughton Printing Co., 1922–69.

Register of Orange County, North Carolina Deeds, 1752–1768 and 1793. Transcribed by Eve B. Weeks. Danville, Ga.: Heritage Papers, 1984.

Rhodes, Daniel. *Kilns: Design, Construction, and Operation.* Radnor, Pa.: Chilton Book Company, 1968.

Richman, George J. *History of Hancock County, Indiana: Its People, Industries and Institutions.* Greenfield, Ind.: W. Mitchell Printing Co., 1916.

Roach, Hannah Benner. "Philadelphia Business Directory, 1690." In *Colonial Philadelphians.* Philadelphia: Genealogical Society of Philadelphia, 1999. Pp. 42–43.

Robinson, Peter, Barry L. Doolan, and John C. Schumacher. "Phase Relations of Metamorphic Amphiboles: Natural Occurrence and Theory." In *Amphiboles: Petrology and Experimental Phase Relations.* Reviews in Mineralogy 9B, edited by David R. Veblen and Paul H. Ribbe. Mineralogical Society of America, 1985.

Ross, Sarah Ester, and Mrs. Lewis Grigg. *Levin Ross and Thomas McCulloch with Related Families.* Asheboro, N.C.: Ross, 1973.

Russ, Kurt. "The Fincastle Pottery (44BO304): Salvage Excavations at a Nineteenth-Century Earthenware Kiln Located in Botetourt County, Virginia." *Technical Report Series No. 3.* Richmond, Va.: Department of Historic Resources, 1990. Pp. 11–23.

Sabean, David Warren. *Power in the Blood: Popular Culture and Village Discourse in Early Modern Germany.* Reprint. Cambridge: Cambridge University Press, 1997.

———. *Property, Production, and Family in Neckarhausen, 1700–1870.* Cambridge: Cambridge University Press, 1990.

South, Stanley A. *Historical Archaeology in Wachovia: Excavating Eighteenth-Century Bethabara and Moravian Pottery.* New York: Kluwer Academic/Plenum Publishers, 1999.

Spargo, John. *Early American Pottery and China.* Garden City, N.Y.: Garden City Pub., 1926.

Stephan, Hans-Georg. *Die bemalte Irdenware der Renaissance in Mitteleuropa.* Munich, Germany: Deutscher Kunstverlag, 1987.

St. George, Robert Blair. *The Wrought Covenant: Source Material for the Study of Craftsmen and Community in Southeastern New England, 1620–1700.* Brockton, Mass.: Brockton Art Center, Fuller Memorial, 1979.

Stradling, Diana, and J. Garrison Stradling, eds. *The Art of the Potter.* New York: Main Street/Universe Books, 1977.

Tucker, Ebenezer. *History of Randolph County, Indiana.* Chicago: A. L. Kingman, 1882.

Watkins, Lura Woodside. *Early New England Potters and Their Wares.* Cambridge, Mass.: Harvard University Press, 1950.

Weeks, Stephen B. *Southern Quakers and Slavery: A Study in Institutional History.* Baltimore, Md.: Johns Hopkins University Press, 1896.

Whatley, L. McKay. "The Mount Shepherd Pottery: Correlating Archaeology and History." *Journal of Early Southern Decorative Arts* 6, no. 1 (May 1980): 21–57.

Whatley, Lowell McKay, Jr. *Architectural History of Randolph County, N.C.* Durham, N.C.: City of Asheboro, 1985.

Wilkinson, Leland, et al. *SYSTAT for Windows, Version 5: Statistics*. Evanston, Ill.: SYSTAT, 1992.

Wondrausch, Mary. *Mary Wondrausch on Slipware: A Potter's Approach*. London: A&C Black, 1986.

Young, Andrew W. *History of Wayne County, Indiana*. Cincinnati, Ind.: Robert Clarke and Co., 1872.

Zug, Charles G., III. *Turners and Burners: The Folk Potters of North Carolina*. Chapel Hill: University of North Carolina Press, 1986.

PRIMARY ARCHIVAL SOURCES

Friends Historical Collection, Guilford College, Greensboro, North Carolina

Guilford County Register of Deeds, Greensboro, North Carolina

Monthly Meeting Records, Springfield Monthly Meeting, First Friends Meeting Library, Richmond, Indiana

Moravian Archives, Southern Province, Winston-Salem, North Carolina

North Carolina State Archives, Raleigh, North Carolina

Old Salem Research Files, Museum of Early Southern Decorative Arts, Winston-Salem, North Carolina

Randolph County Register of Deeds, Asheboro, North Carolina

Index

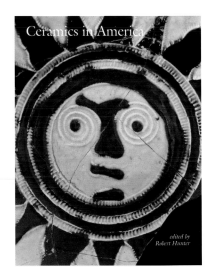

Published Annually
by the
CHIPSTONE FOUNDATION
www.chipstone.org

Distributed By
University Press of New England
upne.com

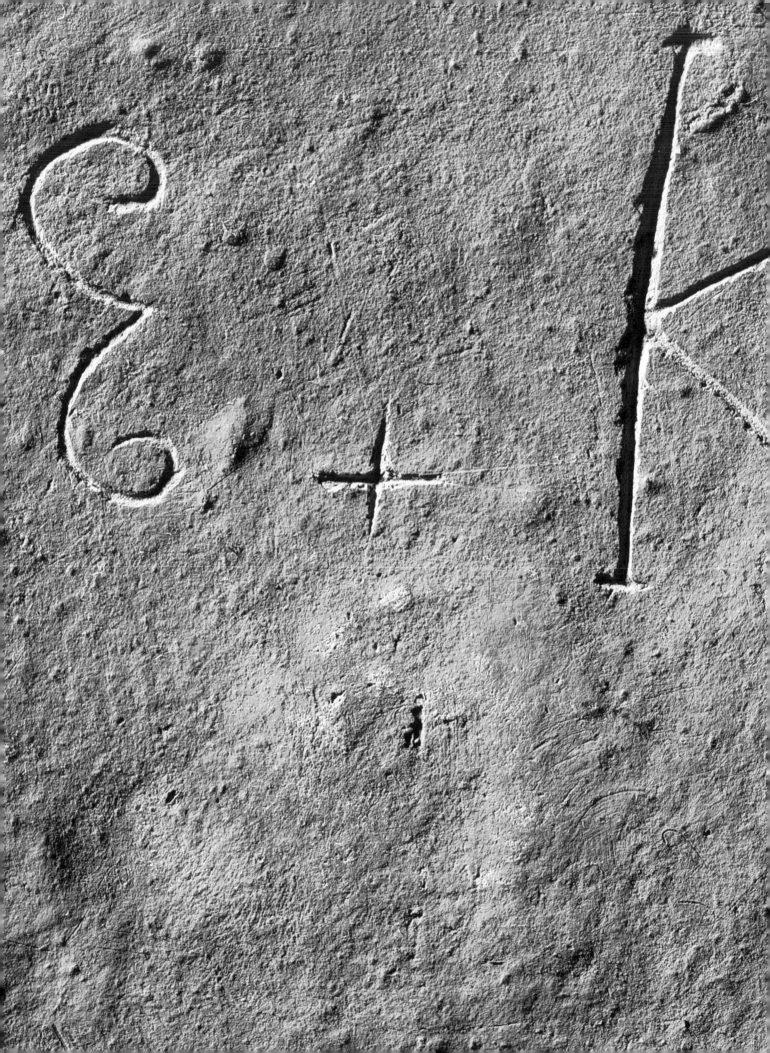